THE STORY OF Disney 100 YEARS OF WONDER

John Baxter, Bruce C. Steele,
and the Staff of the
Walt Disney ARCHIVES

Disney EDITIONS
Los Angeles • New York

Copyright © 2023 Disney Enterprises, Inc. All rights reserved.

The following are some of the trademarks, registered marks, and service marks owned by Disney Enterprises, Inc.: *Astro Orbiter*® Attraction; *Adventureland*® Area; *Adventures by Disney*®; *Audio-Animatronics*® Figure; Aulani, A Disney Resort & Spa; *Big Thunder Mountain*® Railroad; *DinoLand U.S.A.*® Area; *DINOSAUR*® Attraction; Discoveryland; *Disney*®; *Disney California Adventure*® Park; *Disney Cruise Line*® Ships (including *Disney Fantasy*® Cruise Ship, *Disney Magic*® Cruise Ship, and *Disney Wish*® Cruise Ship); *Disney Vacation Club*®; *Disneyland*®; *Disneyland*® Hotel; *Disneyland*® Park; *Disneyland*® Resort; *Disneyland*® Resort Paris; *Disney's Animal Kingdom*® Lodge; *Disney's Animal Kingdom*® Theme Park; *Disney's Animal Kingdom*® Villas—Kidani Village; Disney's Blizzard Beach Water Park; Disney's BoardWalk Inn and Villas; Disney's Contemporary Resort; *Disney's Grand Californian Hotel*® & Spa; *Disney's Hollywood Studios*®; Disney's Polynesian Village Resort; Disney's Typhoon Lagoon Water Park; Disney's Yacht Club Resort; *Dumbo the Flying Elephant*® Attraction; *EPCOT*®; *Expedition Everest – Legend of the Forbidden Mountain*® Attraction; *Fantasyland*® Area; *Frontierland*® Area; Imagineering; Imagineers; "it's a small world;" *It's a Small World*® Attraction; *Kilimanjaro Safaris*® Expedition; *Liberty Square*® Area; *Magic Kingdom*® Park; *Main Street, U.S.A.*® Area; *Mickey's PhilharMagic*® Attraction; *Mickey's Toontown*® Area; Monorail; *New Orleans Square*®; Orbitron; *Pirates of the Caribbean*® Attraction; *Shanghai Disney*® Resort; *Snow White's Scary Adventures*® Attraction; Soarin' Around the World; *Space Mountain*® Attraction; *Tokyo Disney*® Resort; *Tokyo Disneyland*® Park; *Tokyo DisneySea*®; *Tomorrowland*® Area; *Walt Disney Studios*® Park; *Walt Disney World*® Resort; and World Showcase.

Academy Award®, Oscar®, and the Oscar® statuette are registered trademarks and service marks of the Academy of Motion Picture Arts and Sciences. All Rights Reserved.

Buzz Lightyear's Space Ranger Spin Attraction inspired by the Disney and Pixar film *Toy Story 2*.

Blu-Ray™, *Blu-Ray Disc*™, and the logos are trademarks of the Blu-Ray Disc Association.

Cadillac Range Background inspired by the Cadillac Ranch by Ant Farm (Lord, Michels, and Marquez) © 1974.

Dolby and the double-D symbol are registered trademarks of Dolby Laboratories Licensing Corporation. Dolby® Digital © 2023 Dolby Laboratories, Inc. All rights reserved.

Emmy® is a registered trademark of the Academy of Television Arts and Sciences. All Rights Reserved.

Facebook® is a registered trademark of Meta Platforms, Inc.

Golden Globe(s)® is the registered trademark of the Hollywood Foreign Press Association. All Rights Reserved.

Grammy® is a registered trademark of the National Academy of Recording Arts and Sciences, Inc. All Rights Reserved.

The Disney movie *The Great Mouse Detective* is based on the Basil of Baker Street book series by Eve Titus and Paul Galdone.

Hasbro Inc. products Cootie® game, Mr. Potato Head®, Mrs. Potato Head®, Play-Doh®, and Tinkertoys® are registered trademarks of Hasbro, Inc. Used with permission. © Hasbro Inc. All Rights Reserved.

IMAX® is a registered trademark of IMAX Corporation. All Rights Reserved.

Indiana Jones, *Star Wars*, Star Tours, and Willow © & TM Lucasfilm Ltd. All Rights Reserved.

Instagram © 2023 INSTAGRAM. The Instagram Service is one of the Meta Products, provided by Meta Platforms, Inc.

Mattel and Fisher-Price toys used with permission. © Mattel, Inc. All Rights Reserved.

Marvel characters and artwork © Marvel.

The Disney Movie *Mary Poppins* is based on Mary Poppins stories by P. L. Travers.

One Hundred and One Dalmatians is based on the book by Dodie Smith, published by Viking Press.

Pixar properties © Disney/Pixar.

The movie *The Princess and the Frog* Copyright © 2009 Disney, story inspired in part by the book *The Frog Princess* by E. D. Baker Copyright © 2002, published by Bloomsbury Publishing, Inc.

The Rescuers and *The Rescuers Down Under* feature characters from the Disney film suggested by the books by Margery Sharp, *The Rescuers* and *Miss Bianca*, published by Little, Brown and Company.

The Seas with Nemo & Friends Attraction inspired by the Disney and Pixar film *Finding Nemo*.

Technicolor® is a registered trademark of Thompson Technicolor. All Rights Reserved.

TikTok © 2023 TikTok Inc.

Toy Story Mania!® Attraction and *Toy Story Midway Mania!*® Attraction inspired by the Disney and Pixar Toy Story films.

Tony Award® is the registered trademark of American Theatre Wing, Inc. All Rights Reserved.

Wii © Nintendo. Games are property of their respective owners. Nintendo of America Inc. Headquarters are in Redmond, Washington, USA.

YouTube provides its Service through Google LLC, a company operating under the laws of Delaware within the Alphabet Inc. corporate group.

Winnie the Pooh characters based on the "Winnie the Pooh" works by A. A. Milne and E. H. Shepard.

Published by Disney Editions, an imprint of Buena Vista Books, Inc. No part of this book may be reproduced or transmitted in any form or by any means, electronic or mechanical, including photocopying, recording, or by any information storage and retrieval system, without written permission from the publisher.

For information address Disney Editions, 77 West 66th Street,
New York, New York 10023.

Editorial Director: **Wendy Lefkon**
Senior Editors: **Paula Sigman Lowery** and **Jennifer Eastwood**
Senior Manager, Design: **Winnie Ho**
Managing Editor: **Monica Vasquez**
Production: **Marybeth Tregarthen**

Jacketed Hardcover Edition: 978-1-368-06194-0, February 2023
Disney Vacation Club Custom Edition: 978-1-368-09298-2, February 2023
Barnes & Noble Custom Edition: 978-1-368-09799-4, February 2023
FAC-067395-23020
Printed in the United States of America
1 3 5 7 9 10 8 6 4 2
Visit www.disneybooks.com

Logo Applies to the Text Stock Only

To the three women I could never do without: my glorious wife, Gretchen, who makes all my wishes come true; my endlessly interesting and talented daughter, Greer, who inspires me with her sophisticated wit and brilliant music; and my longtime editor and friend, Wendy Lefkon, whose patronage and guidance have allowed me to do what I love best.
—J.B.

To my late parents, Bill and Kaye Steele, who taught me the value of knowing where you came from to get where you're going.
—B.C.S.

To the fans everywhere who find wonder and inspiration in the words and philosophies of Walt Disney. Thank you for keeping alive the incredible legacy of the "Showman of the World."
—The Staff of the Walt Disney Archives

CONTENTS

xii **Introduction**
By Rebecca Cline, Director, Walt Disney Archives

3 **Chapter 1**
Where It All Began

29 **Chapter 2**
Where Do the Stories Come From?

69 **Chapter 3**
The Illusion of Life

105 **Chapter 4**
The Spirit of Adventure and Discovery

133 **Chapter 5**
The Magic of Sound and Music

165 **Chapter 6**
The World Around Us

191 **Chapter 7**
Innoventions

215	**Chapter 8** Your Disney World—A Day in the Parks
249	**Chapter 9** The Wonder of Disney
269	**Chapter 10** We Are Just Getting Started
282	**Acknowledgments**
284	**Index**
287	**Bibliography and Sources**
291	**100 Moments of Wonder**
294	**Image Credits**

I can never
I must explore
I resent the
of my own

stand still.
and experiment....
limitations
imagination.

—Walt Disney

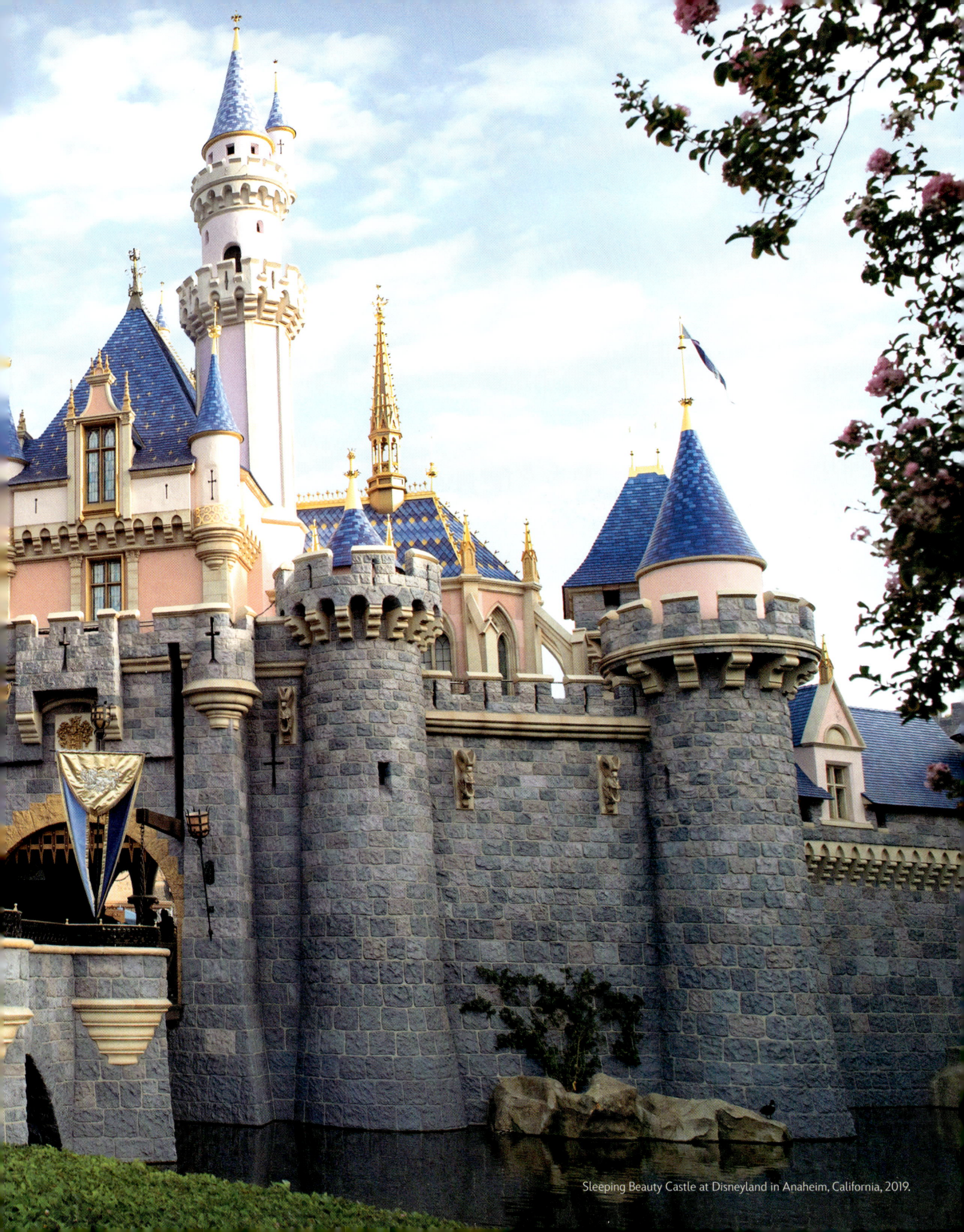
Sleeping Beauty Castle at Disneyland in Anaheim, California, 2019.

INTRODUCTION

A century ago, a young man from Kansas City, Missouri, signed a contract at his uncle's Hollywood home. That contract launched the immediate production of a silent film cartoon series—and a new studio. More importantly, it became the foundation of one of the world's most beloved companies—an entertainment powerhouse that has since produced incomparable stories and characters, tales of adventure and discovery, magic, music, and the wonders of history and nature all over the globe. It was the beginning of The Walt Disney Company!

Looking back, it's difficult to think of any *other* company that uses and shares its own history more than The Walt Disney Company does. Walt Disney's timeless creations are just as popular today as when they were first created many decades ago. Animated feature films like *Snow White and the Seven Dwarfs, Pinocchio,* and *Cinderella* are as fresh and relevant to today's children as they were to their own parents, grandparents, and even great-grandparents who delight in sharing them together. The eternally young Mickey Mouse and his pals are beloved throughout the world on film, television, and streaming and, of course, in person at our theme parks and resorts.

To preserve that unique history, and to make it available perpetually, a very special group was founded halfway through the last century—the Walt Disney Archives. With the passing of Walt Disney in 1966, his brother (and business partner) Roy O. Disney decided to create a formal archive of the company's history, thus the establishment of the Walt Disney Archives in 1970. The mission of the Archives has always been to protect, preserve, and make available for research the history of The Walt Disney Company. Today it is also the mission of the Archives to share that history with fans the world over.

In celebration of Disney's first one hundred years, we at the Walt Disney Archives are thrilled to share a look at our history and Walt Disney's legacy with *Disney100: The Exhibition* and this lovely companion book. When developing this exciting project, we had to decide exactly *how* to tell such a massive story. We quickly realized that a chronological history just would not explain the *magic* that is Disney. We felt our only way forward was by sharing *why* Walt Disney did what he did. What his own philosophies were and how they inspired him to create such wondrous productions and experiences.

Throughout both the exhibition and the book, we present the simple philosophies Walt shared during his amazing career: the importance of storytelling, the addition of personality to beloved characters, the spirit of adventure and discovery, the wonders of the world around us, the magic in beautiful music, and the excitement of experimentation and innovation. These concepts are what made Walt Disney's creations so very unique and special, and they are still the heart and soul of the stories and experiences that The Walt Disney Company produces today. As Walt himself once said, "There's really no secret about our approach. We're interested in doing things that are fun—in bringing pleasure and especially laughter to people. And we have never lost our faith in family entertainment—stories that make people laugh, stories about warm and human things, stories about historic characters and events, and stories about animals."

Please join with us in experiencing this extraordinary once-in-a-lifetime celebration as we take a look at how Walt Disney and the company that he founded have given the world a hundred years of wonder. As Walt himself urged, see how we intend to "keep moving forward"…creating new stories, magical realms, and beloved characters that will enchant and delight our audience for centuries to come.

—Rebecca Cline
Director, Walt Disney Archives
October 2022

ABOVE, TOP: When the Frank G. Wells Building opened on the lot of The Walt Disney Studios in 1997, the Walt Disney Archives offices were among the original tenants. The building's lobby features a window display area managed by the Archives team with items from the collection. Shown is one of the initial presentations.

ABOVE: Disney Legend Dave Smith in the Archives space at the Roy O. Disney Building on the studio lot, 1976.

With Walt, "Let's

it was always, **pretend . . .**"

—Virginia Davis McGhee

Star of Walt Disney's early Alice Comedies

CHAPTER 1

WHERE IT ALL BEGAN

Doc Sherwood's first name is lost to history, but we do know the name of his favorite stallion: Rupert. Sometime around 1909, in Marceline, Missouri, this country doctor asked a young neighbor to draw a portrait of the old man holding his prize horse's halter rope. The boy, just seven years old, had been practicing his sketching abilities, using the pencils and paper given to him by his aunt Margaret. His father, a farmer, didn't seem to approve of one (at any age) wasting time on art.

Young Walter Elias Disney earned a nickel "commission" from Doc Sherwood for that piece—the first money he'd ever made on his own. At the time, "that was the highlight of Walt's life," his brother Roy Oliver Disney later recalled.

Drawing remained a passionate pursuit, something at the core of Walt Disney's life throughout his full, albeit short, sixty-five years. He drew flowers for a fourth-grade assignment (and was rebuked for giving them human faces). He drew caricatures of the customers at a Kansas City barbershop, which the owner framed and hung on the wall. He drew cartoons for his high school newspaper in Chicago. He taught himself animation and started drawing animated cartoons, first as a staffer for a film-ad company, then for his own short-lived Kansas City studio.

By the time he moved to Los Angeles, Walt had realized that drawing was more of a tool than an end point. What drove him, says Ed Ovalle, an archivist with Walt Disney Archives, "was stories, actually creating the story, as opposed to the drawing. He realized that his artistic abilities were limited, so his creativity turned into storytelling." One hundred years later, the worldwide success of The Walt Disney Company is still grounded in story—supported by a lot of drawing.

After Walt and his brother Roy established their company in October 1923, Walt left the cartoon drawing to other artists, but the stories and characters and other ideas sprang from Walt's own imagination: There's a mischievous mouse named Mickey. A fairy-tale hero named Snow White, with

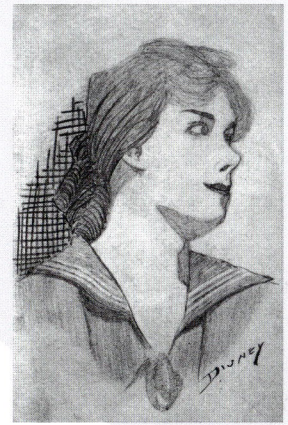 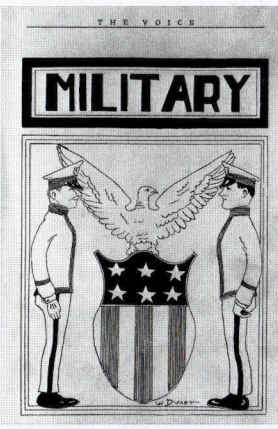 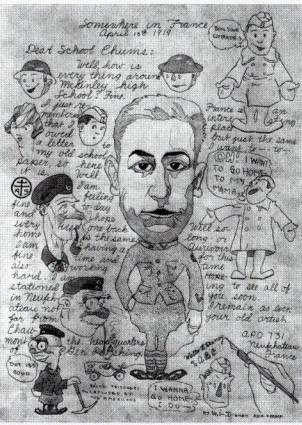

ABOVE (from left): A drawing of a woman by a young Walt Disney, characteristic of his art style (circa 1915). "People say that Walt wasn't a great artist, [that] he didn't draw a lot," said Walt Disney Archives founder Dave Smith in the documentary *Walt: The Man Behind the Myth* (2001). "That was true in later years, but he had an art talent. We have drawings of Walt's that he did when he was 15 years old, and these are very good drawings for a 15-year-old."

In September 1917, five months after America's entry into World War I, a 15-year-old Walt Disney was at last able to have his drawings published when he became a cartoonist for *The Voice*, the magazine of McKinley High School in Chicago.

On April 13, 1919, while serving with the Red Cross Ambulance Corps in France after the end of the War, Walt created this illustrated letter and self-portrait for his former classmates at McKinley.

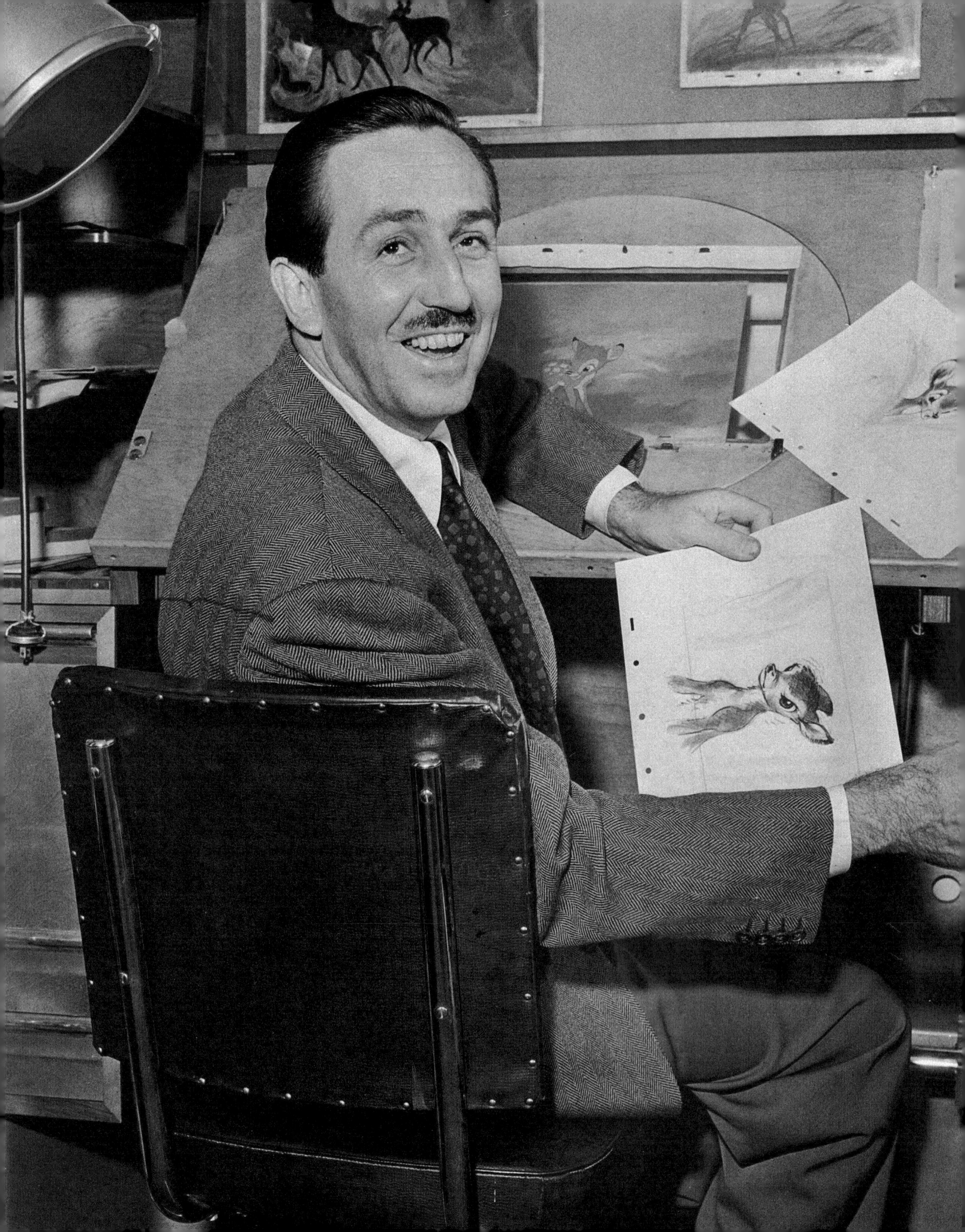

seven memorable men. A new kind of family-fun park he called Disneyland. Along the way, Walt's storytelling came to encompass not just animated films and a theme park, but lifelike Audio-Animatronics figures and frighteningly real sea monsters, television shows, documentary films, transportation innovations, and even a full city.

And always there were more drawings. Many of the best-remembered images of Walt Disney himself are from his weekly television appearances, often standing alongside a concept painting or a map, or pointing out portraits of pirates or ghosts, or sharing the intricately constructed miniature models of wonders to come—illustrations in three dimensions.

The drawing didn't stop after Walt passed away in 1966. The Walt Disney Company has, of course, continued to make heartwarming animated feature films—drafting now with computer styluses—and plans for new, immersive theme park experiences; but its artists have also applied Walt's storytelling philosophy to resort hotels and cruise ships, to Broadway and live theatrical experiences, to streaming television exclusives, and to sports coverage, video games, merchandise, books, and more.

Walt famously said, "I only hope that we never lose sight of one thing—that it was all started by a mouse." True as that is, it's also something of a magician's distraction, because in reality it was all started by a man. Walt Disney's approach to art and life was shaped by his early years, honed by both failures and successes. In many ways, it all began with that commission from Doc Sherwood, which taught him that "maybe he could do something he wanted to do and make a living," says Ovalle. "Back then, he was just a kid, Walter. And, thankfully, we're looking at him now as Walt Disney."

A BOY'S LIFE

To the generation of children who grew up from the mid-1950s through the mid-1960s, Walt Disney was "Uncle Walt," the warm, genial man with the deep, reassuring voice who introduced the stories on the *Disneyland* television series (later renamed *Walt Disney Presents*, then *Walt Disney's Wonderful World of Color*) from its 1954 debut until his 1966 passing.

These core lessons Walt had to impart to his viewers, and his optimistic approach to life, were a lifetime in the making. But they had their seeds in his childhood—most resonantly, the years his family lived in Marceline, Missouri. Walt was born in 1901 in Chicago, the fourth (and youngest) son of Elias and Flora Disney. His closest brother chronologically, Roy, was eight years his senior, and the four boys' only sister, Ruth, arrived two years and one day after Walt. In 1906, when Walt was four, the family

OPPOSITE: Walt Disney at an animation desk during the production of *Bambi* (1942).

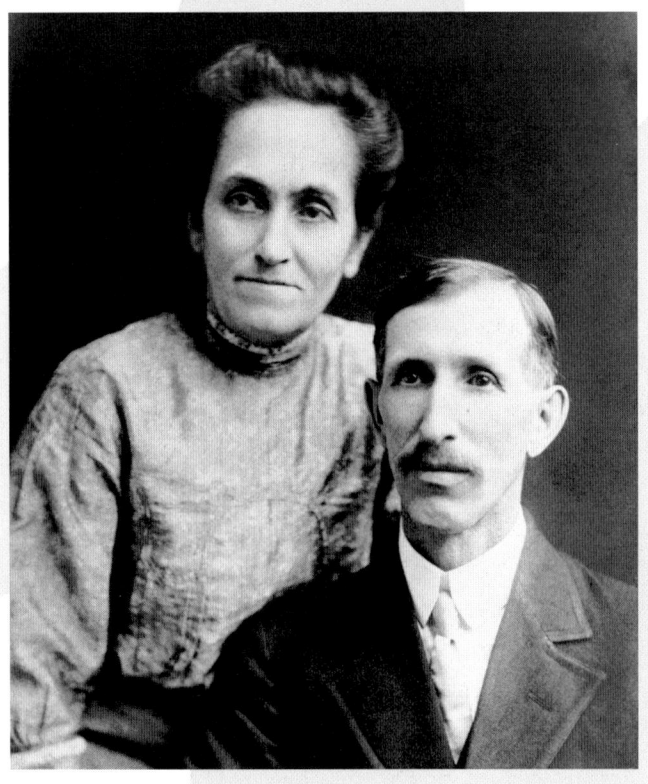
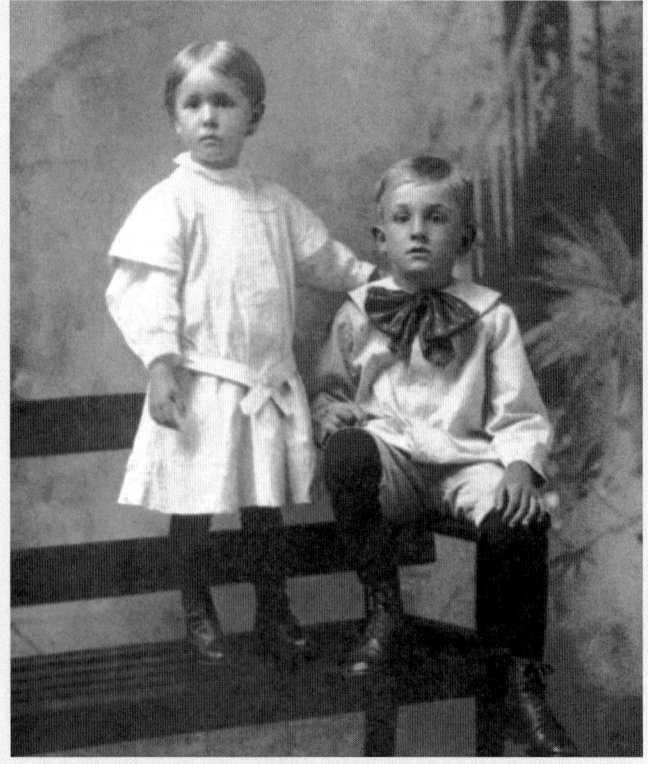

moved from northwest Chicago to rural Marceline, where an uncle owned land and ran an agricultural business. Elias took up farming and moved the family into a house Walt later remembered as having "a wide front lawn [with] big weeping willow trees." Unable to resist spinning a good story, he added that the farm's Wolf River apples were so big that "people came from miles around to see our orchard, to see these big things."

Walt absorbed Marceline into his very soul, where he nurtured his memories of this idyllic village for the rest of his life. Even a brief description of his boyhood in Marceline is rich with foreshadows of his creative pursuits to come. Walt's playground was a nearby countryside with wildlife—rabbits, foxes, squirrels, raccoons, and a wide variety of birds. It was in Marceline that he discovered his love of drawing, learned to sled down snowy slopes, and heard tales of

ABOVE, LEFT: Flora and Elias Disney, Walt's parents, in Kansas City, Missouri, 1913.

ABOVE, RIGHT: Walt (right) with his sister, Ruth, circa 1908.

the Civil War from a veteran of the conflict. As Walt put it in 1938, "To tell the truth more things of importance happened to me in Marceline than have happened since—or are likely to in the future. Things I mean, like seeing my first circus parade, attending my first school, seeing my first motion picture. I know you'll agree with me that such childhood 'firsts' as those are of utmost importance in any human being's life."

Perhaps most important, Marceline owed its existence to the Atchison, Topeka and Santa Fe Railway, and Walt's uncle Mike Martin was an engineer on the line, occasionally staying with the Disney family between his runs from Marceline to Fort Madison, Iowa, and back—a life young Walt no doubt saw as adventurous and exciting, giving him a passion for trains and travel he never lost.

At the end of the school year in 1910, after Walt and Roy's adult brothers deserted the farm and their father, Elias, suffered a health crisis that left him weakened, the remaining Disney family members once again packed up and moved, this time to another big city: Kansas City, Missouri. Yet in some sense, Walt never left Marceline behind. He had loved life in a small town, where everyone seemed to know everyone else, neighbors came visiting, relatives were as close as a nearby farm, and the downtown was a series of shops where people greeted one another by name. It imparted a sense of comfort and belonging he sought to recapture ever after.

Young Walt was not unhappy in Kansas City, but the city generated an impersonal bustle that could be unforgiving of failure, a coldness that just made the warm glow of the home he had lost burn that much brighter. Walt understood that in a small town, everyone is a part of the same story, while in a big city, everyone seems to live separate stories. Not unlike his desire to build a campus-like movie studio lot, the Disneyland project was his attempt to reclaim that sense of a shared narrative—not just on Main Street, U.S.A., but in each of the other lands as well. Watching Walt introduce a Frontierland story on the *Disneyland* television series, Ovalle explained, you knew "you were going to get to visit Frontierland. You weren't just watching it on the screen. You were part of the whole story." Marceline informed not just Main Street, U.S.A., but all of Disneyland, as the sense of inclusion and optimism that permeated the entire park. As critic Anthony Lane wrote in *The New Yorker* in 2006, "That was Disney's own contention—that we all had a Marceline, Missouri, secreted in our hearts, or deep in our common memory, and that his task was to set it free."

Walt had other lessons to learn growing up in Kansas City, where he lived from age eight into young adulthood. Perhaps the most-often-told Walt story from that time recounts his years delivering newspapers with his brother Roy. The boys' father had invested in a distribution deal with the *Kansas City Times*, a morning newspaper published Mondays through Saturdays, and the *Kansas City Star*, a daily afternoon newspaper that also published Sunday

Continues on page 14.

History and Nostalgia

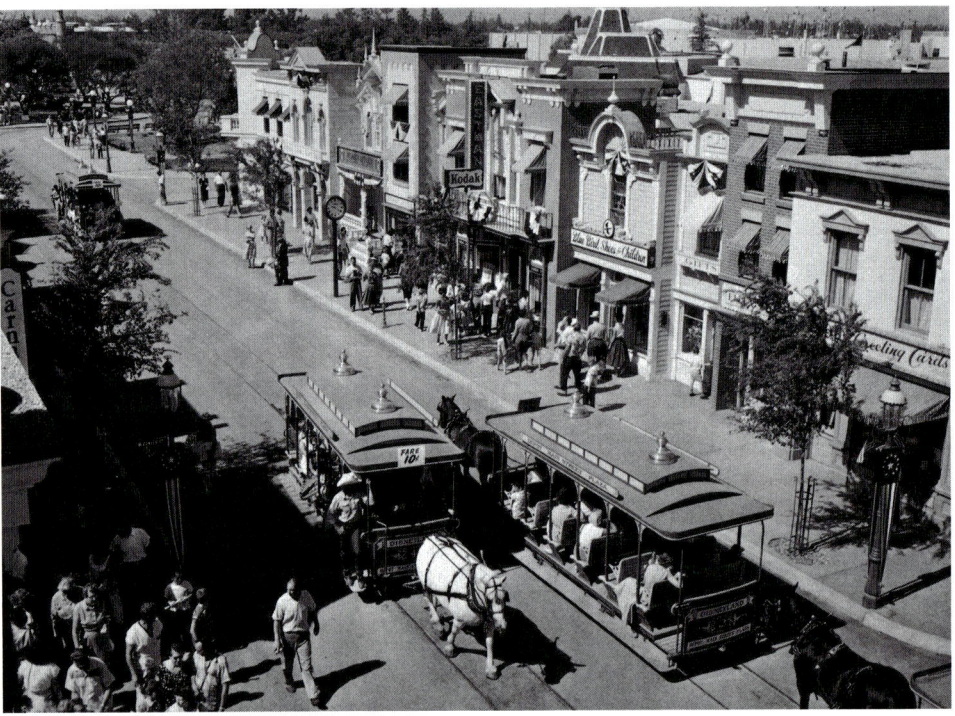

On one side of the Disney farm in Marceline, Missouri, lived Doc Sherwood (and his wife)—the man who gave Walt the boy artist his first cash commission. On the other side lived the Taylors. Erastus Taylor, whom relatives and friends alike called "Grandpa Taylor," was a Civil War veteran in his nineties who shared his stories with his young neighbor. The yarns had a dual effect on Walt, at least as he recalled in his later years. They helped spark a lifelong love of history—particularly the Civil War period, and the president who forged a nation somehow through it, Abraham Lincoln—and they helped him to understand the difference between the facts and the tales that could be spun from those facts. "I don't think he ever was in a battle in the Civil War," Walt recalled playfully of Grandpa Taylor, "but he was in all of them."

History is full of great stories, Walt Disney archivist Ed Ovalle noted, so it's no surprise that a natural-born storyteller like Walt would be fascinated by the past: "It's the great stories of the time—the things he grew up with." Dramatic eras such as the Civil War period and the Old West of the late 1800s, Ovalle observed, "[were history Walt] caught the tail end of . . . as he was growing up." Walt met people like Grandpa Taylor and Doc Sherwood who had lived through times that seemed long ago to Walt, yet simultaneously provided immediacy and a distance that fed his fascination and informed much of the storytelling that would come later from The Walt Disney Company. As Walt grew older, he loved reading the works of Mark Twain, Robert Louis Stevenson, and Walter Scott—authors who specialized in the transformation of history into narrative.

ABOVE: An early image of Main Street, U.S.A. at Disneyland, evoking a turn-of-the-twentieth-century feel, 1955.

The word "nostalgia" is most often used to refer to a fond recollection of one's own past, but Walt Disney broadened the concept to a community level. Walt and his team created a dreamscape version of small-town Americana, inspired by places like Marceline, in the form of Main Street, U.S.A. at Disneyland. He was re-creating a replica not so much of a precise place from his childhood but of a feeling he wanted to communicate—friendliness, beckoning, familiarity—a feeling guests could share even if they had no personal connection to any such time or place. "Anyone could feel the optimism in the variety and sheer exuberant quantity of decorative detail lavished on every surface," wrote scholar Karal Ann Marling in the aptly named book *Designing Disney's Theme Parks: The Architecture of Reassurance*. "On Main Street, life suddenly seemed pleasant, manageable and, well—awfully nice."

Walt underlined the sense that this street was nowhere specific and yet everywhere all at once by appending "U.S.A." to its name. He made sure, as Marling noted, "familiar things . . . have somehow grown sweeter, gentler, and more appealing than they ever were in Fort Collins [Colorado] or Marceline"—both of which partially inspired the design of Main Street, U.S.A.—"or [your] own hometown."

In a similar sense, Frontierland at Disneyland represented both the historical time and place, and the romanticized version of the pioneer days that a boy growing up in Marceline would have gleaned from stories about the Old West. "Disney was far too smart to believe that the American public wanted an exact reconstruction [of the past]," observed writer Christopher Finch in his book *Walt Disney's America*. "He understood very well that nostalgia tends to blur images. What he did [with Disneyland] was to take those misty images and give them a renewed sharpness of detail that was well researched and faithful to its sources, but which eliminated imperfections and evidence of decay."

In the theme parks and many of the stories told by The Walt Disney Company across the past one hundred years, Walt Disney's childhood remains a vibrant and alluring place to visit.

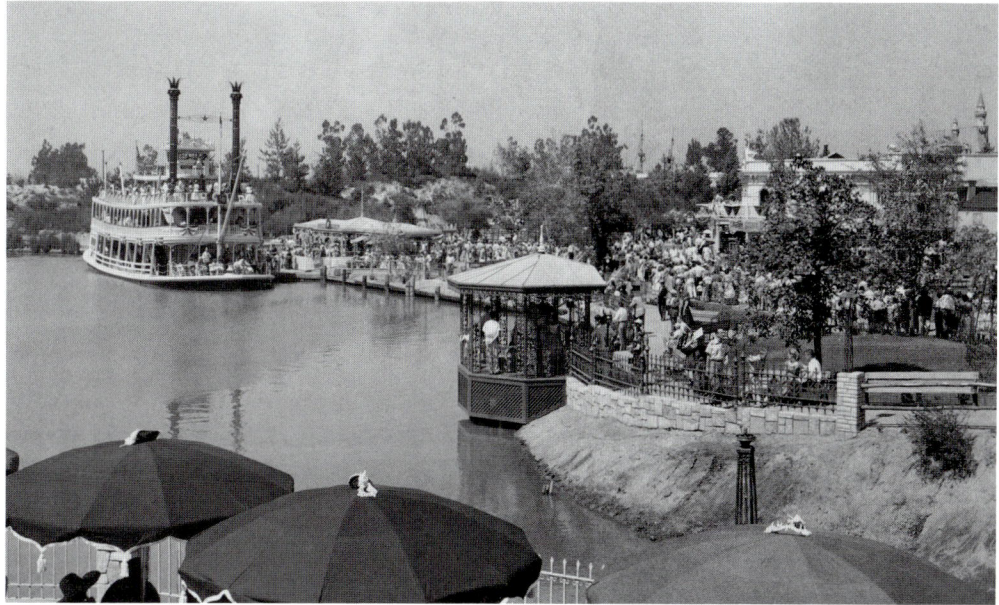

ABOVE: The *Mark Twain* Riverboat and other features of Frontierland recall the mid-nineteenth century, 1955.

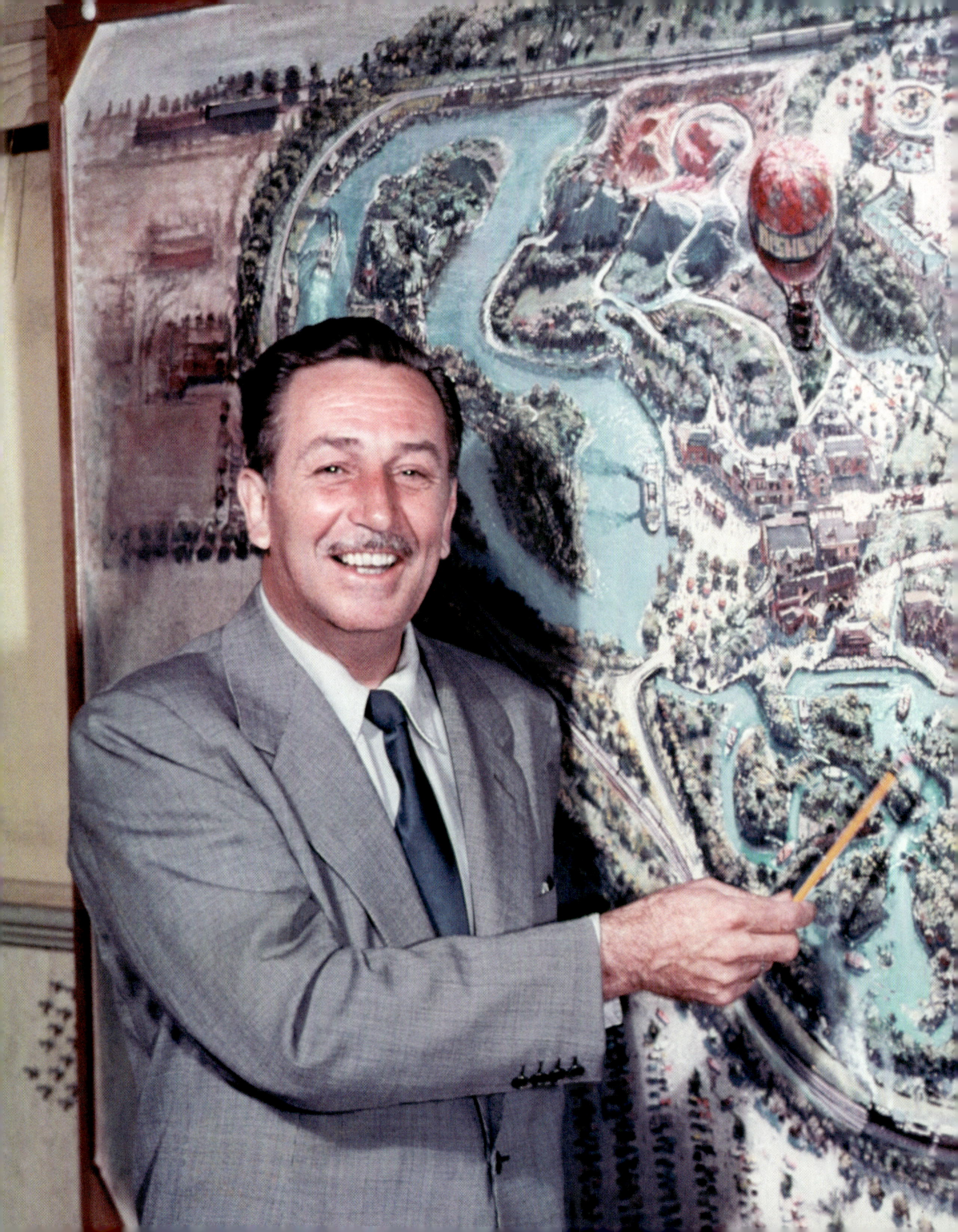

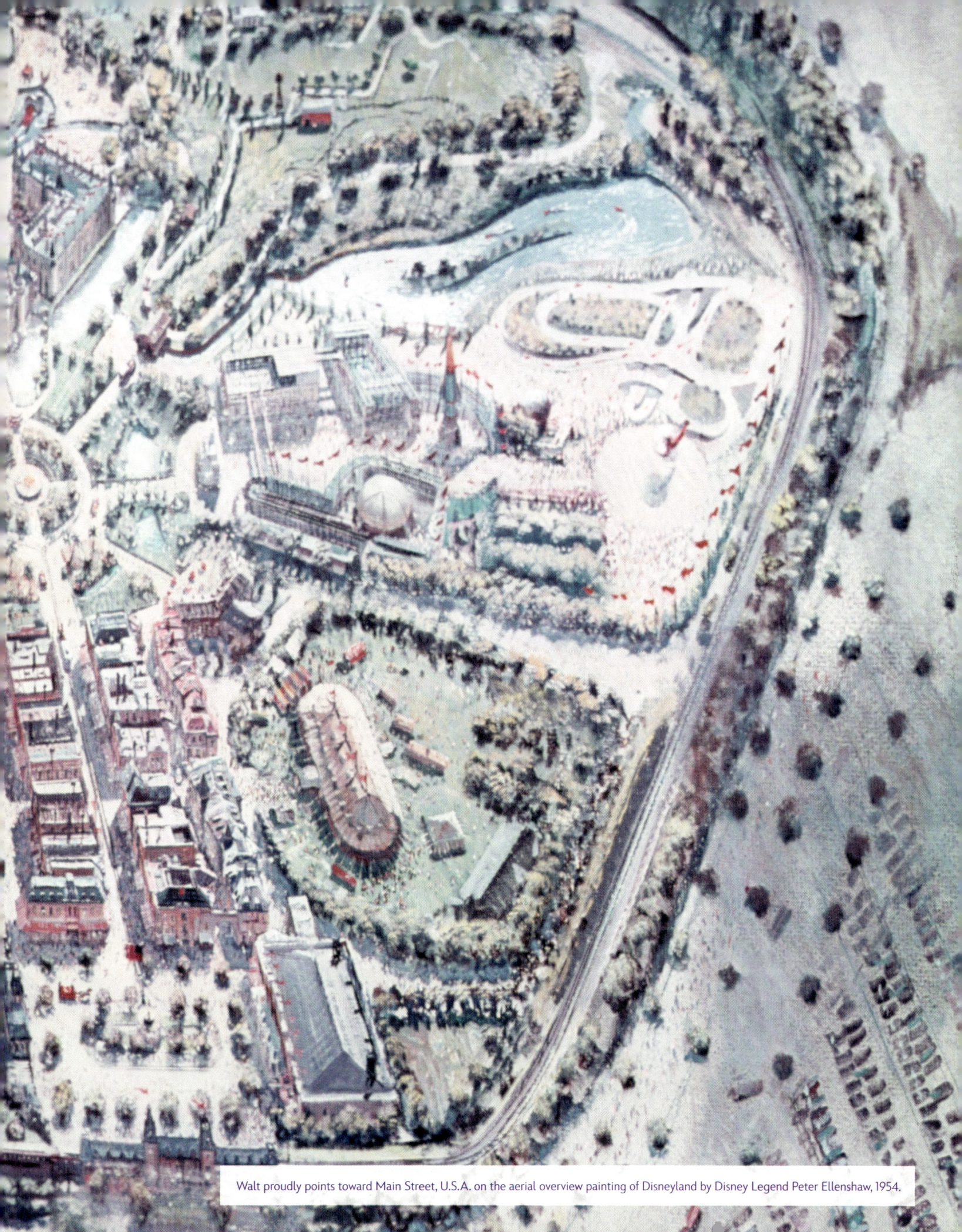
Walt proudly points toward Main Street, U.S.A. on the aerial overview painting of Disneyland by Disney Legend Peter Ellenshaw, 1954.

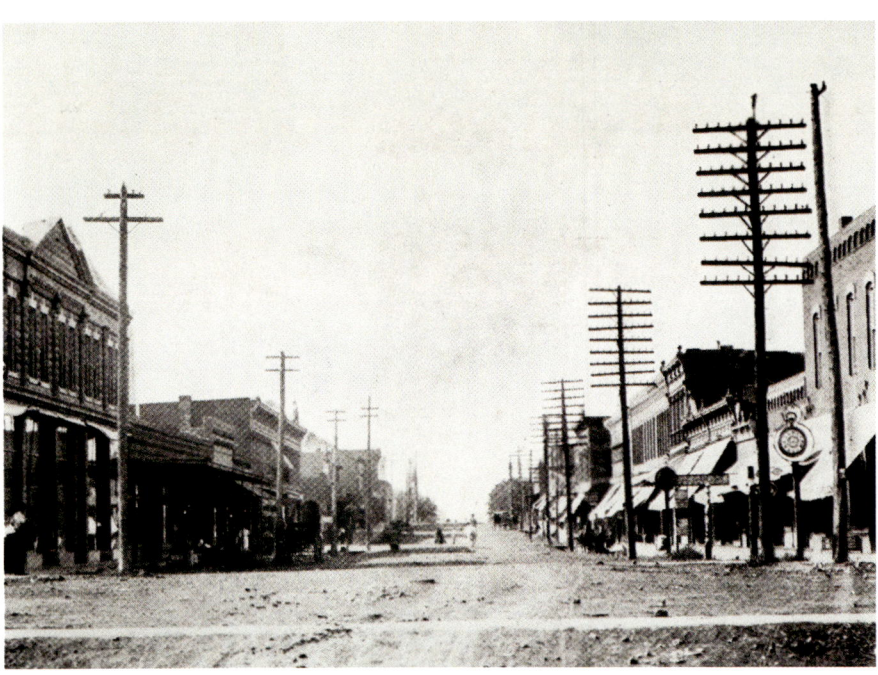

RIGHT: Walt and his team designing Main Street, U.S.A. at Disneyland (illuminated here in 2014 with nighttime show lighting) drew on Fort Collins, Colorado; Marceline, Missouri; and other turn-of-the-twentieth-century small American towns for inspiration.

ABOVE, TOP: A postcard photograph of downtown Marceline (from around the turn-of-the-twentieth-century) reveals its similarities to Main Street, U.S.A.—and its differences.

ABOVE: Walt understood that in a small town, everyone is a part of the same story. His desire to build a campus-like movie studio lot was, similar to his goals with Disneyland, an attempt to reclaim that sense of a shared narrative. The result was Walt's studio lot in Burbank, California, circa early 1940s.

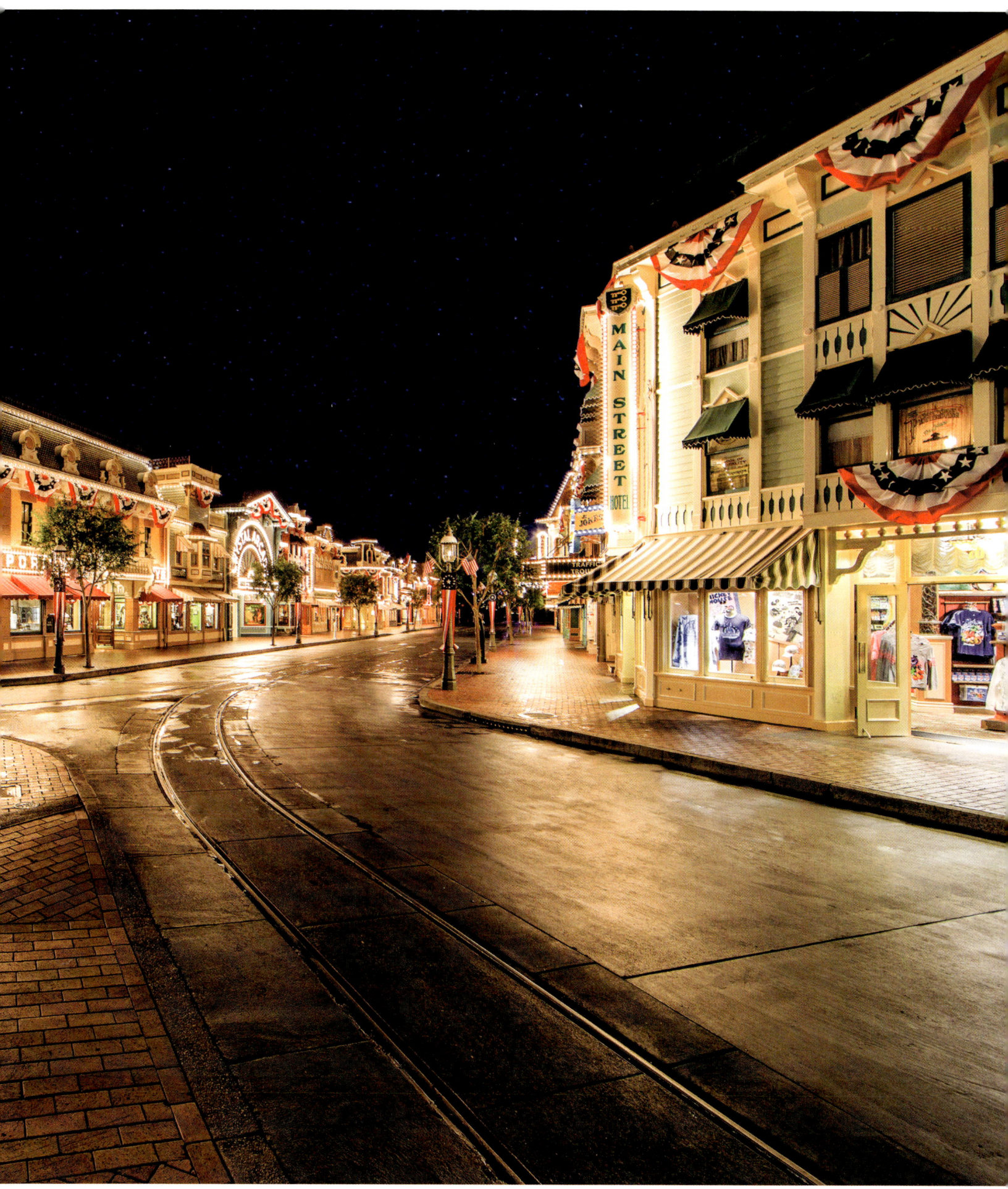

Continues from page 7.

mornings. Elias assigned his sons to deliver the seven hundred newspapers a day he was under contract to provide customers, which meant getting up by 3:30 a.m. to retrieve the newspapers at 4:00 a.m. and finishing the morning routes before school. Elias took the pay himself, providing the boys only a small allowance.

The contract ended up lasting six years, but Roy helped for only the first two years before he left home, at age nineteen. Other boys were hired to assist, but if they were out sick, Walt had to take on their routes as well as completing his own. According to Walt's biographer, Bob Thomas, "Until late in his life, Walt Disney had a recurring dream in which he suffered torment because he failed to deliver some newspapers along his route."

The newspaper route responsibilities instilled in Walt an appreciation for hard work, certainly, and helped him hone his entrepreneurial skills early on. Plus, In addition to the paper routes, Walt was selling fresh butter door-to-door with his mother, hawking newspapers on street corners, and even taking a summer job as a "news butcher" at age fifteen on the railroad. A news butcher paid for a daily allotment of newspapers, fruit, candy, cigars, bottles of soda, and other items, then (hopefully) made a profit by reselling the goods to passengers. Roy, by then a bank teller in Kansas City, provided Walt the capital he needed to start the job, but rotting fruit, lost soda bottles, stolen inventory, and other mishaps drained away Walt's profits. At the end of the summer, Roy had lost his $15 investment. It was far from the last time Roy would find the money to stake his little brother's ambitions, but Walt's future endeavors were more carefully considered.

Walt's youth of constant work also taught the youngster the value of precious and fleeting leisure time. He filled his rare free intervals with amusements that presaged

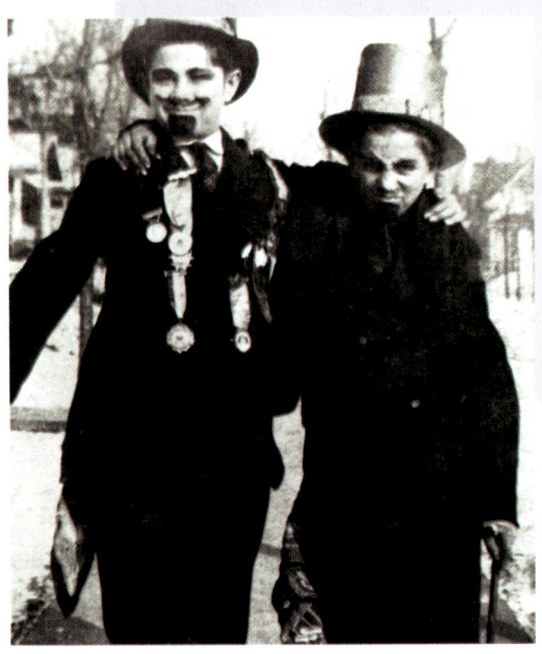

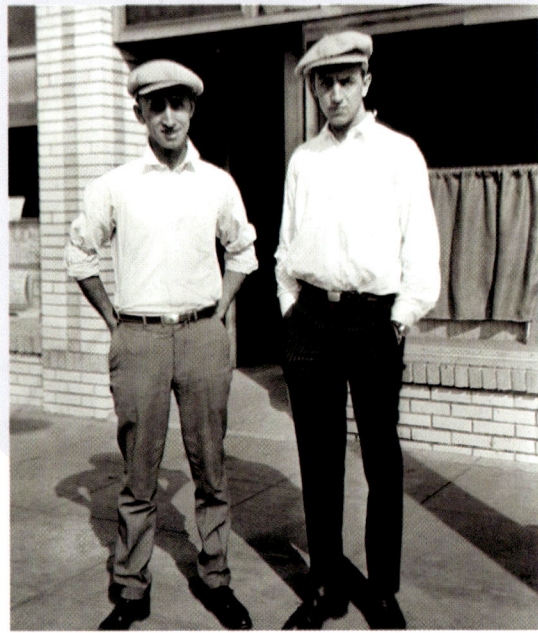

ABOVE, LEFT: Walt and his friend Walter Pfeiffer (left) in Kansas City, Missouri, dressed as vaudeville players for "The Two Walts," one of their amateur-night performance acts, circa 1916.

ABOVE, RIGHT: Roy O. Disney (left) with Walt in front of their Disney Brothers Cartoon Studio on Kingswell Avenue in Los Angeles, circa 1924.

his adult life: drawing, certainly, but also immersing himself in some of the best storytelling in the world. He read everything he could find by Mark Twain, as well as novels by Robert Louis Stevenson and Charles Dickens—all of whom wrote works The Walt Disney Company would later bring to audiences in movies such as *Treasure Island* (1950) and *Oliver & Company* (1988) . . . and in the *Mark Twain* Riverboat and Tom Sawyer Island at Disneyland. Walt was far from a bookish loner, however, and he sought out live entertainment whenever it was available. He loved the circus, silent motion pictures (where he saw an early version of the *Snow White* story), plays (including *Peter Pan*), and vaudeville shows—this last becoming an inspiration for the entertainment at The Golden Horseshoe at Disneyland decades later.

He wasn't always a spectator, either, having early experiences producing and acting for local shows. On at least one occasion, Walt got into the act himself, as his sister, Ruth, related. "There was a small show—a motion picture house close to us that we went to often, and they got to having amateur nights," she recounted. "We were there and the man came out and said now he's gonna juggle some chairs with a boy sitting on top . . . the boy was Walt and all the family was surprised. Mother said he was as white as a ghost—three or four chairs up." For days after these shows, Walt and his best friend, Walter Pfeiffer, would tell the jokes and perform the songs from vaudeville performers they had seen, or act out scenes from movie shorts. That repertoire of gags would become a valuable resource for a director of animated cartoons years later. There's more than a little vaudeville in Mickey Mouse.

Walt's acting sometimes took on more elaborate forms. "On Lincoln's birthday, Walt came to school all dressed up like Lincoln," Pfeiffer recalled of Walt's fifth-grade effort to pay tribute to the sixteenth president. "He made this stovepipe hat out of cardboard and shoe polish. He got the beard—he went down to a place that had theatrical things to sell and purchased it. . . . He had memorized [the Gettysburg Address]. Walt got up in front of the class and the kids thought this was terrific, so [Principal] Cottingham took him to each one of the classes in the school. . . . Walt loved that." Walt's admiration for Abraham Lincoln lasted his entire life and inspired both Great Moments with Mr. Lincoln, created initially for the 1964–1965 New York World's Fair, and later The Hall of Presidents in the Magic Kingdom at the Walt Disney World Resort. On another occasion, young Walt played the lead role in a skit called "Charlie Chaplin and the Count," a bit he did with Pfeiffer that earned them twenty-five-cents and the fourth prize in an amateur-night competition.

Acting was a skill that much later served Walt well in the creation of animated films. "Walt's acting and storytelling ability were an important feature in the success of the studio," Disney animation director Ben Sharpsteen asserted. "He had a terrific personality for telling stories . . . [and] could tell a story so that you could see it as it would appear on the screen. I cannot give the man too much credit."

Disney animators would occasionally shoot reference footage—that is, a live-action performance of the scene to be animated. Although Walt was the original voice of Mickey Mouse, he was also filmed acting out the moment that Mickey comes face-to-face with a bear in the short *The Pointer* (1939). Walt didn't want to be able to see the camera, so it was set up at some distance. On the resulting film footage, animators Frank Thomas and Ollie Johnston related in their book *Disney Animation: The Illusion of Life*, "our image . . . was very tiny, but it still captured the essence of his acting . . . [and] it paid off in a memorable little sequence that reflects Walt's thinking completely." After *The Pointer* was finished, the reference film disappeared forever. (Walt was filmed or photographed as he recorded Mickey's voice on other occasions, too, most notably with Billy Bletcher as Pete for the 1940 cartoon *Mr. Mouse Takes a Trip*.)

PLANE CRAZY

Walt was just fifteen when the United States entered World War I in April 1917. As the fighting continued, Roy Disney enlisted in the U.S. Navy; Walt wanted to join Roy and another brother, Ray, and be a part of the nation's armed services, but he was rejected because of his age. Elias and Flora had moved back to Chicago in the spring of 1917, where Elias had invested in the O-Zell company's jelly factory, and Walt had joined them and enrolled at McKinley High School that fall, after his summer as a news butcher. Once in Chicago again, Walt, in addition to attending school and taking evening classes at Chicago's Academy of Fine Arts, held some more mainstream jobs with the elevated railway (as a guard) and the U.S. Postal Service, sorting letters and emptying mailboxes.

But by the end of the summer of 1918, he was desperate to head overseas. His determination convinced his mother, who forged Elias's signature on a passport application—which Walt then altered to assert that he was seventeen, a year older than he actually was. That allowed him to join the Ambulance Corps, a division of the Red Cross. Walt, however, didn't ship out until November 18, 1918, a week after the armistice initially halting the conflict was signed. Still, Walt was eager for the adventure. "He was there a little under a year, driving ambulances and then doing chauffeur work," explained archivist Ed Ovalle. "It's just something I think Walt, who was proud to be an American, had to do. He was answering the call."

It was a formative time in the teenager's life. "The things I did during those ten months I was overseas added up to a lifetime of experience," Walt recalled. "I know being on my own at an early age . . . made me more self-reliant." After passing through Paris, where the streets were still filled with soldiers, Walt found himself briefly stationed more than 300 kilometers to the southwest,

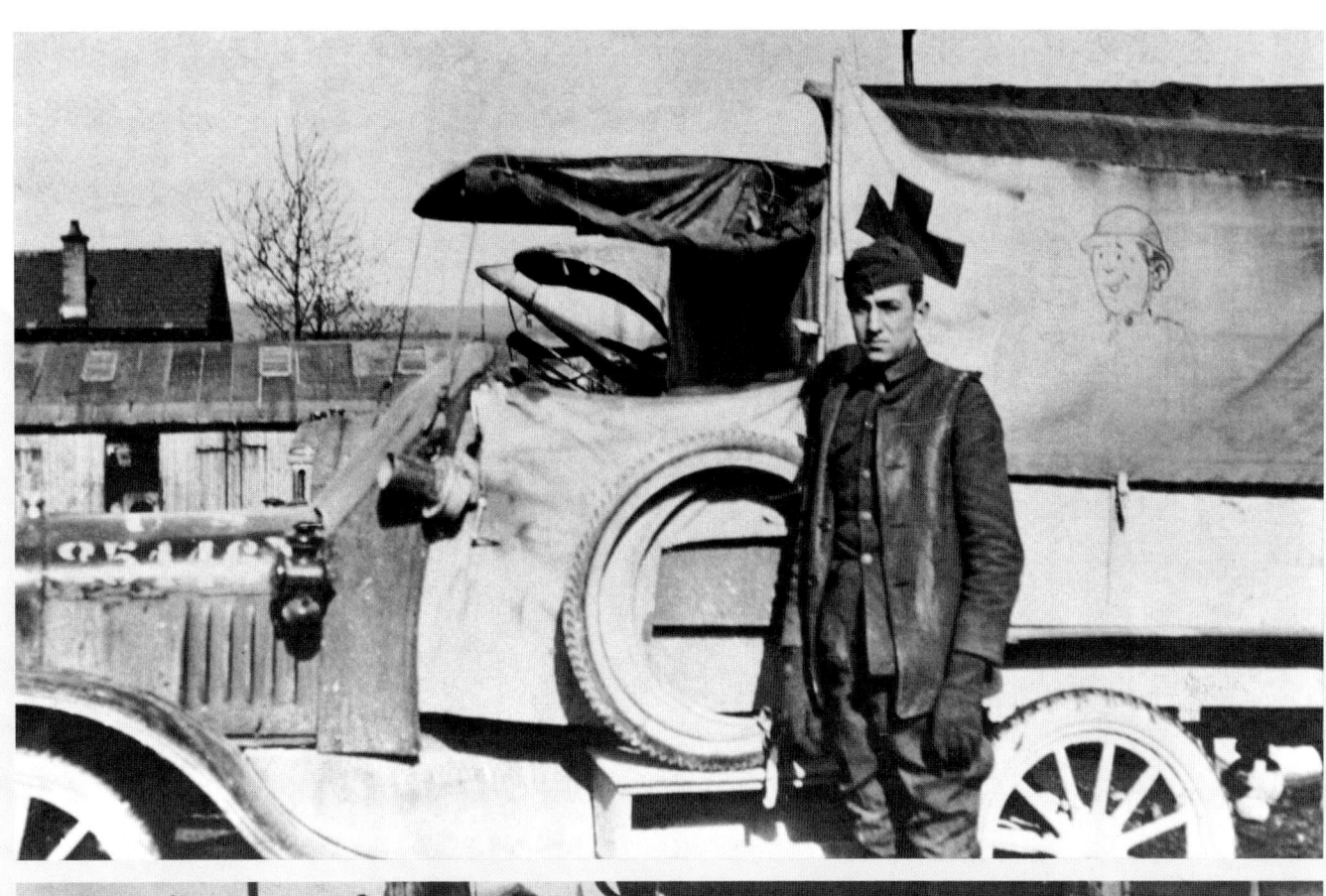

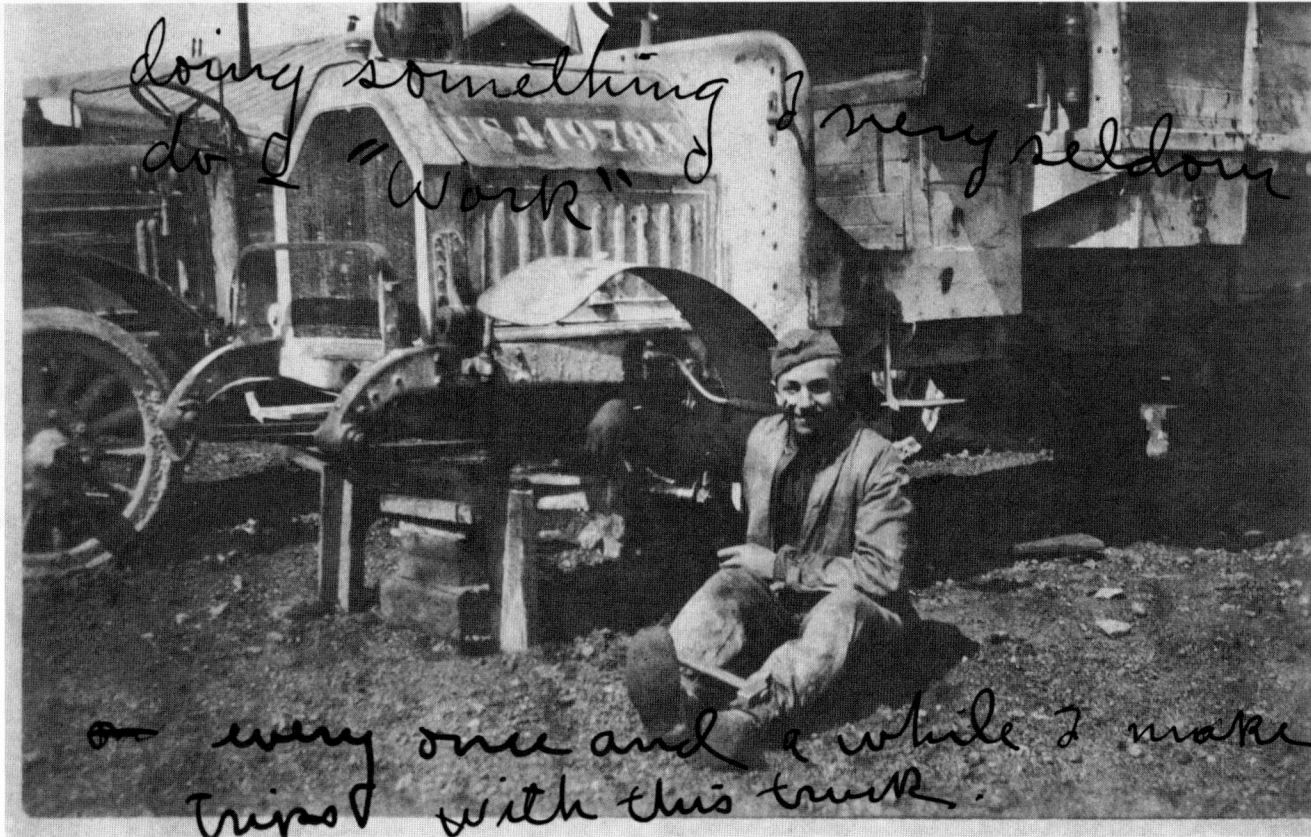

doing something I very seldom do — "Work" every once and a while I make trips with this truck.

ABOVE, TOP: Walt Disney with an ambulance he drove in France, circa 1919, with a cartoon he drew on the vehicle's the canvas.

ABOVE: A snapshot of Walt he captioned before sending home.

in a small town called Saint Cyr. There he celebrated his seventeenth birthday at a café with freshly minted friends who left "Diz" to pick up the tab. In the months that followed, Walt drove ambulances, trucks, and sedans all over the country. As Thomas Price, a volunteer docent at The Walt Disney Family Museum, recounted in 2012, "Walt, who had never been further west than Colorado nor east of the Mississippi [River], absorbed everything. He shimmied up a tree to catch a glimpse of President Woodrow Wilson in Paris and played poker and chauffeured [U.S.] Army bigwigs around town."

The Red Cross reassigned Walt, first to Neuilly-sur-Seine, a commune just northwest of Paris, and later to Neufchateau, a village closer to the border between France and Germany. Price reported that Walt would take in the picturesque elements of these environments and even returned to drawing for small commissions in his free time, with jobs ranging from menu sketches for the local canteen to caricatures for his friends to send back home. Much of the money he made from his driving and his artworks he sent home to his mother, to keep for him—a nest egg he would soon need.

The experience abroad also reignited interest in another one of Walt's fascinations: airplanes and flight, though it was still in its relative infancy. Back in Missouri, in 1911, Roy had heard that the daring aviator Calbraith Perry Rodgers was landing to refuel in a field not far from Kansas City during his attempt to be the first pilot to fly all the way across the United States, from Sheepshead Bay (a neighborhood in Brooklyn, New York) to Long Beach, California. Roy grabbed his brother Walt, who was then nine years old, and headed out to see the adventurer. The airplane the brothers saw Rodgers piloting was a bi-wing Wright Model EX with a skeletal tail and no real cockpit, just a central seat with the necessary flight controls. "When [Walt] saw that, he was just amazed at this plane and that somebody could do this," Ovalle related, paraphrasing an account from Walt himself. "It got him thinking about flight."

Needless to say, Walt was intrigued by all the airplanes filling the skies of France during his time with the ambulance corps. When he crossed paths with those working on a plane one day during his transport duties, he went right up to them. According to Ovalle, the young Walt pressed forward: "So he asked the mechanic, 'Think I can go up in this plane?' And he said, 'Well, no, of course not. This is for French military.' Walt had saved money to go to Paris, and he said, 'Well, how about if I give you 50 francs?' That was enough to make a French aviation mechanic 'wink at the law,' as Walt called it, and Walt was just so excited to be flying."

It was quite an adventure for an American teenager in 1919, and it illustrates the nature of Walt's fascination with technology. Mechanical—and later, electronic—inventions were interesting on their own merits, certainly, but they grabbed Walt's attention primarily as tools to produce memorable experiences. Walt would finally enjoy what he considered the ultimate flying experience in 1965, Ovalle

related, "taking off from the USS *Kitty Hawk*, the aircraft carrier. As he told the commander of the *Kitty Hawk*, it was 'probably one of the best moments of my life.'" It was a moment Walt had been ready for since he'd seen that rickety Wright Model EX in a Missouri field. One can only imagine how much he would have loved sailing over the Great Pyramids of Egypt in Soarin' Around the World at a Disney theme park.

THE VALUE OF FAILURE

The Walt who had left for France was a boy, but the Walt who returned to Chicago was on the cusp of manhood: five feet ten inches tall, and a lean and muscular 165 pounds. He declined his father's offer of a job in the jelly factory and headed back to Kansas City, where Roy had resettled after leaving the U.S. Navy. Both Walt and Roy had rooms in the home of their older brother Herbert and his wife, which had a separate garage that would later prove useful. Plus, Walt also had the savings he had built up during his ten months in France.

There were setbacks. But Walt adjusted. Failing to get the newspaper cartoonist job he dreamed of, Walt worked as an apprentice commercial artist for a company that created short film ads shown in movie theaters before the feature. He researched animation techniques at the Kansas City Public Library and added gags of his own to improve the quality of the firm's animated output. At the same time, he worked nights in a makeshift studio in the garage, using his nest egg to buy the equipment he needed to create animated shorts on commission for the Newman Theater Company, which owned three Kansas City movie houses.

In May 1922, at age twenty, Walt quit his day job and incorporated Laugh-O-gram Films, planning to make animated shorts to sell to film distribution companies. His first was an update of the Little Red Riding Hood story, in which Red takes doughnuts to Grandma's house in a toy car powered by her pet dog, the "wolf" is an evil magician in a top hat, and Red is rescued by (of course!) an aviator. Walt and his youthful staff of animators went on to create similar reimaginings of Jack and the Beanstalk, Cinderella, Goldilocks, and other tales, which a distributor named Pictorial Clubs had agreed to buy. But Pictorial Clubs went bankrupt, having paid Laugh-O-gram just $100 of the agreed-upon $11,100 called for in their contract. Despite Walt's best efforts to launch new projects, Laugh-O-gram's debts kept mounting and the company filed for bankruptcy.

Walt's dreams were not diminished, however, as Roy's sweetheart and future wife, Edna Francis, recalled. "Walt used to come out to our house," she recounted, referring to the home she still shared with her parents. "He was having kind of a struggle, financially, and when he'd get hungry he'd come over. We'd feed him a good meal and he'd talk until almost midnight about cartoon

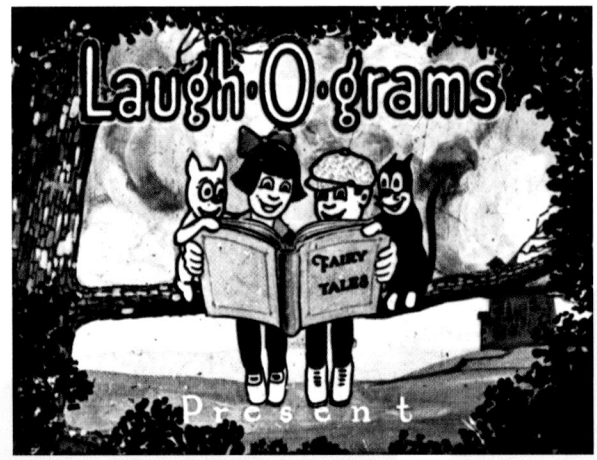 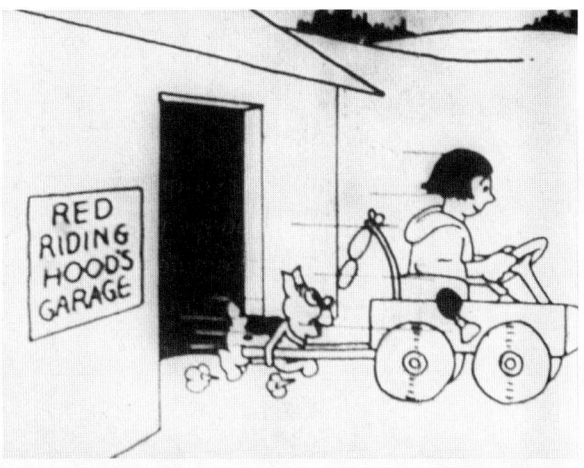

pictures, mostly, and things he wanted to do." As archivist Ed Ovalle observed, "I think he looked at that [failure] as a challenge. 'Yeah, we failed but I'm going to move on to the next thing and I'm going to do it better. I know I have these stories to tell. I know people are going to want to see these, but we need to know what we did wrong, change it, and move on.'

"And that's what he did," Ovalle pointed out. As Walt later put it, "You may not realize it when it happens, but a kick in the teeth may be the best thing in the world for you."

Roy, meanwhile, faced struggles of his own: he had been diagnosed with tuberculosis and sent to a Veterans Administration (VA) hospital in Santa Fe, New Mexico, and then to another facility in Los Angeles.

Done with Kansas City, Walt decided to join Roy in Los Angeles, living temporarily with his uncle Robert Disney. He was determined to get a job directing live-action movies but was turned away by studio after studio. Finally, he unpacked an unreleased pilot film that he had brought with him from Kansas City: *Alice's Wonderland*. It was a comedy short in which a live-action girl, played by preschooler Virginia Davis, interacted with a fully animated world. Walt pitched the idea as a series to a New York film distributor named Margaret Winkler with whom he had corresponded in Kansas City, writing, "I am establishing a studio in Los Angeles for the purpose of producing the new and novel series of cartoons I have previously written you about." To his delight, he received

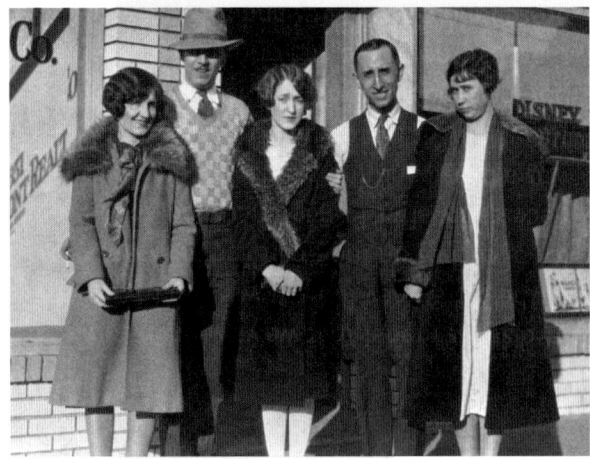

ABOVE, TOP (from left): A title card for Laugh-O-gram Films, a series of modernized fairy-tale cartoons, including *Little Red Riding Hood* (1922).

ABOVE (from left): Lillian, Walt, Ruth, Roy, and Edna Disney in front of the Disney Brothers Cartoon Studio in Los Angeles, circa 1925. Lobby cards and publicity illustrations, such as the one seen here (circa 1926) featuring the second actress to play Alice in the Alice Comedies, Margie Gay, were posted outside movie theaters or in lobbies to promote the films.

a telegram in reply that said, in part: WILL PAY FIFTEEN HUNDRED EACH NEGATIVE . . . IMMEDIATELY ON DELIVERY. Walt took the telegram to Roy and asked his big brother to join his new venture.

Roy checked out of a Veterans Administration ward the next day: October 16, 1923. On that date, the brothers signed a contract agreeing to supply six Alice Comedies to Winkler for $1,500 each. Six more would then be delivered at $1,800 a piece, with two more six-film series as future options. The contract represented the founding of the Disney Brothers Cartoon Studio, operating at first out of a vacant room at the back of a real estate office being rented for $10 a month. Walt wrote letters to the family of Virginia Davis, convincing the family to relocate to Los Angeles so the girl could continue to film with him. Uncle Robert's dog, a German shepherd named Peggy, was recruited as a co-star. The brothers then rented a vacant lot on Hollywood Boulevard, three blocks away from the real estate office, to be their live-action production facility. As Davis recalled, "Curious children from the neighborhood would act as playmates or extras in the live-action story and Walt would pay them each fifty cents." Walt and Roy, she said, "were the whole studio crew—set makers, carpenters, cameramen, writers, and directors."

Such was the modest start of The Walt Disney Company—a dream manifested through Walt Disney's sheer willpower and soon renamed after him: the Walt Disney Studio (1926–1929), then Walt Disney Productions (1929–1986), and finally The

ABOVE, TOP: Still frames featuring Walt and child actress Virginia Davis from *Alice's Wonderland* (1923).

ABOVE: Publicity still featuring Walt Disney, Margie Gay, and Roy O. Disney, circa 1925 (left). Walt and Margie chat, circa 1926, amongst stacks of animation drawings.

Walt Disney Company. Walt was determined not to fail a second time, but perhaps more important, he wasn't afraid of it. "I think it's important to have a good hard failure when you're young," he said later. "Because of it I've never had any fear in my whole life when we've been near collapse and all of that.... I've never had the feeling I couldn't walk out and get a job doing something."

One hundred years of storytelling would follow, but Walt's philosophy was well established, even from the beginning. The Walt Disney Company would tell absorbing stories filled with intriguing and lovable characters. Animator Isadore "Friz" Freleng recalled improvising on an animated scene in a 1927 Alice Comedy in which a mother cat was washing her kittens, and Walt's reaction to his work. Freleng had given one kitten the personality of a small child, and Walt praised his work to the other animators, saying, as Freleng recalled, "That's what I want to see in the pictures, I want the characters to be somebody. I don't want them to just be a drawing."

Walt also wanted virtue to triumph. He already knew from creating his earliest shorts that fairy tales were perfect choices for animation, with their blend of magic, anthropomorphic animals, and dramatic plotlines. But there was more to it than that—something that spoke to Walt's inherent optimism about humanity. "I think what he really liked was good and evil, and showing that even though there's evil, good always wins out," Ovalle said. Audiences, Walt knew, "need something to be uplifting, something positive. It all seems so basic, but it's not. It's very involved," Ovalle explained. "Sure, good wins, but how do you tell that story in an engaging way? You throw in relatable characters. You entertain the people."

Late in his life, Walt Disney said that even after his long career, "My entertainment credo has not changed a whit" since he founded his company. "Strong combat and soft satire are in our story cores. Virtue triumphs over wickedness in our fables. Tyrannical bullies are routed or conquered by our good little people, human or animal. Basic morality is always deeply implicit in our screen legends. But they are never sappy or namby-pamby. And they never prate or preach. All are pitched toward the happy and satisfactory ending. There is no cynicism in me, and there is none allowed in our work."

As frequent Disney actress Hayley Mills recalled, Walt "told me that he wanted to show people the best in themselves. Certainly, he achieved that. You always come out of his movies feeling happier than when you went in, and you feel better about humanity and the human condition."

Despite holding countless often grueling jobs from age eight onward, witnessing the aftermath of a world war firsthand in France, and facing personal failure in Kansas City while still in his early twenties, the Marceline, Missouri farm boy remained optimistic. "People act with good intentions," he once told Disney Legend and Imagineer John Hench. "People are really okay!" The hope instilled by Doc Sherwood's nickel "commission" never faded, and it came to define the business trajectory of The Walt Disney Company.

OPPOSITE: Walt, as a producer, on the set of *The Sword and the Rose* (1953) at Pinewood Studios near London.

Ub Iwerks, Disney's First Innovator

Apart from Walt himself, perhaps nobody was more instrumental in forging the creative identity of The Walt Disney Company than animator, inventor, and special effects designer Ub Iwerks. Born Ubbe Ert Iwwerks in Kansas City, Missouri, in 1901, Iwerks met Walt while both were employed at the Pesmen-Rubin Commercial Art Studio. The two budding illustrators struck up a short-lived partnership and then left to work for the Kansas City Slide Company, briefly, before Walt decided to start his own animation business and convinced Iwerks to join him as principal animator.

After the company, known as Laugh-O-gram Films, went bankrupt, Iwerks eventually followed Walt to California. He helped produce the Alice Comedies for the brand-new Disney Brothers Cartoon Studio and then helped create and refine the design of the Oswald the Lucky Rabbit character, only to see the distributor, Winkler Pictures, take creative control of it a year later when Walt and his brother Roy O. Disney were ousted from producing the series. Most of the Disney staff was hired away by Winkler, but Iwerks and two apprentice animators remained loyal. As Disney Legend Don Iwerks explained, "Right away, Walt, Ub, and Roy began working on a new character ... Mickey Mouse, with a supporting role from his girlfriend, Minnie Mouse. Ub drew the first character designs of the mice as well as other animal characters that were later developed, such as a cow, a horse, and a frog. Walt wrote the first story line, which would be titled *Plane Crazy*."

It was Iwerks who nearly single-handedly animated the first three Mickey Mouse shorts in production: *Plane Crazy*, *The Gallopin' Gaucho*, and *Steamboat Willie*—as well

ABOVE: Disney Legend Ub Iwerks with his new camera used for the Sodium Traveling Matte Process, an Academy Award–winning technique that combined painted backgrounds, traditional animation, and live-action foregrounds to create unforgettable scenes in films like *Mary Poppins* (1964).

as, later on, *The Skeleton Dance*, the first Silly Symphony series short. It has been written that at one point during the production of *Plane Crazy*, Iwerks was working at the furious pace of producing over seven hundred drawings a day. But he was far more than just artistically talented and a hard worker. When Walt wanted to try an innovative approach to anything, he turned to Iwerks to make it a reality.

Iwerks also came up with the idea of the "pencil test," which revolutionized animation production. When Walt needed a way to review the in-process animation footage, Iwerks adapted an old projector to create a viewing device. After leaving the Disney studio during the 1930s to branch out and start his own cartoon studio, Iwerks returned to The Walt Disney Studios in 1940. He focused on camera technologies and special effects, which was critical to the production of the many training films the studio produced for the Allied effort during World War II. He is credited with developing Disney's live-action and animation hybrid technique, as well as the xerographic cel reproduction process first used in *Sleeping Beauty* (1959) as a test, and then fully in *Goliath II* (1960). Notably, the first feature to exclusively use it was *One Hundred and One Dalmatians* (1961).

In the later part of his career, Iwerks helped develop Disney theme park attractions for WED Enterprises (now known as Walt Disney Imagineering). He was the first Disney innovator, and his hundreds of contributions are so intertwined with the artistic and technical foundations of the company that it is impossible to overstate his importance to both Disney animation and the concept of *innovention* that continues to define Disney's unique place in the entertainment world.

Walt Disney and his friend and colleague Ub Iwerks at the Hyperion Avenue studio, circa 1928.

During filming for the Alice Comedies, Walt, Ub, Rudy Ising, and Hugh Harman humorously pose on their Hollywood Boulevard set, circa 1926.

Ub and Imagineer and Disney Legend Wathel Rogers test the facial movements of an Audio-Animatronics figure for the Pirates of the Caribbean attraction at Disneyland, circa 1966.

Everyone working
the same goal
a wonderful story
with heart and
something that is

on the film has in mind—to tell for the ages, filled humor, about important to us.

—Osnat Shurer

Producer, *Raya and the Last Dragon* and *Moana*

CHAPTER 2

WHERE DO THE STORIES COME FROM?

From the beginning, almost every Disney creation has been grounded in storytelling—and for good reason: Walt was himself a uniquely gifted storyteller who could hold a roomful of people spellbound for hours as he narrated and acted out his detailed visions. Spirited story-pitch meetings became a routine at the studio, but nobody could do it quite like Walt.

Yet even more critical to his success was his innate ability to recognize a strong story that would resonate with people. His story-mindedness led him to revolutionize early animation by shifting away from merely presenting a series of stand-alone sight gags toward in-depth storytelling that established an emotional connection with audiences. The gags would remain, but in the service of the story.

THE POWER OF SEVEN

As a storyteller, Walt Disney was drawn to material that had already demonstrated its broad appeal, like popular fairy tales, folklore, mythology, and fables—literary forms that were the direct descendants of the oral tradition dating back to the Bronze Age (and possibly even earlier). It reflected a common need to define, explain, and appreciate the moral dimensions of the human experience. Over the years Walt had adapted a number of fairy tales and fables for his Laugh-O-gram, Silly Symphony, and character-based short cartoons, and when it came time to take on the enormous artistic and financial challenge of producing the first-ever feature-length animated film, he decided to use the Brothers Grimm classic "Snow White."

But why did he choose the story "Snow White" in particular as the basis for the riskiest creative endeavor of his career? According to Disney biographer Bob Thomas, as a teenager in Kansas City, Missouri, Walt saw a silent film version of the story starring Marguerite Clark, and it formed "the most vivid memory of his moviegoing childhood." Both the story and the storytelling power of film as he experienced it that day resonated deeply with Walt, and twenty years later, he had positioned himself and his studio to do for "Snow White" what he had done for the

ABOVE: Walt Disney in action during a story meeting for *Pinocchio* (1940).

fledgling animation industry and what he would later do for the amusement park: take a good thing and make it exponentially better through superior storytelling.

The standard running time of a cartoon short was eight to nine minutes, and thus audiences had been conditioned to see animation as diverting filler before the main event of the live-action feature. The idea of paying to see a feature-length cartoon struck critics and potential distributors as absurd. As Walt's *Snow White and the Seven Dwarfs* was being prepared to roll out to various markets, *Central Press* staff writer Obera H. Rawles noted in a January 12, 1938, article that industry professionals were referring to the seven-reel animated project as "Disney's Folly." The anecdote was later widely picked up by newspapers across the country. But Walt had pushed ahead undaunted because he had the vision and resources to create something that he knew would forever change animation as an art form. He had built a stunningly detailed and layered animated world requiring the talents of the best artists and animators in the business and the illusion of three-dimensional depth afforded by the Disneys' new multiplane camera.

Still, none of that would matter without a strong story capable of engaging the sympathies of an audience for over an hour.

It also meant populating the story with characters that audiences could identify with—something that was in short supply in

ABOVE AND OPPOSITE: Story sketches by Disney studio artists from *Snow White and the Seven Dwarfs* (1937).

the original "Snow White" tale. Although all the characters are crucial to the plot, in terms of relatability, the story needed that Disney touch. Snow White is too innocent, the Queen is too villainous, and the Prince is too noble, plus absent for most of the action. That leaves the Dwarfs, who, in the Brothers Grimm version, are just a monolithic group with no names and no distinguishing personalities.

But Walt saw their potential right away. "The figures of the Dwarfs intrigued me," he later recalled. He tasked the Story Department with creating seven distinct character types that audiences would recognize from real life and giving them names descriptive of their personalities. Among the dozens of monikers considered and rejected early on were Scrappy, Weepy, Shifty, Jumpy, Blabby, and even Snoopy. In the finished film, the individuality of each Dwarf is encapsulated in his name and constantly reinforced, and their charm and humanity ultimately constitute the entertainment core of the story. To this day, it's a point of honor among Disney fans that they can rattle off those seven names without pause: Sneezy, Sleepy, Bashful, Happy, Grumpy, Doc and, of course, Dopey.

The eventual inclusion of some memorable musical numbers also added to the movie's storytelling heft, partly because they helped portray a character's inner thoughts and deepest desires and partly because the songs themselves were good

enough to stay with audiences long after they left the theater. In fact "Whistle While You Work," "Heigh-Ho," and several other songs from the soundtrack became top ten hits, inaugurating a tradition of Disney animated films yielding music that has become a fixture in the collective cultural memory.

In addition to expanding the action of the relatively brief story to accommodate the feature-length format, Walt and his writers made other critical adjustments to the original fairy tale that maximized the story's emotive weight, like building up the relationship between Snow White and the Prince. In the Brothers Grimm story, they meet only after she has been poisoned and revived, whereas in the Disney version, the entire plot is driven by their having met and fallen in love early on. The audience's warm reception was a triumphant moment for Walt, who had successfully created an entirely new long-form storytelling vehicle capable of connecting with moviegoers on a much deeper level than anyone had thought possible for animation. It was both a vindication of Walt's grand vision for the medium and proof that he could breathe spectacular new life into an old story.

ABOVE: The Prince meets Snow White, in a story sketch by a Disney studio artist from the 1937 animated feature.

UNTANGLING OLD STORIES

Walt's insistence on strong storytelling became part of the company's DNA from the early 1930s on, and it is hard to imagine *Snow White and the Seven Dwarfs* (1937) or any subsequent Disney film without the significant story alterations from the original source that transformed the material into a recognizably Disney product. As an admirer of Aesop, the Brothers Grimm, Hans Christian Andersen, Charles Perrault, and Jean de La Fontaine, Walt considered all fables, fairy tales, folklore, myths, and even classic literature as a starting point for story development.

A good illustration of Walt's vision is the way he adapted the original story of *The Adventures of Pinocchio* by Carlo Collodi. In Collodi's tale, the title character is thoroughly unlikable from the start, such as kicking Geppetto as soon as his feet are carved and running away. Walt understood that his audience needed to be able to sympathize with the protagonist, and Collodi's puppet is obnoxious and cruel until his redemption near the end of the book. So Walt changed the story, getting rid of Pinocchio's more violent and depraved behavior and making his mistakes seem less the result of a character flaw and more the product of his inexperience and innocent lack of understanding of good and evil. It also makes more sense for a sentient puppet that has just come into being to be naïve about the world than it is to have him pop into existence as a reprobate in need of a lesson.

ABOVE (clockwise from left): Story sketches by Disney studio artists (left and right) and a character design concept by a Disney studio artist from *Pinocchio* (1940).

However, as Disney historian J. B. Kaufman observes, Walt also decided to make the world that Pinocchio is born into even more fraught with evil than in the Collodi tale. "In some ways," says Kaufman, "Disney's *Pinocchio* (1940) is much darker and more sophisticated than the original book. So for example, in the novel, Pleasure Island is relatively benign, and you can see in the concept drawings that the artists were inclined to picture it as this sunny land of candy and carnival rides, and it was Walt who pulled them back and said, 'No, this is a bad place.' And so in the end, it was depicted as being really dark and sinister." Walt also had the animators and Story Department turn Mangiafuoco, the puppet master character in the book, into the much more terrifying Stromboli. As with making the Pinocchio character more likable, the net effect of enhancing the wickedness of the world he inhabits was a dramatic increase in audience sympathy.

The notion of treating existing source material as a foundation on which to build and reimagine has been around since the earliest days of storytelling. Thus the Disney version of a classic tale is a single point in a continuum of adaptation that may be hundreds or even thousands of years in the making. Take, for example, "The Little Mermaid." The concept of mermaids can be found in the folklore of cultures around the world, and the Hans Christian Andersen story is itself an adaptation of *Undine* by Friedrich de la Motte Fouqué. Fouqué, in turn, was inspired by the story of Mélusine, an ancient French folk tale likely borrowed from even earlier Greek mythology. Therefore, the tale Disney adapted for the feature *The Little Mermaid* (1989) was just the latest in a long line of interpretations that stretched back as far as history records, demonstrating the timelessness of the core story.

The Disney connection to "The Little Mermaid" actually began back in the late 1930s and early 1940s, when Walt was considering creating a package feature consisting of a series of vignettes based on Hans Christian Andersen stories, but the project was shelved. Decades later, Disney writer-director Ron Clements happened upon a collection of Andersen tales in a bookshop

ABOVE, LEFT: The sinister puppet master from *Pinocchio* (1940) glares menacingly from a poster in this story sketch by a Disney studio artist.

ABOVE, RIGHT: A highly stylized concept illustration by Kay Nielsen for a proposed film based on "The Little Mermaid," created decades before the 1989 film went into production.

SEBASTIAN: **UNDER DA SEA!**
CHORUS: UNDER DA SEA...

and was inspired to create a two-page draft for a proposed film version of "The Little Mermaid." Once it was approved for production, Clements and co-director John Musker began working on the script, and when songwriter Howard Ashman became involved, it led to some significant changes in the way the story was presented, eventually giving the production the feel of a Broadway musical. For example, Ashman suggested the prim and proper British crab character called Clarence in the original be changed to a musically talented Jamaican crab named Sebastian, which made him a far more entertaining presence in the film. This also led to a crucial Caribbean influence being added to the musical theme, culminating in the wildly popular song, "Under the Sea."

Music had been used as a storytelling aid in films since the days of silent films being screened with a live piano or organ accompaniment, and over the years Disney films in particular had successfully tapped into the appeal of combining a strong story and visual product with irresistible melodies. However, the soundtrack album for *The Little Mermaid*, written by Ashman and Alan Menken, exceeded all expectations, winning Academy Awards for both Best Original Score and Best Original Song, and becoming a platinum best seller. From a storytelling perspective, it is a rare luxury to be able to connect a story with unforgettable songs that keep the memory of the story alive.

ABOVE: A story sketch by a Disney studio artist from *The Little Mermaid* (1989) captures the exuberance of the film's musical approach to storytelling.

Silly Symphonies

As much as the Mickey Mouse shorts represented the symbolic heart and soul of Disney entertainment in the early years of the studio, the contemporaneously produced Silly Symphony series provided Walt with a versatile medium for experimentation and innovation with both storytelling and animation techniques. The studio made seventy-five Silly Symphony cartoons between 1929 and 1939, and like the Mickey shorts, they increased dramatically in sophistication over time. The Silly Symphony series was originally conceived by early Disney composer and arranger Carl Stalling as an ongoing experiment featuring musical cartoons that would exploit the novelty of the era's recently developed sound technology by pairing it with storytelling. However, even though music was a central feature throughout the production run of the series, what was especially memorable about them was the Disney alchemy that transformed familiar source material into something even more entertaining and emotionally engaging than the classic fables, folklore stories, and works of literature on which they were based.

In some cases, as with *Three Little Pigs*, the original story has been eclipsed in the popular imagination by the Disney version of the tale. It was so universally familiar at the time that the song "Who's Afraid of the Big, Bad Wolf?" became a metaphor of defiance in the face of despair for millions during the early years of the Great Depression. Now the classic cartoon is one of the best early examples of Walt successfully creating an emotional connection with his audience.

Three Little Pigs won an Oscar for Best Short Subject (cartoon), as did five other Silly Symphony shorts. But what exactly did Walt do with these existing stories to turn them into popular, award-winning Disney entertainment products? How were the original stories altered? The answer depends on the story. Many traditional fairy tales contain elements that nineteenth-century readers took in stride but were too gruesome or violent for later generations, especially when presented in a visual medium like film. For example, at the end of the original "Three Little Pigs" tale, the wolf is lured into the chimney, scalded to death, boiled, and eaten, whereas in the Disney version, he is merely scorched by the fire and chased off. This was the general Disney approach to dealing with the more unpleasant aspects of classic European fairy tales, which often included scenes of cruelty, suffering, and even cannibalism; Walt clearly understood that if you are going to create a deep emotional connection with audiences, you must respect their vulnerability in that moment by avoiding ideas or images that are too disturbing.

ABOVE: Story sketches by a Disney studio artist from the Silly Symphony cartoon short *Three Little Pigs* (1933) illustrate the heroes building their respective dwellings.

But there is more to putting the Disney stamp on a story than just softening the rough edges of a character or a plot element. Part of the explanation was that Walt had figured out how to enhance storytelling through visual style. He was pioneering a smooth, high-quality form of animation that was good enough to make audiences suspend their disbelief as completely as they did for live-action movies; this allowed for an emotional connection that the shallow, herky-jerky animation of other cartoon studios couldn't hope to establish. And when Walt began making Silly Symphony releases in Technicolor after the wild success of the first all-color short, *Flowers and Trees* in 1932, that connection became even stronger. At the time, even the most important live-action movies were all filmed in black and white, so the appearance onscreen of a Disney short in the rich palette of Technicolor was a dazzling experience for audiences, rendering them more receptive than ever to Walt's storytelling prowess. In that sense, the color itself became part of the story, and this remains true of all Disney animation.

The Silly Symphony shorts represent the studio perhaps at its most experimental and inventive up to that point, and they allowed Walt to look beyond the character-driven plot restrictions of Mickey's universe and work with a limitless supply of stories from around the world. As a result, Disney reimagined dozens of aging traditional tales, such as *Grasshopper and the Ants* (1934), *The Tortoise and the Hare* (1935), and *Wynken, Blynken and Nod* (1938). The series also permitted Walt to create new kinds of stories. *Flowers and Trees*, for example, is a story that could only have sprung from the imagination of an animator. Another is the stunningly beautiful *The Old Mill* (1937), which was essentially a story born of the technology that was used to create it; Walt wanted to test out his enhanced version of the multiplane camera concept, and *The Old Mill* was developed around the three-dimensional capabilities of Disney's new device. It represents a unique form of story sourcing and storytelling, yet for Walt it was primarily a testing platform for the equipment and techniques that the making of *Snow White and the Seven Dwarfs* would require.

ABOVE (from left): Animation drawings by Disney Legend Norm Ferguson of the Big Bad Wolf and Fifer Pig with the scene's final frame from the cartoon short.

BELOW AND RIGHT: Comparing this story sketch by a Disney studio artist from *Beauty and the Beast* (1991) with the finished scene reveals the importance of storyboarding in helping to establish the look and feel of a Disney film.

A NEW SPELL IS CAST

When it came to selecting stories, Walt was an avid reader and researcher, but he was also deeply influenced by his own life story. One prime source of the material Walt would return to again and again was the trip that he, his brother Roy, and their wives took to Europe in 1935. Apart from his brief stint as an ambulance driver in France just after the end of World War I, it was the first time Walt had traveled abroad, and it made a lasting impression on him. Wolf Burchard, curator of the Metropolitan Museum of Art exhibition *Inspiring Walt Disney: The Animation of French Decorative Arts*, observes that the trip helped determine much of Disney's subsequent creative output. "Over the course of his grand tour of Europe," says Burchard, "Walt Disney acquired about 335 art and illustrated books—the entire pantheon of European children's literature. And this is really important because all those fairy tales are set in historic spaces, ranging from the Gothic to the rococo, and these illustrations in a way provided Disney animators with a first step in translating European visual traditions into this new idiom of animation." The influence of these traditions can be seen not only in the animated details of *Snow White and the Seven Dwarfs* and *Pinocchio*, but also in the entire look and feel of more recent productions like *Beauty and the Beast* (1991) and its 2017 live-action reimagining.

Among the classic fairy tales collected by the Brothers Grimm, "Beauty and the Beast" is perhaps the most popular of all time. Since it first appeared in print in 1740, there have been innumerable adaptations of the story, including plays, novels, an opera, a ballet, and a classic live-action film by Jean Cocteau. The tale's romantic core and its ageless themes of transformation, redemption, and looking beneath the surface for the truth appealed to Walt Disney. And in fact, legendary Disney animator Ollie Johnston recalled that Walt had considered making an animated feature based on the story in 1940. It was also considered for television development in the mid-1950s, but the project never went anywhere.

Then in the late 1980s, the studio's renewed focus on animation led to the idea being picked up again, and screenwriter Linda Woolverton was tapped to draft a screenplay. This was the first Disney animated feature to begin life as a screenplay; since *Snow White and the Seven Dwarfs*, the process of building a narrative had almost always begun with story conferences and storyboard review sessions. Woolverton worked with executive producer and lyricist Howard Ashman, whose contributions to *The Little Mermaid* had been critical to its success, and it was Ashman who came up with the idea of bringing to life the servants that had been turned into household objects by the same spell the enchantress used to transform the young prince into the Beast. The resulting characters of Mrs. Potts and Chip, Cogsworth, and Lumiere all but steal the show, and their presence enlivens

the story's otherwise gloomy middle section, when the Beast is holding Belle captive. Ashman also collaborated with composer Alan Menken to create the now-iconic music that formed an indispensable component of the narrative. As executive music producer Chris Montan put it, "One element that made this movie so successful is that the songs help tell the story."

The film was a huge hit mainly on the strength of the story it told. Producer Don Hahn credits the relatability of the characters and their predicaments for the movie's wide popularity. "People could relate to the Beast," says Hahn, "and his longing to find someone to break the spell or accept him for what he was. Or they could relate to Belle and her desire to get out of her little provincial life and into the fairy tales she read about. That, along with the comedy and the music and the sincerity, are what make this picture. Sincerity embodies why these movies succeed, because you really believe these characters on the screen." This is the basic Disney formula for entertainment, whether it's a film, or a theme park attraction, or a Broadway musical: make fantasy believable by populating it with human qualities that connect the audience to the performance.

As traditional as the basic themes of the movie are, and as much as they harken back to *Snow White*, *Cinderella* (1950), and all the other past fairy-tale features, there is also an almost subversive element to the Disney version of *Beauty and the Beast*. "When we started out," says co-director Kirk Wise, "Belle was essentially the damsel-in-distress model that we've seen in some of the old Disney films. It was fun to turn a lot of clichés on their ear. The hero was not necessarily after Prince Charming, the hero was a beast, and the handsome guy became the villain." It is a unique compliment to the potency and longevity of Disney storytelling that that the studio can originate a style of presenting classic tales and then decades later successfully flip the script on that style to tell an old story in a brand-new way.

Sometimes the story changes made to an existing work came about as a result of the visual possibilities of animation, as with the decision to give each of the Seven Dwarfs his own distinct look and personality. Another example of this influence occurred during the making of *Tangled* (2010), the studio's fiftieth animated feature. As with so many other projects, Walt himself had first considered making a feature out of "Rapunzel," the classic Brothers Grimm tale, but the story was abandoned as impractical because most of the action takes place inside a tower. This same problem—how to get Rapunzel out of the tower without ending the movie— was being discussed decades later during a meeting of the Disney Story Trust, which elicits story development ideas and feedback from directors, story artists, and writers. Suddenly, story artist John Ripa asked, "What if she sees these floating lanterns?" Ripa had seen footage on the internet showing sky lanterns being launched into the air, and knew how beautifully it would animate and how that awe-inspiring sight could provide additional motivation for the escape.

Says co-director Nathan Greno, "We were just blown away. That changed the whole direction of *Tangled*. We knew she had to get out of the tower sooner. John [Ripa] suggested seeing the lanterns and being drawn to them. Having her parents send the lanterns up gave her an emotional connection to them, even if she didn't know it. Suddenly we had a specific goal for her, rather than the generic goal of getting out of the tower—she needed to go see those lanterns. That idea changed *Tangled* forever." As both writers and story artists, the Disney Story Trust members saw the striking visual possibilities of the lanterns, and this familiarity with what animation can do prompted them to take the story in a completely different direction, solving a plot dilemma and providing the film with a touching and beautiful scene that intensified the emotional connection between Rapunzel and the audience.

Another recent example of adapting existing stories into wholly new narratives is the phenomenally successful *Frozen* (2013), which, like *The Little Mermaid*, was inspired by a Hans Christian Andersen original. Walt Disney Animation Studios senior vice president of production Peter Del Vecho describes the changes made to Andersen's "The Snow Queen" after screening several earlier film adaptations of the tale: "In the versions we looked at that had been attempted prior to this, it was hard to understand or feel for that character [referring to the antagonistic Snow Queen, who became protagonist Elsa in the Disney movie]. The key became tying it to a sibling relationship. There was more at stake . . . more reasons that you can feel for her."

The transformation of the Andersen story—a boy-girl friendship put to the test by the cruel Snow Queen—to a pair of sisters

ABOVE: Early character designs by Claire Keane (left) and Bill Schwab (center and right) of Elsa from *Frozen* (2013).

fundamentally changed the story in a way that enhanced the emotional connection between the audience and the film, but it also created new story possibilities. Director Jennifer Lee recalls the Disney Story Trust session where the change was suggested: "The minute we made them sisters, suddenly a million ideas came up. Everyone felt it. I knew the potential it had, but I wasn't emotionally feeling it. And in that moment, we all just looked at each other and said, 'Yes, that's it.'"

Another crucial Disney addition to "The Snow Queen" story was Olaf, whose exuberant presence as a comic relief sidekick balances out the film's more serious themes and darker sequences. These added elements would have been unthinkable in the somber world of Andersen's "The Snow Queen," in which the title character is a villain and the two inseparable children at the center of the story are cruelly parted by the forces of evil.

ABOVE, TOP: A story sketch by Chris Williams suggests both the physical and emotional separation of Anna and Elsa.

ABOVE: Characters designs by Bill Schwab of Olaf.

This iconic scene design concept by visual development artist Hans Bacher from *The Lion King* (1994) sets the mood for the film's opening song sequence, "Circle of Life."

HOW FAR THEY'LL GO FOR A STORY

Prior to 1994, almost all of Disney's animated features had been adapted from previously published material or folklore. *The Lion King* (1994) would be the first to be created in storyboard and writing sessions without an existing work as its basis, though it would involve the moral themes and story arcs common to classic literature, fairy tales, and fables. Producer Don Hahn believes it is the universality and broad appeal of those themes that made *The Lion King* resonate with so many moviegoers. "The story has a little bit of Moses, a little bit of Joseph—the prince being exiled from the tribe," observes Hahn. "Also Hamlet—searching for the murderer of his father and being haunted by his father's ghost. It has very much the hero's journey structure to it."

In addition to scouring existing works for ideas, story supervisor Brenda Chapman traveled to East Africa with several other members of the production team to absorb the local landscape and culture for art and story inspiration. Chapman was deeply awed by the experience, which comes across in the story's reverence for the ancient power of the setting, and she also picked up an expression—"hakuna matata"—that would provide the title and refrain for one of the film's most iconic songs.

Working from an original story for *The Lion King* created no special challenges for the production, perhaps because the tale was inspired by some very familiar literary themes and was only truly original in its particular structure and tone. And of course, it contained the time-honored Disney ingredients for storytelling success: relatable characters contending with the conflict and desires common to the human experience. *The Lion King* proved to be the most successful of the many popular animated features from the period sometimes referred to as the "Disney Renaissance" (between 1989 and 1999), when the studio revitalized its feature animation production and turned out a series of movies that became global pop culture phenomena.

But there's an even more recent Disney film that serves as a clearer example of original storytelling. Even though great stories are timeless, the proper way to tell them must sometimes evolve to reflect

ABOVE: This scene design by background artist Greg Drolette illustrates Pride Rock during the "Circle of Life" song sequence from *The Lion King* (1994).

the sensibilities of the era. The violence and depravity present in many nineteenth-century fairy tales, for instance—often intended to scare children into adopting more virtuous behavior—was no longer in fashion by the twentieth century. And, as we have seen, the more harrowing events depicted in stories like "Snow White" and "The Little Mermaid" had to be toned down considerably in modern adaptations. Similarly, in the twentieth century, there was still mainstream acceptance of the cultural appropriation that results when the stories of other cultures are told by uninformed outsiders, whereas contemporary audiences demand the kind of storytelling authenticity that presents the subjective view all peoples have of themselves. So nearly a quarter century after *The Little Mermaid*, when Ron Clements and John Musker began thinking about an animated feature set in the Pacific islands, they knew they needed to visit the region, steep themselves in the cultures of Oceania, and seek input and guidance from local experts before they could proceed with the film.

They quickly discovered that all of the various Oceanic cultures see their world as consisting of not just the islands where they live but the vast stretches of ocean between them as well. They also learned that the heritage of wayfinding—the superhuman feats of navigation that ancient Polynesians performed when discovering and settling islands thousands of miles apart—remains central to the identity and belief systems of Pacific cultures. "We heard many times from the people we met during our trips to the Pacific islands that the ocean doesn't separate the islands, it connects them," says Clements. "Voyaging is a real source of pride for Pacific Islanders." They also learned that for some unknown reason, the ancient wayfinding suddenly stopped about three thousand years ago and then resumed a thousand years later—and it was this mysterious discontinuity and renaissance that inspired the story idea that eventually became *Moana* (2016), which means "ocean" in many Pacific-culture languages. "In our story," says Musker, "our hero, Moana, is at the heart of the rebirth of wayfinding."

Oceania consists of dozens of individual cultures, and the filmmakers visited as many of them as they could, taking in the music, folklore, cuisine, and ceremonies of each as they went. Because of this cultural diversity within Oceania, they were encouraged to come up with a story that embraced Pacific culture broadly, without focusing on any one group. They assembled a team of advisors named the Oceanic Story Trust (OST) to guide them in this task. The OST,

ABOVE: Design exploration by visual development artist James Finch of the Pacific Islander watercrafts from *Moana* (2016).

which was an outgrowth of the Disney Story Trust, consisted of experts in various fields—anthropologists, educators, linguists, traditional tattooists, choreographers, specialists in the Maori haka ceremony, master navigators, and cultural advisors. Dionne Fonoti, a visual anthropologist at the University of Samoa and a member of the OST, observed, "I think they want the story to reflect what they felt when they were here. The experience truly resonated with them, and they're storytellers—they want to share it."

The idea of setting the film in the distant past dovetailed perfectly with the directive to paint an inclusively broad picture of Pacific culture. Said Dr. Paul Geraghty, associate professor of linguistics at the University of the South Pacific in Fiji, "The filmmakers wanted to be nonspecific, which makes sense since two thousand years ago, when the film is set, what is now specific to Samoan or Fijian or Hawaiian society didn't yet exist, so we looked for a proto-Polynesian characterization as much as possible."

Although the resulting story of *Moana* is a wholly new tale, it is scrupulously faithful to the essence of the culture it depicts. And like all Disney features, it has universal appeal because it showcases the inspirational power of the human spirit that is common to all societies and contains a classical coming-of-age element. But it is first and foremost a reverent celebration of the rich culture and mythological heritage of Oceania that is brimming with authenticity, told in the ancient oral tradition style of the region, and voiced by actors with Pacific island roots. Ron Clements recalled a question he was asked by one of the elders on the island of Moʻorea while doing preliminary research for the movie, and it sums up perfectly what the film accomplished: "For years we have been swallowed by your culture. This one time, can you be swallowed by ours?"

Working with original stories also allows more flexibility in the story development process. During the production of *Encanto* (2021), the power of song was used to get certain things across more effectively than through dialogue alone. Lin-Manuel Miranda, who wrote eight songs for the movie, recalled discussing character exposition: "One of the things I learned on *Moana* was to raise my hand and say, 'Ooh, ooh—we should tell this part of the story through song!'" This resulted in "The Family Madrigal," a song that serves as a guide to who the characters are. "Given how complex this family is," says Miranda, "I realized our first song needs to introduce our main character, Mirabel, in a way that makes us fall in love with her, and understand the dynamics within this large family." Head of story Jason Hand felt the song was not only

ABOVE: Mirabel Madrigal during the "The Family Madrigal" song sequence from *Encanto* (2021).

important as a character introduction tool but that it also set the tempo for the entire story. "It's upbeat from the get-go," said Hand. "In a very short period of time, the song not only introduces each character, it shares their individual gifts in a fun and playful way."

And then, of course, there is the *Encanto* song that broke the internet: "We Don't Talk About Bruno." It describes the family's mysterious, prophetic, and misunderstood brother, and became a viral sensation months after *Encanto*'s release, charting at number one on both *Billboard*'s Hot 100 and its Global 200, bringing a vast new audience to the film.

Telling the story of the Madrigal family unveils a larger story because the diversity within the family echoes that of the culture in which the film is set. "Our characters reflect the diversity of Colombia and how different cultures intermingle in a unique way," observes art director Bill Schwab. The Colombian Cultural Trust acted as consultants on the production of the film, ensuring that the story was as authentic to the people of Colombia as possible. *Encanto* follows the grand tradition of Disney storytelling by entertaining while connecting character to audience on a satisfying emotional level. Yet it also embraces the twenty-first-century storytelling imperative of setting the film in a culturally authentic universe.

ABOVE, TOP: This visual development art by associate production designer Lorelay Bové evokes a sense of Mirabel's personality.

ABOVE: Character design by visual development artist Jin Kim of Bruno.

BEAUTY TELLS ITS STORY

In the postwar era, Disney features such as *Cinderella* (1950), *Alice in Wonderland* (1951), *Peter Pan* (1953), and *Lady and the Tramp* (1955) all became beloved classics. They were fairly traditional in terms of animation style and plot structure, but, especially starting with *Alice*, there was a noticeable shift in the color design and backgrounds that now represent a mid-century modern sensibility. By the late 1950s, after this run of successful films that hewed to formula, Walt Disney wanted his next movie to be a return to his innovative roots. He chose the fairy tale of "Sleeping Beauty," which aptly enough bore some basic story similarities to "Snow White." According to Disney animator Will Finn, Walt approached story development very differently from the way past features were handled. "*Snow White* makes a lot more aggressive attempts to flesh out the story with business and gag sequences, which *Sleeping Beauty* (1959) just doesn't do," says Finn. "It seems to be something Walt consciously wanted to experiment with—making a movie without the subplots, like the mice in *Cinderella*, and just concentrate on the reality of the story and the subtlety of the main characters."

With a leaner plot as a foundation, engaging the emotions of an audience would rely more heavily on visual style and design than ever before. This process began after Disney story artist John Hench returned from a trip to New York, where he saw the famed *Unicorn Tapestries* at the Metropolitan Museum of Art. The *Unicorn Tapestries*, which consist of seven separate but related scenes, served as a medieval form of pictorial storytelling, and although their proper sequence and precise original meaning have

ABOVE: Visual development art by Disney Legend Eyvind Earle for *Sleeping Beauty* (1959).

been lost to time, the emotional impact of their rich imagery still speaks to us across the centuries, the same way Neolithic cave paintings are priceless narrative artifacts that connect us with the human experience of the distant past.

Hench discussed the tapestries with Walt, then showed some sketches to fellow Disney artist Eyvind Earle, who created a series of paintings that established the dramatic, beautifully stylized and emotionally charged look of *Sleeping Beauty*. Perhaps more than any other film made during Walt Disney's lifetime, *Sleeping Beauty* tells its story through the visual impact of its exquisite stylization, which echoed the idealized imagery of the medieval artistry that inspired it. Walt was always seeking to combine the timeless with the cutting edge in his storytelling efforts, and *Sleeping Beauty*, like *Snow White* before it, managed to strike that balance perfectly. It was, as Walt described it, "a spectacular fantasy."

TALL TALES AND TRUE

In the 1940s and 1950s, nostalgia for bygone eras from America's historical and cultural past was at its peak and was reflected in the popularity of Hollywood entertainment that celebrated our country's history of self-mythologizing. This sort of storytelling fare was squarely in Disney's wheelhouse, and starting in the mid-1940s he began producing a number of short subjects, often as part of omnibus or package features, that paid tongue-in-cheek homage to the characters of America's mythical past. *Make Mine Music* (1946) was the first such package film, containing a number of shorts that included "Casey at the Bat," which animated a famous poem from 1888 about an arrogant, fictional baseball player striking out at a crucial moment of the game. *Melody Time* (1948) was the fifth Disney package film, and it features seven segments, including one folklore-based short, "The Legend of Johnny Appleseed," and another titled "Pecos Bill," which is about a cowboy who symbolized the idealized toughness of the American Old West.

Another notable myth-based cartoon short from the period was *Paul Bunyan* (1958), which told the story of the folk legend lumberjack. Like the shorts starring Johnny Appleseed and Pecos Bill, *Paul Bunyan* was a frontiersmen fantasy about a larger-than-life man capable of superhuman feats of strength

ABOVE: An animation drawing by John Sibley of the title character from the cartoon featurette *Paul Bunyan* (1958) includes color reference notes for the Ink & Paint Department.

The Concept Artist

 In addition to buying up books that illustrated the European visual tradition, Walt also imported Old World artistic sensibilities by hiring a number of illustrators with European backgrounds as concept artists, such as Albert Hurter, Ferdinand Horvath, and Gustaf Tenggren. The concept artist was an entirely new idea in animation, and it represented Walt's nuanced approach to storytelling. By allowing a talented and creative draughtsman like Hurter to let his imagination run wild, Walt received in return inspirational sketches that moved production along by suggesting character appearance, personality, and behavior. In the case of one emotionally evocative sketch Hurter made of the Dwarfs grieving over the body of Snow White, the image was used almost without alteration in the final film, and thus Hurter's concept work became part of the storytelling process. It would have been simpler to depict the mourning Dwarfs all standing in a group, heads bowed, but Hurter gave each character his own space and posture of grief, which was a far more dramatic and affecting approach that better connected with audiences by conveying the true individuality of pain and suffering. This was exactly the kind of emotive storytelling power that Walt was always trying to achieve.

 Animator and historian John Canemaker believes Hurter borrowed from Italian Renaissance master Giotto in composing the scene. "In my opinion," says Canemaker, "Hurter used Giotto's *Lamentation,* in which characters are weeping and grieving over the dead Christ—the Blessed Mother, the angels in the sky, all of them are geared toward this event that's happening. I contend that that is something Albert Hurter brought to *Snow White*—that scene with the Dwarfs grieving over Snow White was staged as Giotto might have done it if he were an animator." Hurter's sketch effectively created a direct connection between the visual storytelling genius of Giotto and Disney animation.

ABOVE: Story sketch by a Disney studio artist from *Snow White and the Seven Dwarfs* (1937).

and endurance. Later, *Disney's American Legends* (2001), a home entertainment release, packaged "Paul Bunyan" and "The Legend of Johnny Appleseed" with "The Brave Engineer," which tells the reimagined true story of American railroader Casey Jones, and "John Henry," the tall tale of a freed slave who battles a modern-day steam hammer to ensure his crew receives the land promised to them after completing a railroad-building project. Disney chose to retell these tales with a combination of reverence for the storytelling form of embellished folklore and a contemporary wink at the absurdity of the myths themselves—thus a perfect balance for the patriotic but less credulous audiences of the postwar period.

ALL ABOARD THE STORYBOARD

Given the importance of story to the success of all Disney entertainment products, the Story Department has always figured prominently in the creative process at the studio. In the early days, Walt built up his staff by enticing animators away from competitors, and in 1931, he hired Ted Sears, who had been doing animation and story development for Max Fleischer. Walt gave Sears a long-term contract as the studio's first head of the Story Department, a position he held until his untimely passing in 1958. Sears worked on almost every Disney film made during that time, from *Snow White* to *Sleeping Beauty*, and is credited with being one of the creators of the storyboard. Over the years Walt leaned heavily on Sears's talent for dialogue and story development, and it would be fair to say that the continuity of Disney storytelling quality during the studio's first thirty years owed almost as much to Ted Sears as it did to Walt himself.

Another early key member of the Disney writing team was Bill Cottrell, who was hired as a camera operator in 1929 but soon transferred to the Story Department, making him one of the very few Disney writers who didn't start working at the studio as an animator or artist. Cottrell contributed story ideas for shorts, and impressed Walt enough to be given the director's chair for the Queen and old peddler woman sequences of *Snow White*. In addition to working on stories for most of the animated features, Cottrell later helped develop popular television material and was the first president of WED Enterprises—known today as Walt Disney Imagineering—where he helped create story lines and dialogue for Disneyland attractions and was a driving force behind the realization of the theme park. He was a fixture at the studio long enough to become known as "Uncle Bill," and his influence on the Disney product can still be felt today. Fellow Imagineer John Hench said this of Cottrell: "He was a talented writer and helped shape how we referred to events and attractions

at Disneyland. For instance, he encouraged us to quit using the term 'ride' and refer to attractions as an 'experience,' which is exactly what they are."

Other Story Department legends include former cartoonist Perce Pearce, who was the story director on *Bambi* (1942) and later became a producer for Disney's first forays into live-action filmmaking; Dorothy Ann Blank, who created some of the first story treatments, character development, and dialogue for *Snow White*; Bosnian-born screenwriter Otto Englander, who wrote Mickey shorts, Silly Symphony shorts, features, and episodes for the various Disney anthology series on television; and Sylvia Moberly-Holland, the second woman to work in the Disney Story Department. She was the first to be named story director, for the "Waltz of the Flowers" sequence from *Fantasia* (1940).

The story development routine at Disney has evolved significantly over the years, but the encouragement of collaboration and imaginative problem solving remains a constant and has made possible a significant addition to the process. The Disney Story Trust was formed in 2006 to allow key contributors at Walt Disney Animation Studios to weigh in on the various movies in production, whether they are assigned to them or not, and loosely workshop them in a group setting. Jennifer Lee, chief creative officer, Walt Disney Animation Studios, describes the group's atmosphere this way: "It's not a place where people are keeping score of their ideas. It's just a room where people are giving to each other."

ABOVE: The Story Department has always figured prominently in the creative process at the Disney studio and continues today, as seen in this example from *Raya and the Last Dragon* (2021), where the intensity of the battle between Raya and Namaari comes through in these color story sketches by production designer Paul Felix.

A NEW MEDIUM, EXTRA LARGE

Walt Disney's first completely live-action film came into being as a result of postwar British economic woes rather than artistic ambition. Profits from Disney and RKO films shown in Britain were frozen and could only be spent in England on local productions. Walt couldn't make an animated film without his Burbank studio, so he decided to produce a live-action movie in Britain using local film studio facilities. He chose to adapt Robert Louis Stevenson's book *Treasure Island*, which was another classic story Walt had been eyeing since the 1930s, and it finally went into production in 1949. Although the live-action element and the remote production aspect of *Treasure Island* (1950) made it relatively unfamiliar territory for Walt, the Stevenson story contained all the elements of a perfect Disney vehicle: a boy on a danger-filled adventure, a mentor figure, buried treasure, tragedy, redemption, and a classic, good-versus-evil struggle. It was a very straightforward adaptation, which allowed the power of the original story, the acting, and the rich Technicolor film stock to do the work of captivating the audience.

Treasure Island was a critical and box office success, and it proved that the Disney storytelling magic was not dependent on the brilliant animation that was normally the star of the show. This was important because it was the early 1950s and Walt was on the

ABOVE: The shipboard production set of *Treasure Island* (1950).

Storyboarding

ABOVE: Story sketches by Disney studio artists displayed for review during the production of *20,000 Leagues Under the Sea* (1954).

Another storytelling aid pioneered and perfected by Disney was the use of storyboards in the planning and development of animation. They started out as little more than doodles scrawled in the margins of outlines and scripts to supplement the typed descriptions of the various gags being considered for a production. Soon these doodles had evolved into separate and far more elaborate drawings that visualized not just gags but also character behavior and the general action of the cartoon, and when someone decided to pin these drawings to a corkboard big enough to accommodate the entire story for instant visual reference, the storyboard was born.

Frame-by-frame animation is an incredibly time-consuming and expensive process, and the storyboard allowed Walt and his animators and writers to fix any story and character issues in advance of the animation process. It was also a useful tool for transitioning visually oriented animators into story supervisors. Moreover, not everyone could act out a story like Walt, so having a storyboard to lean on made the task of pitching a story idea to a group a lot easier, and before long it became an indispensable component of the creative process at Disney.

It was a development that revolutionized filmed storytelling in general, as the great director Alfred Hitchcock relied heavily on them for many of his classic movies, as did Orson Welles in the making of *Citizen Kane*.

Storyboarding is still in use today at Disney and at animation, commercial, film, and marketing studios around the world.

verge of entering the burgeoning television entertainment industry, where the ability to produce live-action content would be essential. The success of *Treasure Island* also demonstrated that the studio could tackle longer works of literature and a whole new realm of storytelling options. As Walt himself put it, "When I finally decided to diversify, and I went into the live-action medium, I felt that I could open up a door there where I could pick and choose.... I don't want to be doing things in a feature cartoon that could be done better with a good live cast."

For his most ambitious live-action project to that point, Walt selected the classic Jules Verne adventure *20,000 Leagues Under the Sea* and hired Richard Fleischer, son of Walt's old competitor Max Fleischer, to direct. What drew him to the story and how he chose to adapt it is best described by Dick McKay, then director of publicity for Walt Disney Productions: "Disney saw a world of infinite mystery and menace in the story—a world of frightening depths, silent darkness, and monstrous power. Verne was fascinated by facts, and was careful to describe mechanical devices. Disney emphasizes the human equation, and is fascinated by people's reactions in moments of high drama."

The extensive underwater filming presented a host of technical challenges, but the results were well worth the effort because the inherent danger of that alien environment is what drove the story and gave weight to the conflict between characters. *20,000 Leagues Under the Sea* (1954) was also Disney's first science fiction feature, and while the genre shares some characteristics with the fantasy films the studio specialized in, sci-fi requires a sense of scientific plausibility that is entirely absent from fantasy. In this regard, Walt was very particular during production, rejecting scores of sketches for the design of the movie's main vessel, the *Nautilus*, until he settled on one that he felt was as close to Verne's description as possible, but also one that would appear to audiences as believable— that is, practical enough to actually function. Walt understood that as far-fetched as some elements of science fiction storytelling might be, people automatically suspend their disbelief if you create a believable world filled with believable characters.

One of the most popular live-action films Walt made was *Swiss Family Robinson* (1960), adapted from the 1812 book by Johann David Wyss. The story development process for this movie was a departure for the studio, which kept only the bare bones of the original story and added an almost entirely new plot. Director Ken Annakin and his team came up

ABOVE: Cover art by Paul Wenzel from *Walt Disney Presents the Story of 20,000 Leagues Under the Sea* (1963), a Disneyland Records album.

with a list of scenarios they would most like to see in a movie about getting marooned on a desert island, then storyboarded the results and submitted them to the film's screenwriter, Lowell Hawley. The result was a box office smash and a new Disney classic that connected especially well with family audiences. Parents and children alike saw characters they could relate to, permitting them to vicariously experience the drama of a marooned existence.

The movie followed Wyss's story up to a point, but whereas in the book the family spends only a short time in their island tree house before abandoning it as impractical and moving into a cave, Walt saw the great entertainment potential in making the tree house more elaborate and a focal point in the film. It was definitely the right move, as the tree house proved to be so popular with audiences that it was re-created as an equally popular theme park attraction.

Another storytelling opportunity that live action presented was the chance to make film adaptations of events and legends from history, particularly the nineteenth century, which was among Walt's favorite subjects and was a very popular nostalgic setting at the time. With *The Great Locomotive Chase* (1956), he re-created the drama of an actual military raid that took place during the Civil War. The specific event the film centered on occurred when a daring group of Union volunteers commandeered a Confederate train in Georgia (opposition territory) and headed north, doing as much damage to the vital rail line as they could while being relentlessly pursued by enemy forces. For the audience, knowing that these portrayals represented real human beings in mortal danger heightened the suspense and bolstered character sympathy, especially for the leader of the volunteers, James J. Andrews, played by Disney's go-to leading man of the period, Fess Parker.

Embracing live-action filmmaking broadened the studio's storytelling horizons considerably by adding a wide range of source material options outside of fantasy and folklore. Walt himself produced more than fifty live-action films between 1950 and 1966.

ABOVE: A special effects model of the *Nautilus* used during the filming of *20,000 Leagues Under the Sea* (1954).

THEME PARK STORYTELLING

Walt's development of live-action filmmaking at the studio also helped pave the way for the kind of storytelling that he created for his theme parks. We tend to think of Disney storytelling primarily as we experience it through the films, but the Disney theme parks are popular around the world thanks to the superior storytelling on which they depend for their immersive entertainment value. In the Magic Kingdom at the Walt Disney World Resort, before a guest sets foot on an attraction, they are conscious of a story being told. The carefully conceived and crafted storefronts of Main Street, U.S.A. and hitching posts of Frontierland tell a nostalgic story of an idealized American past, while the sleekly futuristic architecture of Tomorrowland tells a story of optimism and hope for what is possible. The lush greenery and international atmosphere of Adventureland tells a story of world exploration, and Fantasyland tells a story of the power of fairy tales and magic that the child in all of us can still enjoy while at play.

As guests walk through the park, they experience attractions that are more intricate stories set within the larger story of the themed areas. For example, Pirates of the Caribbean tells a richly detailed story of marauding buccaneers that unfolds scene by scene as the guests pass through on bateaux. Haunted Mansion similarly weaves an engaging story that reveals itself to guests as they travel room to room in their Doom Buggies, with an ending that finally pulls the guest all the way into the story.

The Magic Kingdom has continued to expand over the years to include attractions based on both classic

LEFT: Cinderella Castle in the Magic Kingdom at the Walt Disney World Resort, 2020.

and contemporary Disney stories such as *Snow White and the Seven Dwarfs*. Seven Dwarfs Mine Train is a themed family coaster-type attraction that re-creates several iconic settings from *Snow White* using Audio-Animatronics technology, stylized scenery, and the film's original soundtrack and sound effects to immerse guests in the world of the film. The story Walt told so powerfully in 1937 still has such cultural resonance that it can be presented in abbreviated, multimedia form, and guests fill in the story blanks themselves by drawing from their own deep familiarity with the movie. Moreover, this same cultural resonance allows Disney to take the original stories told by their vastly popular theme park attractions and scale them up into feature-length movie versions. In the case of Pirates of the Caribbean, the core concept of the attraction was strong enough to support an entire film franchise.

The Magic Kingdom is itself a themed story within the larger story of the Walt Disney World Resort, as are EPCOT, Disney's Hollywood Studios, and Disney's Animal Kingdom Theme Park. Each park is packed with storytelling, including entertaining and educational narratives that reinforce the overarching themes around which the parks are designed. Within that framework, specific areas are themed to stories from partners across The Walt Disney Company. For example, the colorful and kinetic Toy Story Land at Disney's Hollywood Studios welcomes guests into an iconic world from Pixar Animation Studios with oversized toys and décor that's distinct to the Toy Story film series.

ABOVE (clockwise from top left): Disney storytelling comes to life through the richly detailed, immersive worlds of its theme park attractions and areas, as seen through Pirates of the Caribbean, the Haunted Mansion, Seven Dwarfs Mine Train, and Toy Story Land.

Walt Disney's vision for the Florida Project was so sprawling and ambitious that it required an oversized map to display its many components, 1966, as shown in the "Florida Film."

ALL TOLD

Perhaps the most compelling testament to the unrivaled power of Disney storytelling is the fact that the original versions of many of the stories, fairy tales, folklore myths, and fables the studio has chosen to adapt over the years have been forgotten because the strong collective memory of their Disney adaptations has simply displaced them. For generations of Disney fans, there is only one Snow White, the Snow Queen could only mean Elsa of Arendelle, and the Beast and Belle must have a waltz in the ballroom. But it is not just a case of older versions being supplanted by more recent iterations—it is the way the stories are adapted to maximize their emotional connectivity and entertainment value that gives Disney stories their cultural potency. The storytelling is made even more powerful through the use of Disney's unparalleled animation techniques and the integration of world-class musical accompaniment, but also by the way Disney stories are reinforced and retold through its hugely popular theme park adaptations, reimagined Broadway musicals, and live-action reimaginings of animated classics.

ABOVE: The Beast and Belle glide across the ballroom floor in *Beauty and the Beast* (1991).

The *Brave Little Tailor*

Mickey Mouse was a global phenomenon in the 1930s, and creating his cartoons was a prestigious job at the studio. "It was considered a great honor to work on a Mickey short," recalled Disney Legend Frank Thomas. "He was our star." The Mickey shorts had begun largely as vehicles for gags in 1928 and developed into more story-oriented creations by the middle of the following decade. "They started coming up with new and better story material for Mickey," says Disney historian J. B. Kaufman. "This was because he had evolved into a character that didn't provoke the conflict necessary to create drama. So by the mid-thirties they were coming up with things like *Thru the Mirror*, which is a pretty remarkable story property for Mickey Mouse. People knew *Alice's Adventures in Wonderland* and its sequel *Through the Looking Glass*, so it sort of elevated it to a higher level of story content."

Even so, toward the end of the decade, Mickey had competition in the form of his new companions, Donald and Goofy, and other notable animation at the studio had begun to challenge him for the Disney spotlight, especially the "stars" of *Snow White and the Seven Dwarfs*. And so as Mickey's tenth anniversary loomed, Walt decided to create a pair of big-budget vehicles for him worthy of his stature. One result was *The Sorcerer's Apprentice*, which eventually evolved into the segment in *Fantasia*. The other was *Brave Little Tailor*, another entry from the Brothers Grimm collection about a tailor who must vanquish a giant to win the hand of a princess. The cartoon was slightly longer than the usual running time for a short, and it contains some of the most accomplished animation in the history of the studio. As Kaufman points out, it is "a short that looks like a feature." Walt assigned an A-team of animators to the project, including Disney Legends Hamilton Luske, Bill Tytla, Frank Thomas, Ollie Johnston, and Fred Moore—and it was Moore to whom Walt gave the all-important task of creating an updated model sheet for Mickey that established his new look for the cartoon.

The story adaptation was written by Jack Kinney, who had reason to be nervous since, as he said of the experience, "That was the first time I had a story to do by myself." Given the importance of the project to Walt, he clearly had a lot of confidence in Kinney, and it paid off—*Brave Little Tailor* is full of witty lines and clever gags worked organically into the plot, like showing the perspective of Mickey inside the giant's mouth and the Rube Goldberg–like device at the end of the film consisting of a windmill, turned by the captured giant's snores, which powers a series of carnival rides. The short was nominated for an Academy Award that year.

As the voice of Mickey, Walt had more dialogue to record in *Brave Little Tailor* than in the usual Mickey short, including the classic line, "Well, I'll be seeing you . . . I hope!" Disney artists subsequently co-opted that as their own humorous catchphrase when heading into Walt's office to review their latest work with him.

ABOVE: A model sheet by a Disney studio artist for Mickey Mouse from the cartoon short *Brave Little Tailor* (1938).

Names weren't the Ub and Walt. It personality that

major concern for was character and mattered to them.

—Leslie Iwerks and
John Kenworthy

Authors of *The Hand Behind the Mouse: An Intimate Biography of Ub Iwerks*

CHAPTER 3

THE ILLUSION OF LIFE

Whether they take the form of circus animals, insects, superheroes, video game characters, cars, fish, droids, or teenagers, Disney characters embody deeply human aspirations and emotions. Ariel may be introduced to us as a little mermaid, but her desire to leave her confining ocean home in order to "be where the people are" is a quintessential longing for young people growing up anywhere in the world: the grass must be greener somewhere else, if only they could get there. Timon, from *The Lion King* (1994), is equally familiar: the class clown everyone wants to hang out with—or be. He's the one who can convincingly talk his more earnest friends into shirking their obligations in favor of a little fun, and yet make it sound like a sophisticated moral choice. Even Disney villains typically earn a degree of sympathy. After all, who hasn't felt like Maleficent, the person rejected by their peers for crashing a party to which they weren't invited?

The one-hundred-year history of The Walt Disney Company is built on such beloved heroes, sidekicks, and dastardly (though at times relatable) villains. Some are seen in just one ongoing story line (say, *The Princess and the Frog* [2009]), while others return again and again to spin new yarns (such as Winnie the Pooh and his friends in the Hundred Acre Wood). And, as Walt himself liked to point out, it was all started by a mouse.

LEFT (from top): The sidekick: Timon in *The Lion King* (1994). The villain: Maleficent in *Sleeping Beauty* (1959). The hero: Tiana and her prince, Naveen, in *The Princess and the Frog* (2009). The ensemble: Winnie the Pooh and friends in *Winnie the Pooh* (2011).

MOUSE AND COMPANY

When Walt Disney created Mickey Mouse in 1928, with deft design assistance from his friend and creative partner Ub Iwerks, he wasn't looking to create the most beloved animated character in the history of cartoons. The Disneys were desperate to create a popular, recurring protagonist for their animated shorts. Their previous main character, Oswald the Lucky Rabbit, belonged to distributor Universal Pictures, not to Disney. The Oswald shorts Disney made for producer Charles Mintz were popular, but Mintz had taken creative control of the Oswald series' production away from Walt—plus had lured away most of Disney's staff, save for Iwerks and a couple of others. Walt declined to buckle under pressure from Mintz to take less money for the cartoons or to work for a share of the profits.

Walt and his wife, Lillian, spent weeks in New York in early 1928, trying to come to an accommodation with Mintz, but conceded defeat after nearly a month. Walt had kept his brother Roy up-to-date via telegrams and letters, but on Tuesday, March 13, 1928, he and Lilly boarded a train for Los Angeles. Walt wired Roy simply and optimistically the following:

LEAVING TONITE STOPPING OVER KC ARRIVE HOME SUNDAY MORNING SEVEN THIRTY DON'T WORRY EVERYTHING OKAY WILL GIVE DETAILS WHEN ARRIVE=WALT.

Storyteller that he was, Walt loved to share a tale of how he thought up his soon-to-be-famous mouse on that train ride back to the West Coast. He said he was inspired by a spunky, adorable rodent that lived in his office in Kansas City. He told how he had wanted to name the character Mortimer—the name he'd allegedly given the real Missouri mouse—but that Lilly thought it was an awful name and suggested Mickey instead. But as Ub Iwerks's granddaughter, Leslie Iwerks, observed in her book *The Hand Behind the Mouse*, "Names weren't the major concern for Ub and Walt. It was character and personality that mattered to them."

Expressed through the series of joined circles that defined Mickey's look—many would point out his facial similarities to Oswald the Lucky Rabbit, those big round ears not withstanding—Mickey began as a blend of his creators' visions. For Ub, Mickey was inspired by silent movie star Douglas Fairbanks, Sr., "the superhero of his day, always winning, gallant, and swashbuckling."

LEFT: Disney Legend Ub Iwerks, shown at his drawing board circa 1929, worked with Walt to create Mickey Mouse.

> Scene # 2.
> Close up of Mickey in cabin of wheel'house, keeping time to last two measures of verse of ' steamboat Bill '. With gesture he starts whistleing the chorus in perfect time to music....his body keeping time with every other beat while his shoulders and foot keep time with each beat. At the end of every two measures he twirls wheel which makes a ratchet sound as it spins. He takes in breath at proper time according to music. When he finishes last measure he reaches up and pulls on whistle cord above his head.
> (Use FIFE to imitate his whistle)

Walt's ideas were more down-to-earth, and early Mickey was a happy-go-lucky character, with a job, a sweetheart, and a talent for having fun. (The swashbuckling would come later.) It was these common, recognizable traits that quickly made him the most popular animated character in history.

The first time audiences met Mickey Mouse, he was the boisterous, mischievous aspiring riverboat pilot in *Steamboat Willie* (1928). The eight-minute cartoon was the first animated short with fully synchronized sound, and it used the new medium to express Mickey's personality. He didn't speak words, but he could laugh—in the falsetto voice Walt applied to the character himself—and his actions had audible, comic consequences. He was the protagonist, but not the boss, gaining audience sympathy by the introduction of his bullying supervisor, the hulking Pete. The mean riverboat captain placed Mickey firmly in the role of underdog—a status that would be the starting point for many Disney characters to come, from Mickey's own iconic role as the Sorcerer's Apprentice in *Fantasia* (1940), to Tramp in *Lady and the Tramp* (1955), to Judy Hopps in *Zootopia* (2016) and Mirabel in *Encanto* (2021).

What Mickey Mouse lacks, from his 1928 debut to today, is pretension. "All we ever intended for him or expected of him was that he should continue to make people everywhere chuckle with him and at him," Walt once said. "We didn't burden him with any social symbolism; we made him no mouthpiece for frustrations or harsh satire." Mickey is a pal, a regular guy, who strives for better, often succeeds, but never takes on airs, never lives in the mansion on the hill (although he might visit, if it's haunted). A Disney version of the Charles Dickens holiday classic, dubbed *Mickey's Christmas Carol* (1983), was released as a featurette that debuted with a re-release of *The Rescuers*. When it came time for casting, it was natural that Mickey would be Bob Cratchit—the working stiff who maintains an upbeat attitude despite his burdens—and not, say, Scrooge's snappily dressed and reasonably comfortable nephew Fred (a role that went to Donald Duck). Bob Cratchit was Mickey's first scripted role in nearly thirty years, and it fit him like a glove. What could be a happier

ABOVE: A scene description and story-sketch panel from the *Steamboat Willie* (1928) script.

ending than seeing Mickey Mouse and Minnie Mouse (as Mrs. Cratchit) enjoying Christmas and a suddenly bright future?

Mickey has held many working-stiff jobs over the years: soldier, hot dog seller, lifeguard, musician, pet store clerk, firefighter, taxi driver, delivery man. But even when he's the boss, Mickey struggles mightily to keep his farm or his orchestra or his circus from descending into chaos. His success is most often defined by restoring order or earning Minnie's affection or winning the big game—everyday victories. When he finds himself getting the star treatment at Grauman's Chinese Theatre in *Mickey's Gala Premier* (1933), mingling with dozens of real-life stars, including Joan Crawford, Greta Garbo, and Clark Gable—a star brigade of which he was certainly a member—he wakes up at the end of the cartoon to realize it was all a dream. A more apt metaphor for his audience could hardly be imagined, as filmgoers awaken from their own dreams of hobnobbing with celebrities every time they walk out of a movie theater, turn off their televisions, or click over to a new app on their smartphone.

The character who leads an ordinary life until set against a big, imposing challenge has been a cornerstone of storytelling at The Walt Disney Company throughout its one hundred years. Who is Rey in *Star Wars: The Force Awakens* (2015) if not a hardscrabble striver who finds herself facing seemingly insurmountable challenges? Ditto Judy Hopps from *Zootopia* (2016), and the hero of all three tellings of *Aladdin* (in animated, reimagined Broadway musical, and live-action versions).

RIGHT (from top): Mickey Mouse's occupations have included hot dog vendor (in *The Karnival Kid*, 1929), construction worker (in *Building a Building*, 1933), store cleaner (in *The Pet Store*, 1933), and firefighter (in *Mickey's Fire Brigade*, 1935).

The storytelling recipe remains as if lifted from a Mickey Mouse short: serve up a likable, hard-striving protagonist, just doing their best to survive and get ahead—then have them grapple with a problem that at first seems much bigger than they are; season with action, dramatic, or comedic elements, as desired.

Sometimes the protagonist's challenge emerges from a bit of bad behavior on their part, as in Mickey's most iconic role in "The Sorcerer's Apprentice" segment of *Fantasia*. Walt Disney's musical collaborator on the film, conductor Leopold Stokowski, urged Walt in a letter not to cast Mickey, but to create "an entirely new personality . . . that could represent you and me—in other words, someone that would represent in the mind and heart of everyone seeing the film their own personality, so that they would enter into all the drama and emotional changes of the film in a most intense manner." Yet Stokowski's suggestion was its own answer, because for Walt Disney and millions of fans, Mickey Mouse was exactly that catalyst for seeing "their own personality" projected into the story.

Mickey's look evolved over the years, most notably in the late 1930s from the pencil of Disney animator Fred Moore. As Bret Iwan, the current voice of Mickey Mouse observes, "I love *The Pointer* [1939] so much because it is the first short where we see Mickey with pupils. I remember at a very young age recognizing that he looked much different. The power of a character starts with eyes, just like we as people connect with our eyes, and that left a lasting impression with me." The design changes—a more pear-shaped body, identifiable cheeks, those pupils—magnified the character qualities that Mickey already expressed. As Iwan puts it, he became even more "lovable, appealing, and connected." As D23 writer Jocelyn Buhlman wrote in 2016 on D23.com, for more than ninety years, Mickey Mouse has remained "the everyman we can all relate to: a pure-hearted force of good who sometimes likes to cause a little mischief. We can see ourselves in Mickey's adventures and acknowledge our own potential through Mickey's own achievements—he represents all of us."

ABOVE: The character who became Pluto was introduced in 1930 in the Mickey Mouse cartoon short *The Chain Gang*. A memorable team up was in the Mickey Mouse short *The Pointer* (1939). Story sketch by a Disney studio artist.

Walt Disney surrounded his star character with an assortment of supporting players. Minnie Mouse was his co-star from the beginning—undergoing her own evolution (also see page 90)—but the Disney ensemble grew steadily over the years. Clarabelle Cow and Horace Horsecollar joined in 1929 cartoons. The next year, a pair of unnamed bloodhounds appeared in *The Chain Gang* (1930) and led to *The Picnic* (1930) in which Minnie got a hound dog named Rover, who soon took on the name Pluto. It was the same name given to the planetoid discovered at the edge of the solar system in May 1930—about a year before Mickey's dog was christened "Pluto" for *The Moose Hunt* (1931). Pluto had one line of comic dialogue in that short, but thereafter he largely did not speak, restricted to the barks and other sounds a real dog might make. If Mickey Mouse was Everyman, the playful Pluto was Everydog, and he starred in some forty-eight shorts of his own between 1937 and 1951, in addition to his many supporting appearances in Mickey Mouse cartoons, such as the Oscar-nominated *Mickey's Orphans* (1931).

The Mickey Mouse family was growing, and Mickey was maturing. He quickly outgrew the rude rapscallion role he played in *Plane Crazy*. "By the mid-1930s, he was already a somewhat different character," observes Disney historian J. B. Kaufman. "I mean, he was sympathetic all along, and he was a pretty scrappy little guy from the beginning." But even as early as his fourth role, in *The Barn Dance* (1929), Walt knew he wanted Mickey to be less rambunctious than Oswald had been. In the cartoon, "Mickey and Pete are having a rivalry over Minnie at this barn dance, and Mickey loses out at the end," relates Kaufman, who studied the original letters Walt wrote to his animators while he was on the East Coast during the production. "Roy and Ub and the other people still at the studio evidently were suggesting that they should wind up with some kicking business, where Mickey and Pete were taking turns, kicking each other, which is the kind of thing that would have been suitable for Oswald the [Lucky] Rabbit. But Walt writes back and says, 'I just don't think that that would be a good ending. I don't think that's what Mickey would do. I think it's better to just wind up with some kind of little forlorn expression at the end.' And when you see the cartoon, that's what they use. So that more sympathetic side [of Mickey] is already being cultivated when the character has just barely been born."

While still a resourceful and sometimes mischievous hero, Mickey needed a frankly ridiculous supporting actor to take on the more impulsive and just-plain-silly comic situations he had left behind. That role went to a bit player in the short *Mickey's Revue* (1932), in which a dog-like character seated

ABOVE: Mickey Mouse and Minnie Mouse from *Plane Crazy* (1929) in an animation drawing by Disney Legend Ub Iwerks.

among the animal audience came forth with an explosive laugh that could only be described as "goofy," provided by voice actor and former vaudeville comedian Pinto Colvig. The character, at first called Dippy Dawg, acquired his final name, Goofy, two years later. Unlike Mickey Mouse, Goofy was tall and gangly, giving his principal animator, Art Babbitt, a long, loose-limbed body to work with in devising Goofy's comic shuffle of a walk and many pratfalls. "Think of the Goof as a composite of an everlasting optimist, a gullible Good Samaritan . . ." Babbitt wrote in a 1934 memo. "Any little distraction can throw him off his train of thought." Goofy was not to be "pitied," Babbitt cautioned. "He is a good-natured dumbbell who thinks he is pretty smart."

By the early 1930s, the modest mouse was a star like no animated character before him. He played the lead not only in movies but in a daily comic strip (starting in 1930), a color Sunday strip (beginning in 1932), and a magazine (commencing in 1933). He was a phenomenally popular plush toy and appeared on a soon-to-be-iconic wristwatch, among other products. He was beloved by children and their parents—who had come to view Mickey as something of a role model. Walt felt restricted in what he could have his alter ego do onscreen, joking, "If our gang ever put Mickey in a situation less wholesome than sunshine, Mickey would take Minnie by the hand and move to some other studio."

Mickey Mouse might have had a sweetheart, and a couple of pals to keep him company, but what he needed was a foil who could misbehave—burnishing Mickey's wholesomeness by being the opposite and at the same time adding an amusing delinquency to the cartoons. They soon found just the *duck* for the job—emerging, like Goofy, from an indelible voice.

The same year Goofy got his name, Donald Duck made his debut in the Silly Symphony short *The Wise Little Hen* (1934). The short was an adaptation of the fable "The Little Red Hen," in which a diligent hen asks the other farm animals for help in growing grain and baking bread. They lazily refuse. Disney's inspiration was to cast a vaudevillian named Clarence Nash, who did bird impressions as part of his act, as

the impudent duck in the story. Donald was first paired with Mickey in *Orphans' Benefit* (1934), a short that incorporated a bit from Nash's act, in which he read "Mary Had a Little Lamb" in a duck's voice. In the cartoon, Donald's recitation is continually interrupted by taunting orphans, and he has a temper tantrum—an explosiveness now forbidden to Mickey Mouse.

Continues on page 78.

ABOVE: Donald Duck shown here in an exaggerated pose in *Orphans' Benefit* (1941), a color remake of the 1934 animated short that marked the hot-tempered duck's second onscreen appearance.

Steamboat Willie

Mickey Mouse's first role was in a six-minute, black-and-white cartoon called *Plane Crazy* (1928), where he builds and flies his own airplane, inviting Minnie Mouse along for its first flight. Typical of his later roles, Mickey has grand ambitions, as he is shown looking at newspaper coverage of the American hero Charles Lindbergh, who had completed the first nonstop trans-Atlantic flight from New York to Paris just a year earlier.

In the spring of 1928, Ub Iwerks animated the whole film alone and in secret—lest the other animators, soon to be leaving for jobs animating Oswald the Lucky Rabbit films for Charles Mintz, find out what he was doing. Despite the grueling conditions, and being isolated from others, Iwerks created a lively, sympathetic performance for the character. Even with no dialogue, Mickey's thoughts seemed easily understood to those seeing him in action, as legendary Disney animator Ollie Johnston observed some years later. "I don't know if anyone had done any kind of acting [in animation] like that before," he told Iwerks's granddaughter, filmmaker and author Leslie Iwerks. Mickey was flawed but familiar, with hopes and setbacks anyone could relate to.

Remarkably, the short was ready to show less than two months after Walt and Iwerks had first sketched out the character, and a preview audience responded well. But for some time, they were the only audience to enjoy it. At the time, Disney needed to rely on the larger studios, with distribution departments, to get his cartoons into theaters—and for this new venture, there were no takers. Walt needed something for these distributors to focus their attention on to bring his new star to a much wider audience. And he knew what that had to be.

In the months since the October 1927 debut of the live-action *The Jazz Singer,* the first picture with synchronized sound, everyone in Hollywood was talking about the "talkies," and Walt Disney was determined to give his new character a voice. Walt also knew he needed to do it before any other animation studio beat him to it. He had soon conjured a new role for his Mouse, inspired by two recent Buster Keaton comedies, *Steamboat Bill, Jr.*, and *The Navigator*. Walt called his film *Steamboat Willie* (1928), and Iwerks and his freshly hired—albeit still small—team of dedicated artists animated it from a script by Walt that emphasized all the sound effects they intended to add. But they still needed a means to record and synchronize the audio.

By 1928 a number of start-up companies were competing for the burgeoning sound-film market. Walt settled on the new Cinephone system, which seemed to him to provide the most reliable synchronization, and he agreed to pay its creator, Pat Powers, a princely sum to license his technology for ten years. A trip to New York to record the musical soundtrack with professional musicians would prove to be even more expensive than securing the recording infrastructure. But while Walt was pleased with the result, the major studios (and their distribution units) he showed it to still declined to sign a multipicture distribution deal.

What he could arrange for, however, was a two-week run at the Colony Theatre in New York, beginning November 18, 1928—ten years to the day after a then sixteen-year-old Walt had headed off to France to be an ambulance driver (just as a World War I armistice had been signed). That Walt had been an anonymous cog in the postwar effort, while now this one was about to be the center of attention (well, at least in the animation world). The film used its sound technology brilliantly and continuously, beginning with Mickey's whistling "Steamboat Bill" and continuing through a steady stream

of audio-reliant gags, from Mickey's tongue-flapping raspberry, to the goat who performs "Turkey in the Straw" when its tail is cranked, to the laughing parrot who gets his comeuppance via a tossed potato in the final moments—after which Mickey has the last laugh.

Trade newspapers in Los Angeles lavished praise on the film (*Exhibitor's Herald* dubbed it a "riot of mirth"), as did the *New York Times*. Mintz no doubt read ruefully about Walt's "ingenious piece of work." Working with the soon-to-be-legendary composer Carl Stalling—a friend and collaborator of Walt's from Kansas City—the Disney artists quickly set to work turning the first two silent unreleased Mickey Mouse cartoons, *Plane Crazy* and *The Gallopin' Gaucho* (1928), into sound films.

Walt's next step was perhaps his most ingenious to date: he turned down all the deals offered by the major studios to buy his Mickey Mouse cartoons outright or to treat him and his artists like employees by paying them a weekly fee. Walt wanted his production company to remain independent and to own its output. He eventually struck a distribution deal with Powers, who wanted Disney's movies to promote his sound system, confident theaters would deal with this new company because of the immense popularity that was soon to be realized by Walt's breakout star performer: Mickey Mouse.

ABOVE: *Steamboat Willie* (1928) introduced the world to Mickey Mouse, Minnie Mouse, and the concept of cartoons with fully synchronized sound.

Continues from page 75.

Audiences couldn't always understand what Donald was saying, but they loved his outbursts and his scheming. His popularity soared seemingly overnight, and Disney took notice, giving him major roles in more than twenty shorts before the end of the 1930s. He followed Mickey Mouse into comic strips and storybooks and then into the toy stores. And he did it all by behaving atrociously. As a studio memo later described him, Donald is "vain, cocky and boastful, loves to impose on other people and heckle them; but if the tables are turned, he flies into a rage.... It is his cockiness that gets him into most of his scrapes, because it is seasoned with foolhardy recklessness."

Donald did have some appealing qualities, the memo went on, mentioning his determination and cleverness and the fact that "[he] is easily amused." If audiences saw themselves in Mickey, they saw their friends and neighbors and co-workers in Donald. They liked that he was brash and irrepressible . . . and also that he got his comeuppance in the end. Even Disney artists had mixed feelings about him: "I could kill him sometimes," said Jack Hannah, who directed dozens of Donald Duck films starting in the 1940s. "But he can be fun to work with."

While never the untarnished hero Mickey became, Donald Duck was also never really a villain—at least not in the Disney sense of the word. Calling him an antihero seems too literary for a figure so distinctly grounded in the gags and antics of cartoon storytelling. He's too adorable to be labeled anything other than a hero, if one from a completely different pattern than Mickey Mouse. But it's a pattern that Disney knows well—the ill-tempered but lovable rascal. Just as there's more than a little of Grumpy from *Snow White and the Seven Dwarfs* (1937) in Donald, there's more than a little Donald in the mischievous nature of Stitch in *Lilo & Stitch* (2002), the righteous indignation of Philoctetes (aka "Phil") in *Hercules* (1997), or the flaming outbursts of Mushu in *Mulan* (1998). The difference between the toxic anger of, say, Cruella De Vil from *One Hundred and One Dalmatians* (1961) and the comic anger of these sidekicks was best summed up by that studio memo about Donald Duck: "He doesn't stay angry."

Donald is the hothead who cools off, the devil-may-care duck who's not quite a delinquent. But one thing Donald has never been is an innocent. That role, with all its vulnerabilities and heartbreaking sweetness, defines another kind of Disney hero, from Snow White to Mirabel Madrigal.

ABOVE (from left): Characters with feisty personalities, such as Stitch in *Lilo & Stitch* (2002), Philoctetes (aka "Phil") in *Hercules* (1997), and Mushu in *Mulan* (1998), can draw roots back to the classic character portrayal of Donald Duck.

THE INNOCENTS AND THE EMPOWERED

The problem with Pinocchio, early on, was that no one liked him. It wasn't just the problematic source material, in which the puppet was a selfish brat. Early animation tests at Disney emphasized that Pinocchio was a wooden puppet, making him move more mechanically than the characters in *Snow White and the Seven Dwarfs* (1937), and his stiff face had no warmth to it. Legendary Disney animator Milt Kahl saw the animation and offered a solution: stop thinking of Pinocchio as a puppet and think of him as a boy. "You can always draw the wooden joint and make him a wooden puppet afterward," Kahl said. And that's what the animators did. Pinocchio may have hinges instead of knees and squared-off arms, but save for that famous nose, his face was as soft and expressive as any child's.

From there it was a natural progression that the misbehaviors of a cute little boy could be turned into understandable misadventures, rather than hostile acts, instigated largely by scheming adults. As J. B. Kaufman puts it, "In the movie, he does a lot of things he shouldn't, but they are kind of innocent missteps." Walt knew the more boyish Pinocchio would win over the audience, saying, "If he's cute and likable and full of little tricks, they're going to like him right away."

Both Disney's classic animated features and its more recent storytelling return again and again to the story of the innocent, learning about the cruelties of the world and, in the end, acquiring just enough maturity that audiences can leave the theater feeling comforted that the youngster will be just fine. The 1930s and 1940s saw from the Disney studios not just *Snow White* and *Pinocchio* (1940), but also *Bambi* (1942) and *Dumbo* (1941). Later, the last animated film in which Walt had a guiding hand was *The Jungle Book* (1967), with the boy, Mowgli, at its center. The original story developed nearly thirty years later for *The Lion King* imagined a sheltered cub forced to confront the meanness of the world. Some more recent films with similar themes are closer to coming-of-age stories, with protagonists more Snow White's age than Bambi's or Pinocchio's. But whether it's Moana, Vanellope von Schweetz, or Lilo, these characters still adhere to Walt's principal of being "cute and likable and full of little tricks."

ABOVE: A dimensional puppet of Pinocchio, used by artists to study the wooden boy's movements for the 1940 animated film, is part of the Walt Disney Archives collection.

ABOVE: Animation drawings and sketches by Disney studio artists of youthful Disney heroes offer glimpses into their multifaceted personalities, from inquisitive and perceptive to confident and courageous (clockwise from top left) Moana, Anna, Tiana, Alice, Rapunzel, Raya, Mulan, Lilo, Ariel, and (center) Pocahontas.

The Little Mermaid (1989) connected with a wider audiences than the Disney animated films immediately before it, in part because its filmmakers consciously sought to re-create the experience they had had when they themselves were impressionable young people. "For us, we were Disney fans even before we worked at Disney, when we were younger . . . kind of the baby boom generation," *The Little Mermaid* director Ron Clements reflected in 2006. His fellow director John Musker added, "We just tried to make it for ourselves as the audience, just [answering the question,] what's a movie that we would like to see and would be entertaining and engaging emotionally." That meant creating a hero who could swim in the same waters, so to speak, as Snow White, Cinderella, and Aurora of *Sleeping Beauty* (1959)—but updating her for a more contemporary audience. She might still be an ingenue who gradually learns to fend for herself, but she'd have more agency than her predecessors—a tendency that would gradually reshape Disney heroes in the years that followed.

The arc of the youthful Disney hero—particularly its young women—has bent toward the more aware and empowered in recent decades, as demonstrated not just by animated features such as *The Princess and the Frog* (2009), *Frozen* (2013), *Raya and the Last Dragon* (2021), and *Encanto* (2021), but also by any sampling of lead characters from the family-oriented Disney Channel's fan-favorite television shows: the gadget-savvy *Kim Possible* (2002–2007), the complementary live-action and animated personas of *Lizzie McGuire* (2001–2004), the magic-wielding *Wizards of Waverly Place* (2007–2012), and the Cassandra-like hero of *That's So Raven* (2003–2007), to name just a few.

One shining example of the empowered taking their place alongside the innocents can be found in Disney's iterations of Lewis Carroll's Alice. She seems more of a lost little girl just learning to fend for herself in the original animated *Alice in Wonderland* (1951), but by the time of director Tim Burton's live-action interpretation (2010), she had become more capable and clever. She was also older, embodied by then-twenty-year-old actress Mia Wasikowska, while the animated Alice had been voiced by Kathryn Beaumont, who turned thirteen the month before her animated version came out. Similar live-action makeovers awaited Aurora in the *Maleficent* movies (2014 and 2019) and the title character in *Cinderella* (2015).

ABOVE, TOP: Disney Legend Kathryn Beaumont (the voice of Alice) performing as a live-action reference model for the animated *Alice in Wonderland* (1951).

ABOVE: Mia Wasikowska portrays a more mature Alice in Tim Burton's 2010 live-action reimagining of the tale.

As younger viewers increasingly gravitate toward storytelling that presents aware and active heroes, Disney's youthful protagonists have kept pace with the times. Moana, created by screenwriter Jared Bush and *The Little Mermaid* directors Musker and Clements, was described by Clements just before the film's release as "brave, determined, compassionate, and incredibly smart." The film's producer, Osnat Shurer, added, "She is a strong hero who sets out to retrieve what her people lost a long time ago. . . . Moana wants to save the world—literally—even though she's just about the only person who realizes it needs saving."

The look of the Disney hero had evolved as well. "She's an action hero," observed Bill Schwab, the art director of characters for *Moana*. "We wanted to give her an athletic build." The character was also inspired by some Pacific island people. He added, "we gave her sculptural bone structure with strong cheekbones and a prominent upper lip. We really do sweat the details to get our character design right." In short, Shurer summarized, "She's a powerful role model for today's audiences."

This is not to gloss over the fact that Snow White and Pinocchio still connect with modern viewers in their own way, or to ignore that Ariel's struggle to regain her voice and win over her true love is just as compelling as Moana's quest to save her world. It is, rather, to recognize that the world has evolved during Disney's one-hundred-year history, and Disney's concept of what a young protagonist might be capable of has expanded in response.

Pixar Animation Studios has its own style in conveying a classic coming-of-age tale. In *Luca* (2021), the main character of the Disney and Pixar film named after him is typical of a sweet, inexperienced main character—despite, and partly because of, the fact that he's a sea monster. He's aware of the world above the ocean's waves, but he's been warned that it's dangerous—especially the humans whom he'll inevitably encounter. "He's never been to the surface," says director Enrico Casarosa. "When we meet him, he's beginning to feel that his world is a little too small for him. He starts to follow his nose a

ABOVE: A character design study by art director Don Shank from Disney and Pixar's *Luca* (2021) shows the title character longing to know what's above the surface of the water.

ABOVE: A model sheet may also establish standards for a character's facial expressions, as seen here with Luca from Disney and Pixar's *Luca* (2021), as both sea creature (top) and human boy (bottom).

bit, venturing farther and farther [from his home]. . . . Once a rule-follower, suddenly Luca is checking out an object that fell off a boat. That's how he meets Alberto." And so it often goes for the film's innocents: the growing curiosity that comes with approaching adulthood merges with a lure from outside their previously limited worlds. As *Luca* demonstrates, the self-discovery of sheltered young protagonists continues to resonate, across mediums and through a variety of creative teams.

CHARACTERS ON THE SIDE

Sometimes good things do come in pairs, both onscreen and off. Take the closeness of the friendship between Timon and Pumbaa in *The Lion King*. It reflects the bond between the voice actors who first played the roles: Nathan Lane and Ernie Sabella. The two had already known each other many years when they auditioned for the Disney film, originally testing for two of the hyena characters. So when the filmmakers created Timon and Pumbaa during the story-development process—needing a good dose of humor in a tale that has many serious moments—Lane and Sabella were asked to audition again. They won the roles and did recording sessions for *The Lion King* during the day while appearing together in a revival of *Guys and Dolls* on Broadway at night. Sabella recalls being told that it was one of the first times Disney had recorded more than one voice performer at a time for an animated feature, allowing them to improvise and play off each other the same way the characters do in the film.

The result was an enduring onscreen partnership—brought to life by Lane and Sabella . . . and then by countless other actors through the years—spanning the breadth of *The Lion King* franchise. Timon and Pumbaa appeared in feature films, a *Timon & Pumbaa* television series, theme park shows, video games, and the groundbreaking Broadway musical, as well as making cameos in other tales. The duo play into the long-standing storytelling tradition of the seemingly mismatched couple—in their case, a tiny meerkat and lumbering warthog—in which their apparent differences in size, intelligence, and demeanor provide endless comic opportunities.

Pixar Animation Studios achieved a similarly timeless and hilarious pairing with Mike and Sulley in *Monsters, Inc.* (2001) and *Monsters University* (2013), as did Walt Disney Animation Studios with Ralph and Vanellope von Schweetz in *Wreck-It Ralph* (2012) and *Ralph Breaks the Internet* (2018). The difference, of course, is that those pairs were the main characters in the films, while Timon and Pumbaa steal every scene in which they appear in the more confined role as sidekicks.

Sidekicks have been part of storytelling

since well before Sancho Panza first rode with Don Quixote, more than four hundred years ago. As with Timon and Pumbaa—and, to name another seemingly mismatched pair, C-3PO and R2-D2 in the *Star Wars* films—sidekicks often add a necessary element of comedy. But in Disney stories they usually offer much more. Timon and Pumbaa also serve as sounding boards, commentators, and to some degree, mentors for the lion prince Simba. Their "hakuna matata" attitude may be a far cry from the wise voice of Jiminy Cricket in *Pinocchio* or the reassuring whispers of Timothy Mouse in *Dumbo*, but all these sidekicks exist to complement and guide their companion, the hero of the tale. As J. B. Kaufman points out, "They carry a lot of the story by virtue of personality traits that the protagonist might not have"—whether it's wisdom, muscle, a sense of humor, or something else entirely. They often provide "The Bare Necessities" needed to make a movie's story come together.

Baloo in *The Jungle Book* started off as a minor character, a cameo to allow bandleader Phil Harris (a favorite of Walt's) to sing a tune folk singer Terry Gilkyson had written for the movie titled "The Bare Necessities." (It's the only song in the finished film not written by the Sherman brothers.) For animator Frank Thomas, Harris's recording session "marked the turning point of the picture," as John Canemaker related in his book *Walt Disney's Nine Old Men and the Art of Animation*. Walt himself "did a little dance step, snapping his fingers to show how this jazzy, irresponsible bear named Baloo should act," Canemaker reported. The revelation, Thomas said, was that "from now on we had a story about Baloo and Mowgli and friendship." The cameo grew into the film's most memorable, and arguably most important, character.

Not every sidekick blossoms into a lead role or solves major story problems. Some are there simply to listen, to give the main character someone to talk to, to work through their thoughts and emotions, even if the sidekick themself is without a voice that the audience can understand. In the *Star Wars* galaxy, prominent sidekicks like Chewbacca or BB-8 communicate with a language that only certain onscreen characters will understand, but the obvious connection forged among the characters is clear and meaningful to the story. Within Disney animation, attentive animals in *Snow White and the Seven Dwarfs* don't quite qualify as sidekicks (the princess has seven of those already), but they are the precursors of later nonverbal partners such as Meeko, the raccoon in *Pocahontas* (1995); Aladdin's monkey, Abu; Pascal, the chameleon in *Tangled* (2010); Heihei, the wacky rooster in *Moana* (2016)—and perhaps Disney's most prominent and beloved sidekick, Tinker Bell from *Peter Pan* (1953).

Tinker Bell was created by J. M. Barrie, author of the original *Peter Pan* stage play, and her only voice was the bell sound included in the name Barrie gave her. (The other half of her name was also literal, since Barrie imagined the sprite as an actual tinker, who fixed the other fairies' pots.) In stage productions, Tinker Bell is represented by a speck of light that zips across the scenery;

86 ABOVE AND OPPOSITE: A Tinker Bell animation drawing sequence by Disney Legend Marc Davis created for *Peter Pan* (1953).

87

it took Disney artists to give her form. Her look was in development for years, and it generated more preproduction art than any previous character. She was eventually assigned to supervising animator Marc Davis. "She's a pure pantomime character," he said, "which in itself I think was very interesting—that she didn't talk, but you know what she's thinking."

Davis also gave her a wonderfully expressive face and body, using footage of actress and dancer Margaret Kerry as movement reference, and the features of a Disney studio Ink & Paint artist, Ginni Mack, as inspiration for Tinker Bell's face. Mack was a young woman with blond hair, twinkly eyes, and an elfin face that Davis transformed into one of Disney's most expressive animated characters, with or without a voice.

Walt Disney himself loved Tinker Bell, calling her the "little fairy [who] . . . glows like a firefly and leaves a trail of pixie dust behind her as she flits about with the speed of a hummingbird." Her fame grew the year after *Peter Pan* was released when Walt selected her to introduce show segments of his new ABC television series, *Disneyland* (1954). "Tink," as Peter called her, set a high standard for the many voiceless Disney sidekicks to come. Mindy Johnson, the author of *Tinker Bell: An Evolution*, put it this way: "The lasting impact of this pint-sized pixie has proven remarkable—she has captivated the world. Filled with earthly humors and human frailties, she is the sheer embodiment of magic and fantasy . . . through Walt Disney's persistent vision, J. M. Barrie's darling Tinker Bell has become the most recognized and best loved fairy of all time." Not to mention one of Disney's most enduring sidekicks.

It's appropriate that this discussion of sidekicks follows on the heels of our look at Disney's young and innocent protagonists, since the youngsters in lead roles are nearly always accompanied on their journeys by supportive pals. In Carlo Collodi's *The Adventures of Pinocchio*, a character named the Talking Cricket offers Pinocchio some advice, only to be killed by the puppet boy. Walt Disney rescued the nameless insect from his fate and assigned the character to animator Ward Kimball, who struggled with the design, asking, "How do you make a cricket endearing and cute?" But the insect eventually evolved into the dapper, earnest, well-spoken Jiminy Cricket—the first great solo sidekick in animated features, and an

ABOVE: Tinker Bell in one of her iconic hero poses. Animation drawing by Disney Legend Marc Davis.

enduring embodiment of that inner voice we call our conscience.

Keeping Jiminy "endearing and cute" took skill and strategy, as Kimball outlined in a four-page memo to his fellow artists in 1939. "In drawing the Cricket, try to figure him like Mickey. Divide him into thirds, then make the body like a teardrop in normal relaxed poses." Jiminy had only four limbs, as opposed to the six legs real crickets possess, but he did have antennae, which Kimball noted should be "shifted to the back of the head to look like two wisps of hair." Most of all, he urged, animators should "try to make him funny."

The creation of Jiminy Cricket was for Disney an important lesson on how useful a sidekick can be in solving story problems. Jiminy was sometimes funny, and always the voice of reason, but he also acquired another narrative function, as Kaufman points out. The Disney creative team "actually decided to make him the narrator and the character that would break the fourth wall and talk to the audience.... We have the transcript of the [story] meeting where that idea came up, and it was Walt's idea. Reading the transcript, you can almost feel how pleased he is at how much better the story is going to fall into place if we use this character in this way."

This richly imagined Jiminy Cricket, Canemaker wrote, was "arguably the warmest, most sincere, and psychologically three-dimensional personality that Kimball ever animated." Audiences took to Jiminy immediately, and the character's popularity in *Pinocchio* propelled him to solo stardom in storybooks, comic books, and later on television as well, appearing frequently to host safety segments on the *Mickey Mouse Club*.

One can't really imagine that Jiminy and Timon would get along that well, if they were ever to meet. Jiminy is the voice of prudence and long-term thinking, while Timon seems to discourage too much contemplation in favor of pursuing the pleasures of the day. Vanellope von Schweetz might dismiss both of them as lacking the vim and vigor she represents in *Wreck-It Ralph*. There's no single template that can define a Disney sidekick, except their differences from the person at whose side they remain. They may be serious or comic, wise or foolish, eloquent or silent, but they are created to be at the service of their story and their protagonist. The most memorable of them are not bound by their story utility—they're so captivating that they grow beyond their initial stories and go on to have adventures of their own.

ABOVE: An early Jiminy Cricket animator's model, created during the production of *Pinocchio* (1940), depicts the sidekick in an earlier, more insect-like form.

Minnie Mouse

Mickey Mouse had a partner for his adventures ever since his very first appearance. She's there on the title card for *Steamboat Willie* (1928): it's Minnie Mouse, with her signature polka-dot skirt and oversized high heels already in place (although she wears a plain white skirt in the film). She's no shrinking violet, as she's first seen running full speed, determined to catch the steamboat that's set to depart. Once they are aboard, troubles abound. Minnie has to contend with a goat that devours her ukulele and sheet music for "Turkey in the Straw." But Minnie improvises by shaping the offending goat's tail into a Victrola crank and turns it playfully to produce the music to which Mickey then makes mischief. Ninety-one years later, Minnie took the ship's helm herself, as Disney Cruise Line services introduced Captain Minnie, stylish as ever, wearing her own snazzy red nautical jacket and white officer's cap.

"I think some people at first blush might also think, 'Oh Minnie is the sidekick to Mickey,'" said Laura Cabo, Walt Disney Imagineering portfolio creative executive, working with Disney Cruise Line services. "But Mickey can be mischievous, getting into all these debacles, and Minnie has this personality, this intellect, where she can figure her way out of it. She saves the day more often than not." Author Mindy Johnson called Minnie "a dainty powerhouse combining a dynamic blend of gentility and moxie.... From the start, she is an independent female who will 'squeak' her mind and put any character in his place, if necessary."

Although she initially seemed to exist largely as an object of broad flirtation for Mickey (in *Plane Crazy* [1928], the first Mickey Mouse short to be animated but which was then delayed), and often portrayed as the "damsel in distress" for Mickey to rescue, Minnie also had the independence to take on a series of jobs: nurse, barmaid, street vendor, and dancer, to name a few. She sometimes spurned Mickey's advances and at other times took the role of Mickey's equal, joining him in his playful shenanigans in shorts such as *When the Cat's Away* (1929). As the years passed, Minnie was increasingly domesticated, playing Mickey's established partner and gaining both a pet dog (who became Pluto) and a cat (Figaro, who was recast after his appearance in *Pinocchio* [1940]). In all, Minnie appeared in 63 of the 121 Mickey Mouse cartoons, as well as in Mickey-free shorts that starred Pluto or Figaro.

If she seemed to settle down as the years passed, it was less about making her a homebody than it was to anchor the character of Mickey through their affectionate bond. As animators Frank Thomas and Ollie Johnston observed about the mouse partnership, "From the earliest days, it has been the portrayal of

ABOVE (top to bottom): Minnie Mouse co-stars in the Mickey Mouse films *Steamboat Willie* (1928), *Building a Building* (1933), *Brave Little Tailor* (1938), and *Mickey's Christmas Carol* (a 1983 featurette).

emotions that has given Disney characters the illusion of life."

From the mid-1950s until the 1980s, Minnie could be seen chiefly as a character at Disneyland, where she had her own Totally Minnie Parade in the summer of 1986, and then the Walt Disney World Resort; she returned to the big screen in a small role as Mrs. Cratchit in *Mickey's Christmas Carol* (1983), followed by regular television appearances in series such as *Mickey Mouse Clubhouse* and *Mickey MouseWorks*. In 1988, *Disney's Totally Minnie* television special found Minnie duetting with Elton John, performing "Don't Go Breaking My Heart." She may be Mickey's equal partner, but the two have separate houses, which opened to visitors in Mickey's Toontown in 1993. (They also had separate country houses at Mickey's Toontown Fair in the Magic Kingdom at Walt Disney World until 2011.) The couple was even accorded starring roles in a Disney theme park attraction: Mickey & Minnie's Runaway Railway. The attraction opened in 2020 in Disney's Hollywood Studios (and is set to debut in in Mickey's Toontown at Disneyland in 2023).

Minnie has celebrated her autonomy in recent years with not just the uniform of a Disney Cruise Line captain but also with her first high-fashion pantsuit, designed by Stella McCartney—that features a polka-dot pattern, of course. "What I love about Minnie is the fact that she embodies happiness, self-expression, authenticity, and that she inspires people of all ages around the world," McCartney said. For Women's History Month in 2022, the entry plaza of Disneyland featured a floral rendition of Minnie rather than Mickey for the first time. The display was designed by Disneyland horticulture specialist Stacy Wise and her team. "Minnie Mouse is just as iconic as Mickey Mouse, and she needs a little face time," Wise said.

The story of those taking on Minnie's voice talents, meanwhile, embodies its own tale of equal partnership. Initially, her voice was handled by Walt himself, but later two women from Disney's Ink & Paint Department, Marjorie Ralston and Marcellite Garner, took over the role (also see page 134). Other performers followed, most notably former silent film star Ruth Clifford. But Minnie's most enduring voice belonged to Russi Taylor, who in 1986 beat out nearly two hundred other women auditioning for the role. When she started her new job, Taylor met Wayne Allwine, who had voiced Mickey Mouse since 1977. The two fell in love and married in 1991—a real-life couple portraying an iconic duo (until Allwine's death in 2009). Before she passed on ten years later, Taylor said simply, "I really want whoever comes after us to be aware of the history and the tradition, and to love the characters as much as we do."

ABOVE (top to bottom): *The Wayward Canary* (1932), *Mickey's Rival* (1936). She's part of the ensemble cast in the opening sequence of the *Mickey Mouse Club* and the title lead of *Minnie's Bow-Toons* (the 2011–2016 short-form television series).

ENDURING, ENDEARING, AND EVIL

"Who's afraid of the Big Bad Wolf?" It's not just an enduring song lyric; it goes to the heart of the question of what constitutes a Disney villain. Are we just supposed to be afraid of them? For younger children, of course, the answer is an unequivocal "Yes!" And antagonists from the Queen and Ursula the sea witch to Judge Frollo from *The Hunchback of Notre Dame* (1996) and *Star Wars* sequel trilogy antagonist Kylo Ren have no doubt given youngsters some restless nights across the decades. There are also villains who are straightforward mechanisms of mayhem, without nuances of personality—for examples, the Headless Horseman of *The Adventures of Ichabod and Mr. Toad* (1949) or the Carnotaurs of *Dinosaur* (2000). But these are the exceptions. The most memorable villains are the most complicated ones—scary in their way, particularly to the film's protagonist, but with oversized personalities, a distinctly comic side, familiar flaws, or some combination of all of these that tempers the terror with fascination.

Even the merciless appetite of Shere Khan in *The Jungle Book,* an apex predator if there ever was one, is balanced by the vocal performance of George Sanders, as Christopher Finch points out in his book *The Art of Walt Disney*. "The ideal Disney villain is menacing and comic at the same time," he writes. "We must sense that he is a real threat, but unless we can laugh at him too, he could destroy the whole mood of the film. Shere Khan is a tiger stalking an innocent boy—not the usual stuff of humor—but Sanders' delivery, threatening and pompous at the same time, has just the right edge to it." Finch comes to a similar conclusion about Cruella De Vil from *One Hundred and One Dalmatians* (1961), whom he dubs "the real triumph of the film." He continues, "Animated by Marc Davis, she is the most sophisticated of Disney bad guys.... Her face is a blend of death mask and fashion plate, perfectly expressing her character, which is at the same time evil and laughable."

The Disney villains from *Snow White and the Seven Dwarfs* and later *Cinderella* (1950), just thirteen years apart, make for a fascinating contrast. The Queen's vanity and jealousy were recognizably human, certainly, but her pure villainy outweighed her humanity. A motivation that would have accorded her an element of vulnerability—that she wanted to marry the Prince—was discussed in story meetings but not included in the final film. She was strong and clever, but so relentlessly evil that even her gleeful laughter is chilling. In Disney's other early animated features, the antagonists are often reduced to smaller supporting roles with little consideration of their motives, whether it's the circus ringmaster in *Dumbo*, Stromboli in

ABOVE (from top): The Queen, *Snow White and the Seven Dwarfs* (1937); animation drawing by Robert Stokes. Shere Khan and Kaa, *The Jungle Book* (1967); animation drawing by Disney Legend Milt Kahl. Ursula and Ariel, *The Little Mermaid* (1989); visual development concept by Disney Legend Glen Keane.

93

Pinocchio, or the shadowy human hunters in *Bambi*. In *Fantasia*, Chernabog seems more a literal force of nature than a proper villain with a nefarious plot, despite his having been animated in part based on reference footage of the famed monster actor Béla Lugosi.

The first villain with a leading role subsequent to the Queen is another wicked stepmother: Lady Tremaine of *Cinderella*. She's a fully realized character, with distinctly human features and motivation (social advancement for herself and her biological daughters) and a more subdued demeanor, barely raising her voice. And what a voice she has! Actress Eleanor Audley, a veteran of Broadway, movies, and radio—and known for being aloof—provided both a distinguished vocal performance and a visual model for the character, animated by Frank Thomas. The animator found working on the stepmother "not much fun" but added that she was "the thing that made the picture work." She was a nasty character, certainly, but she was also someone many audience members might recognize from their own lives, transforming the supernatural threat of the Queen into a very human malice, equally if not more unnerving to protagonist and audience alike.

Cinderella was such a success that it was no surprise that Audley was asked back to provide the voice of one of Disney's greatest villains—Maleficent in *Sleeping Beauty* (1959). Audley appeared in reference film footage complete with costume, staff, and horns, performing in "a powerful style of contrasting controlled rage with sudden outbursts, well-chosen scheming words with shattering laughter," as animators Frank Thomas and Ollie Johnston observed in their definitive book *The Disney Villain*. Marc Davis gave Maleficent a walking stick and a cape-like robe that magnified her sweeping gestures—a costuming trick he repeated with Cruella De Vil's fur coat. Maleficent's raven sidekick gave her someone to talk to when she was otherwise alone. Davis struggled to make her interesting, since she was often depicted as static and speechifying, but he more than succeeded by creating, Thomas and Johnston wrote, "a veneer of quiet charm where a curled lip meant more than the excited mannerisms of someone like Cruella or Medusa."

Depicted in a wide-screen format and featuring the lavish backgrounds of Disney artist Eyvind Earle—who was in turn inspired by Gothic and Renaissance artists—*Sleeping Beauty* gave Maleficent quite a canvas on which to work her ill will. Her striking visual presence and voice made a deep impression on audiences and critics, and an extended battle finale in which she transforms into a dragon guaranteed that she would be remembered as larger than life. While the film was not a financial success in its initial release (due to its high costs), re-releases gradually turned it into one of that year's successful movies and made the distinctly designed Maleficent one of Disney's most iconic villains. (The complexity of her motivations—anger arising from feeling unfairly judged and isolated, only hinted at in the original film—was more thoroughly explored in two live-action films

Continues on page 98.

OPPOSITE: (clockwise from left): Cruella De Vil, *One Hundred and One Dalmatians* (1961); animation drawing by Disney Legend Marc Davis. Chernabog, *Fantasia* (1940); animation drawing by Disney Legend Bill Tytla. Maleficent, *Sleeping Beauty* (1959); animation drawing by Marc Davis.

95

Character Through Costuming

Cinderella has her glass slippers. Thor has his hammer. Mirabel Madrigal has her big, round eyeglasses. Jafar has his cobra-headed staff. Rey has her lightsaber. Winnie the Pooh has his little red shirt. Disney characters have memorable faces, certainly, but their distinctive costumes and unique props are as often just as important in defining their essence.

That's an easy observation when discussing Marvel Super Heroes, with their colorful suits and weapons; but it's equally true of even the most "ordinary" individuals. In both Disney versions of *Beauty and the Beast*, Belle's initial appearance tells us a lot about her: she's a hard worker (that apron) who's more practical than vain (that simple ponytail). For Emma Watson's introduction in the 2017 film, costume designer Jacqueline Durran added a necklace and boots, signaling that this Belle was simultaneously feminine and tough. It was, Durran said, a "kind of reinterpretation of Belle as an active heroine who does things and gets things done."

For period films, the costuming is both individually expressive and articulates the precise context of the story. Pocahontas's basic buckskin dress seems simple, but it took months of research to create an outfit that was both historically authentic and accurate to the no-nonsense character. "Now, things from the real world don't always translate into animation," said Jean Gillmore, who led the work on the costume designs for *Pocahontas*. "But we needed to do all that research on factual detail to bring the movie and our work into focus."

All these concerns came together in a practically perfect fashion with the creation of Disney's interpretation of Mary Poppins by costume designer Tony Walton. It was the first film assignment for Walton, a British stage set and costume designer who happened to be married to the film's star, Disney Legend Julie Andrews, at the time. "My most fortunate notion was giving Mary Poppins a secret life,"

ABOVE: Belle's village dress designed by Academy Award–winning costume designer Jacqueline Durran for *Beauty and the Beast* (2017).

he said. "I showed this by making her clothes gray or black or slate, but showing she had a secret life by their linings, which were always flashes of crimson or some very bright color. Julie loved that idea and really made good use of it."

Mary Poppins's costume and props truly earn the label "iconic." Her simple but worn hat, decorated with flowers that had seen better days, and her utilitarian but neatly tailored nanny's blouse, skirt, and overcoat suggested she was aware of what was fashionable but not bound by it. Her carpetbag spoke to her independence—she carried everything she needed with her—as well as to her magic powers, as it somehow contained a floor lamp, a coatrack, and two mirrors. Her umbrella, whose parrot-head handle had a personality and voice of its own, serving as an occasional sounding board, was also seemingly enchanted.

Andrews gave a splendid, understated performance, but the full image of the character emerged only with the authoritative dignity of Mary's clothes and her mastery of her belongings. Together, actress and accessories established what *Mary Poppins* (1964) co-songwriter Richard M. Sherman called "a puzzling, peculiar, fascinating person—full of surprises."

For *Mary Poppins Returns* (2018), a whole new cast, including Emily Blunt in the title role, and filmmaking team looked to Walton's work for inspiration. Costume designer Sandy Powell again gave the nanny's coat flashes of color in its lining, one of which was red with black polka dots. The pattern was echoed in her new bow tie—still red but with white polka dots. In order "to achieve the same effect of eccentricity" provided by Walton's costuming, Powell created two simple hats, each held in place with the same hatpin, topped with a stylized robin—a nod to the bird featured in the original film.

ABOVE: Coat designed by Academy Award–winning costume designer Sandy Powell for the title character in *Mary Poppins Returns* (2018).

Continues from page 94.

with Angelina Jolie in the role, her cheeks modified through makeup magic to resemble those of Davis's original drawings.)

Davis was also the principal designer of another of Disney's most enduring and evolving villains. That villain, Cruella De Vil, had even more prominent cheekbones, as if to amplify her villainy. Her name defines her evil intentions, but in One Hundred and One Dalmatians, she's also something of a paradox. Here was a woman determined to capture dozens of Dalmatian puppies because she wanted their soft, immature hair for a fur coat. Who could be more of an "inhuman beast," as the catchy song describes her? And yet Cruella remains the most memorable character in the original movie and the delicious focus of the live-action retelling, 101 Dalmatians (1996). Indeed, Oscar nominee Glenn Close applies her stellar range of skills not just to evoke a "spider waiting for the kill" but a fully realized and sometimes vulnerable villain, and the actress "succeeds in breathing archly theatrical life into the irresistibly monstrous," as a New York Times critic put it.

By the time of Cruella (2021), with Oscar winner Emma Stone in the title role, the character has herself become the protagonist, ceding the villainess role to a new character, the Baroness (Emma Thompson).

Audiences have embraced every version of Cruella—not hoping she'll succeed in her Dalmatian coat–making, of course, but fascinated by her audacity, her imperviousness, her determination, and, in ways that vary from story to story, her charm. This is surely not what Dodie Smith, the author of the original novel, The Hundred and One Dalmatians, had in mind. The novel's Cruella and her Hell Hall are more awful and frightening than the versions created in the screenplay by Disney story artist Bill Peet. Peet recognized that Cruella was the force in the story that "made it go," as he later put it, and he made sure she came across as both scary and fascinating, with a definite comic spin.

In designing the first Disney Cruella, Davis gave her not just those cheekbones but the signature thin, bony physique on which her furs hang and swing dramatically about. While Roger and Anita, the Dalmatians' owners, are warmly imagined and as human as the Disney princesses who came before them, Cruella is "drawn with more caricature," as Disney animators Thomas and Johnston observed in their book Disney Animation: The Illusion of Life. That choice "immediately made [her] more interesting and stronger." They continued, "No one ever doubted that Cruella De Vil actually would skin those puppies, yet this did not keep her from being a wild, fascinating figure who could get laughs." What's true of the 1961 Cruella is also true of the depictions of Cruella that followed. As Thomas and Johnston put it, "Because of our fascination with her explosive personality and our enjoyment of her outlandish behavior, appearance, and actions, she was funny without losing either her menacing quality or her audience."

According to Emma Stone, who took on the Cruella role for the 2021 live-action origin story film, "There is something about Cruella that is enticing," including her "full acceptance" of who she is, and her unabashed autonomy—characteristics Cruella shares with many Disney villains. Stone likely summed up the feelings of decades of villain performers when she noted, "It's such a blast to get to drop all of the social and empathy . . . and just be ruthless. [To] go for exactly what you want is really cathartic."

In some sense, it's exactly that focused, unbridled determination that turns Disney villains into the favorites of many fans. From Maleficent to Scar in *The Lion King* (1994), some of the most memorable Disney antagonists have been envisioned by writers and animators as people who use their extraordinary gifts to get what they believe they deserve, what they believe they've been cheated out of. That sense of having been unjustly thwarted—a feeling familiar to most viewers—balances their cruelty and makes them simultaneously repulsive and fascinating.

It's basic to the storytelling craft across the centuries and in any culture on Earth that the more intricately imagined the character, the more enduring that character will be. It's a principle adhered to by Disney artists, rather than invented by them. Nevertheless, moviegoers have come to expect and rely upon the complexity of the Disney villain, knowing that whatever form they take, there will be more to their tale than meets the eye. The same can be said for one of the most iconic cinematic villains of all time: Darth Vader in the *Star Wars* films. The American Film Institute ranks Darth Vader No. 3 on their list of the top "50 villains of all time," not only because of his seminal look and portrayal but also due to his rich backstory. A personality with more depth serves other live-action villains as well, be it Kylo Ren in the *Star Wars* galaxy or one of the many Marvel Cinematic Universe villains. Even Loki has a dysfunctional family and an opportunity to appear sullen and disconsolate. As Thomas and Johnston stated at the beginning of *The Disney Villain*, "All of us are potential villains . . . if we are pushed far enough, pressured beyond our breaking point."

So what makes for the most fascinating villains, those who have had "a lasting impact on the public, spreading horror, visual excitement and, in many cases, laughter around the world," as Thomas and Johnston phrased it in *The Disney Villain*? It's looking in their eyes and seeing just a bit of ourselves looking back. After all, who hasn't wanted to shout out loud at times, as Cruella De Vil does, "I'm through with all of you! I'll get even. Just wait. You'll be sorry!"

ABOVE: Emma Stone as the title character in *Cruella* (2021), pictured here in a promotional graphic.

Familiar Faces from the Disney Parks

Some five thousand people gathered outside the entrance to Shanghai Disneyland on December 29, 2021, hoping to be among the lucky few able to purchase a limited Christmas edition of a plush toy known as Duffy the Disney Bear. Just six weeks later a similar scene unfolded at EPCOT, as some fans waited more than six hours to purchase a $25 popcorn bucket in the shape of a dragon called Figment. Die-hard fans also swarmed around the Haunted Mansion at Disneyland back in 2019 during the fiftieth anniversary of its opening. As Madame Leota and her spooky associates celebrated their birthday, some ghost enthusiasts were seen lugging oversized bags of purchases out of freshly stocked souvenir shops immediately after the park opened that day.

Madame Leota, Figment, and Duffy the Disney Bear (and his friends, including ShellieMay, Gelatoni, StellaLou, CookieAnn, 'Olu Mel, and LinaBell) have little in common, ranging as they do from the mysterious to the comedic to the cute and cushy. But all are ageless characters (with devoted fans) who were created exclusively for the Disney parks. And they're all embedded within a narrative that gives them dimensions beyond their visual design. Even Duffy, who emerged from merchandising rather than an attraction story line, has a story: he's the bear Minnie Mouse gave to Mickey Mouse (in a duffel bag) to keep Mickey company on his travels. "The story itself is really what made Duffy come to life," Dara Trujillo, manager of merchandise synergy and special events for Walt Disney Parks and Resorts, told the *Los Angeles Times*. In addition to the "kawaii," or cute, appearance and the fluffiness of the Duffy and Friends characters, the message of friendship, innocence, and collaboration told through their mini adventure stories seems to resonate with audiences. In recent years, stop-motion videos on these themes have been released globally on YouTube channels to an overwhelmingly warm reception.

In the decades before Disneyland opened, an amusement park character was the oddly dressed customer who seemed always to be hanging around, or the barker who lured the "marks" into an exhibit tent. But Walt Disney's park was founded on storytelling, and that meant memorable fictional characters set within compelling narratives. "Everything we do at Imagineering is driven by story," the Imagineers wrote in their book *Imagineering: A Behind the Dreams Look at Making the Magic Real*. "Just as Feature Animation develops characters to tell their stories in film, we develop characters to tell our stories in theme parks."

ABOVE: The Figment popcorn bucket sold at the Pop Eats! station during the 2022 EPCOT International Festival of the Arts.

Many original attractions drew their cast lists from existing Disney stories—Snow White, Peter Pan, Mr. Toad. But as the park grew, the Imagineers crafted original stories to fit their elaborate creations. Walt Disney's Enchanted Tiki Room (1963) introduced a quartet of parrots, but it was the opening of Pirates of the Caribbean (1967) and Haunted Mansion (1969) that firmly established that fresh stories could produce characters that consistently connected with guests. To name a few examples, the Haunted Mansion attraction had Madame Leota and the Hatbox Ghost—a character who maintained a loyal fan base despite going "missing" from the attraction around the time of its opening until his 2015 return. The Pirates of the Caribbean attraction, meantime, had Redd, the fearless redheaded damsel who was originally a captive but joined the pirates herself in a 2018 attraction revamp. To mark her new role, Redd has even stepped outside the attraction to greet park visitors.

Some Disney theme park characters seemed to grow more popular than the attractions that first introduced them. That was the case with Figment, the dragon created by Disney Legend Tony Baxter and Steve Kirk of Walt Disney Imagineering. Figment was first featured in the Journey Into Imagination attraction at EPCOT Center in 1983 as pupil to the professor-like Dreamfinder. When the attraction was revamped in 1999, becoming the nearly Figment-free Journey Into YOUR Imagination, fans campaigned for the dragon's reinstatement, prompting a 2002 overhaul that was pointedly re-titled Journey Into Imagination With Figment. Since then, Figment's story has extended well beyond his EPCOT beginnings. He starred in a series of Marvel comics (*Disney Kingdoms: Figment*) and had cameos in the Pixar Animation Studios films *Inside Out* (2015) in a discarded framed portrait and *Toy Story 4* (2019) on a carnival sign. In 2021, fans voted Figment the winner of D23's annual online bracket "March Hare Mania" featuring Disney dragons versus dinosaurs. The dragon has benefited from "one of the most loyal Disney fandoms ever," Baxter observed.

ABOVE: Figment animation character model drawings (top) and a painted cel (bottom) by a Disney studio artist for the Journey Into Imagination pavilion at EPCOT.

You're trying
that isn't necessarily
it's a totally
So what does that

to make a world based on anything—fabricated world. world look like?

—Danielle Feinberg

Director of photography, lighting, Disney and Pixar's *Coco*

CHAPTER 4

THE SPIRIT OF ADVENTURE AND DISCOVERY

Throughout history, all great leaps forward—from the invention of the wheel to the Apollo moon landings—were made possible by our innate curiosity and sense of wonder. Similarly, curiosity, imagination, and risk-taking have always characterized Disney's exploration of environments and the creation of imaginary yet believable worlds. There's the whimsical fantasy settings of many Silly Symphony shorts; the lifelike forests of *Bambi* (1942); the teeming underwater realms of *The Little Mermaid* (1989) from Walt Disney Animation Studios and *Finding Nemo* (2003) from Pixar Animation Studios; and the richly detailed planets and cultures in the *Star Wars* galaxy. In each example, unparalleled worlds are made possible by a combination of imagination, strong storytelling, and artistic skill.

LIONS AND TIGERS AND SEALS

Disney animated features have always contained elements of adventure—the action in *Pinocchio* (1940), for example, follows the title character's wild journey of discovery. But the studio really began to focus on adventure-based entertainment in the postwar era, beginning with the True-Life

ABOVE: During the production of *Bambi* (1942), Walt Disney had several white-tailed deer sent from Maine to California, so his artists could study their movements and physical traits.

Adventures series of nature documentaries. In a way, the genesis of the series dates back to the late 1930s, during the development of *Bambi*, when Walt Disney sent artist Maurice Day to take more than a thousand photographs of the Maine landscape and wildlife—and it essentially became the first Disney "location shoot." The photos inspired some of the film's concept art, and Day later arranged for two orphaned fawns to be shipped to the studio to serve as live models for the *Bambi* animation team. So it was not the first time Walt had sent nature photographers on location when he hired Disney Legends Alfred and Elma Milotte in 1945 to film the Alaskan wilderness. Their footage of Pribilof Island seals was condensed into a twenty-seven-minute documentary titled *Seal Island* (1948), which turned out to be the first of thirteen True-Life Adventures the studio would produce between 1948 and 1960.

Seal Island won the Academy Award for Best Short Subject (Two-Reel), and the series would go on to win seven more Oscars. But more importantly, for millions of people it pulled back the curtain on the remote natural world for the first time and provided them with a vicarious thrill of adventure. True-Life Adventures was the first serial theatrical release of nature documentaries ever, and the original inspiration for every outstanding nature documentary series that has been made since, including such eye-popping Disneynature features as *Earth* (2009) and *African Cats* (2011).

ABOVE (from top): Promotional artwork for the True-Life Adventures films *Seal Island* (1948)—with the original theatrical poster shown at top—and *The Living Desert* (1953) and *The Vanishing Prairie* (1954)—with the re-release artwork shown at bottom.

It is difficult for us to appreciate how enthralled audiences were in the mid-twentieth century by films like *Seal Island, The Living Desert* (1953), and *The Vanishing Prairie* (1954). Today, every movie, television, and computer screen is a portal to discovery, but True-Life Adventures was a singular wonder of its time, and each installment was an eagerly awaited event, both theatrically and when they later aired as episodes for the various Disney anthology series on television.

BEHOLD THE SQUID

Always looking to apply his creative energies in new areas, Walt entered the live-action film world in style with his surprise hit *Treasure Island* (1950), which established the Disney mastery of the cinematic genre of "family adventure" that continued for decades with such classics as *Swiss Family Robinson* (1960), *Kidnapped* (1960), *In Search of the Castaways* (1962), and *The Island at the Top of the World* (1974). All contain the elements of bold adventure and journeying into the unknown and derive their entertainment value from the audience identifying with relatable, familiar characters, both young and old, in dramatically unfamiliar surroundings.

However, no classic live-action Disney film captures the twin spirits of adventure and discovery better than *20,000 Leagues Under the Sea*. In adapting the Jules Verne tale, Disney was venturing into the realm of science fiction for the first time, and the results were truly spectacular. The success of the production in creating a believable underwater world was due to Disney's insistence on getting the details right—not just the famed *Nautilus* submarine and its influential design, but also the filming of the underwater scenes in the Caribbean. The technical challenges were such that making the movie was itself an adventurous and experimental endeavor, with as many as forty-two cast and crew members working on the ocean floor at the same time during shooting, using a series of hand signals to communicate. And filming the titanic battle between the *Nautilus* and the giant squid required the building of an entire soundstage with a huge water tank, as well as the two-ton mechanical squid, which took twenty-eight people to operate.

It was this attention to detail that made the fictitious world of the film believable—like consulting with scientists about the features and habits of giant squid and designing the *Nautilus* to look the way we imagine an advanced submarine would have appeared in the 1860s. Then an entire eighty-foot set on hydraulic rockers was constructed to approximate the pitching and yawing of a sea vessel. It was respecting the importance of these and countless other details that kept the adventure real for audiences. As far as Walt was concerned, the more fantastic the scenario, the more it mattered getting the details right. And *20,000 Leagues Under the Sea* was a resounding success because of this philosophy.

108 ABOVE: These set photos from the production of *20,000 Leagues Under the Sea* (1954) highlight some of the film's daunting technical complexities.

ADVENTURE AHOY

Hollywood has long appreciated the entertainment value of pirates—lawless, swaggering figures from a romanticized past who represent the dramatic threat, just over the horizon, of a whole shipload of cutthroat villains. When Walt chose the oft-filmed classic *Treasure Island* (1950) for his first live-action movie, he was tapping into the power of the quintessential literary pirate adventure, as well as his own youthful imagination. "I have always been fascinated by *Treasure Island* ever since my boyhood," he observed. Walt was confident the movie would be a success, yet he couldn't have predicted that it would become the definitive film version of Robert Louis Stevenson's book and that Robert Newton's Long John Silver would establish the archetype of the swashbuckling pirate in the twentieth-century collective imagination. Nor could he have anticipated that in the new millennium, another fictitious pirate—this time a Disney original—would eventually claim an equal share of the spotlight.

Everything the studio had learned over the years about creating believable animated worlds helped them make the live-action *Treasure Island* an instant classic. This included detailed storyboarding that left nothing to chance, though Walt also spent three months with the production team figuring out camera movements and setups in advance, a standard live-action filmmaking process today known as "pre-viz" (but a revolutionary approach in 1950).

Additionally, because much of the film was shot at Denham Studios in England, matte paintings of backgrounds proved vital to maintaining the illusion of tropical and seafaring locations. British artist Peter Ellenshaw was hired to create more than forty mattes for the film, and would go on to become a Disney Legend, working his magic on dozens of productions, including *20,000 Leagues Under the Sea* and *Mary Poppins* (1964), for which he won he won the Academy Award for Best Special Visual Effects.

Pirates are also at the dramatic heart of the action in other Disney adventure films of the period such as the Johann Wyss–inspired classic *Swiss Family Robinson* (1960), which was the studio's first film shot almost entirely on location. Despite the enormous costs involved, Walt decided filming in an authentic Caribbean setting would transport audiences to the time and place of the film's setting more effectively than shooting everything on a soundstage and relying on special effects for realism. The island of Tobago was chosen for its foliage, terrain, turquoise waters, and relative remoteness.

And as with *20,000 Leagues Under the Sea*, the making of *Swiss Family Robinson* was itself a bold journey into the unknown. In the words of studio publicist Joe Reddy, "Johann Wyss himself could not have dreamed up more adventure than [what] Walt Disney found awaiting him on Tobago." Getting the crew and material to the island was

a challenge in itself, and the changeable weather and seas "kept a thousand behind-the-scenes people and hundreds of tons of equipment on twenty-four-hour alert, set to shift plans momentarily each day of the six-month shooting schedule." But Walt's instincts paid off as audiences appreciated the movie's on-location physical realism. Said producer Bill Anderson, "I think the proof in this picture was in the way we did it and the way it was accepted by the public . . . it's a bigger than life adventure that gives the feeling of being on the island with the . . . family." The film became a major box office hit, proving once again that the undisputed master of animation was just as adept at live-action world building.

Other Disney films that derived their drama from the pirate menace included *Kidnapped*, *Shipwrecked* (1991), and *Muppet Treasure Island* (1996). There was also Ron Clements and John Musker's animated space adventure *Treasure Planet* (2002), which built an entire universe of cosmic wonders for its setting and featured a cyborg version of John Silver that echoed Wallace Beery's take on the iconic character in the 1934 *Treasure Island* version from MGM. But undoubtedly the most significant Disney foray into the romanticized universe of piracy was one of the last Disneyland attractions that Walt helped design and develop personally: Pirates of the Caribbean. Its genesis as an attraction began one day when Walt approached animator and Imagineer Marc Davis, who had helped design the Audio-Animatronics figures of Enchanted Tiki Room. Walt said, "I've been meaning to do a pirate thing." In fact, Davis had drawn some pirate-themed concept art for the Haunted Mansion in 1957, so he got to work. He first designed a walk-through exhibit featuring static figures representing a rogue's gallery of historical pirates, but the rapidly advancing Audio-Animatronics technology soon inspired a far more ambitious adventure that eventually became the most popular experience at the Disney theme parks we know today.

Davis put together a sketchbook of characters that would establish the Disney pirate look and form the basis for the appearance of the three-dimensional Audio-Animatronics figures. Davis's wife, Alice Estes Davis, who had helped Mary Blair design the international costumes worn by the dolls in "it's a small world," was tasked with using her husband's sketches to create dozens of pirate outfits, which needed to be both visually appealing and practical. "My job," she modestly noted, "was mainly to make the

ABOVE: On the island of Tobago in the West Indies for the filming of *Swiss Family Robinson* (1960).

garments cover all the wires and tubes." She did her job to perfection, as did the scores of Imagineers, writers, musicians, and artists who developed the attraction, because Pirates of the Caribbean has since transported millions of delighted guests back in time to an idealized world of adventure that continues to ring true.

Technological advances periodically create new forms of storytelling for Disney entertainment that reimagine and reintroduce the studio's iconic past creations for new generations, like character and story-inspired theme park attractions and live-action remakes of animated features. And the most extraordinary of many such Disney transmutations is the chain of development that begins with *Treasure Island*, which helped inform the themes of the Pirates of the Caribbean attraction, which in turn inspired the immensely popular Pirates of the Caribbean movie series, which in turn inspired the addition of film characters like Captain Jack Sparrow and Davy Jones to the theme park attraction, as well as the vast Pirates of the Caribbean-themed Treasure Cove at Shanghai Disneyland.

And now, three quarters of a century after Robert Newton's Long John Silver gave us the quintessential pirate figure, Johnny Depp's Jack Sparrow has achieved the same iconic status as his predecessor. In his book *Disney Pirates: The Definitive Collector's Anthology*, Michael Singer describes the cinematic link between the two characters: "When we last see the delightfully villainous Long John Silver in the final frames of *Treasure*

ABOVE (from top): Disney Legend Marc Davis works on character designs for the Pirates of the Caribbean attraction. Davis and his wife, Disney Legend Alice Estes Davis, with one of their co-creations for the attraction, the Auctioneer. Captain Jack Sparrow in a scene from the blockbuster film franchise inspired by the attraction.

A 2017 aerial overview by concept artist Stephan Martiniere of Treasure Cove at Shanghai Disneyland.

Island, he's all alone in a tiny one-mast skiff, headed toward a Caribbean port. When we first see the gloriously eccentric and gleefully amoral Captain Jack Sparrow in *Pirates of the Caribbean: The Curse of the Black Pearl* (2003), he's all alone in a tiny one-mast skiff, which is un-heroically sinking as he swaggeringly steps onto the dock of another Caribbean port." It is a nod to the cultural legacy of the original film, but it also establishes that the new film's dark pirate world has the humorous soul of the theme park attraction that inspired it. That this circular, cross-promotional magic works at all is partly due to the durability of the pirate adventure myth, which Walt recognized from the beginning. But it would never have happened without the creative ingenuity and skill of the Disney world builders who make the impossible real.

BRANCHING OUT

Walt Disney initially approached the idea of doing a regular television program as a means of financing his Disneyland theme park. However, he soon took full creative and promotional advantage of television, which was rapidly replacing radio as the primary source of news and entertainment for millions of Americans. Television's reach allowed Walt to expand his brand significantly. It allowed him to experiment with new short-form and serial entertainment that wouldn't have worked in a theatrical release format, which was mostly limited to feature-length films and short cartoons. Rather than seeing television as a competitor to the movie industry, as other film studios did, Walt used the medium to excite audiences that eagerly awaited his next project. As a conceptual tie-in to the layout of his brand-new theme park, each episode featured content belonging to one of four categories. Fantasyland showcased the whimsical side of Disney with clips or segments of hundreds of shorts and animated features the studio had produced over the years. Frontierland included adventurous stories relating to the exploration and development of the American frontier, such as the 1956 shows "Along the Oregon Trail" and "The Liberty Story." Adventureland included travel- and nature-based content, such as the People and Places and True-Life Adventures films. Finally, Tomorrowland was a platform for what Walt referred to as "science-factual" material and anything from the realm of future possibilities.

The most memorable Tomorrowland series was a trilogy of episodes focusing on the exploration of space, which was a hugely popular subject at the time. In his televised introduction, Walt described it this way: "In this Tomorrowland series, we are combining

the tools of our trade with the knowledge of the scientists to give a factual picture of the latest plan for man's newest adventure." Between audience curiosity and the time-slot dominance that the series enjoyed, an estimated forty-two million people tuned in to the first of the three installments when it aired in March of 1955—nearly a quarter of the country's population at the time! Virtually an entire generation of young viewers saw "Man in Space," "Man and the Moon," and "Mars and Beyond," and many a future astronaut, Jet Propulsion Laboratory engineer, and NASA scientist would later recall the *Disneyland* television episodes themed around space as inspirational.

ABOVE: Walt Disney with a large-scale model of the moon used during the production of his "space" shows for the *Disneyland* television series, the first of which was "Man in Space" (1955).

Discovering Wakanda

When it comes to 3D world building, Marvel Studios is well-known for creating completely believable fantasy environments that audiences discover and explore along with a film's characters. From Asgard, home planet to Thor and Loki, to midtown in New York City during the first interplanetary battle involving the Avengers—or from space travel with the Guardians of the Galaxy to planets like Titan and Xandar to the mazelike forest pathways leading to the mystical realm of Ta Lo—Marvel layers in visual details that set the stage for their epic tales. In doing so, these domains become as emotionally relevant as the characters themselves.

Perhaps one of the most captivating of these worlds is the hidden nation of Wakanda. Comic book aficionados have been reading about Black Panther and his kingdom of Wakanda since they first appeared in the July 1966 edition of Marvel's *Fantastic Four*, and movie audiences were introduced to the character as part of the Super Hero ensemble of Marvel Studios' *Captain America: Civil War* (2016). But it was the wildly popular film *Black Panther* (2018) that catapulted him and his extraordinary realm to prominence. The late Chadwick Boseman's electrifying portrayal of T'Challa was a breakthrough moment in cinematic history because it was the first international blockbuster with a Black lead actor and a predominantly Black supporting cast. Audiences were also utterly mesmerized by the remarkable feat of worldbuilding that Wakanda represents.

For director Ryan Coogler and production designer Hannah Beachler, the challenge was creating a fictitious setting that seamlessly blended reality and fantasy, because unlike the typically alien places of origin created for other Marvel Studios Super Heroes, Wakanda is located in the heart of present day East Africa. Beachler stresses how important it was for the depiction of Wakanda to incorporate elements of the East African societies that inhabit the area where the fictional kingdom is supposed to be located. "We wanted to make sure that we were including these other cultures, [both] tribal and traditional," she says. And while Beachler and Coogler constructed a convincing fantasy world that echoed the cultural DNA of the region, they also imagined the possibilities of a hidden African nation that was spared the ravages of European exploitation. As Beachler puts it, "Wakanda has never been colonized, so what does *that* look like?"

One of the most effective ways the film conveys the African universality of Wakanda is by displaying clothing, jewelry, and other sartorial accessories that attest to the continent's rich cultural variety. "We brought so many elements all together in

ABOVE: Teaser poster for the 2018 Marvel Studios blockbuster and cultural phenomenon, *Black Panther*.

one place," says costume designer Ruth Carter. "We had the Northern African Tuareg, we had Mali, we had Nigeria represented, South Africa . . . that was kind of bringing our past forward and showing it in a way that was mystical and futuristic in a Super Hero film."

Wakanda's singularity is also established through its arresting topography. For the most part the film avoids recognizably African landscapes and instead conjures up dreamlike natural vistas that impart a sense of romantic unfamiliarity to Wakanda. The prominently featured Warrior Falls, for example, are actually Brazil's and Argentina's Iguazu Falls. They form the largest and most spectacular waterfall system in the world, making them the ideal backdrop for showcasing the grandeur of Wakanda while emphasizing the country's unique place among African nations by featuring the otherworldly landscape of another continent.

When *Black Panther* took the box office by storm, the rallying cry of "Wakanda Forever!" and its accompanying crossed-arms salute became not only a symbol of Black pride and excellence but also an inspiration to people around the world who saw in the technologically advanced and benevolent kingdom of Wakanda the kind of society that humanity needs more than ever.

ABOVE: "Since Wakanda doesn't exist, it gave me a lot of freedom to create and go crazy!" said Hannah Beachler, production designer on *Black Panther*. "I really wanted to be thoughtful about the look of it—to take ideas from [comics co-creator Jack] Kirby and bring them into the twentieth century . . . We also visited South Africa, and you can see what architecture of the future looks like there." In these final frames, T'Challa's Royal Talon Fighter arrives in Wakanda (top) and soars over the majestic kingdom (center). The production shot reveals the behind-the-scenes background (bottom), as T'Challa's bodyguards, the Dora Milaje, move as one, combining elements of African dance and martial arts into their actions.

WHOLE NEW WORLDS

The key to all Disney entertainment is the creation of believable worlds, both familiar and fantastical, that can be discovered by characters and audiences alike. This means meticulously constructing an artificial reality that people will accept as genuine, such as the undersea realm of *The Little Mermaid*. Beneath the surface, the water itself is invisible and therefore its presence has to be suggested by the way things look and move in that environment. Veteran animator Glen Keane spent a lot of time getting Ariel's underwater hair just right and was partly inspired by footage of astronaut Sally Ride in zero gravity.

Disney films are set in every conceivable kind of terrain, from urban to natural to otherworldly. When the story calls for a forest or jungle environment, it takes a lot of painstaking animation work to create a believably detailed background consisting of individual trees and other plants at various heights and distances, along with subtle gradations of color and shading. The inordinate amount of time and labor required to accomplish this eventually led to the development of Deep Canvas, a 3D painting and rendering technique that produces CGI backgrounds that look more like traditional analog paintings; the new technology proved to be so useful that it won Disney an Academy Award for Technical Achievement in 2003.

In Disney's *Peter Pan* (1953), Never Land is a fantastical world of adventure that can be reached only by those who can magically fly, and be located only by following the charmingly poetic navigational clue of heading toward "the second star to the right, and straight on till morning," as Peter tells Wendy. Never Land is comprised of a number of separate regions, which have been added to over the years by multiple generations of Disney artists. Each leads to a different type of adventure, including Skull Rock, Mermaid Lagoon, Tiki Forest, Pixie Hollow, and Crocodile Creek. As the names suggest, it is a world calculated to excite the imaginations of children, full of magic and fairies but also toothy reptiles and, of course, pirates. Walt undoubtedly appreciated the similarity in layout between Never Land and his theme park. Disney artists John Hench and Al Dempster later created a map that illustrated the different adventure zones of Never Land for the *Peter Pan* Golden Book, much like the maps of Disneyland that guests use to navigate the park.

Of course the similarity between Peter Pan's Never Land and Walt's theme park wasn't just structural. The whole point of the Disneyland theme park experience was to escape to a place of adventure, discovery, and wonder—to fly through the air in a rocket or float along on uncharted waters or

enter a pirate's lair or brave a haunted house, and to do all of these adventurous things in complete safety. And that remains the Disney theme park experience: offer carefully curated adventures that are designed to feel entertainingly unpredictable and exciting.

Many of the imagined worlds from Pixar Animation Studios are far away and unfamiliar places, but one of the most unlikely of them all exists right under our feet. Wanting to first visualize the microscopic universe that animators would have to create for Disney and Pixar's *A Bug's Life* (1998), the filmmakers rigged up a miniature video camera and attached it to toy wheels. The "Bugcam," as they called it, was then rolled through the undergrowth. The ground-level perspective that it captured allowed animators to create the lush canopy of supersized grass, flowers, and other plants that gives the world of *A Bug's Life* its visual plausibility.

Another critical element in making this micro world believable was animating ant crowd scenes so that hundreds of individuals appeared to move autonomously at all times. However, this would have taken animators far too long to accomplish working on them one by one, so supervising technical director Bill Reeves helped develop software that cloned and animated multiple characters while ensuring no two ants ever looked or moved the same. The film also enhanced the believability of its environment by using "subsurface scattering," a recently developed technology that added a translucent dimensionality to CGI surfaces.

Like Disney, Pixar films require the worlds they create to feel authentic, and none more so than the Land of the Dead in *Coco* (2017), because of both its prominence in the story and the importance of the Día de los Muertos holiday in Mexican culture. To get it right, producer Darla K. Anderson and director Lee Unkrich assembled a cultural consultant group led by writer and producer Marcela Davis Avíles (who was a former producer of San Jose's Mariachi festival), Pulitzer finalist and cartoonist Lalo Alacaraz, and playwright Octavio Solis to advise the filmmakers during production. Using Día de los Muertos iconography for visual inspiration, the animators made the Land of the Dead fantastical, magical, and above all vibrantly colorful, which distinguishes it from the deliberately subdued tones of the Land of the Living in the film. This dramatic contrast, along with the soaring towers, the warm, effervescent light, and the infinite, bustling, joyously celebratory energy of the Land of the Dead, took world building to a new level. As a result, *Coco* was a smash hit around the globe, but most poignantly in Mexico, where it became the highest grossing film of all time.

Another type of world building at which Pixar excels is the creation of alternate universes that are wildly creative variations on the real world, such as the anthropomorphic automotive society in Disney and Pixar's *Cars* (2006). As always, the strength of the story and characters creates a willingness to suspend disbelief and accept even the most fantastical premise—such as a world of automobiles that is missing the human beings needed to design and build them—

The breathtaking beauty of the Land of the Dead from Disney and Pixar's *Coco* (2017) is captured in this visual development artwork by Pixar lighting studies artist Ernesto Nemesio.

Original cover art featuring Lightning McQueen created for the coffee-table book *Poster Art of Cars* (2017). Base art and graphics are by John Lee.

but it is the sheer volume and the subtlety of the film's animated details that allows the audience to enjoy it without a hint of skepticism. For example, much time and effort went into making sure the cars moved as if they were real cars made of steel weighing three or four thousand pounds. Explains Character Department manager Jay Ward, "When they move around, they need to have that feel. They shouldn't appear light or overly bouncy to the point where the audience might see them as rubber toys."

Similar attention was paid to the chrome and paint on the car surfaces, and to creating shadows from multiple light sources, as well as to giving the cars recognizably human movement and gestures and expressiveness. Even the clouds were painstakingly designed to add another layer of psychological believability to the film. "The clouds do in fact have some character and personality," says technical director Lisa Forssell. "The notion was that just as people see themselves in the clouds, cars see various car-shaped clouds. It's subtle, but there are definitely some that are shaped like a sedan. And if you look closely, you'll see some that look like tire treads." Taking the time to apply this level of intentionality to the details is what makes the world of *Cars* real. "There is no pixel on the screen that does not have an extraordinary level of scrutiny and care applied to it," adds Forssell. "There is nothing that is just throwaway."

Disney and Pixar's *Monsters, Inc.* (2001) is another alternate universe creation that works because of the thought that went into everything that appears onscreen. Monstropolis needed to be a recognizable urban environment but with monster-centric touches. For instance, the buildings had to look sturdy enough to support the weight of the bigger monsters, which could tip the scales at eight hundred pounds, so twentieth-century brick and steel structures were the model for the city's architecture. In addition, doors, furniture, and appliances needed to look capable of accommodating any monster, no matter the size or body shape, because they are all quite different. Because monsters don't exist, there was no monster reference material to pore over in the effort to depict believable examples. Thus, the creative team had to start from scratch. They first tried interviewing kids about their ideas of monsters, but this failed to yield any usable details, so it was decided to let the artists and animators conjure them up from their own imaginations.

ABOVE (from top): Disney and Pixar's *Monsters, Inc.* (2001) concept art: Layout sketch of the factory exterior by Pixar production designer Harley Jessup, 1997. Character design study of Sulley, Boo, and Mike by Pixar story artist and character designer Ricky Nierva, 2001.

This proved to be the right decision, as the staggering variety and remarkable design ingenuity of the monster characters in the film demonstrate.

And then there are the psychologically significant micro details, like Pixar artists drawing inspiration from factory architecture built during the post-World War II baby boom era when designing *Monsters, Inc.* buildings. This would have been a very profitable period of child-scaring that later declined with the coming of television, movies, and video games—and the resulting desensitization of youth culture; hence present-day Monsters, Inc., cannot afford a new factory. As with the subtle shaping of the clouds in *Cars*, this extrapolation of imagined behavior helps make *Monsters, Inc.*, believable on a subconscious level.

It isn't hard to imagine a bleak, dystopian future because science fiction has given us so many vivid examples over the years. But animating a believable one for modern audiences is far more difficult than showing a standard, postapocalyptic landscape. In *WALL·E* (2008), Disney and Pixar's cautionary tale for the ages, there is almost no dialogue, yet the granular perfection of the wasteland it depicts is so cleverly rendered and so full of thought-provoking details that the silence is welcome. And the film's later scenes aboard the colossal spaceship, *Axiom*, required the building of a second world that is completely different from the first but equally laden with purposeful images that allow the audience to piece together the narrative.

Creating and sustaining these worlds was a monumental task because there are no lulls in the movie's expository visuals, which required 125,000 storyboards as compared with the usual 75,000 for earlier Pixar films. Much effort also went into using subtle changes in lighting and hues to convey emotional shifts, and co-writer and director Andrew Stanton even duplicated the look of the science fiction movies he grew up watching by replicating the imperfections of 70mm film, like lens flare and unfocused backgrounds—a brilliant touch that adds to believability by disguising the digital appearance of the animation while also invoking the familiar cultural memory of the classic analog movies that first defined what a dystopian future should look like.

ABOVE: Digital concept art from Disney and Pixar's *WALL·E* (2008) by Pixar matte painter Paul Topolos, 2006.

STAR POWER

When Disney acquired Lucasfilm Ltd. and brought the *Star Wars* franchise into the fold, there had already been six "Skywalker saga" films made that established the look and feel of the *Star Wars* galaxy. With that, there was an element of nostalgic faithfulness that went into the creation of the worlds for the *Star Wars* sequel trilogy. One important factor was choosing locations that suggested an environment that might exist on another planet that was similar to Earth, the way all the previous movies had done. Part of *The Force Awakens* (2015) was shot near the Liwa Oasis in Abu Dhabi, continuing a *Star Wars* tradition of desert settings, and another sequence was filmed on Skellig Michael, a rain-swept, mountainous island off the coast of Ireland. Locations for *The Last Jedi* (2017) included Salar de Uyuni in Bolivia, the world's largest salt flats, which provided the backdrop for the battle scenes on the planet Crait. And in *The Rise of Skywalker* (2019), the scenes that took place on the desert planet Pasaana were shot in Wadi Rum, also known as the Valley of the Moon, in Jordan. In each case, the skill of the cinematographer combined with the naturally dramatic atmosphere of the setting to create a believable stand-in for an alien world.

But the film trilogy, along with new original *Star Wars* content such as the enormously popular Disney+ streaming series *The Mandalorian* (premiering in 2019), is only one form of Disney storytelling that captures the variety and vastness of the *Star Wars* galaxy. For over twenty years, guests at Tomorrowland experienced the thrill of interstellar travel and galactic intrigue on the Star Tours attraction, which uses hydraulic motion simulators and specially made film sequences to mimic an eventful space journey that incorporated story lines and characters from the first *Star Wars* movies and turned them into a dazzling tour of the *Star Wars* legend. And as the *Star Wars* galaxy expanded with the release of the sequel trilogy, the Star Tours attraction was upgraded and evolved into a state-of-the-art 3D attraction that was rechristened Star Tours — The Adventures Continue. The new iteration features multiple new story lines created from a menu of randomly combined sequences that tie into the later films; guests can enjoy it over and over while experiencing a different adventure each time.

The popularity of Star Tours and the sequel trilogy eventually led Disney Imagineers to create Star Wars: Galaxy's Edge, a sprawling, visually spectacular themed area that enables guests to immerse themselves in their very own *Star Wars* adventure. For fans of the franchise, Star Wars: Galaxy's Edge provides the thrill of a lifetime as they find themselves completely surrounded by the familiar sights and sounds of the universe they know so well. The setting is Black Spire Outpost, a village full of smugglers, droids, and strange creatures on the remote frontier planet of Batuu. As

squads of surly Imperial stormtroopers patrol nearby, guests can try their hand at piloting the *Millennium Falcon*, join an epic battle between the Resistance and the First Order, and sample blue milk. Scott Trowbridge, the Imagineering portfolio creative executive who oversaw the building of Star Wars: Galaxy's Edge at both Disneyland and the Walt Disney World Resort, said the intent was "to make it feel as if you just walked into one of the movies" and "to really engage all of the senses."

SMALL AFTER ALL

Recent additions to the in-person Disney experience like Star Wars: Galaxy's Edge are just the latest in a long line of Disney theme park offerings that provide guests with far-flung adventures. With the opening of Disneyland in 1955, guests began traveling back in time to nineteenth-century America in Frontierland, ahead into an exciting future of scientific wonders in Tomorrowland, around the globe to interesting destinations in Adventureland, and to the limits of imagination in Fantasyland. Over time, additions such as EPCOT, Disney's Animal Kingdom Theme Park, Tokyo DisneySea, the Disney Cruise Line ships, and curated international excursions through Adventures by Disney and National Geographic Expeditions have continued to expand and improve upon the Disney universe of world exploration.

The Jungle Cruise attraction has been thrilling explorers young and old with its creation of an unpredictable jungle river wilderness full of Audio-Animatronics figures of the animals native to the Asian-, African-, and South American-themed zones through which guests glide on their vintage steamers. At the time Jungle Cruise was designed and built, international travel to remote regions was logistically difficult and far too expensive for the average citizen to manage. So Walt intended the attraction to be a realistic experience in the spirit of True-Life Adventures that would allow guests to feel like they were halfway around the world on a voyage of discovery. It was upgraded over the years as the technology improved and travel narratives became more culturally inclusive, but the essence of the Jungle Cruise experience is still a journey along distant rivers that hearkens back to a time when the world seemed much larger and more mysterious.

At World Showcase at EPCOT, guests become international travelers on a whirlwind tour of eleven countries, sampling the food, culture, and customs of Mexico, France, Italy, Japan, Norway, China, Germany, Morocco, the United Kingdom, Canada, and the United States. Built around a central lagoon, the circular, 1.2-mile-long

ABOVE (from top): A 1967 aerial overview of Adventureland by Disney Legend Sam McKim, featuring the loading and unloading dock of the Jungle Cruise attraction. A 1954 visual development piece by Disney Legend Harper Goff of a jungle launch navigating the world's tropical rivers.

World Showcase promenade re-creates iconic national architecture, such as the Koutoubia minaret, the Eiffel Tower, and St. Mark's campanile. And each pavilion is staffed in part by cast members from the country represented, adding another layer of cultural authenticity to the experience. Then in the evening, guests can sit back and enjoy *Harmonious*, a nighttime spectacular that uses fountains, pyrotechnics, lasers, and huge floating screens to present a multi-language history of Disney internationality through song and imagery.

Harmonious derives its emotive power from the unforgettable stories and music that have made Disney the world's preeminent family entertainment company. This show is presented in three acts, respectively titled "Gather," "Celebrate," and "Unite," connected by a stunning soundtrack. It is a pan-cultural creation courtesy of more than 240 composers, arrangers, vocalists, and instrumentalists from nine countries. "Gather" is a convocation that pays tribute to the universality of music. "Celebrate" explores global diversity via Disney songs set in the United States, India, and China, along with countries in the Middle East, Africa, Europe, and Latin America. Finally, "Unite" concludes the show with a rousing, multilingual rendition of "Someday" from *The Hunchback of Notre Dame* (1996). Like the Disney creations that inspired it, *Harmonious* celebrates both the individuality and the commonality of the human cultural experience.

ABOVE: A floating platform featuring Mulan from the nighttime spectacular *Harmonious* at EPCOT, 2021.

Marc Davis

The Disney approach to world building has always required the talents of a broad range of creative professionals who are the best in the business. Occasionally this prestigious talent pool yields a multi-tool phenomenon like master draughtsman, artist, animator, and Imagineer Marc Davis (1913–2000).

"Marc can do story, he can do character, he can animate, he can design shows for me," Walt once said of Davis. "All I have to do is tell him what I want and it's there. He's my Renaissance Man."

To appreciate just how essential Davis was to The Walt Disney Studios during his tenure, the list of characters he designed and/or animated includes Snow White, Bambi, Thumper, Flower, Mr. Toad, Cinderella, Prince Charming, Alice from *Alice in Wonderland*, Tinker Bell, Aurora, Maleficent, and Cruella De Vil. Later, as one of the earliest Imagineers, Davis designed the characters for iconic Disney theme park attractions such as the Jungle Cruise, Walt Disney's Enchanted Tiki Room, Great Moments with Mr. Lincoln, Carousel of Progress, "it's a small world," Pirates of the Caribbean, Haunted Mansion, and the Country Bear Jamboree.

Davis was also a beloved instructor at the famed Chouinard Art Institute for many years, where he inspired and molded new generations of Disney artists. As one of Walt's "Nine Old Men," the group of distinguished animators from the first golden age at the Studios, Davis wasn't the only brilliant artist whose foundational work helped to define Disney's signature entertainment style. But he might well be one of the most influential and important of them all, given the number of familiar and enduring characters that owe their distinct look and feel to his singular artistic skill and creative vision.

ABOVE: Disney Legend Marc Davis working on concepts for new vignettes in the Jungle Cruise attraction at Disneyland, 1976.

Music is magnifying glass the emotion

like a gigantic
when it comes to
of a story.

—Mark Mancina

Composer, *Moana*

CHAPTER 5

THE MAGIC OF SOUND AND MUSIC

Just as he did not invent animation, Walt Disney did not produce the first cartoon with sound. What he did, along with his trusted animator Disney Legend Ub Iwerks, was create the now legendary *Steamboat Willie* (1928), which introduced Mickey and Minnie Mouse to an astonished and delighted world and demonstrated the possibilities of new fully synchronized technology in the hands of a master storyteller and entertainment visionary.

Once sound arrived with the first "talkie," Warner Bros.' *The Jazz Singer* (1927), the days of the silent film were numbered, and Walt knew it. The following year, as he struggled to find a distributor for a series of silent cartoons featuring his new mouse character, Walt held a meeting at which he told his brother Roy, "I think sound is here to stay. Think what we can do with it! Think of how we can use music. Think how much better we can tell stories and put over gags with sound!"

Shortly thereafter, Walt set out to make a cartoon that was specifically designed to exploit the entertainment value of sound, and the result was *Steamboat Willie*, which was a takeoff on a recent Buster Keaton silent comedy film and contained as many noise and music-making moments as they could cram into the story.

The first sound Mickey ever makes is whistling the 1910 vaudeville tune "Steamboat Bill," which was performed by a piccolo player in the orchestra. It is a song that would have been long forgotten if it hadn't become forever identified with the birth of Mickey Mouse, the rise of Disney, and the debut of fully integrated sound animation. Today, that scratchy old recording is both a priceless artifact and a revealing piece of history. It also represents the global popularity of songs from Disney classics, beginning with the release of "Minnie's Yoo Hoo" from *Mickey's Follies* (1929). This was the first Disney song ever published on sheet music. Plenty of others have followed, from "Who's Afraid of the Big, Bad Wolf?" from *Three Little Pigs* (1933), which became a Depression-era anthem of hope, to the present with "We Don't Talk About Bruno" from *Encanto* (2021), which became an internet sensation and took both TikTok and the world's pop charts by storm.

After the success of *Steamboat Willie*, Walt and his core team decided to make a number of musically themed shorts that would become the Silly Symphony series. The idea of animating a cartoon to match a musical soundtrack was first suggested by composer Carl Stalling, working with Disney Legend Wilfred Jackson. Walt met Stalling while he was playing organ accompaniment for silent films in a Kansas City theater. Walt eventually hired him as the studio's first music director, and though his stay was relatively brief, Stalling wrote and arranged the score for *The Skeleton Dance* (1929), which became the very first Silly Symphony.

ABOVE: Cousins Dolores and Mirabel Madrigal dance during the song sequence "We Don't Talk About Bruno" from *Encanto* (2021).

Eventually, movie sound and image would be recorded simultaneously on film stock that had dedicated tracks for both, but in 1929 the two were recorded independently and then combined and synchronized afterward—actions that required great precision. Stalling worked out the timing, initially using a metronome and then a "click track" that cued the orchestra, and soon thereafter he introduced several innovations that helped the studio refine and improve the sound synchronization process. He left Disney after two years, working for Iwerks (who had also moved on from Disney to start his own independent cartoon studio in 1930), before eventually becoming the longtime music director at Warner Bros., where he scored the separate Merrie Melodies and Looney Tunes cartoon series the company created in response to Disney's success with the Silly Symphony series.

TALKING PICTURES

So much of an animated character's personality is shaped by the actor's stylization of the voice that its importance to the finished product cannot be overstated. Walt was the original voice of Mickey Mouse, and while he was perfectly suited to portray the beloved mouse, it was merely the serendipitous result of Walt having to do so many things himself in the early days. (Walt passed on the role of Mickey's voice to Disney Legend Jimmy Macdonald, who was later replaced by Disney Legend Wayne Allwine, and now Bret Iwan, who shares his duties with Chris Diamantopoulos for select projects.) It was also the reason Walt first voiced Minnie Mouse. That changed in 1930, when it was decided to cast a woman in the role, and the job went to a volunteer from the Ink & Paint Department. Director Burt Gillett was working on *The Cactus Kid*, in which Minnie's character is from Mexico, and he asked if anyone would be able to read the lines in Spanish. Marjorie Ralston, who had recorded Minnie's lines for a few shorts already, and Marcellite Garner offered to help, but Garner got that gig because she was willing to sing. Garner went on to play Minnie in more than forty cartoons in the early 1940s.

From there and into the 1950s, Minnie was played by voice actor (and later a television screenwriter) Thelma Boardman. Ruth Clifford, a silent-era actor whose career continued on television well into the 1970s, followed. Disney Legend Russi Taylor took over as Minnie's official voice from 1986 until her death in July 2019.

In addition to serving as a platform for animation innovations like synchronized sound and color, the Silly Symphony shorts also introduced us to the character of Donald Duck, who has proved to be one of Disney's most popular figures besides Mickey himself.

Originally a secondary character in the short *The Wise Little Hen* (1934), Donald quickly became an indispensable member of Disney's core character group by serving as the resident comic foil. One reason for his popularity is Donald's very human frailties, especially his trademark quick-tempered nature. But arguably his most winning feature is his unmistakable voice. Of all the Disney cartoon vocal characterizations, Donald's stands out as a true one-off invention, requiring a special talent that only a handful of people have been able to master in the nearly nine decades of his existence.

The original voice of Donald was Disney Legend Clarence "Ducky" Nash, who auditioned when he heard they were looking for voice actors adept at making animal noises. He was kept very busy as Donald appeared in over 128 theatrical releases. Nash would continue to voice the character until he died in 1985, though not before coaching his replacement, animator and Disney Legend Tony Anselmo, who remains the official voice of Donald to this day. Another Disney Legend and voice actor from this period was Pinto Colvig, who is best known for his beloved Goofy. Colvig was a former vaudevillian who had worked as a writer and animator for Walter Lantz (who created Woody Woodpecker), even doing a brief stint as the voice of the post-Disney version of Oswald the Lucky Rabbit. Then in 1930 he was hired by Disney as a writer and a sound effects artist, creating a variety of character sounds, including Pluto's barks, and going on to do the voice of Practical Pig from *Three Little*

RIGHT: Disney Legends Clarence Nash (top) and Pinto Colvig (center), the original voices of Donald Duck and Goofy, respectively, as well as a variety of other Disney characters. Nash singing an avian duet with Florence Gill (bottom), the voice of Clara Cluck in *The Reluctant Dragon* (1941).

Pigs, as well as Sleepy and Grumpy—and Dopey when he's hiccuping—from *Snow White and the Seven Dwarfs* (1937). Colvig even did Pete's singing voice in the short *Mickey's Amateurs* (1938), which he also co-directed.

No short list of the twentieth-century Disney vocal talent would be complete without mentioning Billy Bletcher, who voiced both the Big Bad Wolf and the speaking role of Pete; Florence Gill, whose specialty was poultry, who voiced the recurring character Clara Cluck, as well as the title character from *The Wise Little Hen* and many other barnyard fowl found in Disney cartoons from 1931 to 1951; Disney Legend Sterling Holloway, who created the soft and cuddly voice of Winnie the Pooh but also the sinister sibilance of Kaa, the python from *The Jungle Book* (1967); ventriloquist Paul Winchell, who originated the lovable lisp of Tigger and, remarkably, was later credited with inventing and building an early artificial heart; jazz singer, bandleader, and comedian Phil Harris, who played Baloo and sang the unforgettable "The Bare Necessities" in *The Jungle Book*, as well as voicing Thomas O'Malley the alley cat from *The Aristocats* (1970) and Little John from *Robin Hood* (1973); and the great Verna Felton, whose impressive list of Disney credits includes the elephant matriarch from *Dumbo* (1941), the Fairy Godmother in *Cinderella* (1950), the Queen of Hearts in *Alice in Wonderland* (1951), Aunt Sarah from *Lady and the Tramp* (1955), Flora from *Sleeping Beauty* (1959), and finally, Winifred the elephant in *The Jungle Book*, bringing her Disney pachyderm portrayals full circle.

Whether it's Nash squawking with convincing rage during one of Donald's temper tantrums, or Jerry Orbach breathing suave, continental life into Lumiere, the anthropomorphic candelabra in *Beauty and the Beast* (1991), Disney voice actors are responsible for adding an essential emotional quality to the images flickering on the screen. Disney animators are always striving to increase the emotional connection between the audience and their images. There is a tendency to think of voice work as complementary to that process, but because the voices are recorded in advance, it's technically the other way around.

The actor's vocal characterizations help the animators establish how that character is going to look by suggesting the emotional range of their features. Sometimes the character ends up resembling visual aspects of the voice actor, too, as with the satyr character Phil from *Hercules* (1997), played by Danny DeVito, which adds a layer of entertainment value and connectivity to the character for audiences. Animator Mark Henn was so influenced by the physicality of Disney Legend Anika Anika Noni Rose, who voiced Tiana in *The Princess and the Frog* (2009), that he decided to make the princess left-handed to match the actress's real-life attributes. For *Pocahontas* (1995), Linda Hunt's acting inspired Grandmother Willow—a character literally rooted to the ground and whose emotional relatability is conveyed through facial expressions and voice acting. Likewise for *The Little Mermaid* (1989),

Samuel E. Wright—the versatile Broadway, television, and movie star—breathed a lively spirit into Sebastian the crab that clearly influenced the animator's choices.

SOUND AND VISION

Making the Silly Symphony series was an enlightening experience for Walt, and it led to numerous technical advances and greatly expanded the studio's creative capabilities. However, the original purpose of creating animation inspired by music had been largely abandoned in favor of using music to enhance the story. Then, in 1938, with Donald and Goofy starting to gain in popularity and the phenomenon of *Snow White* still holding the spotlight, Walt and his team decided it was time to burnish Mickey's image with a couple of exceptional animated shorts that would reaffirm his star status and return to his musical animation roots. One was the sumptuous *Brave Little Tailor* (see page 65); the other was an adaptation of "The Sorcerer's Apprentice," the famous symphonic poem by French composer Paul Dukas. According to Disney biographer Bob Thomas, the action of the short was "done in pantomime to the Dukas music."

When Walt ran into legendary conductor and Disney fan Leopold Stokowski at Chasen's in Beverly Hills, he described the Dukas-Mickey short idea to him, and the maestro offered to conduct the music. Then while Stokowski was recording at the studio, he began suggesting other classical music that he felt would lend itself well to this adaptive process. "Walt listened to the recordings," says Thomas, "and his imagination soared." He decided "The Sorcerer's Apprentice"—which was already costing more than he could hope it to recoup as a short—would now be part of a feature-length film comprising a series of such animated musical interpretations, and *Fantasia* (1940), then known by the working title "The Concert Feature," was born.

There had never been anything like *Fantasia* before. "The Sorcerer's Apprentice" sequence was appropriately brilliant and dramatic, especially the way the duplication of the brooms aligns perfectly in both tone and cadence with the repetition of the piece's marching motif. The dissonances and dynamic clashes of Igor Stravinsky's "The Rite of Spring," along with its final transition from storm to calm, made it the ideal musical accompaniment to a depiction of Earth's violent geological and evolutionary history. The sequence featuring "Toccata and Fugue in D Minor" by Johann Sebastian Bach was the most experimental element of the film, using abstraction as a means of conveying the visual equivalent of the music's texture and form. And it wasn't enough to provide an orchestral soundtrack—Walt wanted the audiences to

ABOVE AND OPPOSITE: Mickey Mouse and an enchanted broom move in time with the music of "The Sorcerer's Apprentice" in an animation drawing sequence by Disney Legend Les Clark (Mickey Mouse) and Dan MacManus (broom) created for *Fantasia* (1940).

139

experience the music in a more immersive way than ever before.

In fact, what he was trying to accomplish with sound in *Fantasia* couldn't be done with the technology of the day, so, in typical innovative fashion, he had his audio engineers team up with RCA to create "Fantasound." This was a multichannel reproduction system that used microphone placement and a "Panpot" (panoramic potentiometer) to simulate the movement of sound from one speaker to another—basically a very early form of "surround sound." But reproducing this effect in the theaters showing the film also required the speaker arrangements to be customized, which added to its costs and limited distribution significantly.

The film delighted audiences that saw it in one of the "road show" venues that were set up properly—nobody had ever experienced a commercial film in stereo before, let alone one designed to match the action onscreen with the music that miraculously seemed to swirl around the theater. Bosley Crowther of the *New York Times* described the film, "as terrific as anything that has ever happened on a screen."

Walt was thrilled with the results and excited by the seemingly endless possibilities of this artistic intertwining of animation and music. "It is our intention to make a new version of *Fantasia* every year," he said at the time. "Its pattern is very flexible and fun to work with—not really a concert, not a vaudeville or a review, but a grand mixture of comedy, fantasy, ballet, drama, impressionism, color, sound, and epic fury."

But the idea of treating the *Fantasia* concept as a continuing work in progress was soon abandoned because, like *Pinocchio* (1940) and *Bambi* (1942), it was very expensive to make, and soon after, World War II would drastically limit the overseas market, leading to disappointing box office returns.

Nonetheless, *Fantasia* remains one of those great works of art showcasing how Walt's creativity pushed him to take bold risks. Its popularity continued to grow over time with each re-release, and eventually the studio made a sequel for the new millennium titled *Fantasia/2000*, using "The Sorcerer's Apprentice" segment as a bridge between the two films. Like its predecessor, *Fantasia/2000* drew on the power of iconic classical pieces like Ludwig van Beethoven's "Symphony No. 5," Ottorino Respighi's "Pines of Rome," and Igor Stravinsky's "Firebird Suite (1919 Version)." It was precisely the continuation of Walt's concept.

After the experience of making *Fantasia*, Walt became more enthusiastic than ever about the value-added qualities that music brought to cinema. And when postwar box office doldrums forced him to go with a more affordable animation style than the spare-no-expense artistry of *Fantasia, Pinocchio*, and *Bambi*, he turned to musical package features to pick up some of the slack. This new approach actually began with the South American goodwill films *Saludos Amigos* (1943) and *The Three Caballeros* (1945) and continued into the postwar period with omnibus features such as *Make Mine Music* (1946) and *Melody Time* (1948).

OPPOSITE: Film poster for *Fantasia/2000* (2000).

A LITTLE PARK MUSIC

Walt Disney Animation Studios and Walt Disney Imagineering collaborated in the early 1990s on the creation of *Fantasmic!*, a spectacular, *Fantasia*-esque nighttime show at various Disney theme parks. The show uses a combination of live actors, Disney characters, pyrotechnics, Audio-Animatronics figures, lasers, mist-screen projection, and—most importantly—music to build a narrative in which Mickey engages and defeats a succession of Disney villains, including Chernabog from the "Night on Bald Mountain" segment in *Fantasia*. Many of the biggest musical moments from Disney films appear in a montage, and the finale at Disney's Hollywood Studios features the Disney characters onboard a replica of the vessel from *Steamboat Willie*—where the magic of Disney music all began.

Another direct descendant of *Fantasia* is an attraction at several Disney theme parks called Mickey's PhilharMagic. It's an immersive theatrical experience that combines music, Audio-Animatronics figures, 3D animation, aromas, and a little water to create an unforgettable narrative journey through the history of Disney film songs, including "You Can Fly! You Can Fly! You Can Fly!" from *Peter Pan* (1953), "I Just Can't Wait to Be King" from *The Lion King* (1994), and "Be Our Guest" from *Beauty and the Beast* (1991), with additional tunes from subsequent releases being added over time, including "Un Poco Loco" from the blockbuster *Coco* (2017) from Pixar Animation Studios. Each song in the montage is synchronized to adapted scenes from their respective movies, so that when "A Whole New World" from *Aladdin* plays, guests feel like they really are following a magic carpet through the air, propelled along by the power of the music. In a nod to the original *Fantasia*, the narrative begins with an orchestra setting, where a mischievous Donald Duck makes unauthorized use of Mickey's sorcerer's hat, leading him on a chaotic, dreamlike chase that ends when Mickey regains possession of the hat and restores order.

Among the many musically focused theme park attractions are some very popular ones for which wholly original music was written that has become as iconic as the experiences themselves, such as "Yo Ho (A Pirate's Life for Me)" from Pirates of the Caribbean. The song, sung by regular Disney contributors The Mellomen, conjures up the revelry-filled atmosphere of a pirate stronghold and plays more or less continuously throughout the attraction. The melody was written by Disney Legend and composer George Bruns, who had scored such classics as *Sleeping Beauty* (1959) and *One Hundred and One Dalmatians* (1961), as well as several Disney live-action film and television show themes. The lyrics were written by animator, Imagineer, and Disney Legend Xavier "X" Atencio, who also wrote the lyrics for the Haunted Mansion attraction

ABOVE (counterclockwise from top left): Disney Legend George Bruns composed the melody of "Yo Ho (A Pirate's Life for Me)" for the Pirates of the Caribbean attraction at Disneyland. Disney Legend X Atencio, the show writer of the attraction and lyricist of its memorable song, with the "Peg Leg Parrot barker bird" figure for the Walt Disney World version. "Yo Ho (A Pirate's Life for Me)" plays in various arrangements throughout the different scenes of the attraction.

143

song "Grim Grinning Ghosts" and worked on the original scripts for both attractions. "Yo Ho (A Pirate's Life for Me)" is as integral to the Pirates of the Caribbean experience as the bateaux, the sights and smells, and the Audio-Animatronics figures themselves—and played a big part in making the attraction culturally resonant enough to form the basis of a hugely successful film franchise.

One particularly iconic Disney song that was written especially for a Disney attraction was "It's A Small World," penned by Walt's favorite songwriting duo, Disney Legends Robert and Richard Sherman. When Walt was designing the attraction for the 1964–1965 New York World's Fair, he originally planned to have each country's national anthem play within each section, but then realized the sonic overlap would have made it too cacophonous. What he needed was a short, simple, and catchy song that could be easily translated into multiple languages, and for this he turned to the Sherman brothers, who delivered, as always. In an article for *American Songwriter*, music journalist and songwriter Paul Zollo praised the ingeniousness of their composition: "The brothers brilliantly devised a kind of roundelay form; the verse and chorus have different melodies, but over the same chord changes. Like the traditional rounds in old music, the two melodies can be sung at the same time and intertwine melodically and rhythmically. In this way, the song changes with each scene, but harmony is maintained throughout."

"it's a small world" has become one of Disney's most enduring attractions, in large part because of the timelessness of the theme song's melody and the universal appeal of lyrics about unity. And because the attraction is always in motion for sixteen hours a day at Disney theme parks around the world, it is now the most performed and most translated song of all time. As Richard Sherman points out, "Since 1983, there has not been a moment when 'It's A Small World' wasn't playing in at least two locations on the globe. Who else can claim that?"

ABOVE, LEFT: Walt Disney surrounded by the iconic dolls from the "it's a small world" attraction, which was first introduced at the 1964–1965 New York World's Fair.

ABOVE, RIGHT: Disney Legends Robert B. (standing) and Richard M. Sherman (seated), the respected songwriting duo often referenced as the Sherman brothers or, by Walt, as "the boys."

ABOVE: These 1963 visual development pieces by Disney Legend Mary Blair set color queues, scene by scene, for the "it's a small world" attraction at the 1964–1965 New York World's Fair.

145

A PRACTICALLY PERFECT MOVIE

As focused as Walt had been on achieving the special alchemy that occurred when animation and music were artistically combined, it was his branching out into live-action moviemaking that would eventually lead him to create his musical magnum opus and the highest-grossing film of his career. Like so many projects that interested Walt, the *Mary Poppins* project was an idea that he first pursued in 1938 and dropped for practical reasons, only to revisit years later when circumstances were more favorable. In the early 1940s, Walt saw the P. L. Travers book on his daughter Diane's bedside table and was more intrigued than ever by the flying nanny character. He had Roy visit Travers in New York in 1944 to talk about buying the film rights, but she didn't like the idea of an animated version of the story. Then, about a decade later, Walt visited her in England while he was traveling abroad, but it wasn't until 1961 that she finally relented. The story of his pursuit and dealings with Travers would later be dramatized in Disney's *Saving Mr. Banks* (2013).

But there is little doubt that the ultimate success of *Mary Poppins* (1964) was owed to Walt's hiring of the Sherman brothers as his in-house music writers in 1960. Walt had always loved being able to rely on talented and intuitive music people to give him exactly the kind of songs that his projects needed. And in Disney Legends Robert and Richard Sherman, he had found a brilliant songwriting duo who understood how to create songs that were completely integrated with the storytelling of the project. Their compositions would do more than just enhance the films and

ABOVE (from top): The Disney studio orchestra recording music for *Mary Poppins* (1964), under the baton of Disney Legend and orchestrator Irwin Kostal, and the symbolic snow globe from the "Feed the Birds" song sequence.

theme park attractions they were written for—they would immortalize them. It is difficult to imagine *Mary Poppins* becoming a megahit without the musical center created by irresistible songs such as "Supercalifragilisticexpialidocious," "A Spoonful of Sugar," and "Chim Chim Cher-ee." The Shermans' genius was not lost on Walt, who referred to them affectionately as "the boys" and gave them an office just down the hall from his own. According to Bob Thomas, Walt liked all the songs they wrote for the movie, but he couldn't get enough of "Feed the Birds," once declaring, "That song'll replace Brahms' lullaby." After a long week, the brothers would often go to Walt's office at the end of day and play the song for him on his piano.

Walt was deeply nostalgic, so it's no surprise he fell in love with the *Mary Poppins* songs, some of which were composed to sound like old British music hall standards. "Take a song like 'Boiled Beef and Carrots' by Harry Champion," says Richard Sherman. "There's an honesty and vigor to it you can't beat. Those songs really influenced what Bob and I wrote for *Mary Poppins*."

But the Sherman brothers were more than just talented—they were blessed with the creative intuition to give Walt what he wanted in a song. And as Richard explains, the respect was mutual: "He understood song the way he understood the visuals. If he didn't like a number, he could take it apart and explain why it didn't fit the moment. So to deal with someone with that kind of brain was special." Richard also relates that "Step in Time," the song for the rooftop finale, came about when Walt summoned him and his brother to his office one day, and they arrived to find him and the film's writers and matte artist all kicking up their legs and dancing in a chorus line while singing the old East End of London pub song "Knees Up, Mother Brown." Walt told "the boys" to write him a tune like that, and half an hour later, they came back with "Step in Time."

ABOVE: Chimney sweeps dance to the musical number "Step in Time" from *Mary Poppins*.

THANKS FOR THE MEMORIES

Pinocchio is among the most visually stunning works of animation of all time, yet it also featured one of the most memorable songs in movie history. When Disney Legends composer Leigh Harline and lyricist Ned Washington wrote "When You Wish Upon a Star" in 1938, Walt and his production team knew they had their spotlight song and the overarching musical theme for the film, which was still in its early stages of development. Voiced by Disney Legend Cliff Edwards, Jiminy Cricket famously serves as Pinocchio's conscience, but his deeply moving rendition of "When You Wish Upon a Star" is the emotional heart and soul of the movie. It went on to win the 1940 Academy Award for Best Original Song, and Walt, who loved to repurpose his best material, chose it for the opening and closing title sequences of his groundbreaking television series *Disneyland*. To this day, "When You Wish Upon a Star" remains a signature song of The Walt Disney Company and can be heard when the logo appears at the beginning of Disney live-action films, as well as when guests enter Fantasyland through Sleeping Beauty Castle at Disneyland. Even the Disney Cruise Line ships use the first seven notes of the song as one of their horn signals.

But what is it about this song that has made it so lasting and iconic? And what is it that makes it such an ideal musical motif to represent the Disney brand? Part of the explanation is its melodic structure. According to composer Charlie McCarron, the song, melodically, "is all about subverting expectations. The tonic note [which establishes the key of the song, in this case E] is like the star, off in the distance. We keep longing for it, but the melody keeps skipping around it." There is also a melodic rising and falling and rising throughout, which adds to the sense of yearning, culminating in a gratifying ascent to a B that is the highest

ABOVE: The cover to sheet music of "When You Wish Upon a Star," published in 1939.

note in the song—as if our tantalizing goal has finally been reached.

Then there are the lyrics, which not only align perfectly with the song's hopeful, melodic message but with the Disney mission statement as well: making dreams come true for young and old, and the sky's the limit. Given these attributes, "When You Wish Upon a Star" is the ideal musical emblem for the world's preeminent entertainment organization, and it's easy to see why the song is still an evergreen favorite after so many years.

Written by Broadway powerhouse Lin-Manuel Miranda, "We Don't Talk About Bruno" from *Encanto* is many things: a melodic and rhythmic tour de force, a cleverly crafted storytelling device, and a contemporary embodiment of the rich Latin musical heritage that has become such an important feature of the global cultural landscape. Still, even by Disney standards, the song's record-breaking popularity is astonishing; such crossover hits in the past have been limited to solo ballads, such as "Colors of the Wind" and "Let It Go," or the duet in "A Whole New World," the previous number one Disney hit song back in 1993. "We Don't Talk About Bruno" is an ensemble number that is contextually inseparable from the film it appears in. So how did it manage to thrive as a stand-alone pop hit?

There's no question that the vocal talents of Carolina Gaitán, Mauro Castillo, Adassa, Rhenzy Feliz, Diane Guerrero, Stephanie Beatriz, and the rest of the cast were a critical factor, but it was Miranda's musical genius that crafted the song's irresistible melody and rhythm, and its cascading and overlapping structural flow. "Every verse and every stanza introduce a different character," says Miranda. "They're all riding the same musical landscape, but they ride it completely differently. Everyone sings the same chord progression with a totally different rhythm and totally different cadence." The song's co-producer, Mike Elizondo, observes, "There is a cross-blend of genres between hip-hop and Colombian music that I think works very well." The song's universal popularity represents the culmination of a century's worth of brilliant Disney storytelling combining state-of-the-art animation with musical themes strong enough to become hits that reach a much larger audience than the films alone.

ABOVE: The brilliant Lin-Manuel Miranda is the latest in a long line of distinguished film composers and songwriters who have made Disney films as memorable for their music as for their characters and stories.

MAKE SOME NOISE

When Walt first started exploring the possibilities of cartoon soundtracks, he was focused on both the music and the sound effects that are essential to creating a believable animated environment. The real world is full of noises, and the advent of sound in film meant finding a way to reproduce not just dialogue and the sound of action, like a door slamming, but also the quieter but omnipresent noises like footsteps, wildlife, and traffic. Walt wanted his fantasy world to feel as close to reality as possible, but there were as yet no sound effects recordings in existence, so he had to create them in the studio.

At first, this was an informal and experimental process, undertaken by existing staff using whatever was handy to produce the various clangs, bangs, and whistles the particular production called for. But as the studio's workload and the sophistication of the animation increased, coming up with the proper sound effects became a full-time job. So Walt hired Jimmy Macdonald as the head of the Sound Effects Department in 1934. Macdonald, who would become a Disney Legend, was what would eventually be known in Hollywood as a "Foley artist," after Hollywood sound effects pioneer Jack Foley, though it could easily have been called a "Macdonald artist" based on his own significant and early contributions to the art and science of sound effects. Macdonald invented and built an array of ingenious devices that approximated the noises of everyday life, mimicking everything from machinery to animals to the weather, and it is estimated that he came up with more than twenty-eight thousand separate effects during his time at Disney. He was also hand-picked by Walt himself to be the voice of Mickey in 1947, when Walt's schedule became too busy for him to record Mickey's dialogue.

ABOVE: Disney Legend Jimmy Macdonald, the Disney Studios' sound effects wizard, works his magic to create realistic insect sounds in 1974.

Howard Ashman

The Disney renaissance that began with *The Little Mermaid* (1989) represented a second flowering of Disney animation, but it was also a return to the classic Disney formula of using strong music to help tell the story—only this time, the music was front and center. Rather than intersperse a few songs throughout the movie, *The Little Mermaid* began the new Disney film tradition of creating a hybrid cinematic and Broadway musical adaptation. And behind it all was Disney Legend Howard Ashman.

As a playwright, lyricist, and director, Ashman teamed up with composer and Disney Legend Alan Menken to create the songs for *The Little Mermaid*, *Beauty and the Beast*, and part of *Aladdin*, a movie idea that Ashman had pitched to the studio. He saw the tremendous potential for reimagining fairy tales as robust stage musicals, once declaring, "As a lyricist, the last great place to do musicals is in animation." His work helped make Disney animation relevant again, and songs like "Under the Sea" and "Be Our Guest" became part of the life soundtrack of a generation of young moviegoers.

Ashman was much more heavily involved in the productions than a typical lyricist. He played a big role in the story development. He would act out all of the roles himself, just as Walt Disney had done in the early days, and urge his voice actors to really get inside the heads of their characters. According to Jodi Benson, the voice of Ariel, Ashman was such a positive force behind the making of the movie that the film's directors, John Musker and Ron Clements, deferred to his judgment throughout the production. "If you were smart," says Benson, "you would just let him go and drive the train. Ron and John were smart." Ashman also exerted that same holistic creative control during the making of *Beauty and the Beast*, and his dynamism was all the more remarkable given that he was losing his battle with AIDS during production; tragically, he did not live to see the premiere.

The new approach to animated feature production Ashman helped set in motion has become a template for Disney filmmaking, and thus every brilliant musical moment in movies like *Frozen*, *Moana*, *Coco*, and *Encanto* is, in part, thanks to the creative genius of Howard Ashman.

ABOVE (from top): Disney Legend Howard Ashman (far left) at a New York City recording session for *Beauty and the Beast* (1991) with orchestrator Danny Troob (center) and composer and Disney Legend Alan Menken; Ashman with Disney Legend Paige O'Hara, the voice of Belle; and (left to right) Menken, Ashman, Troob, and musical director David Friedman.

THAT'S WHAT I WANT

So many Disney protagonists have a pivotal moment in their films where they use song to express a yearning for some kind of transformative change in their lives. For Snow White, it was the hope of realizing her romantic ideal with "Some Day My Prince Will Come"; for Ariel, it was dreaming of a life on land with "Part of Your World"; and for Rapunzel, it was questioning what lay outside the walls of her tower with "When Will My Life Begin?"

"I want" songs are an established tradition in musical storytelling. They reveal vital information about the film's central character, usually tied to a coming-of-age story arc, and they are always among the strongest compositions on the soundtrack. This is especially true of "Let It Go" from *Frozen* (2013), which showcased Queen Elsa's determination to finally live as her authentic self and may be the most potent and popular "I want" song in the Disney repertoire. With its inspirational lyrics and soaring, triumphant chorus, "Let It Go," written by multiple Oscar winners Kristen Anderson-Lopez and Robert Lopez, became a hit single that sold over ten million copies and helped turn *Frozen* into the top-grossing animated film of all time. Director Jennifer Lee relates that when she and the production staff heard the song for the first time, they were blown away. "Half of us were crying," she says. "I was just like, *I'm going to lie down for a couple of minutes*. But it was the best thing. We knew we had the movie."

The "I want" moment in *Moana* (2016) occurs when the title character belts out "How Far I'll Go," a rousing number about yearning desperately to push boundaries and realize your potential, penned by Broadway superstar Lin-Manuel Miranda and sung by the voice of Moana, Auli'i Cravalho. Through this song we learn everything we need to know about Moana's character, and we get a foreshadowing of the epic journey she is about to make. And, as with "When You Wish Upon a Star," the structure of "How Far I'll Go" dramatically reinforces the message of the lyrics. The music surges ever forward, repeating over and over the pattern of taking a few quick strides followed by two bold leaps, suggesting the melodic equivalent of the character's daring journey into the unknown.

In *Encanto*, the "I want" song "Waiting on a Miracle" is about Mirabel's desire to contribute to her family's well-being because she lacks a special gift. Songwriter Miranda says the composition process was complex: "If anyone ever says writing a Disney 'I want' song is easy, they're lying. A lot of the story work throughout the whole film is clarifying as specifically as possible what the journey is for our main character. It takes a lot of work from every department to finally find that answer in a way that the character can sing about it."

In addition to the lyrics and the melodic

feel of "Waiting on a Miracle," the song's rhythmic structure underscores Mirabel's predicament as an outsider in her own home. "Her song is in a different time signature," says Miranda. "Every other song is 4/4—with really driving rhythms that you could hear at a club. But Mirabel's song is in 3/4—which is a characteristic rhythm of Colombian bambuco. She is literally out of rhythm with the rest of her family."

But Mirabel isn't the only Madrigal family member who has been keeping her true feelings a secret for the good of the family. For the muscular Luisa, "Surface Pressure" reveals the vulnerability behind her superhuman strength, and for golden child Isabela, "What Else Can I Do?" delivers the shocking news that she isn't happy with the role of being the perfect daughter. These tunes are what might be called "I don't want" songs and are just as revealing as their counterparts.

Then there are the character-revelation songs performed by Disney villains, like Honest John in Pinocchio singing "Hi-Diddle-Dee-Dee," which, like his ironic nickname, is a con job intended to mask his true intentions. Or there's Dr. Facilier in The Princess and the Frog crooning his sell-your-soul sales pitch, "Friends on the Other Side." When Ursula in The Little Mermaid launches into her minor key extravaganza "Poor Unfortunate Souls," she reveals her own sardonically evil nature as well as the central plot element of Ariel's desperate sacrifice. And in Tangled (2010), the villainous Mother Gothel tries to dash Rapunzel's "I want"

song dreams of independence with "Mother Knows Best," a demeaning rant, deceptively sung as cheerful advice, in which she tells Rapunzel that she won't survive outside the tower. In The Jungle Book, the villain is Shere Khan the tiger, though Kaa the python serves as a sort of demi-villain, comical and ultimately ineffectual. His song "Trust in Me" is an alliterative lullaby designed to enhance his powers of hypnosis.

There are also songs about villains sung by other characters, like Roger, the out-of-work songwriter in One Hundred and One Dalmatians, finding his mojo again with "Cruella de Ville," a memorable takedown of the villain that contains melodic echoes of the bebop classic "Ba-Lue Bolivar Ba-lues-Are" by legendary jazz pianist and composer Thelonious Monk. And there are even hybrids like "Gaston" from Beauty and the Beast, in which the villain's acolytes start singing his praises until the hopelessly vain Gaston feels compelled to join in, revealing all the pertinent details of his flawed character and delivering them with the same violence and self-importance for which he is being praised—an entertaining example of the way Disney songs reinforce the themes they represent.

In addition to the "I want" songs of Disney protagonists and villains, other characters vital to the story being told also use song to reveal important information about themselves. It focuses the attention of the audience on the character, and it allows a lot of details to be conveyed in a single scene that would otherwise take half

Continues on page 155.

Oliver Wallace

Through the years, Disney has employed talented composers, from Disney Legend Frank Churchill to Lin-Manuel Miranda. One characteristic common to all of them has been their ability to write music that is of its time but also memorable enough to become timeless. Along with Churchill and fellow Disney Legends George Bruns, Paul Smith, and Leigh Harline, Oliver Wallace was another early Disney music star who would become a Disney Legend. His credits include *Cinderella*, *Alice in Wonderland*, *Peter Pan*, *Lady and the Tramp*, work on more than a hundred shorts, and winning an Oscar, with co-writer Churchill, for the score of *Dumbo*.

Notably, Wallace also composed a novelty piece for a World War II–era Donald Duck short titled *Der Fuehrer's Face* (1942). As a propaganda relic of a long-ended conflict, the song has no contemporary relevance, but the anti-Nazi theme delighted audiences of the day, and a cover version by Spike Jones and His City Slickers became a massive hit on both sides of the Atlantic during the war. With its cathartic mockery of totalitarianism and use of the enemy's own pompous martial style of music, "Der Fuehrer's Face" was said to be a clandestine radio favorite in Occupied Europe. It was certainly not a typical Disney hit, and it lacks the studio's usual quality of timelessness, yet it is noteworthy, because it was the one instance where creating lasting entertainment was less important than harnessing Disney's musical clout for a cause—in this case to boost Allied morale at a time when it was most desperately needed.

ABOVE: Eccentric composer and songwriter Oliver Wallace, who created memorable music for Disney productions from 1936 until his passing in 1963, once estimated that he had written more than thirty miles of soundtrack for The Walt Disney Studios.

Continues from page 153.

the movie to establish through ordinary narrative exposition. The character of Maui in *Moana*, for example, is a central figure in the mythology of Polynesian culture. He is both a hero and a convention-defying trickster in the classic folklore tradition, and the rapid-fire lyrics of "You're Welcome" give him the opportunity to catalogue his long list of herculean achievements on behalf of the people, and to do it with the false modesty that befits his personality.

We learn from Maui that he is responsible for everything that matters to Oceanic cultures, including pulling the islands up out of the water with his fishhook, and then, true to form, he ends the song by tricking Moana out of her boat. Using song to tell his story takes less than three minutes, but it provides the audience with a complete picture of Maui's character, as well as an entertaining introduction to Polynesian mythology.

MUSIC TAKES THE STAGE

With the Disney renaissance in full swing in the 1990s, one successful musical animated feature followed another, and the vast appeal of *The Little Mermaid*, *Beauty and the Beast*, *Aladdin*, *The Lion King*, *Pocahontas*, *The Hunchback of Notre Dame*, *Hercules*, and *Mulan* reaffirmed Disney's status as the leader in animation and popular entertainment. Given the Broadway musical sensibilities that had shaped the development of these films, it was a logical next step to transfer their stories to the stage, and on February 8, 1993, Walt Disney Theatrical Productions Ltd. was formed for this task. A little over a year later, *Beauty and the Beast* opened at the Palace Theatre on Broadway, inaugurating a wildly popular new form of Disney entertainment and helping to spark a resurgence of Broadway itself. Disney Legends Alan Menken and lyricist Tim Rice wrote six additional songs for the show, including the Beast's own number, "If I Can't Love Her." Linda Woolverton, who had written the screenplay for the film, adapted it into a two-act libretto for the stage that further enhanced the emotional depth of the characters. The talents of Menken and Rice and the story's flexibility to accommodate theatrical additions allowed a seventh song, "A Change in Me," to be written specifically for R & B star Toni Braxton when she joined the cast in 1998.

ABOVE: R & B star Toni Braxton as Belle in the Broadway musical *Beauty and the Beast* in 1998.

Beauty and the Beast ran for thirteen years on Broadway and has been produced in more than 35 countries, introducing new generations of fans to the original film and later inspiring a live-action feature film reimagining.

The next notable stage adaptation was *The Lion King* (1997), directed by Disney Legend Julie Taymor, whose singular vision was responsible for the musical's groundbreaking theatrical style; Taymor also oversaw the creation of the musical's remarkable character costumes that utilized innovative puppetry. As with *Beauty and the Beast*, additional songs were written for the stage version, which also included an ensemble led by South African producer, composer, arranger, and performer Lebo M. He, along with renowned composer Hans Zimmer, contributed to the Oscar-winning score for *The Lion King* film and wrote a sequel soundtrack album, *Rhythm of the Pride Lands*, that was inspired by the movie and contained songs sung in a variety of African languages.

The Lion King is now Broadway's third-longest running production in history, earning six Tonys, including a first ever Best Direction of a Musical awarded to a woman (Taymor), and has been seen worldwide by over one hundred million people.

To date, Disney Theatrical Productions has released more than 15 musical titles for self-production or professional licensing. That number is certain to rise as Disney Theatrical continues to reimagine Disney titles. Broadway shows such as *The Little Mermaid* (2007), *Aladdin* (2014), *Frozen* (2018), and *The Hunchback of Notre Dame*, produced for licensing in 2014–2015 after a 1999–2002 run in Germany, have all been staged as successful musicals based on animated classics. And there have also been adaptations of live-action Disney films, such as the Broadway shows *Mary Poppins* (2006) and *Newsies* (2012), as well as a licensed production of *Freaky Friday* (2016) and national and international productions of *High School Musical on Stage!* (2007). Even the Disney Theatrical play *Peter and the Starcatchers* (2012), based on the Disney-published *Peter Pan* prequel book series by

Continues on page 159.

ABOVE: The cast of *The Lion King* performs "Circle of Life" in this photo by Matthew Murphy.

ABOVE: Poster art and title designs for a variety of Broadway stage shows from Disney Theatrical Productions.

Alan Menken

Disney Legend Alan Menken has won eight Oscars, eleven Grammys, seven Golden Globes, a Daytime Emmy, and a Tony Award so far. He is the musical genius whose creative partnership with Disney Legend Howard Ashman inaugurated a Disney renaissance in filmmaking in 1989 with *The Little Mermaid*. Menken and Ashman followed it up two years later with *Beauty and the Beast*. In fact, they had been collaborators on several pre-Disney projects dating back to 1979, including the original stage musical *Little Shop of Horrors*. Ashman died of complications from AIDS while working on *Aladdin*, leaving the future of both *Aladdin* and further Disney animation plans in doubt.

However, only at Disney could you be assigned a last-minute replacement partner of the caliber of Disney Legend Tim Rice, who was already a Broadway legend for his work with Andrew Lloyd Webber. The new team of Menken and Rice finished *Aladdin*, including composing the multiple award-winning megahit "A Whole New World," and went on to co-write the Broadway version of *Beauty and the Beast* and new material for the 2017 live-action reimagining, carrying on Ashman's legacy and his vision for what a Disney musical could become.

Whether working solo or paired with a partner, Menken has established himself as one of Disney's greatest composers. He is behind the music of fan-favorite *Newsies*, both the live-action film and stage musical versions. He scored and wrote songs for the animated features *Pocahontas*, *The Hunchback of Notre Dame*, *Hercules*, and *Tangled*, as well as composed signature songs for *Enchanted* and its sequel, *Disenchanted*; the anthem "Star Spangled Man" for *Captain America: The First Avenger*; and the "I want" ballad "A Place Called Slaughter Race" for *Ralph Breaks the Internet*. As one of the leading creative voices of Disney storytelling for more than thirty years, he has also worked on extensions of many of these favorites, such as the stage musical versions of *The Little Mermaid*, *Newsies*, *Aladdin*, and *Hercules*. Menken's currently collaborating with Lin-Manuel Miranda on the reimagined live-action film version of *The Little Mermaid* as this book goes to press.

ABOVE (from top): Disney Legend Alan Menken at a recording session for the song sequence "Human Again" (originally planned for the 1991 theatrical release of *Beauty and the Beast* but ultimately introduced in the stage musical adaptation, and later added to a 2002 IMAX re-release of the film) with fellow Disney Legend Tim Rice.

Continues from page 156.

Dave Barry and Ridley Pearson, showcases an unapologetically campy musical number: "Mermaid Outta Me (Entr'acte)."

The Giuseppe Verdi–inspired rock opera and Broadway musical *Aida* (2000), written by Disney Legends Tim Rice and Elton John, was one of the rare Disney musicals conceived as a fully stage production rather than as a film-to-stage adaptation.

FULL CIRCLE

In 2013, Disney released an extraordinary new cartoon that was a mash-up of animation technology from eras nearly a century apart. *Get a Horse!*—which was plotted like the earliest Mickey Mouse shorts—combined archival sound recordings of Walt as Mickey (and even briefly as Minnie), Disney Legend Jimmy Macdonald as Mickey, Billy Bletcher as Peg Leg Pete, and Marcellite Garner as Minnie, with new recordings of character voices, including a Minnie Mouse performance by Disney Legend Russi Taylor, who had voiced her for thirty-three years and had been married to voice actor and Disney Legend Wayne Allwine, the longest-tenured voice of Mickey Mouse. *Get a Horse!* also combined hand-drawn, black-and-white animation with color CG and digital 3D technology in the same scenes and was peppered with exaggerated sound effects that took full advantage of modern theater sound systems. It was a glorious tribute to the magical pairing of animated imagery and sound that propelled Walt and his menagerie of characters into the international cultural mainstream, and a reminder that the grand and complex universe of Disney entertainment evolved from that watershed moment when a cartoon mouse captivated the world by whistling.

ABOVE: Final frames from the cartoon short *Get a Horse!* (2013), directed by Lauren MacMullan.

Disney Voices around the World

Snow White and the Seven Dwarfs was Disney's first feature-length film, as well as the first Disney production to be dubbed into multiple languages. The film's dialogue and songs were rerecorded in French, Italian, German, Spanish, Portuguese, Dutch, Swedish, Danish, Czech, and Polish. That allowed audiences around the world to enjoy the groundbreaking movie in their own languages, without the distraction of subtitles to break the animated fantasy spell. Millions of people from Europe to South America became instant and devoted fans of the studio after experiencing the magic of Disney storytelling translated into their native tongues. This was especially true in Brazil, where a national "Snow White Day" was declared.

In the intervening half century, Disney has continued to create dubbed versions for the international market, covering an ever-expanding number of languages. "*Snow White* was dubbed into ten additional languages," observes Rick Dempsey, senior vice president of Disney Character Voices International (DCVI). "And now we're up to as many as sixty-five." But Dempsey and his department aspire to more than just presenting films in other languages. "We want audiences to feel like this film was made for them, in their language—not just a basic translation, but an adaptation," adds Dempsey. "We want to capture the local idioms and humor so audiences feel like they're really connected to our content."

Although subtitled versions are also made available to the international market, dubbing remains the most artistically desirable means of localizing films from The Walt Disney Company. One reason is that kids and subtitles don't mix. "Our animation is so appealing to children, but even those old enough to read find subtitles challenging," says Dempsey. "If you put your four-year-old in front of a Disney film, they want to hear it in their language." Another reason is that dubbing dialogue and song into a language allows the team to record local talent, which adds another layer of cultural authenticity to the process. To this end, DCVI has in-territory offices with experienced employees scouring the planet for the voice that best reflects a relevant character, which requires a nuanced approach to casting. For example, the team worked in partnership with Pixar Animation Studios on a variety of languages for Disney and Pixar's *Toy Story*. In the U.S., Woody was played by Tom Hanks, but for dubbing in other languages, while sounding similar to

ABOVE (from left): The 2016 re-release cover of *Snow White and the Seven Dwarfs* on DVD and Blu-Ray translated into French (Parisian), Italian, Japanese, and Spanish (Latin American).

Hanks is important, the greater emphasis is on embodying the spirit of Woody through personality and performance.

As Disney films have evolved to combine storytelling with the celebration of cultural uniqueness and diversity, dubbing has created opportunities to connect people with the stories and landscapes that inspired them. *Moana*, for instance, which interprets a fantastical history of Pacific Island culture, was dubbed into several Polynesian dialects. "Since it is a story about Polynesians, it is also important to us to have at least one version in a native Polynesian language," says Hinano Murphy, president of the Association Te Pu Atitia. "Hopefully this will also inspire other Polynesian islanders to find innovative ways to teach their languages."

The team found similar opportunities in working with Pixar. Dubbing films into languages that are not widely spoken is also a way of preserving them, as was the intent behind the Navajo version of Disney and Pixar's *Finding Nemo*. "The Navajo translation was an effort to promote a dwindling indigenous language," points out Dempsey. "We believe that when the language dies, a part of the culture dies with it, so we created a version that Navajo kids will watch over and over again and get re-familiarized with the language, bringing it back into the culture for the next generation."

The Walt Disney Company has been quietly perfecting the art and science of dubbing for the past seventy-five years while utilizing it as a means of reaching across international borders to acknowledge the importance of language diversity and cultural identity—all in an effort to ensure the universality of quality storytelling.

ABOVE (clockwise from top left): The 2009 re-release cover translated into Dutch, French (Parisian), Cantonese (for Hong Kong), Thai, Mandarin Chinese (for Taiwan), and Korean.

If you get a bit contemporary into the fields and riverside, and take wild nature

shaky about . . . civilization, go out forests, desert and a good look at as we see it.

—Alfred Milotte

Disney Legend and co-cinematographer (with his wife, Disney Legend Elma Milotte) of many True-Life Adventures films

CHAPTER 6

THE WORLD AROUND US

At the heart of Disney entertainment is an appreciation of planet Earth and its astonishing variety of wonders, from its land and seascapes to the flora, fauna, and peoples who inhabit it. By presenting and honoring this diversity of natural and cultural riches through film, theater, travel, and theme park experiences, Disney reminds us that we are all passengers on the same pale-blue dot that's hurtling through space and encourages us to conserve and protect our shared home and heritage.

BACK TO NATURE

By the mid-twentieth century, global tourism was on the rise, but travel to remote wilderness areas was still far too expensive and logistically challenging for most people to undertake. And then along came Disney's True-Life Adventures, which were released theatrically beginning in 1948 and later broadcast on the various Disney anthology television series, exposing millions of people to the wonders of nature for the first time and kindling the spirit of conservation in many a young viewer. With its stunning color footage, dramatic orchestral soundtrack, and lively voice-over narrative, True-Life Adventures was not just the first series of its kind but the template for every great nature documentary that has followed.

In all, thirteen nature films were produced over a twelve-year span, as the series racked up five Oscars for Best Documentary Short Subject and three more for Best Documentary Feature. True-Life Adventures covered a lot of terrain, from the mountains, deserts, swamps, and prairies of the United States to the Arctic wastes of northern Canada, the lush jungles of South America, and the grasslands of Uganda. Most installments were directed by Disney Legend James Algar, who also scripted most of the series, and the distinctive narration was provided by studio jack-of-all-trades and fellow Disney Legend Winston Hibler. The narrative often leaned heavily on anthropomorphic humor, but the sheer beauty of the locations and the astonishing footage

ABOVE: Disney Legend Alfred Millotte filming elephants for the True-Life Adventure film *The African Lion* (1955).

of wild animal behavior allowed audiences to see for themselves that the planet is a complex and fragile biosphere teeming with life and not just a resource for human consumption and exploitation.

The first feature-length installment of the series was *The Living Desert* (1953), which was filmed near Tucson, Arizona, and gave audiences a detailed and up close look at the lives of various species native to the Sonora Desert. The idea for the documentary came about when Walt viewed a ten-minute film by UCLA doctoral student N. Paul Kenworthy, Jr., showing a fight between a tarantula and a wasp. Kenworthy, who would become a Disney Legend, and another cinematographer were hired to create a longer film that would capture the unique behaviors of desert life. Walt was enthusiastic about the potential of the longer format, saying of the project, "This is where we can tell a real, sustained story for the first time in these nature pictures." *The Living Desert* went on to win the Academy Award for Best Documentary Feature in 1954—one of four Oscars Disney would earn that year—as well as the International Prize at Cannes, and it was so popular in Japan that it surpassed *Gone with the Wind* (1939) as the highest grossing film of all time. It was also the first Disney film to be released by Buena Vista Distribution Company, which Walt had created specifically in response to RKO's reluctance to distribute his documentaries. Thus, in addition to being new cinematic ground for the studio, the True-Life Adventures series also greatly expanded Walt's creative horizons because he could

ABOVE: Pioneering nature cinematographers creatively capture nature's wonders on film for the True-Life Adventures series, including Stuart Jewell (top and bottom) and Disney Legends Alfred and Elma Milotte (center).

finally choose the kinds of films he wanted to make without having to please an outside distributor.

True-Life Adventures encouraged a reverence for nature, and in some instances an appreciation of the benefits of conservation. As its title suggests, the feature-length entry *The Vanishing Prairie* (1954) was a detailed history of the great American prairie and the destructive impact settlers had on the vast region that permanently altered a unique ecosystem. Winning the Oscar for Best Documentary Feature that year, *The Vanishing Prairie* also contained an early discussion on endangered species, which was an entirely new way of looking at animal life for most Americans. It resonated with many, especially kids. "We know that those films influenced generations of young people," said Walt's nephew, Roy E. Disney, who worked as a producer on the series.

Walt had always loved the natural world. "I don't like formal gardens," he once remarked. "I like wild nature. It's just the wilderness instinct in me, I guess." He had also won praise from conservationists with the release of *Bambi* (1942), in which the heroes are clearly the flora and fauna. But while producing the True-Life Adventures, Walt felt more keenly aware than ever of the importance of preserving and protecting nature. "The immediate need for education and practice in using our natural resources of soil, forest, water, wildlife, and areas of inspirational beauty to the best advantage of all, for this generation and others to come, is apparent to every observant citizen,"

ABOVE: The Milottes on photo safari (top and bottom) and Disney Legend James Algar (center), who directed most of the True-Life Adventure films.

he said at the time. "My interest in these problems has been sharpened by our motion picture production of wildlife subjects and the relation of animal life to all the other conservation issues during the past few years."

Jungle Cat (1960), Disney's last True-Life Adventure, was released theatrically, though the films continued to air for years in serial and edited form on Disney's anthology television series. Its popularity immediately inspired many similarly styled nature documentary television series and specials, such as *Mutual of Omaha's Wild Kingdom* and *The Undersea World of Jacques Cousteau*. Then, in 2008, Disney reentered the field it helped create with Disneynature, its Paris-based film studio dedicated to producing grand-scale nature documentaries that have become the spectacular apotheosis of the genre.

Appropriately, the first release was *Earth* (2009), which provided a sweeping overview of our planet from the Arctic to the Antarctic by following the fortunes of several representative species in the face of accelerating environmental change.

Each Disneynature film is an awe-inspiring view of a different creature or environment, captured with astonishing intimacy and dramatic sweep by some of the best nature photographers in the world, and they are popular enough to compete at the multiplex with Hollywood blockbusters. Among the many now-classic Disneynature features are *Oceans* (2010), *African Cats* (2011), *Chimpanzee* (2012), *Bears* (2014), *Monkey Kingdom* (2015), *Born in China* (2017), and *Penguins* (2019). Yet Disneynature films are more than just entertaining documentaries. The absorbing conservation-themed narratives are voiced by the likes of Disney Legend James Earl Jones, Patrick Stewart, and Samuel L. Jackson. The cinematography immerses the audience in the remote natural world so thoroughly that it, too, serves as a powerful statement about the irreplaceability of our planet's animal wonders.

But Disney also recognizes that the protection of Earth's threatened ecosystems requires immediate action, which is why a portion of the profits from these films has been applied directly to regional conservation efforts through partnerships with organizations including The Nature Conservancy, the African Wildlife Foundation, the National Park Foundation, the Jane Goodall Institute, and Conservation

ABOVE AND OPPOSITE: Film posters for eight Disneynature films released 2009–2019.

International. Some of the Disneynature-funded actions include establishing 65,000 acres of conservation corridors in Kenya's savanna, the planting of three million trees in Brazil's most endangered forest, setting aside 130,000 acres of wild chimpanzee habitat and educating sixty thousand local youth in the Congo, and protecting nearly a half million acres of forest for wild pandas (as well as founding a new snow leopard conservation program) in China. Walt Disney could hardly have imagined that his pioneering True-Life Adventures would one day spearhead the force for positive change that is Disneynature. But he undoubtedly would be pleased with the result.

Almost simultaneously with Walt's releasing of True-Life Adventures films was the production of another entertaining and informative documentary series that brought a variety of international cultures and landscapes into local theaters and living rooms across America: People and Places. From 1953 to 1960, the series crisscrossed the globe, treating viewers to the world's rich cultural and geographical diversity, from Sardinia to Samoa, winning three Academy Awards along the way. One of the more popular episodes, *Men Against the Arctic* (1955), explored the frozen north, which remains something of a mysterious frontier even today, and showcased the precarious human foothold in the region.

Another award winner was *Ama Girls* (1958), a close-up look at the lives of a dwindling population of Japanese fisherwomen called ama, or "sea women," who practiced free diving for pearls, abalone, and other sea life—a tradition that dates back five thousand years. People and Places was another example of Walt taking an existing form of entertainment—in this case, the travelogue featurette—and creating his own more ambitious, popular, and ultimately influential version.

With the acquisition of 21st Century Fox's controlling interest in National Geographic Partners in 2019, Disney greatly expanded its platform for the shared exploration of the planet and its endlessly fascinating variety of natural and cultural phenomena. Television outlets such as the flagship National Geographic channel, Nat Geo People, Nat Geo Music, and Nat Geo Wild have the same purpose as the earlier Disney documentaries that established the genre: bringing the unique natural vistas of the world and the lifestyles, artistic customs, and even culinary

identities of the international community into focus for millions of viewers while encouraging the responsible stewardship of nature and a deeper appreciation of cultural diversity.

THE WORLD ACCORDING TO DISNEY

Disney's focus on exploring and celebrating cultural diversity has expanded over the years, going beyond the cinematic and theme park experiences to include travel options such as Adventures by Disney, which provides guests with curated explorations of other lands and cultures across seven continents, and Disney Cruise Line services, whose growing fleet of vessels traverse the sea lanes of the world and invites guests in a variety of culturally unique destinations.

And with the opening of the Aulani, A Disney Resort & Spa, back in 2011, Disney has combined the luxury-hotel experience with a deep dive into the ancient and fascinating world of Hawaiian culture and mythology. Located in Kapolei on the island of Oahu, Aulani—which loosely translates as "the place that speaks for the great ones"—is a perfect example of the way Disney's commitment to maintaining

ABOVE: Aulani, A Disney Resort & Spa (shown in 2013–2015), delivers the Disney magic with a respect for the Hawaiian culture that inspired it.

OPPOSITE: The *Disney Fantasy* cruise ship docks at Disney's island in the Caribbean, Castaway Cay, in 2012.

cultural authenticity in its products informs its approach to presentation. The resort was designed and its construction was overseen by Joe Rohde of Walt Disney Imagineering in collaboration with the architectural firms WATG and Architects Hawaii Ltd. (AHL), local cultural experts, and an advisory council of Hawaiian elders to ensure that the structure and its features were in keeping with traditional cultural values. Aulani prioritizes hiring staff members who speak Hawaiian so that guests are exposed to the language of the region, and every detail of the resort is inspired by Hawaiian culture and infused with its symbolism. For example, the curved arch logo for the resort is based on a traditional Hawaiian canoe house, and this shape dominates the lobby ceilings and the overall external architecture of the hotel.

"The resort was designed to reflect the sense of a Hawaiian valley opening out toward the ocean from highlands to lowlands," says Rohde. "This organization has many connotations. One is the *ahupua'a*, the traditional organization of land that followed a watershed from the mountains to the sea and knitted all members of the community together in a working relationship and a functionally sustainable relationship to the land. Another is a Hawaiian concept of time itself as flowing from the past, which is in the mountains, to the future, which is in the sea. The architectural statements of Aulani tend to follow this organizational layout." The figure of the canoe is also a prominent feature throughout the resort because of its importance to Hawaiian culture. "They express the highest form of artistry, engineering, symbolic meaning, purposefulness, and social cooperation that Hawaiian culture stands for," adds Rohde.

Another way to experience exploration and a semblance of international travel is through a visit to EPCOT at the Walt Disney World Resort. Although Walt originally envisioned EPCOT as a carefully curated urban environment, generations of visitors to Walt Disney World are grateful that the EPCOT concept eventually evolved from an "Experimental Prototype Community of Tomorrow" into a theme park that celebrates human achievement, diversity, and the magic of possibility. The themed "neighborhoods" of EPCOT include World Celebration, World Nature, World Discovery, and World Showcase, all of which encourage guests to explore the ways humans have evolved to interact with the planet and each other. Within World Nature, The Land pavilion focuses on the history of farming, travel, and humanity's impact on the environment, allowing visitors to fly over

Continues on page 178.

ABOVE: Imagineer Joe Rohde with his sons, Kellan and Brandt, at Aulani, A Disney Resort & Spa in 2011.

The Living Laboratory at EPCOT

The heart of The Land pavilion at EPCOT is the Living with the Land attraction, a boat journey that includes a tour of cutting-edge farming practices with real-world applications. This Living Laboratory highlights current and future developments in sustainable cultivation techniques and produces some of the fruits, vegetables, and fish that are actually served at EPCOT restaurants. There are five sections within the laboratories. The Tropics Greenhouse features crops from tropical areas of the planet, such as plants bearing fruits like bananas, jackfruits, and papayas alongside flowering herb shrubs like cleome. The Aquacell focuses on fish farming and displays a range of species that includes tilapia, bass, shrimp, and American alligator. The Temperate Greenhouse showcases large-sized crops like Atlantic giant pumpkins and nine-pound lemons. The String Greenhouse illustrates innovative agricultural methods such as the hydroponic-based Nutrient Film Technique and vertical growing techniques that cause herbaceous plants to greatly increase their yield. One of its tomato plants became the largest and most productive tomato plant in the world, according to *Guinness World Records*. Finally, The Creative Greenhouse highlights some promising future agricultural approaches, like aeroponics, in which a fine mist of water-borne nutrients is sprayed over the exposed roots of the plant.

In addition to these attractions, The Land also contains a working biotechnology lab where several United States Department of Agriculture (USDA) scientists perform research on methods of improving crop yields, as well as an integrated pest management lab that raises beneficial insects such as ladybugs for distribution all over the Walt Disney World Resort. Of all the attractions at the park, these working nurseries and laboratories are perhaps the closest in spirit to Walt's original EPCOT dream of using science and Disney resources to improve the human experience.

ABOVE (from top): Farming at The Land pavilion at EPCOT includes cultivating marine life (tanks in 2013) and vegetables dwarf peppers in 2012).

Visual development art from the Walt Disney Imagineering Art Collection shows the vibrant internationality of EPCOT, such as with this 1981 concept piece by Disney Legend Herb Ryman.

A sampling of visual development art created for World Showcase at EPCOT:

ABOVE: A 1979 visual concept piece of the Mexico pavilion by Disney Legend Collin Campbell.

LEFT: A 1979 visual concept piece of the Japan pavilion by Imagineer and visual effects artist Bob Scifo.

RIGHT: A 1982 visual concept piece of the Morocco pavilion by Bob Scifo.

Continues from page 172.

the rich variety of Earth's landscapes in a hang glider at Soarin' Around the World, and take a boat trip through a working greenhouse and hydroponics lab. Those touring the greenhouse and the lab float by agriculture's past and present, before heading on to see future groundbreaking practices being implemented that spur increased agricultural production.

ABOVE: The cool blues and greens of undersea environments are a consistent theme in photos of The Seas with Nemo & Friends, shown here in 2013 and 2020.

The Seas with Nemo & Friends, also within World Nature, brings guests face-to-fin with a host of aquatic life, including dolphins, sharks, and sea turtles, while the interactive show *Turtle Talk with Crush* allows kids to ask the popular character from Disney and Pixar's *Finding Nemo* (2003) questions about life under the sea.

World Showcase is devoted to honoring internationality and cultural variety by presenting a cross section of the world's nations. Guests journey at their own pace around a central body of water through a series of overlapping, nationally themed areas—a configuration that encourages exploration and symbolizes the twin qualities of international individuality and unity.

GETTING REAL

Notwithstanding Disney's phenomenal success in the real world of documentaries, the studio's identity is forever tied to animation, whether it's through the imaginative world building of *Pinocchio* (1940) or the re-creating and the reimagining of the real world through animation in features like *Bambi* (1942), *The Lion King* (1994), *Lilo & Stitch* (2002), and *Moana* (2016). The world of *Bambi* is a stylized artistic re-creation of a living forest that feels convincing because of the same impressionistic authenticity that gives life to Monet's water lilies. *The Lion King* reimagines the world of the African savanna as an anthropomorphic society ruled by love, desire, greed, treachery, and courage, complete with species-appropriate personalities, but it is also the world of human society reimagined in a natural landscape. *Moana* re-creates the world of ancient Oceania by combining scrupulous attention to visual detail with a story that captures the authentic spirit of Pacific Island culture's own self-image and mythology.

Similarly, Pixar Animation Studios is known for creating rich worlds inspired by real-world locals. Disney and Pixar's *Finding Nemo* (2003) reimagines the rich oceanic biodiversity off the east coast of Australia as a teeming melting pot of familiar personality types. And for the South American sequences in *Up* (2009), writer-director Pete Docter and his development team traveled to Brazil and Venezuela for inspiration but decided to reimagine the fantastic landscape they saw rather than duplicate it. "We saw plants and rock formations . . . that we couldn't use," says Docter, now Pixar's chief creative officer. "Reality is so far out, if we put it in the movie, you wouldn't believe it."

Neither entirely animation nor strictly live-action, *The Jungle Book* (2016) from Walt Disney Studios is a hybrid movie that places living actors inside a computer-rendered jungle world; nearly seventy species of

animals native to India appear in the film. It is a representation of the real world that just happens to have the fantasy core element of talking animals, which are animated through the use of photorealistic rendering and motion capture technology that makes them appear genuine, even when they are talking. Director and Disney Legend Jon Favreau recalls considering a live-action jungle, but that producer and then–studio chief producer Alan Horn encouraged him to take full advantage of the latest in computer-generated effects, telling him, "Why not use the technology to create a whole new world that transports you?"

The film is also a hybrid in that Favreau retained some of the jovial atmosphere of the 1967 Disney animated classic while adding a more contemporary sense of tension and conflict. He also wanted the film to project a feeling of reverence for the natural world. "In [author Rudyard] Kipling's time," says Favreau, "nature was something to be controlled. Now nature is something to be protected." His instincts, as usual, were spot-on, as *The Jungle Book* was enormously popular, grossing almost a billion dollars worldwide.

ABOVE: Director and Disney Legend Jon Favreau working with Neel Sethi, the actor who plays Mowgli, on the soundstage set of *The Jungle Book* (2016).

MESSAGE RECEIVED

Sometimes the most effective way to deliver a conservation message is through cautionary tales that imagine a future or alternate reality in which a failure to respect and conserve nature has led to catastrophe. For example, at Pixar Animation Studios, every detail of the cluttered, postapocalyptic world of *WALL·E* (2008) was designed to drive home the importance of our collective responsibility as stewards of our planet's health, like the fragile, solitary seedling whose fate will determine the future of humanity, and the similarity between *WALL·E*'s towering mounds of stacked waste and an overdeveloped urban skyline in our own time.

Sometimes the Disney conservationist message is conveyed more allegorically than overtly. In *Strange World* (2022), from Walt Disney Animation Studios, the Clades are a family of legendary explorers who travel deep underground to save Pando, an energy-producing plant that revolutionized the humble town of Avalonia, turning it into a technologically advanced metropolis. But as the family journeys farther into this strange and beautiful world, they discover that the issues facing Pando reveal a far more dire truth that makes us wonder: how do we pay attention to the generational impacts of the decisions we make today?

ABOVE: Digital concept art from Disney and Pixar's *WALL·E* (2008) by Pixar artists Glenn Kim and John Lee, 2006.

ABOVE, TOP LEFT: The Walt Disney Animation Studios action-adventure film *Strange World* (2022) journeys deep into an uncharted and treacherous land where fantastical creatures await the legendary Clades, a family of explorers. Clockwise from top left: President Callisto Mal, Searcher Clade, Jaeger Clade, Legend, Meridian Clade, and Ethan Clade.

ABOVE: In the film, the Clade family navigates through a strange underground land where the powerful plant, Pando, is rooted.

THE FUTURE IS NOW

In 1990, Disney embraced conservation as corporate policy by officially committing to reducing the company's environmental footprint. That same year, then–Disney chairman and CEO Michael Eisner tasked Imagineer Joe Rohde with developing a basic plan for a new park at the Walt Disney World Resort that celebrated the animal kingdom, which Eisner envisioned as comprising a theme park, an EPCOT-style pavilion, and a nontraditional zoo or safari experience. But whatever its ultimate configuration, it would use classic Disney entertainment techniques to create an emotional connection between guests and the animals. "When we Imagineers started the development of Disney's Animal Kingdom [Theme Park], we knew that we were entering a new territory of storytelling," said Rohde. "These stories were not fantasies but real. They were not classic tales, but ongoing epics whose conclusions are still unknown. They were not ours alone, but shared with people all around the world, who lived with and cared about the lives of animals."

To learn about what sort of care and habitats the animals would require, Rohde and his fellow Imagineers started attending meetings conducted by the Association of Zoos & Aquariums as well as soliciting advice from international animal specialists. They quickly realized that what would eventually become Disney's Animal Kingdom would be more than just a zoological theme park—it was an opportunity to use Disney's global influence to further the cause of conservation by engaging and educating millions of guests each year. In the same spirit of "getting it right" that inspired the creation of the Disney Story Trust, an advisory board of experts from an array of fields and interests was created to help formulate policy and advise on the new park's design and development.

Opening on Earth Day in 1998, Disney's Animal Kingdom covers hundreds of acres, making it the largest theme park in the world, though it is also unique in its combination of live animals and themed attractions and experiences. It strikes the perfect balance between guest comfort and animal welfare, closing a little earlier than the other theme parks, eschewing the use of fireworks at its nighttime closing show, and prohibiting plastic straws and other items hazardous to the animals. In return for those small sacrifices, guests are transported to a re-created world of wildlife in its natural habitat, as well as to a world of dedicated animal specialists telling the story of conservation while sharing the joys of observing and appreciating the many species that roam the park. There are no cages in Disney's Animal Kingdom, just naturalistic barriers to protect guests and animals alike; a day at the park is a journey through a variety of global habitats, from Africa to Asia, and even back in time to DinoLand U.S.A., which conjures up a fanciful Cretaceous world with Audio-Animatronics figures of dinosaurs and prehistoric plant species.

OPPOSITE: Dr. Natalie Mylniczenko—a veterinarian within Disney's Animals, Science, and Environment group—cares for a rhinoceros at Disney's Animal Kingdom Theme Park.

Another Disney property that brings guests and nature together is Disney's Vero Beach Resort on Florida's scenic Atlantic Treasure Coast. The resort overlaps with the primary nesting grounds of the loggerhead sea turtle in the Northern Hemisphere, and its beachfront has been designed specifically to avoid disturbing the turtles' nesting habits. Every year, guests watch in awe as hatchlings make their journey across the sand to the ocean, using the moon to guide them. In keeping with Disney's commitment to conservation, the resort has no outside lighting on the ocean side, and all east-facing windows are tinted to prevent interior lighting from interfering with this breathtaking rite of passage.

Disney's commitment to environmental causes is not always obvious. To begin with, nearly a third of the land purchased for the Walt Disney World Resort had been set aside as a permanent conservation area. And forty-five minutes south of the resort, at the headwaters of the Everglades, is The Nature Conservancy's Disney Wilderness Preserve, a twelve-thousand-acre tract of pine flatwoods and wetlands that is home to hundreds of native species and serves as a natural laboratory for training in land-management practices.

Given the importance of nature to the Disney legacy, Walt's decision to send artist Maurice Day up to Maine to take some reference photos for *Bambi* back in 1938 may have had as big an impact on the future direction of the studio as any he had made since settling on the name "Mickey Mouse." It further inspired him to branch out into documentary filmmaking, to use his entertainment platform to encourage conservation and respect for nature in general, and to make environmentalism a permanent part of the company's DNA going forward.

ABOVE (from top): Atmospheric details and an aerial overview of Disney's Vero Beach Resort, shown here in 2010 and 2018, display the resort's natural serenity.

Disney Conservation Fund

The Disney Conservation Fund (DCF) was inspired by Walt Disney's conservation legacy and established on Earth Day 1995 to help protect wildlife and wild places around the world. Since that time, Disney Conservation has expanded its mission to save wildlife and build a diverse global community inspired to protect the magic of nature together. Through investments from The Walt Disney Company and generous contributions from guests, the fund's philanthropic efforts have directed more than $120 million to support nonprofit organizations working with communities to save wildlife and inspire action to protect the planet. And through the expertise, talent, and dedication of its cast members, Disney Conservation Team Wildlife leads best-in-class scientific programs to conserve wildlife in Disney's backyard and beyond and to connect people to build a network for nature.

Grants from the Disney Conservation Fund have helped more than six hundred nonprofit organizations protect more than a thousand species around the world, including elephants, cranes, and more. And through the work of Team Wildlife, the group has recorded more than 1.5 million sea turtle hatchlings on the beaches surrounding Disney's Vero Beach Resort, monitored and protected by Team Wildlife; raised and reintroduced more than six thousand rare Atala butterflies back into the wild in Florida; provided habitats for nearly four hundred species of birdlife at Disney theme park and resort areas globally; and planted more than a thousand corals to rehabilitate five coral reef patches in The Bahamas.

These efforts are all part of Disney Planet Possible—the way in which The Walt Disney Company talks about its collective efforts to take action to support a healthier planet for people and wildlife around the globe. Beyond caring for wildlife and their habitats, efforts also include reducing the company's environmental footprint and creating stories that inspire action, putting possibility into practice.

ABOVE: A green sea turtle hatchling makes its way to the ocean near Disney's Vero Beach Resort. Photograph by Rachel Smith.

Walt was always us, searching for new forms of

way ahead of any of new procedures, entertainment.

—Frank Thomas and Ollie Johnston

Animators, Disney Legends, and co-authors of *The Illusion of Life: Disney Animation*

CHAPTER 7

INNO-
VEN-
TIONS

During its first hundred years, The Walt Disney Company pioneered a century's worth of technical innovation that that transformed the studio and eventually the entire entertainment industry. Walt Disney didn't set out to innovate but rather was inventive by necessity because his creative ambitions often exceeded the capabilities of existing methods and technology. He had a restless entrepreneurial energy that he channeled into creating the finest products of their kind on the market, which meant always finding ways to improve on the industry standard.

Animation, for example, was decades old when Walt entered the field, but he made it more fluid, more emotionally engaging, and added synchronized sound and then color. He took a rough multiplane camera concept that was available in the 1930s and turned it into a state-of-the-art tool that brought real depth to animation for the first time. When he needed a sound recording system that would do justice to the symphonic pulse of *Fantasia* (1940), he and his team created a sophisticated, multichannel sound recording and playback system. By the early 1950s, amusement parks had been around for a long time, but they were strictly for kids, usually dingy, often rickety, and always predictable, so Walt reimagined his amusement park as a unified, themed, and immersive experience for all ages and as a world-class vacation destination. He approached his filmmaking techniques and theme park attractions as perpetual works in progress, forever subject to the enhancements, upgrades, and refinements that come with experience and technological progress. His constant push toward improvement through innovation has remained a driving force at the company ever since.

ABOVE: As host of the weekly television series *Disneyland*, Walt Disney became one of the best-known faces in the United States in the late 1950s. In introducing "Mars and Beyond" on the December 4, 1957, program, the forward-looking Walt talked about possibilities involving space travel.

REINVENTING THE REEL

Walt's first innovation came in 1923 when he conceived of a novel animation idea that he hoped would enable his struggling Laugh-O-gram Films studio to compete with the more established cartoon enterprises in New York. "We have just discovered something new and clever in animated cartoons!," he wrote excitedly in a letter to his distributor. He pitched the idea of a series of shorts in which live actors would interact with animated figures in a cartoon world, which had never been done before. At the time, Walt's soon-to-be rival, Max Fleischer, had begun producing the popular Out of the Inkwell series of cartoons, in which an animated character crosses over into the live-action world. Walt took Fleischer's cartoon-live action composite concept and turned it inside out, creating *Alice's Wonderland,* the pilot film for what would become a series of fifty-six Alice Comedies that Walt produced after relocating to California and founding the studio that bears his name. (Many years later the same concept of inserting live-action characters into fantasy-animated worlds would be used again to great effect in *Mary Poppins* [1964] and *Bedknobs and Broomsticks* [1971], among others.)

Subsequent Disney innovations followed on a regular basis. *Steamboat Willie* (1928) signaled the birth of fully synchronized sound in animation. *Flowers and Trees* (1932) was the first commercially released film to feature three-strip Technicolor. Disney's new multiplane camera combined three-dimensional depth with the studio's sophisticated animation to produce the strikingly beautiful *The Old Mill* (1937), which was intended as a test run for the new multiplane technology prior to its use on *Snow White and the Seven Dwarfs* (1937) and ended up winning an Oscar for Best Short Subject. And later that same year, animation history would be made again when *Snow White* became the first fully animated feature film. In 1940, Disney sound engineers pioneered a multichannel reproduction system dubbed Fantasound that gave audiences their first stereophonic movie theater experience and inspired later standard cinema sound systems like surround sound and Dolby Digital.

ABOVE: Original theatrical posters for four Alice Comedies released in 1924.

OPPOSITE: Walt Disney next to one of his studio's groundbreaking multiplane cameras during production of *Alice in Wonderland* (1951).

SWEATING THE SMALL STUFF

Another Disney innovation was the creation of the pencil test. Walt was a perfectionist, but he was also on a very tight budget in the early days. With all of the labor and expense that went into a finished cartoon short, he needed a way of checking the animation before inking and painting the cels. Disney Legend Ub Iwerks came up with the idea of filming the drawings first to address this. However, at the time there was no available room where the film could be projected, so it was run through a Moviola, a film-cutter's viewer in a small, enclosed space under the stairs that became known as the "sweatbox." The pencil test became an essential step in all Disney animation, and long after air-conditioned projection rooms were installed, animators still referred to the process as "sweatboxing."

It may seem like a commonsense development, but Disney expanded on some of the key steps within which animation is produced. It began with inspirational concept art and was followed by storyboarding, pencil animation, inking, painting, and finally photographing the composited cel images. Indeed, almost every production method and animation technique developed at Disney in the 1920s and 1930s proved to be an innovation in the field, and most were quickly adopted by other animation studios. But no other studio's work could ever quite measure up because the many layers of quality control that were built into the Disney animation process were a reflection of Walt's own meticulousness.

Walt expanded and advanced preproduction by deciding that the story idea would first be sketched out and gags would be added, along with dialogue and a preliminary musical accompaniment. When the preproduction process was complete, the layout would be established; the backgrounds for the production would also be created at this stage. Following that would be the rough animation, which was just that—sketches that captured the action in rough form. The roughs were then reviewed, and once any problems were addressed, the in-between work would commence, which would consist of drawings that fit in-between the key animation frames. Next came cleanup, which entailed smoothing out the rough animation into polished form, followed by another review.

Color models were created and referenced throughout the inking of the cels, followed by their own unique ink-check review process. The cels would move to painting, along with the adding of any needed special effects, and would then be reviewed within paint check. One last final check would be conducted, and following any corrections, the cels were ready to be photographed.

These layers of production control were put in place by Walt, and were either industry innovations or innovative refinements to existing practices. They are the reason why a Disney short could take up to six months to complete, but they also account for the unique richness, depth, and fluidity of Disney's golden age animation.

OPPOSITE (from top left): Walt Disney with Disney Legend Hamilton Luske, a supervising director on *Pinocchio* (1940), looking at a pencil test through a Moviola viewer. A Figaro animation drawing sequence by Disney Legend Eric Larson created for *Pinocchio*. Ink & Paint artist Betty Smith painting a cel of Pinocchio.

195

MIX AND MATCH

The earliest iteration of what would become the practically all-female Ink & Paint Department at Disney came into existence in 1923, when Walt hired Kathleen Dollard, followed by Ann Loomis. Dollard did a little bit of everything early on, including "blackening" in cels so they would read on camera. During Disney's monochrome early years, the process became an official department at the studio known as Tracing and Opaquing and was presided over by Walt's sister-in-law, Hazel Sewell. The indefatigable Sewell was responsible for

ABOVE, TOP: Early inkers working at the Disney studio on Hyperion Avenue.

ABOVE, CENTER: Mary Weiser (left), head of the Paint Laboratory, methodically devised new processes for color development and experimentation that resulted in department efficiencies and two key U.S. patents. Hazel Sewell (right), Lillian Disney's older sister and a talented artist, headed the early Ink & Paint Department.

hiring and training, but also developed new inking and painting processes that set the standard for color animation. Since applying color paint to celluloid was a brand-new art form, the women of the Ink & Paint Department had to innovate their way through the many problems that arose, such as paints that dried too slowly or cracked from the heat when being photographed, or failed to blend properly with other colors.

In addition, with the ever-increasing sophistication of Disney animation, the standard paint colors available on the market comprised too limited a palette for the studio's needs. Enter Mary Weiser, the brilliant, hardworking Color Model Department supervisor who analyzed these and other deficiencies and filed a report in 1936 concluding that the best solution was for the studio to create its own paints.

Weiser met with pigment suppliers and studied paint chemistry, and within a year, the first Paint Lab was up and running, making Disney the first and only animation studio to create its own custom paints. "It took a chemist to make combinations," said Disney Legend Ruthie Tompson of Weiser's groundbreaking efforts. "I don't know how she did it, but she worked up formulas for mixing paints." Stone grinders were used to give the pigments just the right texture, and Weiser scoured the planet for rare vegetable and mineral pigments.

New colors needed to be created for each production so that every character could be given its own distinct set of hues, and the number of different colors stocked by the Paint Lab soon grew from a few dozen to over 1,500. Paint colors also needed to be adjusted for consistency when stacked in layers for photography. Before retiring from the business in 1938, Weiser had acquired two patents for her work: one for her technique to enhance the textures and add dimension to the painted cels and another for the tool she created for that purpose. She had also compiled a best-practices reference guide that became known at the studio as "The Painter's Bible."

The list of early Disney innovations includes some less conspicuous but important developments, like modifying the industry standard of paper used for production drawings. Sequential animated drawings needed to line up perfectly with one another in order for the animation to flow smoothly, and before Walt had even started in the business, animation paper had been created with peg holes that would maintain what is called "registration"—the anchoring of the sheets of paper to keep them in alignment.

However, Disney animation aspired to the highest possible level of quality, leading Walt to improve on the existing industry standard by increasing the number of peg holes. "Disney animation paper originally only had two holes like everybody else's," recalled animator, story director, and Disney Legend Dick Huemer. "Then he added slits for better registry." The modification was a simple improvement, but one that contributed significantly to Disney's dominance of animation in the 1930s.

OPPOSITE, BOTTOM: Two photographs of the Paint Lab at the Ink & Paint Building at the studio in Burbank, California, were colorized as storyboard inspiration for Ink & Paint scenes from *The Reluctant Dragon* (1941) and feature Weiser (left) and Paint Lab chemist Jeanette Tonner (right).

INTO THE THIRD DIMENSION

When Walt traveled abroad for vacation, he often returned with something that impacted the studio in important ways. His 1935 trip to Europe yielded a trove of story material that he adapted from fairy tales, fables, and folklore. It was the same with his 1941 trip to South America, which led directly to the making of the immensely popular goodwill features *Saludos Amigos* (1943) and *The Three Caballeros* (1945).

Then, in 1949, Walt took his family back to Europe, and while in Paris he bought an assortment of windup items. Eldest daughter Diane later recalled Walt's fascination with them as he wound up each one and watched it operate. "It's amazing that you can get such interesting movement from a very simple mechanism," he remarked. Walt later brought one of the toys with him to the studio, handed it to machinist and Disney Legend Roger Broggie, and told him to take it apart and find out how it worked. Broggie and sculptor Wathel Rogers, who would become part of the first wave of Imagineers and a Disney Legend, were subsequently assigned the task of creating a nine-inch-tall figure that moved and talked, and "Project Little Man" was born.

For movement reference, actor, dancer, and Disney Legend Buddy Ebsen, familiar to most as Jed Clampett in the classic 1960s sitcom *The Beverly Hillbillies*, was filmed

ABOVE (from top): Disney Legend Roger Broggie helped develop the first functioning Audio-Animatronics figures. Walt Disney presents an Audio-Animatronics figure of a robin from *Mary Poppins* (1964) to actor and television producer Fletcher Markle during a Canadian Broadcasting Corporation interview. Imagineer John Franke demonstrates an Audio-Animatronics model from the Enchanted Tiki Room for Walt.

while performing vaudeville dance routines—directed by Walt himself—in front of a gridded backdrop. The project was back-burnered, however, when Walt's attention and the talents of his Imagineers shifted to the development of Disneyland.

In the early 1960s, Walt revisited the development of physical, three-dimensional animation, which he called and is now trademarked as Audio-Animatronics technology. The first attraction to utilize the new technology was Walt Disney's Enchanted Tiki Room, which opened in 1963 in Adventureland at Disneyland. Originally conceived as a restaurant, the Enchanted Tiki Room features a cast of over 150 tropical birds and dozens of flowers that talk and sing in a musical revue that includes an original song by songwriters and Disney Legends Richard and Robert Sherman. There have been numerous improvements made to the show's Audio-Animatronics technology over the years, as well as musical and narrative updates; characters like *Aladdin's* Iago and Zazu from *The Lion King* were added to the attraction in the Magic Kingdom at Walt Disney World from 1998–2011. The most recent incarnation of the attraction at Tokyo Disneyland is titled The Enchanted Tiki Room: Stitch Presents "Aloha E Komo Mai!"

Walt revived Project Little Man, but this time it would involve life-sized rather than miniature prototypes. "I told Walt that if we were allowed to build full-sized figures," remembers Broggie, "we could put the equipment inside the figure. We wouldn't have to go through cables and cams; we could build integrated figures." The Imagineers got to work and soon had built a human head with eyes that blinked and a mouth that could open and close. They showed it to Walt, who said excitedly, "Now let's make him talk!" But just opening and closing the mouth and adding sound would not be enough for the verisimilitude Walt was trying to achieve, and he told the Imagineers to start watching television with the volume all the way down, and to observe the precise way people's mouths moved when speaking. "You could always tell who was working on the job," Broggie recalled. "They never looked at your eyes when you were talking to them, always at your mouth."

As his Audio-Animatronics technology continued to develop, Walt had an inspiration: the first complete figure would be a talking Abraham Lincoln look-alike that would form the centerpiece of a proposed "Hall of Presidents" attraction at Disneyland. Walt tried in vain to interest sponsors into funding the project, but fortuitously, the 1964–1965 New York World's Fair was being headed up by urban planner, city administrator, and power broker Robert Moses, who was a fan of Walt's work. When he visited WED Enterprises in 1962, Moses was shown the still unfinished President Lincoln figure, which extended its hand to him on cue, prompting Moses to exclaim, "I won't open the fair without that exhibit!" Walt responded, "Well, we couldn't get the entire Hall of Presidents together in time, but we might be able to finish Lincoln."

Continues on page 202.

Imagineering Pioneers

Walt Disney Imagineering is an innovation factory within The Walt Disney Company division focused on theme parks and guest experiences. Within the group, creativity meets ingenuity, and its rich legacy includes contributions by innovative women in key roles.

The first woman hired by WED Enterprises—the organization that would become Walt Disney Imagineering—in a creative capacity was Disney Legend Harriet Burns, who started her Disney career painting props and sets for the *Mickey Mouse Club* television show, where she designed and built the show's famous clubhouse.

As an Imagineer, Burns worked on such classic attractions as Sleeping Beauty Castle and the Haunted Mansion and designed many of the singing birds in Walt Disney's Enchanted Tiki Room. She also did figure finishing and stage design for the Disney installments at the 1964–1965 New York World's Fair and made occasional appearances in segments of *Walt Disney's Wonderful World of Color* television show.

Other early women Imagineers included Disney Legend Alice Estes Davis, wife of Disney Legend Marc Davis and designer of the clothing worn by the figures in the "it's a small world" and Pirates of the Caribbean attractions; Disney Legend Leota Toombs Thomas, who started in Ink & Paint and later worked for Imagineering designing attractions at the 1964–

ABOVE (from top): Walt Disney and Disney Legends Julie Reihm Casaletto (center) and Harriet Burns (right) review a model of the Plaza Inn at Disneyland. Disney Legend Alice Estes Davis with an "it's a small world" doll.

1965 New York World's Fair and then at Disneyland, where her face was used for the character Madame Leota in the Haunted Mansion; Disney Legend Mary Blair, who brought modern art to Disney, worked as an art supervisor on *Saludos Amigos* and *The Three Caballeros,* and was responsible for not only the artistic concept and style of "it's a small world" but influencing the color and styling of numerous postwar Disney productions; and painter, illustrator, and Disney Legend Dorothea Redmond, whose artistic impact can be seen throughout the theme parks but most famously in the exquisite mosaic murals she designed for the entry passage to Cinderella Castle in the Magic Kingdom at the Walt Disney World Resort.

Today Walt Disney Imagineering is replete with talented women whose contributions are vital to the Disney brand. Sue Bryan is an executive creative director who heads up concept development and production for new Disney parks attractions around the world and was instrumental in the early work on Shanghai Disney Resort. Shelby Jiggetts-Tivony, originally a writer with a theater background, is vice-president of Imagineering Creative & Advanced Development, which is the wellspring for inspiring innovation throughout the organization, and she has been responsible for many popular theatrical Disney attractions, such as *Twice Charmed: An Original Twist on the Cinderella Story* for Disney Cruise Line ships and *Aladdin: A Musical Spectacular* at Disney California Adventure. Architect Hilcia Pena is a senior facility designer in charge of creating themed environments and buildings for Disney parks, including Star Wars: Galaxy's Edge. And archivist Denise Brown co-manages more than 185,000 pieces of original artwork preserved in the Walt Disney Imagineering Art Collection.

ABOVE (clockwise from top): Disney Legend Mary Blair works on designs for "it's a small world," while Disney Legend Leota Toombs Thomas inspects models of Audio-Animatronics rascals and rogues that would soon populate Pirates of the Caribbean. A 1971 color elevation by Disney Legend Dorothea Redmond for the Cinderella Castle corridor mosaics at Walt Disney World is part of the Walt Disney Imagineering Art Collection.

Continues from page 199.

Now that it was to be part of the upcoming world's fair, Lincoln's home state of Illinois agreed to sponsor the attraction in their pavilion. Technical problems with the figure were numerous, but it was finished in the nick of time, and Great Moments with Mr. Lincoln astonished world's fair attendees, immediately becoming one of the most popular attractions and ushering in Disney's age of full-sized, lifelike Audio-Animatronics figures.

At the same time the Lincoln exhibit was being built, Walt secured the sponsorship of General Electric to build an even more ambitious world's fair attraction involving a full cast of Audio-Animatronics figures. Carousel of Progress was a rotating bank of theater seats built around a stationary stage that featured sets showcasing the ways in which electricity had gradually transformed the American household from the 1890s to the 1960s. The members of the family at the center of the attraction interacted with one another using humorous expository dialogue that referenced the technological developments from each era. As the theater seat area rotated from one era to the next, the narrative pauses were accompanied by a

ABOVE (from left): The underlying electronics of an early Audio-Animatronics figure of President Abraham Lincoln, and the resulting figure, created for the 1964–1965 New York World's Fair.

OPPOSITE: Great Moments with Mr. Lincoln, shown in 2010 at Disneyland, was refurbished to enhance the quality and capabilities of the headlining Audio-Animatronics figure.

ABOVE (counterclockwise from top left): One attraction Walt Disney was especially fond of was the Carousel of Progress; Walt with an attraction model on the set a filmed progress report for General Electric in 1963. Disney Legend Blaine Gibson, who sculpted the faces of the Audio-Animatronics figures for the attraction, reviews two finished models. The exterior dome of the Progressland pavilion at the 1964–1965 New York World's Fair. The attraction has evolved through the years, always focusing on a family and technological advancements, as seen in these 2013 examples of interior scenes and an exterior photo from the Magic Kingdom at the Walt Disney World Resort.

Sherman brothers song titled "There's a Great Big Beautiful Tomorrow," which "the boys" felt captured Walt's enthusiasm for what was just over the horizon.

Carousel of Progress was the main attraction inside the Disney-presented General Electric Progressland pavilion and was another instant hit with the world's fair crowds. Its blend of nostalgia for the wholesome simplicity of the past and optimism for the scientific wonders of the future reflected Walt's own worldview, and shortly after he passed, Carousel of Progress was shipped to Anaheim and reopened in Tomorrowland at Disneyland. The attraction was later moved to the Magic Kingdom and continues to run there in Walt's honor. Since then, Carousel of Progress has been upgraded several times over the years to keep pace with the rapid advance of technology and is believed to be the longest-running stage show in the history of American theater.

While the original Audio-Animatronics figures such as Lincoln and the later Pirates of the Caribbean and Haunted Mansion characters were completely analog and utilized hydraulics and pneumatic actuators to create movement, Imagineers took another step forward in 2009 when they unveiled Otto, the first "Autonomatronics" figure. The action of Audio-Animatronics figures relies entirely on pre-programming, whereas Autonomatronics uses cameras, sensors, and other digital technology to give the figure the ability to make choices about what to say or how to move while interacting with people. The technology also allows for a much more lifelike set of muscle movements, which enables the figure to display a greater range and subtlety of facial expression and body dynamics. When asked how Autonomatronics would impact Disney's theme park storytelling, Disney Legend Tony Baxter, Walt Disney Imagineering, said, "To add emotion to performance is a huge thing."

Citing the refurbished Great Moments with Mr. Lincoln attraction from 2009, Baxter pointed out that Lincoln's serious demeanor had to be maintained for the sake of historical accuracy, which precluded giving him the full spectrum of emotional expressiveness that the upgraded technology made possible. "But you'll see the emotion, that heart and warmth, that's there in the face that wasn't really there before."

Walt Disney Imagineering continues to explore new applications for robotic technology such as Stuntronics, which combines advanced robotics with untethered dynamic movement to create high-flying, stunt-performing figures capable of superhuman feats of acrobatics. Most of the roughly six thousand Audio-Animatronics figures in use at Disney parks worldwide are bolted to the floor inside attraction buildings. But Stuntronics figures are not attached to anything and are controlled internally through onboard sensors and gyroscopes, and by harnessing the law of conservation of angular momentum, which is the same physics principle that allows a flying disc to go straight.

Disney also helped pioneer computer animation, beginning with the groundbreaking

Tron (1982) and followed by *The Black Cauldron* (1985) and *The Great Mouse Detective* (1986). They were among the very first films to employ CGI, and while it was still too early for these movies to demonstrate the full entertainment potential of the fledgling technology, they helped establish the term "computer animation" in the cultural vocabulary. As the premier producer of traditional animation, Disney remained primarily focused on hand-drawn features in the early years of CGI, when the technology was still too rudimentary to produce Disney-quality results.

But that changed when Pixar Animation Studios, whose films had been released by Walt Disney Pictures, officially became part of The Walt Disney Company in 2006. When Disney acquired Pixar, Disney made a promise to leave Pixar with creative autonomy so they could continue to make ground-breaking

ABOVE (from top): Advancements in computer graphics paved the way for films like the Disney live-action science fiction adventure *Tron* (1982) and Disney and Pixar's *Lightyear* (2022).

films. The result has been some of the most memorable features and short films ever produced, such as *Cars* (2006), *Ratatouille* (2007), *WALL•E* (2008), *Up* (2009), *Toy Story 3* (2010), *Inside Out* (2015), *Coco* (2017), *Bao* (2018), *Float* (2019), *Out* (2020), *Soul* (2020), *Turning Red* (2022), and *Lightyear* (2022).

As CGI technology and tools have evolved through the years, the approach to utilizing them at Walt Disney Animation Studios has evolved with it. It is noteworthy that although 3D computer animation is typically rendered digitally from start to finish, much 2D computer animation still requires hand-penciling before the individual drawings are scanned to the computer to be colored and digitally sequenced. Moreover, animators sometimes take a hybrid approach by creating traditional animation that is later enhanced using digital techniques, and even completely hand-drawn animation is now photographed digitally.

As people become more and more familiar with and reliant on technology in the digital age, their expectations for the Disney theme park experience are changing, and Imagineering is keeping pace with this trend by always working on new attractions that push the limits of what is possible. "We think a lot about relevancy," says Josh D'Amaro, chairman of Disney Parks, Experiences and Products. "We have an obligation to our fans, to our guests, to continue to evolve, to continue to create experiences that look new and different and pull them in." Most if not all of these experiences will involve the latest developments in Audio-Animatronics figures, both tethered, like the Hondo Ohnaka figure from the queuing area for the Millennium Falcon: Smugglers Run attraction, and freestanding, like the next-gen Groot figure currently in development that can walk, dance, and react with emotion during guest interactions. "This guy represents our future," says Jon Snoddy, a senior executive at Imagineering, about the Marvel Studios character. "It's part of how we stay relevant."

WHAT'S OLD IS NEW

During the production of *Star Wars: The Force Awakens* (2015), director J.J. Abrams desired to capture—and call back to—the look and feel of the original *Star Wars* films. To accomplish this, CGI and practical effects

ABOVE: The advanced Audio-Animatronics figure of Hondo Ohnaka recruits flight crews at the Millennium Falcon: Smugglers Run attraction in Star Wars: Galaxy's Edge.

were created to complement each other to produce the best possible image onscreen. This approach led to the development of BB-8, the astromech droid that steals every scene in which it appears, both in *The Force Awakens* and throughout the sequel trilogy, and has become a fan favorite and merchandising phenomenon. BB-8 is neither a costumed actor, like C-3PO and R2-D2, nor a traditional Audio-Animatronics figure, but an interactive prop manipulated by specialized handlers. Created by Neal Scanlan, head of the *Star Wars: The Force Awakens* creature shop, the BB-8 that appears on film is actually a number of different units: a rod puppet operated by puppeteers Dave Chapman and Brian Herring; some radio-controlled versions with limited specialized capabilities; and some static props. Because of BB-8's rolling movement, Scanlan covered the droid's base with asymmetrical soccer ball patterns to make it easier for audiences to track movement. "If you had parallel patterns that ran around the circumference," he observes, "they would be less informative as to the direction BB-8 was traveling."

Although a free-moving BB-8 without wires or puppeteers proved to be impractical for use during filming, Scanlan and his team were determined to create one anyway. Said the team's senior Audio-Animatronics figure designer, Joshua Lee, "I started to design this crazy idea of one that would roam around and that we would show to the fans as well. We really couldn't do it for filming, but it had to be done." Apart from the challenge of designing a ball robot with a free-moving dome on top, there was also the difficulty of matching BB-8's signature onscreen movements, which had been made possible by Chapman and Herring's skillful off-camera manipulation and some seamless postproduction digital erasure of puppet rods. Lee worked on a prototype and Matthew Denton, the electronic design and development supervisor, came up with the software that would allow remote control of the droid. They soon completed a functioning gray-ball prototype, which was handed over to the creature shop's paint-finish designer, Henrik Svensson, and a BB-8 accurate in every detail was literally rolled out at the 2015 *Star Wars* Celebration in Anaheim, circling, tilting inquisitively, and beeping to the utter delight of the thousands of roaring fans. It formally established BB-8 as a solid, practical-effect creation, augmented to its full potential through digital effects tools, and it was yet another example of the way Lucasfilm harnesses innovation to deepen the connection between character and audience.

Today's cutting-edge technology will continue to be eclipsed by tomorrow's breakthroughs, and although we can't predict what the next hundred years of Disney entertainment innovations will bring, we can be certain that they will remain true to Walt's original vision by creating new and exciting storytelling platforms that engage our emotions and bring out the child in all of us.

ABOVE: BB-8, the loyal astromech, in *Star Wars: The Force Awakens* (2015).

The Art of Innovation at Industrial Light & Magic

When The Walt Disney Company bought Lucasfilm Ltd. in 2012, it acquired not only the rights to continue building on two of the greatest cinematic franchises in history, *Star Wars* and Indiana Jones, but also the technology, expertise, and production infrastructure that made the films possible in the first place. Founded in 1971 by George Lucas, Lucasfilm revitalized the adventure fantasy movie genre and revolutionized Hollywood by creating the market for spectacular, big-budget filmmaking. With the release of the *Star Wars* sequel trilogy (2015–2019) and fan-favorite Disney+ Original series' like *The Mandalorian* (2019–), Lucasfilm has reaffirmed its dominant role in onscreen entertainment for the new millennium.

In 1975, when Lucas learned that there was a scarcity of visual effects teams available—and none capable of realizing the complex shots he required—he did what Walt Disney had throughout his career when facing similar obstacles: he hired the talent capable of inventing technologies that could bring his vision to life. Thus was born the Lucasfilm visual effects division Industrial Light & Magic (ILM), so named because it was originally headquartered in a warehouse that was zoned for only "light industrial." in Los Angeles' Van Nuys neighborhood. ILM is home to gifted artists, engineers, and craftspeople who are all driven by the same spirit of innovation to create unforgettable storytelling magic.

For nearly half a century, ILM has been the leading visual effects company in the world, pioneering new technologies and pushing the boundaries of the entertainment industry ever forward—with examples ranging from blue screen photography, matte paintings, and complex miniatures, to computer graphics, performance capture, and cutting-edge virtual production. With studios located around the globe, ILM—along with Lucasfilm's sound design, mixing, and audio postproduction division, Skywalker Sound—serves the motion picture, television, streaming, commercial production, and attraction industries. Its expertise even extends to include virtual reality, augmented reality, and immersive entertainment by way of their ILMxLAB subdivision.

Having been honored with an incredible forty-eight Academy Awards and three Emmys as of this printing, ILM has pioneered visual effects techniques such as morphing, enveloping, and film input scanning technology. And now, with one of its latest innovations, StageCraft, ILM has launched yet another industry revolution. StageCraft is an on-set virtual production tool-set that utilizes a high-resolution video wall consisting of multiple LED displays that combine to form either a single LED volume, or in some cases, a smaller pop-up application, depending on the needs of the filmmaker. StageCraft provides backgrounds and lighting that can be manipulated in real time, allowing for in-camera finals that obviate the traditional need for postproduction green screen compositing.

Development on ILM's real-time production technologies go back over twenty years on pictures such as *A.I. Artificial Intelligence* (2001), and more recently on *Rogue One: A Star Wars Story* (2016), and *Solo: A Star Wars Story* (2018), helping to pave the way for ILM StageCraft.

Today, StageCraft provides filmmakers with seamless in-camera finals using photorealistic backgrounds and real-time lighting on a wide variety of projects, from Disney+ Originals such as *The Mandalorian*, *The Book of Boba Fett* (2021), *Obi-Wan Kenobi* (2022), *Andor* (2022-), *Ahsoka* (2023), *The Acolyte* (2023), and *Percy Jackson and the Olympians* (2024), as well as music videos, commercials, television shows, and feature films from Marvel Studios and beyond.

Industrial Light & Magic (ILM) StageCraft LED Volume is in use during this season two episode shoot of *The Mandalorian*. ILM's real-time cinema render engine fills the massive volume's walls and ceiling with perspective-correct, high-resolution imagery.
© 2019 Lucasfilm Ltd™. All Rights Reserved.

I told my husband, on, but who's going play park." No one that [Walt

"This is great to work to drive that far to a had the foresight Disney] did.

—Harriet Burns

Imagineer and Disney Legend

CHAPTER 8

YOUR DISNEY WORLD— A DAY IN THE PARKS

A green park bench sits just inside the entrance to the Opera House along Main Street, U.S.A., at Disneyland, but no one is allowed to sit on it. It's a historical artifact. Affixed to the back of the bench is a plaque that reads, THE ACTUAL PARK BENCH FROM THE GRIFFITH PARK MERRY-GO-ROUND IN LOS ANGELES, WHERE WALT DISNEY FIRST DREAMED OF DISNEYLAND. As Walt often told the story, "It came about when my daughters were very young, and Saturday was always daddy's day. . . . I took them different places and as I'd sit while they rode the Merry-Go-Round and did all these things—sit on a bench, you know, eating peanuts—I felt that there should be something built where the parents and the children could have fun together. So that's how Disneyland started."

As with any real-life origin story, the reality is more complicated. Before he broke ground on the park in 1954, Walt Disney "dreamed of Disneyland" for many years while visiting and observing an array of places scattered across the world. He headed to the rough and rudely staffed amusement parks of Brooklyn, New York's famed Coney Island. He assessed the pristine historical re-creations in Williamsburg, Virginia, and at Greenfield Village in Dearborn, Michigan, near Detroit. He spent many hours in rapturous appreciation of the grand vision behind Tivoli Gardens in Copenhagen, Denmark, which combined the thrill rides of American amusement parks with excellent food, polite service, the presentation of various cultural events, and gorgeous landscaping. He learned the ups and downs of inviting guests to partake in a train ride on his Carolwood Pacific Railroad, the one-eighth-scale miniature rail line he built around his home in Holmby Hills, located north of Sunset Boulevard in Los Angeles. He visited zoos, state fairs, circuses, and carnivals. He observed the flow of pedestrians at Knott's Berry Farm in Orange County, south of Los Angeles. He even sent some Disney executives to attend a 1952 conference of amusement park operators—all of whom

ABOVE: A Griffith Park Merry-Go-Round bench that Walt Disney sat on while dreaming of Disneyland, where the bench is now displayed.

thought his ideas for Disneyland were bound to lose money.

He persisted even when his own wife, Lillian, expressed her doubts. "But why do you want to build an amusement park?" she asked. "They're so dirty." As Walt later recalled, "I told her that was just the point—mine wouldn't be."

That *was* just the point. The experience at Walt's park would be fundamentally different from the barker-and-mark sensibility of carnivals and midways. While amusement parks sought to empty customers' wallets with as little overhead and atmosphere as possible, Disneyland and its sister parks would (and still) seek to empty their visitors of their cares and woes, with as much courteous attention and ambience as possible. Since the beginning, the parks have not just been places to ride attractions, eat fast food, and buy souvenirs; they are extensions of Disney's long tradition of storytelling. Guests can encounter beloved characters, enter into all-encompassing narratives, visit varied locations, and see both the past and future brought to life. The parks offer the uncomplicated joys of the local Merry-Go-Round—there's a carousel in every Magic Kingdom–style park, as well as in Tokyo DisneySea and in Disney California Adventure. But the parks are also, as Walt envisioned, places with something to offer every member of the family, both individually and collectively.

The creators of this interactive new art form came to be known as Imagineers, a combination of "imagination" and "engineering" that hinted at these dreamers' diverse backgrounds in scenic design, animation, architecture, fine arts, landscaping, engineering, and countless other fields. "Walt Disney's own genius lay not just in the ideas he himself generated," wrote Disney Legend Marty Sklar, who served as a longtime president of Walt Disney Imagineering, "but in the casting of talents—many of whom were Disney studio veterans embarked on 'new careers' in the second half of their creative lifetimes."

As the decades passed, Imagineers were recruited earlier in their careers, and those with other specialties were sought as well: computer programming, projection technology, digital recording, micro-mechanics, and many other pursuits and interests. The team of artists at WED Enterprises (the previous name of Walt Disney Imagineering, borrowing from Walt's full-name initials) who were the core

ABOVE: Disney Legend Marty Sklar, longtime president of Walt Disney Imagineering, was instrumental in carrying forward Walt Disney's creative vision during his 54 years of service to The Walt Disney Company.

creative force behind the rapid construction of Disneyland numbered just a few dozen. Now hundreds of Imagineers plan years in the future, working not just on attractions for Disney's twelve theme parks around the world, but aboard Disney Cruise Line ships, at Disney resort hotels, and even on residential communities, like the Storyliving by Disney project announced in 2022.

When Walt famously said, "Disneyland will never be completed. It will continue to grow as long as there is imagination left in the world," he was also predicting the greater destiny of the whole bouquet of theme parks Disney has created, and the destiny of Walt Disney Imagineering. The experiences that make up your day in the park are as unlimited as the ever-growing variety of the stories Disney tells and the ever-evolving technologies that enable them to be told.

THE SPIRIT OF REINVENTION

The design and construction of the original Disneyland theme park is an epic story that could fill volumes—and has. In short, Walt Disney was determined to reinvent the amusement park. By the time he brought his friend and artist Herb Ryman (who would become an Imagineer and a Disney Legend) to the studio in September 1953 to sketch out the now-famous "aerial view" of the park that Roy O. Disney would use to help secure funding, Walt already had much of the park's makeup in his head. "Herbie," he told Ryman at the start of a two-day artistic marathon to get the drawing finished, "I just want it to look like nothing else in the world. And it should be surrounded by a train." Walt sat with Ryman as he drew the oversized pencil sketch, guiding his work.

A flat diagram of the park's layout had been made under Walt's supervision by another original Imagineer, Hollywood art director, and Disney Legend Marvin Davis. But Ryman's dimensional rendition would be seen as if from an airplane soaring over the site toward the central castle, with all the buildings coming into view, along with two steaming locomotives traversing the circular railroad track on the perimeter.

Amusement parks tended to have multiple entrances, to improve traffic flow.

ABOVE: Disney Legend Herb Ryman, seen here painting an early concept for Euro Disneyland (later known as Disneyland Paris) in his later years.

A 2014 view of Main Street, U.S.A. from Sleeping Beauty Castle, past the *Partners* statue of Walt Disney and Mickey Mouse, and toward the Disneyland Railroad station.

Walt wanted a single entrance, so every guest would have the same experience of entering his park from beneath a railway station and up onto Main Street, U.S.A.—the boulevard inspired, in part, by Walt's childhood memories of Marceline, Missouri. Amusement parks typically had midways with deceptive games, low-quality food stations, and souvenir stands. Main Street, U.S.A., would have no games of chance, and its culinary and merchandise offerings would be presented at Walt's high standards in an atmosphere consistent with the street's early twentieth-century theme. Amusement parks often had one main throughfare with cross paths leading to different rides. Disneyland was designed in a hub-and-spoke configuration, similar to the urban planning for Paris and Washington, D.C.

Most important, amusement parks did not have huge central structures that were neither rides nor capable of generating revenue. Disneyland would have Sleeping Beauty Castle, providing a beautiful landmark that served chiefly as a visual anchor for navigating the park and as a scenic entryway to Fantasyland. (A walk-through display of dioramas telling the *Sleeping Beauty* story was added to the castle in 1957.)

Walt's ideas had been taking shape for many years. In 1952, he had proposed a park on sixteen vacant acres across from the Walt Disney Productions studio lot in Burbank. He soon decided sixteen acres was too small. After reviewing several possible locations, a consultant and research economist named Disney Legend Harrison "Buzz" Price recommended a site in Orange County, south of Los Angeles, in Anaheim, not far from Knott's Berry Farm. The land—mostly orange and walnut groves (and a few residences)—was bought quietly

ABOVE (from top): Walt Disney built and often rode the 1:8 scale Carolwood Pacific model railroad surrounding his home in the Holmby Hills neighborhood of Los Angeles.

while, back in Burbank, WED Enterprises worked on the designs. Among the WED crew was Ryman, who told Walt, "I'll work on this thing as long as it's interesting and exciting," and went on to have a long and robust career with the company.

Thanks, in part, to Ryman's 1953 sketch, the ABC television network agreed to provide much of the financing for the Disneyland theme park in exchange for airing a weekly television series, originally titled simply *Disneyland*, starting in the fall of 1954.

Somehow the park got built in less than twelve months, and it opened on time, July 17, 1955—an event documented on ABC via the most complicated live television broadcast ever attempted to that point, titled *Dateline Disneyland*. The show was seen by an estimated ninety million Americans—more than half the nation's population at the time.

The televised opening was intended to include only invited guests, whose arrival times had been strategically staggered to avoid overcrowding, but no one paid any attention to their assigned entry times.

The park looked great on television, but it was hot and overcrowded . . . plus had few drinking fountains operating due to a plumbers strike. The still-sticky asphalt sucked high heels off women's feet, and by the end of the day, almost every car at the Autopia attraction had broken down—to cite just a few of the opening event's many challenges. But it didn't matter. The next day—the first day the park was open to paying guests—people came by the thousands. Roy O. Disney bought admission ticket No. 1 that day, but more than twenty-six thousand guests followed.

The park was a success, and new attractions were immediately planned, while some already in the works could now be finished. To name a few early additions, there was Tom Sawyer Island (opened in 1956), Alice in Wonderland (in 1958), and Matterhorn Bobsleds, Submarine Voyage, and the Monorail (all in 1959).

An early fan was novelist Ray Bradbury, who responded to a negative report in the *Nation* magazine in 1958 with a letter of support. On his first visit to Disneyland, Bradbury wrote, he had "never had such a day full of zest and good humor. . . . I found, in Disneyland, vast reserves of imagination before untapped in our country. . . . I shall be indebted to [Walt Disney] for a lifetime for his ability to let me fly over midnight London looking down on that fabulous city, in his Peter Pan ride. The Jungle Boat ride, too, is an experience of true delight and wonder." Since that first visit, Bradbury wrote, he had been back six more times.

ABOVE: Walt Disney reads the Fantasyland dedication plaque prepared for the *Dateline Disney* telecast during a rehearsal for the park's Invitational Press Preview on July 17, 1955.

Gotta Get an E Ticket

Admission to Disneyland on the first day it opened to the public was $1—just 50 cents for children. The sponsored exhibits were free, as was the show at The Golden Horseshoe; guests could enjoy walking around the park and window shopping without paying another dime. But a dime was just what it cost to ride one of the vehicles traversing Main Street, U.S.A.; it was 50 cents for those hopping aboard the Jungle Cruise. Many attractions had a ticket booth nearby, so guests could pay on the spot; it was not a not terribly efficient system. In October 1955, coupon books were introduced, the purchase of which covered admission to the park as well as eight attractions. The booklets were $2.50 for adults, $2 for "juniors," and $1.50 for younger children. Each included an assortment of coupons labeled A (covering the 10-cent attractions), B (for specific attractions priced at 25 and 50 cents), or C (for attractions priced at 35 to 50 cents). Guests presented the coupons in place of tickets to enter the attractions of their choice—say, the *20,000 Leagues Under the Sea* exhibit (A), the Mad Tea Party (B), or the Fantasyland "dark rides" (C). If guests exhausted their coupons and wanted to visit additional attractions, individual tickets remained available for sale.

The next year, with the opening of Tom Sawyer Island (accessible only by rafts, which required a ticket or a coupon), the Storybook Land Canal Boats, and the narrow-gauge Rainbow Caverns Mine Train (later replaced by Big Thunder Mountain Railroad), another coupon tier was introduced: the D ticket. In addition to covering the new attractions, some existing attractions, including the Jungle Cruise, were upgraded from the C level to D, though its price remained at 50 cents.

That system lasted just over two years, until the much-heralded introduction of a number of dramatic new attractions in a celebration dubbed "Disneyland '59!" That June, as presented in another ABC television special, the Matterhorn Bobsleds and Submarine Voyage opened, along with the Disneyland-Alweg Monorail System, on which then U.S. vice president Richard M. Nixon and his family were the first guests. These elaborate and impressive attractions required another admission upgrade, and an E level was added to the coupon booklets. Other attractions elevated to E-ticket status then were the *Mark Twain* Riverboat, Rocket to the Moon, the Santa Fe and Disneyland Railroad, and, of course, the Jungle Cruise. (Peter Pan's Flight and some other Fantasyland attractions remained C and D level.)

The coupon system lasted several years, but alas didn't last forever. On June 20, 1981, Disneyland began selling an all-inclusive Passport, with unlimited admission to all park attractions, alongside the coupon booklets—and within a year, the coupons were gone at both Disneyland and the Magic Kingdom at the Walt Disney World Resort. (Tokyo Disneyland continued to sell the coupon books until March 31, 2001.)

The E ticket itself was no more, but the phrase has lived on. The tiered system had accorded a special status to those attractions deemed E tickets, and within a few years of their introduction, as Walt Disney archivist and Disney Legend Dave Smith wrote, "The term 'an E ticket ride' entered American slang meaning the ultimate in thrills." Most famously, NASA astronaut Sally Ride used the phrase in 1983 when asked to describe her first trip to space and back: "Ever been to Disneyland?" she playfully asked a reporter. "That was definitely an E ticket!"

ABOVE: Roy O. Disney purchased the first admission ticket sold for Disneyland on July 18, 1955, now part of the Walt Disney Archives collection and pictured here.

THE ULTIMATE REINVENTION

Walt had reinvented the amusement park so thoroughly that that term could not even be applied to Disneyland. It was known as a "theme park." Its patrons were called "guests," and its immersive amusements were designated "attractions." Eventually, to emphasize the experience of visiting Disneyland as more of a show than a business transaction, employees became known as "cast members"—each of whom wore a friendly badge displaying their first name. Those who were interacting with guests were said to be "onstage," while staff-only areas were "backstage." Language itself had to move forward to accommodate Walt's vision.

The reinvention never stopped at Walt Disney Imagineering. In 1982, EPCOT Center joined the eleven-year-old Magic Kingdom at the Walt Disney World Resort and redefined what a theme park could offer, with its unique combination of looking to the past and future for real-world inspiration. Disney's Hollywood Studios came next at Walt Disney World in 1989, reinventing the concept of the studio tour, followed by Disney's Animal Kingdom Theme Park in 1998; that park boldly reimagined how guests could interact with live animals residing in their natural-like habitats.

By the 2010s, Imagineers had built theme parks inspired by Disneyland and the Magic Kingdom at three other Disney resort locations, but Shanghai Disneyland was to be "like no other," Imagineer Doris Hardoon recalled for the documentary series *The Imagineering Story*. "As we started working with our Chinese partners and the information funneled down to the team levels, it was the bigger, the better—the wider, the higher, the more unique, the unusual, never been done before, but yet it's a Magic Kingdom."

The Shanghai Disneyland team of Imagineers set out to rethink the traditions of the Magic Kingdom in ways that spoke to their new audience. Thus, Main Street, U.S.A., which referred to a place and period that held no meaning for the Chinese, was reconceived as the timeless Mickey Avenue, a kind of downtown hangout for characters from Disney animation those and audience felt a connection with. (For example, CookieAnn Bakery Café is themed to both Minnie Mouse and CookieAnn, Duffy's creative and food-loving friend.) The castle, rather than being linked to a single princess, became the Enchanted Storybook Castle, which would include a walk-through attraction introducing guests to many different Disney fairy tales. The park would have neither a Frontierland (an era unfamiliar to the Chinese) nor an Adventureland. Instead, the worldwide popularity of Pirates of the Caribbean stories was used as the anchor for the new Treasure Cove, while a completely new mythology, with

distinctly Chinese elements, was developed as the narrative bedrock for Adventure Isle.

Some seventy years had passed since Walt sat on that park bench, watching his young daughters on the Merry-Go-Round, and now the Imagineers were focused on another family configuration. Instead of "daddy's day" with the girls, this family was referred to as "4-2-1," for four grandparents, two parents, and one child—the makeup of many families in China under its long-standing "one child" policy. The policy was relaxed before Shanghai Disneyland opened in 2016, but the park was nevertheless ideally suited to these still prevalent multigenerational families. In place of the previously compact Central Plaza, where Main Street, U.S.A. connects with the main castle, the Shanghai park would have the lush green Gardens of Imagination. The expanded area was designed to appeal particularly to younger children, with its Dumbo the Flying Elephant attraction and Fantasia Carousel shifted here from their usual spots in Fantasyland. The idea was simple: While young parents headed off to visit more challenging attractions elsewhere in the park, or to have a romantic break from parenting, the older generation could supervise their grandchild and perhaps enjoy a less frenetic attraction or two themselves. Or they could all simply enjoy the eleven acres of landscaping, finding a shady spot to rendezvous with the young adults upon their return.

The idea of providing attractions for the whole family was integral to Walt's vision, and it's borne out in each Disney park. The original Disneyland introduced the simple joys of the Dumbo the Flying Elephant with an eye to young children—and it proved so popular that it was reproduced in every subsequent Magic Kingdom–style park. (It was doubled in size for the refurbishment of Fantasyland in the Magic Kingdom in 2012.) Its simple design—Disney-themed vehicles rising and dipping on spokes that circle a central hub—has been repeated in other attractions, such as the Magic Carpets of Aladdin in Adventureland at the Magic Kingdom and the similar Flying Carpets Over Agrabah in the Walt Disney Studios Park at Disneyland Paris.

Space-themed variations have been part of Tomorrowland at both Disneyland and the Magic Kingdom (Astro Orbiter) and at Discoveryland at Disneyland Paris (Orbitron). Unlike the simpler cars-on-spokes rides at carnivals and amusement parks, Disney's attractions give guests roles within a familiar narrative: they are flying with Dumbo, guiding Aladdin's magic carpet, or piloting rocket ships as junior astronauts. It's the immersion, not the motion, that keeps families lining up year after year, generation after generation.

Dumbo also gets parents up off the park bench. A search for "Dumbo ride" on Instagram any day of the year will pull up dozens, if not hundreds, of images of children riding with a parent or family member who seems as excited as the little ones. The magic in Walt Disney's vision for the world's first theme park goes back to his initial inspiration on that bench—not for a moneymaking

venture, but for a place where people like him could enjoy time with their families. As reporter Jack Jungmeyer observed of Walt in the July 1955 issue of *The Disneyland News*, "[He], too, was a Main Streeter, never weaned away from the common bond with the great majority of American small town and country folk, their tastes and ideals." Of course, Disney parks appeal equally to city folk—another demographic Walt knew well.

But wherever guests come from, when they arrive at a Disney park, their needs and expectations have been anticipated, because Walt and his successors put themselves in their guests' shoes, even if those shoes belong to the people of another country.

THE ART OF PLACEMAKING

It's understandable why some people characterize Disney theme parks according to the attractions they contain. The Magic Kingdom at the Walt Disney World Resort is the only park with The Hall of Presidents. If you want to zoom around on the car-themed Test Track, you'll have to visit EPCOT. The Imagineers' first "dark ride" with a trackless vehicle guidance system was Pooh's Hunny Hunt in Tokyo Disneyland, and it remains unique and more elaborate than its similarly themed counterparts. The only castle with a dragon in its dungeon is Le Château de la Belle au Bois Dormant in Disneyland Paris. The thrilling and always jam-packed Expedition Everest – Legend of the Forbidden Mountain exists only in Disney's Animal Kingdom Theme Park. Every park has its exclusive attractions.

But the overall experience of your day in the park derives not from individual attractions but from the carefully designed and constructed lands and worlds in which they exist. This is what Imagineers refer to as "placemaking," and it's what puts the "theme" into a theme park. It is architecture in the service of storytelling. "In Imagineering architecture," Imagineers explain in *Walt Disney Imagineering: A Behind the Dreams Look at Making the Magic Real*, "the obvious function of a building is secondary to its primary purpose: to help tell the story. Each building's foundation not only supports a physical structure, but it also supports a story structure. Whether façade, mountain, tower, sphere, an entire resort hotel, the wacky neighborhood of Mickey's Toontown, the rustic long structures of Frontierland, the rich-in-detail World Showcase pavilions at EPCOT, or the fairy-tale settings in Fantasyland, Imagineering's approach to architectural storytelling communicates the theme of an entire area."

One reason Disneyland has a single entrance is to funnel every guest down Main Street, U.S.A., which Walt intended as a transitional corridor to "leave today—and

visit the worlds of yesterday, tomorrow and fantasy." Guests move through the entry tunnel from the inner ticket plaza to Town Square. Far from re-creating a realistic turn-of-the-twentieth-century downtown, Main Street, U.S.A., is a filmmaker's rendition of the era, with a series of separate façades on what are essentially two structures, one on each side of the street. The buildings appear to be two-stories tall from the outside but are actually shorter, their upper floors rendered slightly smaller than the lower floors. This is "forced perspective," which the Imagineers described as "the art of making something appear taller than it actually is . . . by starting with normal scale elements at the base of a building and progressively making them smaller as they continue towards the top." The story of Main Street, U.S.A., then, is not exactly the story of small-town America around 1900. More precisely, it's the story of a period more idealized than real.

Forced perspective was utilized even more extensively in the design of Sleeping Beauty Castle, a structure that stands as a beacon and dreamscape, as well as a promise of the stories to come once guests pass under its arches to reach Fantasyland beyond.

People who don't appreciate the rich creativity that Imagineers put into their placemaking are missing an "incredibly energetic collection of environmental experiences," architect Charles Moore wrote in an essay from the book *The City Observed: Los Angeles*. Disneyland, he continued, "offers enough lessons for a whole architectural education in all the things that matter—community and reality, private memory and inhabitation, as well as technical lessons in propinquity and choreography."

MANY HOUSES, MANY TALES

Disney parks fans looking for examples of how theme park architecture is determined as much by what's outside the attraction as by what's inside need look no further than the various incarnations of the Haunted Mansion. Early sketches for Disneyland included variations on a haunted house, including one that would have been located just off Main Street, U.S.A. But the Imagineers didn't get started on the actual Haunted Mansion attraction until the late 1950s and early 1960s, at the same time they were planning an expansion of Disneyland along the Rivers of America that would become New Orleans Square. Walt never liked the idea of a big dilapidated house in his pristine theme park, so Disney Legend Marvin Davis designed a beautiful but abandoned structure, built in the early 1960s on the edge of New Orleans Square. It sat empty for several years while Walt Disney Imagineering focused on the attractions that would amaze guests at the

1964–1965 New York World's Fair. ("But we haven't got the ghosts in there yet," Walt told viewers of the *Walt Disney's Wonderful World of Color* television series in 1965. "But we're out collecting the ghosts.") Once the fair pavilions were installed, attention turned back to Disneyland. Finishing Pirates of the Caribbean, also in New Orleans Square, was the top priority, but the Haunted Mansion would be next. A host of early Imagineers contributed to the mansion, including Disney Legends Ken Anderson, Marc Davis, John Hench, Blaine Gibson, X Atencio, Wathel Rogers, and especially Yale Gracey, considered WED's master of visual illusions. ("We had a lot of art directors there," Davis remarked.) Walt Disney did not live to see the completed attraction, which opened in August 1969, more than two years after Walt's passing.

A second Haunted Mansion was slated to be an Opening Day attraction in the Magic Kingdom at Walt Disney World in 1971. The inside experience would be only slightly changed from the Disneyland version, but the Magic Kingdom at the Walt Disney World Resort had no New Orleans Square, so the Haunted Mansion was placed in the new park's Liberty Square, which honored the early history of the United States. A mid-1800s home made no sense there, so it was replaced by a Gothic manor structure, which blended with the look of Liberty Square and kept guests focused on the story of the country's founding and development that the area was telling.

ABOVE, LEFT: The official portrait of the Haunted Mansion at Disneyland by Disney Legend Sam McKim, painted over a reproduction of an original sketch by Disney Legend Ken Anderson, 1958.

ABOVE, RIGHT: Exterior elevation art of the Haunted Mansion in the Magic Kingdom by Imagineer George Jensen, 1970.

When Euro Disneyland (now Disneyland Paris) opened in 1992, its ghostly attraction was dubbed Phantom Manor, and it was the most prominent structure in the newly reconceived Frontierland. While many of the scenes and visual effects inside the attraction were based on similar elements from the Disneyland and Magic Kingdom versions, Phantom Manor told a new story, one that encompassed all of Frontierland. The home was said to have belonged to Henry Ravenswood, who founded the town of Thunder Mesa—that is, the rest of Frontierland—after striking it rich as a gold miner. He had a beautiful daughter, Melanie, whose suitors all died in mysterious and violent manners—the last one on the day of her wedding. The ghosts of Melanie, in her wedding dress, and her father appear at various places along the attraction, and the story of the Ravenswood family is carried out in other ways throughout Frontierland.

Creating the stories was just as important for the Imagineers as for the guests. Visitors could no doubt enjoy Frontierland and its Phantom Manor without knowing the history of the Ravenswood family. But the Imagineers needed to know everything about the story they were telling in order to establish the comforting consistency that gives every Disney park its sense of reassurance and authority. "In order to convey ideas, you have to be precise in the way you handle forms," Imagineer and Disney Legend John Hench told author Karal Ann Marling in *Designing Disney's Theme Parks: The Architecture of Reassurance*. "You do not want to introduce any ambiguity, and certainly not contradictions."

The characters and their stories are inseparable from the lands that encompass them—neither comes to life without the other. Every discussion of the placemaking at Disney theme parks inevitably comes back to filmmaking—not just because most of the original Imagineers were recruited from the movie business, but because both art forms seek to detach viewers from their day-to-day cares and envelop them in an imaginative narrative.

"Walt set a standard early on with the Imagineers," said Bob Iger, Chief Executive Officer, The Walt Disney Company. That high standard, he said, "enabled people to come in expecting something and then giving them something even beyond that. Beyond really their own imagination. So they left thinking, 'Wow . . . only Disney could do that.'" When he first became CEO, in 2005, Iger cited three guiding principles for his leadership philosophy across the company: the best creative content, the latest technological innovation, and continuing international expansion—all of which supported the ongoing evolution of Disney

ABOVE: Overall exterior elevation art of Phantom Manor at Disneyland Paris by artist Dan Goozee, 1987.

theme parks globally. "Walt wasn't about creating something and leaving it as it was—including Mickey Mouse. Over the years, Mickey changed because Walt knew that times change," Iger said. "He gave us this unbelievable canvas to paint on."

STORIES AND BACKSTORIES

The placemaking in a Disney theme park sometimes began with an existing story, or a number of stories blended together. In the original Disneyland, for example, Peter Pan, Dumbo, Snow White, and Mr. Toad united to populate Fantasyland. But Adventureland at Disneyland, the park's smallest parcel in land area—at least before the addition of New Orleans Square—was grounded in neither a particular historical era, like Frontierland, nor an existing fictional narrative (although the leads from *Swiss Family Robinson* would eventually take up residence there). Adventureland expressed Walt's desire to take his guests to locations that most of them would never have an opportunity to visit in real life—not to take them through a specific plot so much as to surround them with the settings for countless stories. He knew from the popularity of his True-Life Adventures documentaries that fact-based stories of far-off destinations could fascinate Americans, and even early layouts for what became Disneyland included a "True-Life Adventureland."

Long before the advent of Pirates of the Caribbean, the heart of Adventureland was the Jungle Cruise, designed by Hollywood scenic designer, Imagineer, and Disney Legend Harper Goff. But the idea was Walt's, perhaps inspired by a thirty-mile steamboat trip into the rain forest of Colombia he had partaken in during his 1941 tour of South America. "In many ways, the Jungle Cruise defined what Disneyland was all about," Karal Ann Marling wrote. "It was a cinematic experience, an art director's pipe dream composed of curves and well-placed switchbacks that hid one part of the set from another and so preserved the illusion. . . . And it was a vast, complicated experiment."

Goff designed the riverway and the sets, evoking sights along some of the most famous waterways of the world, from Southeast Asia to Africa to South America. He determined the exact angle of the curves by driving through the trench construction workers were digging in a Jeep with a model of the passenger boat attached to the roof. Landscape architect and Disney Legend Bill Evans, who helped oversee landscaping throughout the park, selected plants that would thrive in Anaheim yet still pass for tropic foliage, including replanting some of the property's walnut trees upside down, so their bare roots became evocative tangles of "vines." Once digging was completed, the

Jungle Cruise waterway was next lined with a thick layer of impermeable clay, since the Disney team discovered during this phase that the existing soil absorbed all the water they had poured into it.

As soon as Disneyland opened—and for years thereafter—the Jungle Cruise attracted some of the longest lines in the park. But as successful as it was, Walt was determined to make the attraction even better, to add anecdotal scenes that layered humor and sharper narrative onto the experience. "Walt liked this idea of kind of doing moving tableaux, which he called them, and since you rode by them, the animation [of the Audio-Animatronics figures] would be relatively simple," recalled Disney Legend Marc Davis, the Imagineer Walt asked to supervise what Walt called a "rehab" of the attraction in 1960. "We had more than you were able to see at any one time, so people would be encouraged to come back and try to catch it on the next time around—this was [Walt's] reasoning."

Davis added the sacred elephant bathing pool and created elaborate Cambodian ruins populated by playful monkeys and a hunting tiger. Davis's humor was magnified by the narration from boat skippers throughout the "trip," which was rewritten from its original, mostly dry descriptions to include some of the jokes and groan-inducing puns guests now associate with the attraction. It's a testament to the enduring popularity of this experience's punch lines that many of them were included in the *Jungle Cruise* (2021) feature film inspired by the attraction.

The Jungle Cruise was early proof that the Imagineers could take an idea—a feeling, an atmosphere—and turn it into a storytelling opportunity, and that they could hone that storytelling over time without discarding an attraction's original inspiration.

Over the years, the process of enhancing or creating new park attractions has settled into a familiar development pattern at Walt Disney Imagineering. As described by the Imagineers themselves yes, "For each ride, show, or attraction, a logical story sequence is created. Almost every aspect of a project is broken down into progressive scene sketches, called storyboard panels, that reflect the beginning, middle, and end of our guests' park experience. The boards are eventually covered with every written thought, idea, and rough sketch we can come up with . . . [and used] to explain the concept to all of the Imagineering departments that will contribute to the evolution of the project."

As a case in point, in the summer of 2021, the Jungle Cruise once again benefited from a series of story-driven enhancements. A bicoastal team of Imagineers based at both the Walt Disney World Resort and Disneyland worked together to develop new characters and deeper backstories to preexisting ones. The revised story focused more on the boat skippers and included new action driven by energetic monkeys. Both teams shared a desire to bring an inclusivity mindset to the updated narrative—all while keeping the classic fun that guests have come to adore—which influenced every detail. "Working with the Walt Disney World team, we developed

Dressing for the Occasion

The stars of the Pirates of the Caribbean theme park attraction are some of the best-dressed pirates anywhere, donning new outfits every four to six months. That's how long it takes for the nonstop movements of an Audio-Animatronics figure to wear out their clothing, despite extra padding being added by the skilled workers in the park's sewing department to strengthen the fabric from being quickly worn through by the mechanics and movements. The time frame differs from figure to figure and from attraction to attraction, but all the Audio-Animatronics figures in every Disney park around the world need their costumes repaired or replaced on a regular cycle—whether it's the black suit of a president of the United States or the pink boa of Teddi Barra in the Country Bear Jamboree. It's enough to keep sewing departments full of costume fabricators busy year-round. Many of their cast members arrive in the park well before dawn, going through the silent attractions before the guests arrive, making sure each figure is perfectly attired for the day to come.

Some characters' costumes, such as those Pirates of the Caribbean, require an additional step after they are sewn: they have to be made to look well-worn to fit the story. "We build [these costumes], and then we pass them to the art department," explains Lupe de Santiago, special projects lead for Audio-Animatronics figures at Disneyland. "Why you do that?" she teases the costume finishers who "age" the clothing. "I put in a lot of time to make it beautiful, and then you destroy it!" Then she laughs and lets them get on with their work; it's another behind-the-scenes step to hone the storytelling within the parks.

The art of Disney costuming for Audio-Animatronics figures reached a fever pitch in the early 1960s when the Imagineers were working on four pavilions for the 1964–1965 New York World's Fair. Only a few primitively stitched hides were needed for the prehistoric people seen in the dinosaur-dominated Magic Skyway, and there was just one man to dress in Great Moments with Mr. Lincoln, but the other two shows had numerous Audio-Animatronics figures. General Electric sponsored Carousel of Progress in its Progressland pavilion at the world's fair. The show featured four scenes, depicting an extended family dressed in the outfits of three historic periods, as well as in the present. The biggest challenge was the last pavilion to be put into production: Imagineers had just nine months to design, build, and ship to New York for the "it's a small world" attraction.

Costume designer, Imagineer, and Disney Legend Alice Estes Davis supervised the team creating the hundreds of outfits for the doll-like children of "it's a small world," researching the costumes of dozens of countries and working with a small army of seamstresses to fabricate hundreds of tiny outfits. Walt Disney's standards were high; as he told Davis, "I want you to design a costume for each one of these dolls that every woman would love to have from the age of one to a hundred." Duplicates of Davis's original patterns are still used today to maintain many of the costumes in the attraction, which is now in several of the Disney parks across the globe.

ABOVE: Disney Legends Mary Blair and Alice Estes Davis, consulting on Davis's costumes for the dolls of "it's a small world."

the props together," said Disneyland-based Imagineer Kim Irvine. "It was a lot of conversation about the gags, so we worked very hard on making sure that we were in sync together with the story that we were telling."

Another example is Mickey's Toontown at Disneyland, which was partly inspired by a backstory created by the Imagineers that said Mickey's Toontown "existed long before Disneyland was built right next door." According to the story, Walt was visiting Mickey Mouse there in 1952, talking about his dream to build a park, and Mickey suggested the plot of land next to Toontown. "Many years went by before it finally dawned on the toons . . . that since it was so easy for them to go next door to visit all their non-toon friends at Disneyland, their non-toon friends could just as easily come visit them."

This narrative helped to provide a guiding vision for the area's designs, right down to the smallest details. After drawing guests into this lively neighborhood for nearly thirty years, in the fall of 2021, Imagineers announced that they would build upon the backstory of Mickey's Toontown and treat it to a grand expansion. Newly anchored by an additional main attraction, Mickey & Minnie's Runaway Railway (a counterpart to the one that first opened at Disney's Hollywood Studios), the reshaped Mickey's Toontown offers more spaces befitting a modern family with young children and a wide range of accessibility needs. The story-driven enhancements included open, grassy spaces for families to take a quiet moment to relax and refreshed nooks offering active and tactile play experiences. The new center of Mickey's Toontown became CenTOONial Park, featuring areas to splash, touch, and listen through interactive sensory elements. A nearby "dreaming tree" area, inspired by the story of a tree that a young Walt Disney would daydream under in his hometown, became a hub for guests to explore a mazelike system of sculpted tree roots and rolling hills.

HOME BY THE SEA

Perhaps the broadest blank canvas to which this story development process was applied was Tokyo DisneySea, the second theme park constructed in partnership with the Oriental Land Company (OLC) in Tokyo. OLC was the Japanese corporation set up to develop commercial and residential properties and the construction of large-scale leisure facilities; the company has a unique licensing agreement with The Walt Disney Company, the creative force behind the project. Tokyo Disneyland was closely modeled on the Magic Kingdom at the Walt Disney World Resort and opened in 1983—the first Disney theme park outside the United States.

Since Tokyo Disneyland proved immensely popular, OLC soon asked Disney to propose ideas for a second park. By the time Disney and OLC began to talk in detail about this new park, a studios park had opened at the Walt Disney World Resort, and the Imagineers suggested a similar park for Tokyo. But OLC wanted something else, something as fantastic and whimsical and diverse as the Magic Kingdom—but completely different. This presented Walt Disney Imagineering with both a challenge and a clean slate on which to sketch a park unlike any other.

The result was Tokyo DisneySea, a park full of Disney characters and stories, reimagined from previous parks. "We had to come up with a menu [of attractions] that was equal weight [to a Magic Kingdom–style park]," recalled Steve Kirk, the senior designer for the project. "They wanted equal quality. They wanted as much intellectual property as they could get, but it was all [to be] fresh. It was all new." The Imagineers compiled a list of Disney stories that could be represented in the new park that had little to no presence at Tokyo Disneyland. Among them were *20,000 Leagues Under the Sea* (1954), *The Little Mermaid* (1989), and *Aladdin* (1992). Then, Kirk said, the question became, "'How do we stitch these different [stories together] with each other?'" The answer the Imagineers came up with was, "'We put them as addresses along a body of water. Seven different lands, seven seas.'"

These were not the Seven Seas of western legends. These were representations of both real bodies of water and pure fantasy. Aladdin and Sindbad would be woven into a land called the Arabian Coast. Expanding on the Jules Verne themes of Discoveryland at Disneyland Paris, the central Mysterious Island would have attractions based on *20,000 Leagues Under the Sea* and *Journey to the Center of the Earth* (two of Verne's novels). *The Little Mermaid* would influence Mermaid Lagoon, an anchor for families with young children, while the mysterious Central American rain forest would inspire the Lost River Delta. The American Waterfront would evoke early-twentieth-century ports of call in the United States and would include a small railway connecting it to Port Discovery. At the park's entrance, in place of a Main Street, U.S.A., or a World Bazaar (as the street was themed at Tokyo Disneyland), would be the Mediterranean Harbor. Imagineers conveyed a romantic vision of northern Italy. The curved façade of Mediterranean Harbor would include both the line of shops and restaurants expected near a Disney park's entrance and, on the upper floors, Tokyo DisneySea Hotel MiraCosta. Mediterranean Harbor's initial draws would be its Venetian Gondolas and a landing for the DisneySea Transit Steamer Line, which circled the park on the interior waterway that connected the seven lands.

The DisneySea name had been adapted from earlier plans considered for a never-built ocean-side theme park in Long Beach,

234

California. Yet everything about Tokyo DisneySea would be new and different. For one thing, the traditional berm—the levee-like rise that surrounded most Disney parks, typically thick with vegetation to block out views of the outside world—would be modified along one side. "As far as berms go, one flank of that whole park looks out as if it is along Tokyo Bay," Kirk said. "We had to choreograph that. That is a major personality character of that park that's unique. DisneySea is on the sea."

Almost everything about Tokyo DisneySea was similarly unique. In place of a central castle was a 189-foot-tall volcano called Mount Prometheus that would periodically rumble and erupt. The point was not to change things for the sake of variety, but to ensure that the guest experience at the new park was equal to that at its older sibling, Tokyo Disneyland.

OLC wanted "a unique park that cannot be experienced anywhere else in the world," and that's what the Imagineers delivered after more than ten years of discussion, collaboration, planning, design, and construction. By 2019, Tokyo DisneySea was the most visited among the six Disney parks not modeled on the Magic Kingdom. The storytelling was almost entirely fresh, which guests embraced from the start. Disney magic, it seems, lays not only in familiar characters and beloved narratives but in Imagineering's artful expression of whatever stories a park has to tell.

ABOVE: A 1997 aerial overview concept piece by Dan Goozee and Will Eyerman depicts an early version of the Tokyo DisneySea layout.

Walt's Favorite Artist

Visionary artist and Disney Legend Mary Blair left the Disney studio twice—and came back to greater acclaim each time. Without her particular flair for color and design, the Disney films *Cinderella*, *Peter Pan*, and many others would look very different, and the classic "it's a small world" attraction might not exist at all.

A lifelong watercolorist who also worked in gouache, pastels, and acrylics, Blair first took a job in 1940 at Walt Disney Productions—where her husband, Lee Blair, was already working as an artist. Assigned to create story and visual development art, Mary was frustrated to be creating art based on others' ideas rather than her own, and she left after a little over a year. But when Walt invited Lee Blair on a planned goodwill tour of Latin America in August 1941, Mary asked to join the Disney entourage. Her passion for vivid colors and simple shapes meshed almost mystically with the look of the people, costumes, towns, and landscapes of Brazil, Argentina, Bolivia, and Peru. As Mindy Johnson wrote in her book *Ink & Paint: The Women of Walt Disney's Animation*, "her South American travels fed Blair's art and transformed her style," and her bold, colorful paintings impressed Walt, who recognized a fellow genius.

After the trip, Blair rejoined the Disney studio as a designer and concept artist, guiding much of the look of the two features inspired by the Latin American adventure, *Saludos Amigos* (1943) and *The Three Caballeros* (1945). She stayed on after World War II, and her vibrantly hued designs shaped the visual schemes of Disney's animated features through 1953. Among her hundreds of concept paintings can be seen the deep blue turrets of the castle

ABOVE (from top): Walt Disney and Disney Legend Mary Blair, in 1966, as Blair presents her visual development artwork for a mural inspired by "it's a small world" being designed for the Jules Stein Eye Institute in California. Blair, reflects on "it's a small world" near a dimensional design model created for Disneyland.

from *Cinderella* (1950), the composition of the Mad Tea Party from *Alice in Wonderland* (1951), the shadowy Skull Rock from *Peter Pan* (1953), and countless other iconic images.

Mary's art was infused with whimsical geometric shapes, and she broke all the accepted rules of what colors should be used together, whether in her art, on film, or in her clothing choices. "Walt said that I knew about colors he had never heard of before," she once said. But her originality was more sophisticated than just juxtaposing pink and orange. As Disney animator, Imagineer, and Disney Legend Marc Davis observed, Blair "brought in a sense of modern art that was very lacking in the films up to [that] time."

Blair left the studio again in 1953 to work on children's books and commercial art. But a decade later, Walt convinced her to return to supervise the design of the "it's a small world" boat journey at the 1964–1965 New York World's Fair. With sets, costumes, and Audio-Animatronics figures of children entirely shaped by Blair's designs, the attraction would become the first of her two final masterpieces for Disney—a view of world unity rendered as if the children themselves had made it using "cotton balls and doilies and pipe cleaners," as Imagineer Kim Irvine observed. Her "childlike vision," noted fellow Imagineer and Disney Legend Tony Baxter, "really became the backbone of why that [attraction] has stayed so unique. There's nothing else in Disney or anywhere in the world that has this styling that was unique to Mary Blair."

"She wasn't always happy with how her artwork got translated to animation," her friend, Imagineer, and Disney Legend Joyce Carlson told Johnson, "but she was happy with the finished product of 'small world.'"

Blair's last contribution to Disney was a ninety-foot-tall mural for the central Grand Canyon Concourse of the Contemporary Resort hotel at the Walt Disney World Resort. The ceramic tile work utilizes Blair's signature brilliant colors and playful figures (including a five-legged goat).

Within Disney, Blair's influential aesthetic has expanded well beyond its original intent. Her concept art for the castle in *Cinderella* became a key design influence for the centerpiece of the Magic Kingdom at Walt Disney World—and her color choices were again influential in the "EARidescent" lighting of the castle to celebrate the park's fiftieth anniversary in 2021. Blair's singular style continues to inspire animation artists across multiple studios, as the stylized look of *The Emperor's New Groove* (2000) and the color palette of Disney and Pixar's *Monsters Inc.* (2001) each pay homage to "Walt's favorite artist," as she is often described.

ABOVE (from top): A 1963 design and color concept piece by Blair for "it's a small world." During the construction phase of Disney's Contemporary Resort at the Walt Disney World Resort, Blair holds one of the tiles of the ninety-foot-tall mural she designed for the hotel's Grand Canyon Concourse.

YOU ARE SURROUNDED

The stories told by Disney theme parks exist on several levels at once. The overall story of Disneyland is turning a harmonic union of "yesterday, tomorrow, and fantasy" into one spectacularly memorable day. Within that story are the park's several lands, each with its own narrative to share: the fairy tales made real in Fantasyland, the possibilities of the future glimpsed from the present in Tomorrowland, American history and folklore coming to life in Frontierland, and so on. Then, within each land, individual attractions tell a series of stories, whether it's a linear tale such as Peter Pan's Flight or Buzz Lightyear Astro Blasters or a tale that is more about spinning a sense of adventure in a specific place, such as Space Mountain or Matterhorn Bobsleds. Each attraction is unified with the land in which it sits and contributes to the park's larger stories.

In looking across the Disneyland Resort, there are also examples of Imagineers building a cohesive storytelling area based on either one, single story—or a series of related stories, as was the case for Disney and Pixar's *Cars* (2006). Cars Land, constructed at Disney California Adventure, was groundbreaking in uniting all décor, shops, restaurants, and attractions through one franchise to showcase a collection of stories and characters from the world of *Cars*.

Every paving stone, drapery, menu item, and light fixture had its origins in the first *Cars* movie. The idea for a "Carland" was hatched by Imagineer and auto aficionado Kevin Rafferty as early as 2004. *"Would it be possible to wrap an entire land around the single theme of the automobile?"* Rafferty remembered asking himself, as he recalled in his memoir, *Magic Journey: My Fantastical Walt Disney Imagineering Career*. And so he set about creating concept art and storyboards for his automotive theme park idea with his creative partner, Robert (Rob't) Coltrin.

Meanwhile, Imagineering had already begun to form some creative partnerships with Pixar Animation Studios, resulting in themed attractions and areas such as the opening of A Bug's Land at Disney California Adventure in 2002. After Rafferty and Coltrin heard the news that Pixar was working on a movie called *Cars*, the duo flew to Pixar's Emeryville, California, headquarters to get a preview from the filmmakers, and the "Carland" concept became Cars Land. Rafferty and Coltrin had the story for its central Radiator Springs Racers sketched out before their flight back landed in Burbank.

When Cars Land opened in 2012, guests had lined up to get in at 8:00 p.m. the night before. Radiator Springs Racers was a hot ticket from the get-go and remains so. *Los Angeles Times* writer Mary McNamara called

Cars Land "the most thoroughly realized land in the whole Disney resort. Walking down the forgotten bit of Route 66 that served as spine and theme of the first film . . . it's easy to forget you're anywhere but here." That observation must have brought joy to the hearts of Rafferty and the other Imagineers, since it expressed the fulfillment of that goal Walt had set for himself before Disneyland had even opened: inside a Disney theme park, guests should feel that they have left the real world and entered fully into a world of imagination. And the Imagineers had more worlds left to build.

Walt always thought of his theme park cinematically, with "dissolves" between lands, and "reveals" as guests entered new spaces—and plenty of movie-based attractions—so the creation of Cars Land seemed a natural extension of Walt's approach. For another cinematic example, the Imagineers looked toward a faraway galaxy. Star Wars: Galaxy's Edge, which opened at Disneyland and Disney's Hollywood Studios in 2019, didn't just re-create the *Star Wars* universe—it expanded it. The story of the planet Batuu and its Black Spire Outpost was told in detail in these sprawling, mazelike theme park lands, complete with a bazaar, alien languages, familiar starships, and uniformed Stormtroopers patrolling the pathways. "One of our core guiding principles since day one was to build a place that felt authentic," said Imagineer Scott Trowbridge, the land's design lead. "Everything from the buildings we build, to the wardrobe that the cast members

ABOVE: Cars Land in Disney California Adventure at the Disneyland Resort immerses visitors in the high desert setting of Radiator Springs from the Disney and Pixar's Cars films.

An illustration of Black Spire Outpost by Erik Tiemens, Lucasfilm concept design supervisor, revealed at D23 Expo in 2017 to generate excitement for Star Wars: Galaxy's Edge

wear, to the merchandise in the stores, to the food in the shops. If you wouldn't see something in a film, you shouldn't see it in this land."

Batuu wasn't just a theme park land: It also entered the *Star Wars* galaxy, becoming the site of events within novels and comic books. Its main attraction, Star Wars: Rise of the Resistance—a twenty-minute experience told in a series of fully immersive scenes set within grand, cathedral-size sets—extended the narrative of the film *Star Wars: The Force Awakens* (2015) and its key characters in thrilling ways. In fact, visitors to Star Wars: Galaxy's Edge were invited to participate in two missions for the Resistance—the other was the attraction Millennium Falcon: Smugglers Run, in which compact teams of six guests piloted Han Solo's iconic ship. Within the attractions, or just on the streets outside, guests could interact with the stories. They could shop for a lightsaber or a droid, confront Stormtroopers, and use their smartphones to translate alien languages.

Interactivity may not have been one of Walt's watchwords, but it was an impulse he would have recognized. He understood that guests wanted not just to be amazed but to have the opportunity to amaze themselves, whether as the junior drivers on Autopia, as sharpshooters in a Frontierland shooting gallery, or explorers on Tom Sawyer Island. In the theme parks and resorts built after Disneyland, the Imagineers gradually increased interactivity, particularly with the many participatory exhibitions at EPCOT and the fully "submersive" water parks Disney's Typhoon Lagoon and Disney's Blizzard Beach. Many attractions, too, became directly interactive, led by Buzz Lightyear's Space Ranger Spin in 1998 in the Magic Kingdom at the Walt Disney World Resort and continuing in related variations at the five other Disney resorts—all of which allowed riders to shoot lasers at targets to score points. Toy Story Mania! at Disney's Hollywood Studios (and its counterpart Toy Story Midway Mania! at Disney California Adventure) followed in 2008. Star Wars: Galaxy's Edge took this interaction even further, as it was an entire land devoted to guest participation in the stories surrounding them.

That was also true of the next multi-park initiative, themed to the Marvel Cinematic Universe. Avengers Campus opened at Disney California Adventure in 2021 and at Walt Disney Studios Park in Paris in 2022, with a third campus on the horizon. Like Cars Land and Star Wars: Galaxy's Edge, each campus immersed guests within a familiar narrative. At Avengers Campus, Super Heroes could be seen on the street or on a rooftop, and guests could join them for their adventures.

A KISS GOOD NIGHT

The attractions at Disney parks may get the most attention, but they define only a portion of the guest experience. A visit is not complete without

taking in a live show or meeting a favorite character. As the Imagineers themselves phrased it, "Live entertainment at Disney Parks and Resorts is never the same thing twice; it's . . . as memorable as the music of the [Main Street] Electrical Parade, as communal as standing in the dark among a crowd with all eyes fixed on fireworks sparking high above a castle, and as unique as being onstage with Ariel." Parades and live performances have been part of the Disney parks experience from the start, and many events have become beloved traditions that endure for decades.

None has quite the endurance and devoted following of the Main Street Electrical Parade, first seen at Disneyland in 1972. Its creators, Disney Legend Bob Jani and Ron Miziker, had been inspired by Jani's creation of the Electrical Water Pageant on Seven Seas Lagoon for the 1971 opening of the Walt Disney World Resort—a pageant that continues to this day. The Main Street Electrical Parade has lit up Disneyland on and off for more than fifty years, including a return engagement beginning in April 2022, while also traveling to the Magic Kingdom, Disneyland Paris, Disney California Adventure, and, in reconfigured versions, to Tokyo Disneyland and even to New York City for the debut of the movie *Hercules* (1997). The concept of a bright, celebratory nighttime cavalcade has also made its way around the world, inspiring SpectroMagic at the Magic Kingdom, Fantillusion at Tokyo Disneyland, and the spectacular Tokyo Disneyland Electrical Parade Dreamlights.

The show *Fantasmic!* has a similar story of humble origins and enduring success propelled by guest enthusiasm. Begun in 1992 as a site-specific show on the Rivers of America at Disneyland, it combined live performers (many of them aboard the Rivers' watercraft), familiar music, lighting and sound effects, and animation clips projected onto fans of water. This new, uniquely told story about Mickey Mouse and the power of the imagination incorporated many other Disney heroes and villains and drew overflow crowds from the start. An expanded staging of the show was soon added to Walt Disney World in a specially designed and built waterside theater at Disney's Hollywood Studios, where it could entertain nearly seven thousand guests at a time, often with two shows a night.

Not all Disney park shows are so elaborate. Whenever he visited Disneyland, Walt liked to visit Frontierland for the Golden Horseshoe Revue, which featured live music, dancing, and comedian Disney Legend Wally Boag. "Walt really enjoyed seeing that show. Some nights he would come down to the park and go to The Golden Horseshoe just to watch the Firehouse Five Plus Two and Clara Ward Singers," recalled Disney Legend Dick Nunis, who started working at Disneyland before the park even opened and eventually became chairman of what was then called Walt Disney Attractions, overseeing all the parks.

Across the decades since, guests have no doubt latched on to their own must-see shows, whether it's a character-filled welcoming program in front of one of the

castles, *Festival of the Lion King* at Disney's Animal Kingdom Theme Park, the Broadway-quality *Beauty and the Beast – Live on Stage* at Disney's Hollywood Studios, or another production. There are so many, and the Disney Parks Live Entertainment team is regularly developing new offerings and updating existing shows, as well as inventing innovative ways for guests to interact with Disney characters.

There may be no better example of how traditions within the park evolve than the nightly fireworks productions. Featuring fireworks timed to a musical soundtrack that was broadcast throughout the park, *Fantasy in the Sky* began at Disneyland shortly after the park opened and ran until 2000. According to Disney Legend Dave Smith, "Tinker Bell began her nightly flights from the top of the Matterhorn and above Sleeping Beauty Castle in 1961 as part of the show." *Believe . . . There's Magic in the Stars* debuted as part of the forty-fifth anniversary of Disneyland in February 2000. It ran seasonally in conjunction with its holiday counterpart *Believe . . . in Holiday Magic* until the summer of 2005, when *Remember . . . Dreams Come True*, notably narrated by Disney Legend Julie Andrews, premiered as a nostalgic tribute to the park's fiftieth anniversary.

Many other nighttime shows have followed at both Disneyland and Disney California Adventure as well as at theme parks across Walt Disney World and, in some form, at each of the international resorts. Not all have included fireworks—many make use of advanced laser and digital projection technologies, water-based effects, drones, and pyrotechnics—but all qualify as "spectaculars."

The addition of projection mapping and other high-tech effects has guaranteed these popular spectacles remain cutting-edge entertainment. Whatever the exact combination of pyrotechnics, projections, music, dancing waters, and other effects magic, every evening show fulfills a unified purpose. According to Disney Legend Richard Sherman, they are what Walt Disney liked to call the "kiss good night" after a magical day in the park.

ABOVE: Fireworks illuminate the skies over Sleeping Beauty Castle at Disneyland in 2019.

Design Made to Stay a While

Some of the best advice Walt Disney ever got came from his friend Welton Becket, the renowned Los Angeles architect. In 1952, when Walt was frustrated that architects could not understand his plans for Disneyland, Becket told him, "No one can design Disneyland for you. You'll have to do it yourself." Walt's decision to do just that represented the birth of Walt Disney Imagineering. But that was just the beginning of Becket's impact on Disney theme parks and resorts. After Walt's passing, Becket's firm worked with the Imagineers (and the United States Steel Corporation) to design the company's first two resort hotels at the Walt Disney World Resort: Disney's Contemporary Resort and Disney's Polynesian Village Resort, both of which opened in October 1971, at the same time as the Magic Kingdom.

With its distinctive A-frame design and interior Monorail station, the Contemporary made quite an impression. In the book *A Portrait of Walt Disney World: 50 Years of The Most Magical Place on Earth*, Imagineer Bhavna Mistry recalled seeing the hotel on *The Wonderful World of Disney* as a child: "When the Monorail went through the building and came out the other end, it was like, 'Whoa, what just happened?'"

This was just the start of resort hotel design for The Walt Disney Company. Each project is another exercise in placemaking, as the resorts relate their own stories, whether recalling the classic California Craftsman era (Disney's Grand Californian Hotel & Spa at Disneyland), the romance of Italy (Tokyo DisneySea Hotel MiraCosta), or a toy's perspective in Andy's room (the Toy Story hotels in Shanghai and Tokyo). Marvel Super Heroes are the core of Disney's Hotel New York – The Art of Marvel, the Paris hotel that's also a kind of living museum, with more than three hundred original artworks inspired by Marvel. The company's portfolio of stunning resort hotels has also grown to include properties not adjacent to theme parks, including Aulani, A Disney Resort & Spa, on the Hawaiian island of Oahu, designed by Imagineers to tell the story of the island state's unique culture.

In addition to hotels designed by the Imagineers, the company has worked with a "Who's Who" of award-winning architects, including Robert A. M. Stern (Disney's Yacht and Beach Club Resorts and Disney's BoardWalk Inn and Villas at Walt Disney World) and Antoine Predock (Disney Hotel Santa Fe, Disneyland Paris). Michael Graves was the original architect of Disney's Hotel New York, as well as the Walt Disney World Swan Hotel and Walt Disney World Dolphin Hotel. A review of the Swan in *Progressive Architecture* magazine seemed to sum up the guest experience in any Disney resort: "lavish and entertaining but in a genre all its own."

Becket did not live to see the Contemporary and Polynesian Village Resort hotels finished, as he passed away in 1969. But his influence remains salted throughout Disney history. The Ford pavilion he created for the 1964–1965 New York World's Fair (containing the Disney-designed Magic Skyway) is long gone, but Disney parks visitors pass by one of Becket's most famous designs every day: the entrances to both Disney's Hollywood Studios and Disney California Adventure, which re-create the look of one of Becket's most beloved creations—the façade of the Pan-Pacific Auditorium in Hollywood.

Walt would have approved.

ABOVE: Disney's Polynesian Village Resort, shown here in 2009, was one of the company's first hotels at the Walt Disney World Resort.

I think there's
Mickey
that makes
And I think
bubble you

an aura around **Mouse** you feel safe. within that are safe.

—Shinique Smith

Visual artist and Mickey Mouse fan

CHAPTER 9

THE WONDER OF DISNEY

If there is one factor that has made Disney the global leader in entertainment, it is the emotional connection that exists between the company's beloved characters and their audience. From the moment Mickey Mouse first appeared onscreen, whistling at the helm of his steamboat, people couldn't get enough of him. Soon movie audiences would groan with disappointment when there was no Mickey short before their feature film, prompting the popular song, "What, No Mickey Mouse?" The public demand for the Disney star reached such a fever pitch that some form of merchandising was inevitable.

Selling products bearing the likeness of Hollywood stars began in earnest in the late 1920s with the advent of movie "fanzines" featuring lavish cover art depicting the most popular actors of the day. However, even though Mickey's fame was growing exponentially—and Walt and Roy O. Disney would soon develop a veritable character-merchandising industry—the idea of attaching his creations to other companies' products did not appeal to Walt at first. Part of his initial reluctance likely stemmed from the bitter experience of losing creative control of his Oswald the Lucky Rabbit character, which had been used by Universal Pictures to sell a children's stencil set in 1928.

But on a trip to New York the following year, Walt was approached in his hotel lobby by a determined printing and lithography company representative who offered him $300 in cash (over $4,000 today) for the right to use Mickey designs on a series of covers for a children's writing tablet. Walt reluctantly agreed to the deal in order to secure the revenue. However, the arrangement underscored the potential of merchandising to create additional revenue and expand brand awareness, so Walt and Roy established a new division, Walt Disney Enterprises, to handle all future licensing.

In January 1930, a talented seamstress and entrepreneur named Charlotte Clark began designing and creating Mickey Mouse plush dolls. For assistance in coming up with drawings that she could use for her design, Clark turned to sixteen-year-old Bob Clampett. Clampett was an aspiring artist who would later become a legendary animator at Warner Bros. He took his sketch pad to the Alexander Theatre in Glendale, California, where Mickey Mouse shorts were being screened; shortly after that Clark and Clampett created a prototype doll. Clampett's father advised the pair to seek Disney's approval, and when Walt and Roy saw the prototype, they were so pleased that they

ABOVE: The first officially licensed Mickey Mouse products in the United States were a series of school tablets with a variety of covers, including this 1930 example.

hired Clark and rented her a house near the studio so she could devote her energies to producing the dolls.

In the beginning, the doll was a novelty item given out to friends, family, and VIP studio visitors. Soon, however, requests for it came pouring in, and by November 1930, Clark and her small team of seamstresses at the "Doll House" were churning out three to four hundred plush Mickeys a week. Clark also made dolls of Minnie Mouse, Pluto, and Donald Duck. (During World War II, there were even a few promotional dolls featuring Gremlins, mythical creature characters being developed by Disney and novelist Roald Dahl for an animated feature that was ultimately abandoned.)

The New York–based George Borgfeldt & Company signed the first United States–based Disney merchandising contract on February 3, 1930, not long after one of Disney's representatives in London had approved a contract with Dean's Rag Book Company to set them up as a licensee in the United Kingdom. George Borgfeldt & Company were granted the exclusive right to manufacture and sell Mickey and Minnie toys and figurines, which they proceeded to do with great success. But when they proved incapable of mass-producing plush Mickeys of the same quality as Charlotte Clark's hand-stitched dolls, Walt and Roy circumvented their exclusivity arrangement with Borgfeldt by selling Clark's doll-making patterns directly to the public through the McCall Pattern Company.

This essentially allowed the fans to do their own manufacturing. A "Child's Fancy Dress Costume" version of the patterns came out in October 1933, and many a young Disney fan went trick-or-treating that year dressed as Mickey or Minnie. Providing the public with the materials and instructions necessary to construct Mickey and Minnie dolls and Halloween costumes brought Disney out of the movie theater and into the home, and the DIY element of the transaction created an even deeper connection to the product.

The mania for Disney character merchandise was by no means limited to Mickey. Images of the rest of the company's cartoon menagerie began appearing on household items that included a very popular, Japanese-made ceramic Three Little Pigs toothbrush holder (examples of which still abound in the collectibles market nine decades later). The range of merchandising included coloring books, jeweled pins, toy projectors, windup trains, cereal boxes, and

ABOVE: Walt Disney poses with a shipment of early Mickey Mouse dolls from Charlotte Clark (plus a grinning Mickey doll by Dean's Rag Book Company) outside the Disney studio offices on Hyperon Avenue in Los Angeles.

many other household items. The appeal of Disney stars was such that they could help to sell virtually any product that could accommodate a character image. And as proof that Disney characters were both an international sensation and popular with all age groups, licenses were soon granted to companies in Switzerland and England for the production of items like Mickey and Minnie handkerchiefs and toffee. This proliferation of merchandise built on itself by keeping Disney's stable of characters highly visible, passively promoting the brand and further driving demand.

ABOVE (counterclockwise from top): Among the merchandising artifacts in the Walt Disney Archives collection are McCall patterns for Mickey Mouse and Minnie Mouse dolls, various versions of the popular Mickey doll, and a *Three Little Pigs* (1933) toothbrush holder.

VICTORY THROUGH STAR POWER

World War II temporarily slowed down Disney brand expansion both at home and abroad; international markets were cut off and Americans began tightening their belts and focusing their energies on the defense effort. But even though the company became a virtual assembly line of military training film production during the war, Disney's famous characters were not idle. In response to the national emergency, the U.S. Department of the Treasury called on Donald Duck to help them convince Americans to pay their income taxes on time, leading to an animated short titled *The New Spirit* (1942). Donald's clout with the taxpaying public proved to be a difference maker, as millions of moviegoers who saw the film responded by meeting the deadline. He was also used as a goodwill ambassador in the South American features *Saludos Amigos* and *The Three Caballeros*, demonstrating the universality of the strong emotional connection between Disney characters and their global audience.

Perhaps the best example from the period of the special bond between Disney's star performers and their fans was the Disney-designed military insignia. The vast majority of the young men and women who were fighting the war had grown up being entertained by Disney animation, wearing Mickey Mouse watches and playing with Disney-themed toys, and a number of them wrote the company to request military or auxiliary unit insignia designs that incorporated their favorite Disney character. It was a morale builder because it reminded them of home, and it gave them a sense of unit pride to have an insignia designed by the talented artists at The Walt Disney Studios.

As the letters began pouring in from American, British, Australian, and other Allied units and individuals, Walt set up a special department devoted to honoring the requests free of charge. He assigned publicity art department head Hank Porter to oversee the insignia team, which included future *Mickey*

ABOVE: Walt Disney and Disney studio publicity artist Hank Porter, whom he referred to as a "one man art department," looking over Porter's latest military insignia design during World War II.

Mouse Club regular and designer of the iconic Mouseketeer ear cap Roy Williams. Not surprisingly, the most requested character was Donald Duck, whose famous irascibility translated easily into postures of martial defiance. Even though they were constantly swamped with requests, the artists never rushed the designs, carefully imbuing each insignia with Disney's trademark draftsmanship, wit, and charm. A full-color gouache version of the final image would be sent to the requesting unit for display at their respective headquarters and to use as a template for reproducing the image on aircraft, vehicles, buildings, and uniforms.

Military censorship prohibited the display of an insignia that showed any specific unit information, so Porter and his colleagues came up with the idea of denoting unit numbers by adding groups of stars and other objects to the image. For example, three groupings of four, seven, and five stars respectively stood for the number "475." Some of the insignia images became famous, such as the female gremlin character Fifinella that appeared on the leather flying jackets of members of the pioneering group of women pilots who ferried military aircraft between the United States and combat theaters around the globe.

By the end of the war, more than 1,200 of the unique Disney masterpieces had been produced, and the astonishing variety of the specialized units they represented testified to the conflict's enormous scope. There were also many unauthorized Disney-themed unit insignias created by well-meaning soldiers, sailors, and flyers with varying degrees of artistic skill, but the net effect was the same: giving homesick young adults a much-needed reminder of the world they left behind and of the better days to come.

Disney's brand grew exponentially in the 1950s with the arrival of the *Disneyland* television show and theme park. The studio's merchandising increased accordingly in scale, variety, and sophistication.

And that expansion has continued ever since. Today, it is no longer just a matter of reproducing the image of Disney characters— it is also about creating products that allow consumers to infuse their wardrobes and living spaces with the studio's beloved iconography, integrating their lifestyles with the personalities of the characters they love. Mickey waffle irons, teapots, measuring cups, and spatulas brighten the functionality of the kitchen with the whimsicality of Disney and satisfy the devoted fans' desire to surround themselves with Disney. No other entertainment entity comes close to inspiring that level of brand appreciation and loyalty.

ABOVE: Donald Duck, featured here in his "starburst" cel and background that introduced his wartime-era animated shorts, was the most requested character for military insignia artwork requests during World War II.

CHANGING WITH THE TIMES

Maintaining a connection with audiences has been the Disney mantra all along, and just as the studio had pivoted in the 1940s to accommodate the needs of a wartime economy and audience while staying on brand, the company was able to successfully adapt to the rapidly changing entertainment tastes of the postwar era without altering its core sensibilities. When teen movies became all the rage in the early 1960s, Walt began producing films that would attract the same youthful consumers that were flocking to see the beach-themed films from movie studios that often starred former Mouseketeer and Disney Legend Annette Funicello. The Disney version of a teen movie relied on star charisma paired with family-friendly situational humor and drama that teenagers could identify with. Beginning with *Pollyanna* (1960) and followed by the box office smash *The Parent Trap* (1961), Walt made a total of six films starring a teenage newcomer, Disney Legend Hayley Mills, daughter of stage and screen great John Mills. And when he cast fifteen-year-old Disney Legend Kurt Russell alongside Disney Legend Fred MacMurray in *Follow Me, Boys!* (1966), Walt decided he'd found his charismatic teen lead and signed him to an exclusive studio contract. Russell went on to star in numerous memorable Disney projects in the 1960s and early 1970s, becoming the youthful face of Disney live-action films before successfully transitioning to more mature roles. "The Disney years were my education in the film business," Russell later recalled. "I was fortunate to be able to work there consistently." And the studio was fortunate that Walt saw the young actor's potential, as audiences lined up to see him, especially as handsome brainiac Dexter Reilly in *The Computer Wore Tennis Shoes* (1969) and its two sequels, *Now You See Him, Now You Don't* (1972) and *The Strongest Man in the World* (1975).

ABOVE: Disney solidified stardom for a young Hayley Mills by casting her opposite herself in the box office smash *The Parent Trap* (1961).

CORNERING THE ART MARKET

Because the animation process for each short cartoon generated thousands of cels (and over a hundred thousand for features), a lot of beautiful, early hand-painted imagery was either discarded or washed off in order to recycle the celluloid when production wrapped. The idea of repurposing these cels as stand-alone paintings and pieces of art first occurred to a San Francisco gallery owner named Guthrie Courvoisier, who was so impressed with the exquisite artistry of *Snow White and the Seven Dwarfs* that he was convinced the cels could be marketed to serious art collectors.

Courvoisier first contacted Disney merchandiser Kay Kamen, who loved the idea and began preparations to sell them through department stores. However, Courvoisier felt this approach would bring down their value as collectible art. He sent a letter to Walt, Roy, and Kamen explaining his position: "Through my own business," he wrote, "I have come to know many museum directors, most of the important art dealers of America[,] and a great host of collectors and people interested in art. They have . . . often expressed a great respect for Mr. Disney as an artist of profound ability in the same sense as a great painter or composer."

He pointed out that the cels were more than just novelty items and deserved a sales platform worthy of their lasting artistic value: "They are, after all, not ordinary prints but original paintings from the hands of the Disney artists themselves, and as such open up a whole new field for their sale." Walt and Roy concurred, and in July of 1938 they signed a contract with Courvoisier Galleries to be the sole representative for marketing Disney original art. Courvoisier publicized his agreement with Disney, causing a sensation in the art world. Soon galleries and museums around the country were exhibiting and selling the pieces. One review of an exhibition exclaimed, "Down came the Rembrandts, the Dürers, and the works of other old masters. And up went the picture of Grumpy being doused in the watering trough."

By 1939 the sales figures of the cels from *Snow White* were so impressive that it was decided to market other Disney art to the public, such as background paintings, story sketches and animation drawings, and not just from *Snow White* but also from Silly Symphony productions such as *The Ugly Duckling*. At first, a team of twenty Disney artists worked to prepare the cels for sale by creating new airbrushed or stenciled backgrounds because the original painted backgrounds were so few and far between compared with the thousands of cels used in each cartoon. But after the release of *Pinocchio* in 1940, Roy decided the cost of this preparation work was too high and thereafter Courvoisier took over the task, hiring local art students to help.

With the coming of World War II, Courvoisier closed his gallery to work for the

government, though he continued to sell his inventory until 1946, after which Disney took over the marketing of their art through periodic releases. In 1955, Walt opened the Art Corner in Tomorrowland at Disneyland, where the cels and drawings were sold until 1966. A vigorous collector's market for the cels developed thereafter and continues to this day. Both Courvoisier and the Art Corner shop sold the images at bargain prices that made it possible for almost anyone to own an original Disney work of art and a genuine piece of animation history. For many fans, this was the ultimate in connecting with Disney characters, stories, and magical moments.

Today, those modestly priced pieces of art fetch thousands of dollars each in the collectibles market.

JOINING THE JAMBOREE

While Disney merchandising and artwork had extended the brand by giving Mickey and the gang a presence outside the movie house, the premiere of the *Disneyland* television anthology series in 1954 brought Disney entertainment itself into the living rooms of millions of postwar families eager for

ABOVE: Cels featuring characters from *Snow White and the Seven Dwarfs* (1937) created specifically for sale in the collector's market.

programming suitable for all ages, which was then practically nonexistent. Baby boomers, their parents, and their grandparents were thrilled to have the entertainment that Disney provided, and watching the show quickly became a weekly family tradition across America—definitely the first and probably the most popular example of appointment television in the history of the medium.

Walt himself introduced each episode, and his warm, avuncular smile, resonant voice, and reassuringly familiar presence soon had audiences affectionately referring to him as "Uncle Walt." Disney fans felt very much like they were welcoming him into their homes once a week, and in return they were treated to a variety of engaging programming that included classic cartoon shorts, nature documentaries, and original dramatic content.

After nearly four years, the series's title changed from *Disneyland* to *Walt Disney Presents*. And in 1961, Walt switched networks to take advantage of the ability to broadcast in color—a relatively new phenomenon that lent itself perfectly to Disney content, which was all filmed in Technicolor. The new incarnation of the show was called *Walt Disney's Wonderful World of Color*. Then once color television had become the standard in the 1960s, it was re-titled *The Wonderful World of Disney*, followed by *Disney's Wonderful World*, *The Disney Sunday Movie*, *Walt Disney*, *The Magical World of Disney*, back to *The Wonderful World of Disney*, and finally, *The Wonderful World of Disney: Presented by Disney+*.

Perhaps the best remembered original Disney television programming was the *Mickey Mouse Club*, which premiered on October 3, 1955. Some of the parents watching the show with their kids had themselves been members of an earlier Mickey Mouse Club that was pioneered in 1929 by the Fox Dome Theater in Ocean Park, California. It was an actual club, complete with membership rolls and credos, and the concept quickly spread to movie theaters across America and the United Kingdom. The clubs would hold regular meetings every Saturday, at which Mickey cartoons were shown and Mickey-themed bands would play, and by 1932, more than one million Mickey enthusiasts had joined. Although the clubs were largely phased out by the mid-1930s, Walt no doubt recalled their viral popularity when he gave his kid-centric television show the same name nearly a quarter century later.

Beginning in 1955, *Mickey Mouse Club* originally broadcast as an hour-long variety television show every weekday afternoon, giving kids something to look forward to after school each day and establishing a steady Disney entertainment presence in the American household. With a large cast of talented kids called Mouseketeers, the show featured musical numbers, skits, guest stars, serials, newsreel segments—and of course, lots and lots of Disney cartoons. Walt was always eager to repurpose previous work, and the show provided an ideal platform for this while introducing a new generation to classic Disney shorts that hadn't been shown in years.

The original Mouseketeers cast included the likes of future Disney Legend Annette Funicello, Cubby O'Brien, Bobby Burgess, Lonnie Burr, Tommy Cole, Sharon Baird, and Karen Pendleton, although to their adoring fans watching from home, they were friends and fellow Mickey Mouse fans who were known familiarly by their first names. A total of thirty-nine Mouseketeers appeared on the show during its initial four-year run. There were also three adult co-hosts: actor and singer-songwriter Jimmie Dodd, who sang and strummed his Mousegetar and penned the show's unforgettable theme song, "The Mickey Mouse Club March"; Bob Amsberry, who wrote skits and played Bob-O, the clown; and the aforementioned Disney Legend Roy Williams, known as "Big Mooseketeer," who designed the Mickey Mouse ear hats that everyone in the cast would wear; he was also the studio's preeminent spot-gag man.

The show had a separate theme for each day of the week. Monday was "Fun with Music Day," Tuesday was "Guest Star Day," Wednesday was "Anything Can Happen Day," Thursday was "Circus Day," and Friday was "Talent Roundup Day." The most popular serials produced for the show included *The Adventures of Spin and Marty, The Hardy Boys, The Secret of Mystery Lake*, and *Annette*. The show also involved young people around the world who served as "reporters," sharing stories of life in their home countries. With so much kid-friendly programming running all week long, it's no wonder the show became part of the fabric of home life for millions of youngsters and their approving parents. By the end of its four-year run, *Mickey Mouse Club* had aired 260 one-hour and 130 half-hour episodes and added the show's catchy marching song theme, with its unforgettable "M-I-C-K-E-Y M-O-U-S-E" refrain, to the cultural soundtrack of twentieth-century America. It also made famous the now-iconic Mickey Mouse ear caps, which have since sat atop the heads of many of happy Disney theme park guests.

ABOVE AND OPPOSITE: Cast members from the four versions of the *Mickey Mouse Club* across the years.

When the original show began running in syndication in 1962, its renewed popularity inspired the creation of a "new" *Mickey Mouse Club*, which ran for two seasons from 1977 to 1978, and starred twelve new Mouseketeers, as well as being introduced by former *Club* members Annette Funicello and Tim Considine. Then in 1983, The Disney Channel premiered on cable television and began showing the first series, which once again proved so popular that it eventually spurred the creation yet another "all-new" *Mickey Mouse Club* in 1989. Updated and aimed at a young teen audience and replacing the classic Mickey ears hats with cool letterman jackets, this take on the *Mickey Mouse Club* was a hipper, more musically oriented incarnation of the show. And over the course of its six seasons, it became a talent platform that launched the entertainment careers of an impressive number of future superstars, including Britney Spears, Justin Timberlake, Ryan Gosling, Keri Russell, and Disney Legend Christina Aguilera.

After another lengthy hiatus, the most recent incarnation of the program debuted on September 8, 2017. *Club Mickey Mouse*, a completely overhauled, social media–era version of the variety program, was shown exclusively on Facebook and Instagram and followed the musical, choreographic, and social doings of eight Gen Z Mouseketeers, and because it was social media–driven, *Club Mickey Mouse* is available around the clock. Like the original *Mickey Mouse Club* and every version in between, the latest iteration was fueled by the energy of its talented young performers, though it also reflected the changes occasioned by the social evolution of youth culture in the nearly seven decades that have passed since the show premiered in 1955. It was both Disney's timelessness and the company's willingness and ability to adapt that had allowed it to remain relevant, continuing to create lasting emotional connections with its customers and maintaining its position as the world's foremost entertainment organization.

BE KIND AND REWIND

In the 1970s, the introduction of videocassette recorders, or VCRs, revolutionized home entertainment by allowing consumers to record and play back content on their own schedule, as well as to buy or rent content recorded professionally on VHS (Video Home System) tapes. At first, the television industry was concerned that the newly affordable and cutting-edge technology would adversely affect ratings, just as Hollywood had originally feared the advent of television would lead to the demise of the movie theater. But once the industry adapted, the VHS revolution became a new and highly profitable source of revenue for both the film studios and the television networks, and as usual, Disney was among the first to successfully embrace the change.

After some early experimentation with third-party laser disc rentals, the company established Walt Disney Home Video in 1980 to capitalize on the new and rapidly expanding market. A series of post-golden-age Disney features were made available for rental and sale that year, including *The Love Bug* (1969), *Escape to Witch Mountain* (1975), *The Apple Dumpling Gang* (1975), and *The Black Hole* (1979). The first classic Disney animated features to be released on videocassette were *Dumbo* (1941) in June of 1981 and *Alice in Wonderland* (1951) that October. Both were rental only, but the desire of Disney fans to buy their own copies of the films soon prevailed, and both features were made available for sale the following year.

By the middle of the decade, Disney was selling videocassettes of their most popular classics on a regular basis, staggering the release dates to keep demand focused on one film at a time. In 1985, it was *Pinocchio* (1940). 1986 was *Sleeping Beauty* (1959), and so on. The company also limited the sale window to a few months, after which the title would be "vaulted" for the next five to seven years. (This practice actually originated with Walt in 1944 when *Snow White and the Seven Dwarfs* was re-released theatrically seven years after its premiere, and then again in 1952, 1958, 1967, 1975, 1983, 1987, and 1993.) The moratorium on sales was implemented to ensure that the films would remain fresh for later generations of young fans—a key strategy in how the company managed the market for its remarkable back catalog.

If subsequent sales are any indication, Disney's vaulting practice was a brilliant success; when *Snow White* was first made available on home video in 1994, it proved to be as popular as ever, and a year later it had sold a staggering twenty-four million units. And with the advent of DVD technology, *Snow White* was digitally restored and released as a two-disc set with commentaries and other extra features in October of 2001. The set sold a record-breaking million copies in twenty-four hours, proving that the charm and wonder of the first Disney animated feature will never fade. It also demonstrated that instead of revealing the limitations of early animated film technology, the more

advanced the media used to present *Snow White*, the better it looks and the better able we are to appreciate just how far ahead of its time it was in 1937.

Because DVDs contained more space for content and were less bulky than videocassettes, they enabled Disney to *un*-vault and make available to fans for the first time a vast trove of rarely seen features, shorts, documentaries, and television shows that spanned the history of the company's first half century through a special collectors' series called *Walt Disney Treasures*. Each multidisc set was introduced and given historical context by renowned film critic and Disney enthusiast Leonard Maltin. The material ranged from the earliest days of the Alice Comedies and Oswald the Lucky Rabbit shorts, to the complete appearances of Mickey Mouse, Minnie Mouse, Donald Duck, Goofy, and Pluto. Other sets focused on Disney films created for the government during World War II; episodes of *Disneyland*, *Walt Disney's Wonderful World of Color*, and the *Mickey Mouse Club* series; and behind-the-scenes footage of The Walt Disney Studios and the Disneyland theme park. It was a way for older fans to reconnect with the Disney they grew up experiencing. Younger fans could explore the rich history of the iconic characters they love and discover the pioneering entertainment practices that have made the unique Disney emotional connection possible.

Nearly the complete library of classic and current feature films is now available through Disney+, the company's premium streaming service. Disney+ has also attracted millions of new fans to the *Star Wars* franchise through *The Mandalorian*, *The Book of Boba Fett*, *Obi-Wan Kenobi*, *Andor,* and *Willow*. However, Disney also continues to sell DVD and Blu-Ray discs of its content as well in order to allow everyone to continue tapping into the Disney entertainment universe, wherever they may be.

DIVING DEEPER INTO THE STORIES

With the demise of the video game arcade and the rise of various home gaming consoles throughout the decades, an opportunity arose to use Disney characters in an entirely new entertainment format. In 2010, the company

ABOVE (from left): Both the 1994 Walt Disney's Masterpiece VHS and the 2022 85th Anniversary Edition Blu-Ray, DVD, and Digital Code home entertainment releases of *Snow White and the Seven Dwarfs* are part of the Walt Disney Archives collection.

introduced *Disney Epic Mickey*, a platform game developed for the Wii by Junction Point Studios and game designer Warren Spector. The new format allowed the design team to let their Disney imaginations run wild, and the result was a surreal game in which Mickey accidentally damages a world created by the *Fantasia* sorcerer Yen Sid for discarded Disney characters and concepts. Mickey must save the damaged world, Wasteland, which is inhabited by such notable Disney castoffs as Horace Horsecollar, Clarabelle Cow, Gremlin Gus, and Oswald the Lucky Rabbit, who is torn between good and evil. There is also a "Shadow Blot" creature that is based on Mickey's famed archenemy, "The Phantom Blot," from a Disney comic strip drawn by artist Floyd Gottfredson.

The game was designed to appeal to teens, with a darker, retro Mickey who retains the character's lost mischievous streak from the early 1930s. The edginess of the game's plotting and characterization shows the company's willingness to reconfigure and recast its entertainment product as the audience and times require while remaining faithful to the long-established story and character parameters of the Disney universe.

Game development is not the only area within the company to play with expanding character portrayals. The resounding success of Disney's Broadway musical adaptations is due to their ability to delve deeper into storytelling and character development from the original animated feature films they are based on. While participating in the unique live theatrical experience, audiences learn more about the beloved characters and their backstories. But long before Disney became a stage sensation, there was *Walt Disney's World on Ice*, which premiered in July 1981. In the late 1990s, it evolved into what is now know as *Disney on Ice*, with multiple shows touring worldwide. Each show includes selections from popular Disney films. For the children and kids at heart who are emotionally connected with these stories and characters, the touring shows are yet another way of experiencing the wonder of Disney with the whole family.

Every aspect of the Disney entertainment experience is calculated to enhance the connectivity between its product and the guest or audience member. A perfect example of this intentionality is the way Disney Cruise Line services designs the interior spaces of its ships. A certain percentage of the cabins on board any ship do not face the ocean and thus have no porthole through which to view the outside. Cruise lines have traditionally accepted these limitations, but not Disney. Walt Disney Imagineering was tasked with finding a solution to the problem, and as usual, they outdid themselves. They came up with a porthole-shaped video screen that is connected to a high-definition camera mounted on deck and pointed in the same direction as the cabin porthole, so that it provides a true image of the ocean or port of call as they would appear if the porthole were real.

But as ingenious and thoughtful as

that innovation is, Imagineering went a step further and added randomly timed appearances of animated characters on the video screen. It resulted in recognizable faces from Walt Disney Animation Studios, such as Rapunzel from *Tangled* (2010), or from Pixar Animation Studio, such as Peach from *Finding Nemo* (2003), popping up unexpectedly, surprising and delighting the kids and strengthening their sense of connectivity with the respective stories. It is one of the thousands of little details that make lifelong fans out of casual consumers once they experience it and about which one can say unhesitatingly that Walt would be very proud.

Another fan-based phenomenon that is unique to Disney is pin trading. Buttons and pins showing Disney characters had been around since the 1930s. But trading them as a hobby largely began in 1999 during the Millennium Celebration at the Walt Disney World Resort. It quickly spread to the Disneyland Resort and since then has become a hugely popular fixture at every Disney theme park and retail outlet. Beginning in the 2000s, cast members wore lanyards that displayed a variety of the enamel pins that guests could trade for, and regular pin trading events would take place in the parks, attracting collectors from far and wide. The pins are of all sizes and shapes; some have three-dimensional elements, some feature moving parts—one set even contains frames of 35mm film taken directly from original prints of Disney films. They range in value from under $10 to several thousand for special limited-edition issues, but the basic appeal is the same: beloved Disney characters, colorfully presented in an infinite number of poses and styles, and in a format that is both decorative and collectible. And

ABOVE: Disney Legend Marty Sklar's distinctive hat, here in his home office, back in 2013, features various pins representing Disney parks, resorts, and attractions visited across the years.

the activity of trading the pins creates the sense of belonging to a worldwide community of fans for whom Disney characters are a pleasantly familiar source of entertainment and cultural continuity.

Over the years, enough Disney fans became regular visitors to the theme parks and resorts that this consistent return business inspired the creation of the Disney Vacation Club (DVC). The program allows members to purchase flexible ownership in Disney accommodations located around the world using an annual points system. Points can be applied to traditional Disney theme park hotels and resorts, Disney Cruise Line ship voyages, Adventures by Disney vacations, and even other accommodations unrelated to Disney. It allows guests the flexibility and affordability to travel every year and to explore different locations each time.

The options include spacious villas with all the comforts of home, as well as cabins, villas, and studios located in far-flung destinations. The original DVC property, today known as Disney's Old Key West Resort, welcomed its first guests in 1991 as the Vacation Club Resort. Today's array of properties range from Aulani, A Disney Resort & Spa, in Hawai'i to Disney's Vero Beach Resort along Florida's Atlantic Ocean coast to Disney's Hilton Head Island Resort in South Carolina. DVC-specific sections have even been incorporated into popular Disney resorts, such as Disney's Animal Kingdom Villas—Kidani Village at Walt Disney World and Disney's Grand Californian Hotel & Spa at the Disneyland Resort. The array of options allows fans to plan ahead and further merge the wonder of Disney entertainment into their lives on a regular basis.

ABOVE: Charming details from around Disney's Old Key West Resort at the Walt Disney World Resort, shown here from 2008 to 2009, include the property's peaceful marina and canals, as well as its whimsical main pool area amenities.

Kay Kamen and the Invention of Merchandising

In 1932, an inflection point in the growth of Disney merchandising occurred when Walt received a call from a Kansas City salesman named Herman "Kay" Kamen, who offered up an irresistible sales pitch: he wanted to put a Disney character in every American household. Kamen met with Walt and Roy at the studio shortly thereafter and impressed them enough to negotiate a marketing contract with a fifty-fifty profit split, which turned out to be a bargain for Disney given Kamen's boundless energy and peerless salesmanship. Soon Mickey Mouse and Minnie Mouse began appearing in department stores across the country on products ranging from toys and books to clothing and accessories. Kamen started a promotional publication called *Mickey Mouse Magazine* and later produced catalogs of Disney merchandise to facilitate licensing deals.

Notably emerging from this era on the merchandise end was the popular Mickey Mouse watch. In 1933, Kamen signed a deal with struggling Ingersoll-Waterbury, a watch manufacturing company. Their now-iconic product would make its debut in May at the 1933 Chicago World's Fair. Later that fall, eleven thousand excited fans bought the brand-new Mickey Mouse watch on the first day it became available at Macy's in New York. Nothing before or since has embodied the emotional bond between Disney and its fans better than the original Mickey Mouse watch. More than five million would be sold over the next fifteen years, bringing the magic of Mickey into the daily lives of Disney fans everywhere.

Kamen's efforts provided Disney with a revenue stream that helped finance *Snow White and the Seven Dwarfs*. In addition, he also contributed to the film's resounding box office success by implementing an ambitious marketing campaign that flooded the market with *Snow White* merchandise. It was truly a mutually beneficial partnership—Disney created a product that was easy to sell, and Kamen sold it relentlessly. "Kay Kamen invented the whole licensing industry," according to Tom Tumbusch, author and Disney merchandise historian. He helped turn Mickey and his fellow Disney characters into megastars by bringing them to life outside the movie theater and inside the American home, just as he had originally envisioned.

By the time of his untimely passing in 1949, Kay Kamen's efforts had generated over $100 million in Disney merchandising revenue and had created a branding and sales infrastructure on which the company continues to build more than seventy-five years later.

ABOVE: Kay Kamen with Walt Disney at the Disney studio on Hyperion Avenue in 1932.

I am constantly by the creativity as the passion of our . . . cast employees

awed and inspired and talent, as well and dedication members and around the world.

—Bob Iger

Chief Executive Officer, The Walt Disney Company

CHAPTER 10

WE ARE JUST GETTING STARTED

Walt Disney couldn't wait for the tenth anniversary celebration for Disneyland to get started. The party was set to begin the moment the calendar turned over to 1965—though the actual birthday wasn't until six months later. But on the first Sunday of the year, January 3, Walt's anthology television series, then called *Walt Disney's Wonderful World of Color*, aired "The Disneyland Tenth Anniversary Show" to kick things off. The show did not begin with a retrospective, however. Walt made it clear from the start that he was more interested in looking forward than looking back.

After telling his on-camera guest, Julie Reihm, the first Disneyland Ambassador and a park tour guide, that it was the tenth anniversary of Disneyland, his first question to her was, "What do you tell people about our future plans?" There followed for about the next fifteen minutes an all-star tour of a Walt Disney Imagineering set created for the show, and details on numerous ongoing projects for the theme park's upcoming attractions. Reihm first met artist and Imagineer Mary Blair, who talked briefly about the new façade planned for the 1966 opening of "it's a small world" (which had debuted at the 1964–1965 New York World's Fair). Blair was followed by John Hench, who talked about the Plaza Inn restaurant (due to start up

ABOVE (from top): Walt Disney in *The Disneyland Tenth Anniversary Show* (1965), as well as Disney Legends Mary Blair and Julie Reihm Casaletto with Walt later in the television show.

that July). Marc Davis and Rolly Crump were next; they presented ideas for the Haunted Mansion (three and a half years in the future) and the Museum of the Weird (which never materialized). Finally, Blaine Gibson and Claude Coats showed Walt and Julie artwork and models for Pirates of the Caribbean (two years down the road).

Yes, the remaining forty-five minutes of the TV show featured an anniversary parade and a brief history of the groundbreaking park, but the focus on the future came first.

About six months after the show aired on NBC, Walt and Roy O. Disney invited theme park and Imagineering cast members to an anniversary celebration at the Disneyland Hotel honoring those who had been with Disneyland since Opening Day (or earlier). "I've always said, in my end of the work, that it takes people to run a business," Roy told the crowd. Walt's message echoed the opening of his earlier *Wonderful World of Color* episode. The first ten years of Disneyland, Walt said, had been "a sort of dress rehearsal and that we're just getting started. So if any of you start resting on your laurels, I mean just forget it . . ."

Fifty-eight years later, The Walt Disney Company is still "just getting started," and, just as Walt did, shares with its fans the wonders to come. Imagineers still share informative, entertaining previews on park attractions through a wide range of media and social outlets. For example, Disney fans learned about the making of Guardians of the Galaxy: Cosmic Rewind at EPCOT from project controls estimator Ashley Levine on Instagram and from senior creative director Alex Wright on the Walt Disney Imagineering YouTube channel. Fans learned about upcoming projects from Disney, Pixar, Marvel, Lucasfilm, and 20th Century during panels held in front of thousands of guests at D23 Expo 2022 in Anaheim, California. Fans not able to attend the event in person could watch the livestream featuring many of the presentations and specially curated content, or read about everything showcased at D23 Expo on D23.com, fan blogs, and social media and through mainstream print, online, and television coverage. In a time when it's no longer possible to gather most of the country during a set hour every Sunday night to watch a television show together, Disney tells its stories wherever people gather, in person or virtually. And it still puts the future first.

ABOVE: Alan Bergman, chairman, Disney Studios Content, shows a brand-new film title card introduction for The Walt Disney Studios in honor of Disney 100 Years of Wonder at D23 Expo 2022 in Anaheim, California. Photograph by Craig Sjodin.

Of course, those gathering places still include living rooms. The launch of Disney+ on November 12, 2019, encouraged families to come together—particularly during the months and years of pandemic isolation that soon followed—to enjoy Disney stories old and new. With many subscribers now comfortable enjoying their media on laptops, tablet computers, and smartphones, the cross-platform accessibility of Disney+ also catered to new viewing habits. And in keeping with Walt Disney's twin focus on both nostalgia and innovation, the service has created a new story-sharing paradigm. As Bob Iger, Chief Executive Officer, The Walt Disney Company, put it back in 2019, "With the launch of Disney+, we're making a huge statement about the future of media and entertainment and our continued ability to thrive in this new era."

Placing legacy stories up alongside fresh storytelling, in both film and serial forms, is the foundational appeal of Disney+. Viewers who signed up to see Grogu, the Child on *The Mandalorian*, may then discover all the Skywalker Saga feature films they missed. Those who just wanted to rewatch all their favorite classic Disney animated movies may fall in love with the wit and colorful visuals of new series such as *Amphibia* and Disney and Pixar's *Monsters at Work*.

As has been the case across its first hundred years, the success of Disney requires attention both to legacy storytelling and to fresh narratives shared in creative ways, utilizing the latest innovations. Disney+ will always provide a means for viewers to select their own film or show whenever and wherever they want to watch it. Disney+ cuts out the middleman, or in this case, the middle-media, and empowers the viewers themselves. The evolution of this technology could also allow for other storytelling areas, such as interactive experiences. In support of new approaches in that vein, in early 2022, Disney named longtime interactive guru Mike White as its first senior vice president for the Next Generation Storytelling and Consumer Experiences division. "Next Generation Storytelling is a framework . . . for how Disney is thinking about the opportunity to create and explore new storytelling paradigms at a time when physical, digital, and virtual environments are connected," he explained.

It extends well beyond virtual reality to encompass what is often called the "metaverse." White said, "What is really going on is that connected platforms are becoming central to people's lives and the internet is evolving to a point where your 'real' self and your 'digital' self have greater continuity . . . as you move more seamlessly between physical, digital, and virtual worlds."

As always, "This is about our audience," White emphasized. "It is about how people live and experience life when digital, physical, and virtual worlds are more blended. . . . At our core, Disney is about the story. We have been using technology to reinvent storytelling for almost one hundred years." White's examples of industry-shaping advances included quite a range: Walt Disney's multiplane camera; Imagineering's Audio-Animatronics figures; Industrial

Light & Magic's groundbreaking filmmaking innovations; the creation of the first feature-length CG film, Toy Story (1995), accomplished by Pixar Animation Studios; the simple but game-changing use of augmented reality for ESPN's 1st & Ten digital on-field marker line; MagicBand and Disney Genie systems developed for the Disney theme parks; and the multi-decade, multimedia storytelling of the Marvel Cinematic Universe. "That's just a few," he said.

"This use of technology is in our DNA," White concluded. "It is our legacy, and it will be our future."

FANS TAKE CHARGE

Time will fill in the specifics of Next Generation Storytelling, but it reflects a concrete reality: modern audiences respond enthusiastically to opportunities to interact with their favorite stories and characters—even when they don't yet have the words to describe the experience. To cite one example, just as Disneyland arrived in a world that had never heard of a "theme park," there was no precedent for the immersive Star Wars: Galactic Starcruiser—which led the media to struggle with what to call it. The Halcyon starcruiser included rooms to sleep in, but it was more than a hotel. It included cast members playing roles, but it wasn't just theater. It included organized activities and collective fine dining, but it wasn't a cruise

ABOVE (from top): Within the Star Wars: Galactic Starcruiser experience, guests enter into the world of Star Wars, not just interacting with familiar characters but taking on a role themselves. First Order stormtroopers stop a young guest in a corridor; a young guest holds a lightsaber in a Standard Cabin, and Chewbacca greets a young guest in the Engineering Room.

ship. It included an unfolding story amplified by sets, projections, and special effects, but it wasn't like any previous park attraction. It was . . . Star Wars: Galactic Starcruiser. It was something entirely new.

As a multiday storytelling adventure, the experience of Star Wars: Galactic Starcruiser would blend together elements of a theme park attraction, a cruise ship, and a resort hotel. The adventure itself would also be different things to different people, depending on their willingness to participate fully in the stories unfolding around them during their two-day "voyage" on the *Halcyon*—accessed via a "spaceport" at the Walt Disney World Resort.

"We knew some guests would play lightly and take a more casual approach," said Alex Lee, production manager, Disney Live Entertainment. "It all depends on how you want to engage. We knew other guests would want to go heavy, LARP [Live Action Role Playing]-style. We built the story line so that you could take in all points of view, depending on how you play, and we could provide all those touch points for guests." It was an entirely new environment with a forward-looking storytelling philosophy: it would be altered in each incarnation by its particular participants, and designed from inception to change and adapt to future technology and developing audience interests.

Spearheaded by Walt Disney Imagineering, the experience required creative input from Imagineering experts in attractions as well as Disney Live Entertainment, and the hospitality and culinary teams from Disney theme park operations groups. Development of the immersive experience began while Bob Chapek was chairman of Walt Disney Parks and Resorts (which became Disney Parks, Experiences and Products, or DPEP, under his leadership, from 2015 to 2020). "I think it's important to keep pushing the envelope," said Chapek, former Chief Executive Officer, The Walt Disney Company. "When Galactic Starcruiser was first brought to my attention . . . [it] broke every dogma about what a multiday experience would have to be—because we had never done it before. But it seemed to me that taking a risk and doing something that really was going to define and redefine that entertainment experience going forward was important. And so we went with it."

The interactivity is both fully immersive—through scheduled activities, elaborately detailed spaces, and incidental conversations between cast members in character and fellow passengers—as well as virtual, through an app on guests' smartphones or tablets. The passengers shape their own experience from the moment they come on board after a "shuttle ride" from the "spaceport." "We know that our guests are very diverse, so we wanted to create story lines that would appeal to different people," Marc Rothschild, producer, Disney Live Entertainment, said. "We have traditional *Star Wars* story lines with the Resistance and the First Order, but then we've also introduced some other story lines, like a romance story line that everyone can interact

with that was crafted for them and their interests." All the narratives interlock with the attractions and theming in Star Wars: Galaxy's Edge at the nearby Disney's Hollywood Studios, and the Starcruiser experience includes a "shore excursion" to Batuu, the home planet for Star Wars: Galaxy's Edge.

The *Halcyon* starcruiser also represents a model for cross-platform storytelling that has become integral to many Disney properties. Elements of the Starcruiser experience draw on Lucasfilm's feature films and television series, as well as Disney's theme parks, and the *Halcyon* and its characters have also now been integrated into *Star Wars* novels, comic books, and other stories. Its many creative tendrils bear some resemblance to the Marvel Cinematic Universe, in which comics inspire interconnected movies and steaming series as well as ever-evolving attractions at the Disney theme parks, particularly the continually updated offerings at each Avengers Campus. Such interwoven storytelling underlines the fact that the term "franchise" no longer refers simply to periodic movie releases complemented by ride-through attractions at the theme parks. Today, a franchise is a living entity with countless incarnations and permutations.

Intersecting, cross-platform narratives are almost as old as the company itself, having begun with Mickey Mouse and Minnie Mouse, Donald Duck, Goofy, and Pluto. From early on, these characters have populated one another's stories and appeared on merchandise and in printed comics and books. Once Disneyland opened, they found new expression there, where guests could finally meet them in person. Mickey & Minnie's Runaway Railway, at Disney's Hollywood Studios, may be the first ride-through park attraction to feature Disney's most beloved couple, but they've both been central to all the theme parks since character greetings were first introduced.

Opening as well in 2023 in Disneyland's Toontown, Mickey & Minnie's Runaway Railway represents another aspect of mining the past to build the future. The character designs for the attraction are based not on the mid-twentieth-century Mickey who became The Walt Disney Company's corporate icon, but on those for the Disney+ shorts series *The Wonderful World of Mickey Mouse*, a continuation of the cartoons that first aired under the simple series name *Mickey Mouse* on Disney Channel from 2013 to 2019. These shows, developed by Paul Rudish, an animator and executive producer, took Mickey's design back to a style close to his earliest shorts but kept him fresh and contemporary, with cameos from characters across the current Disney universe, as well as new locations and original narratives. "I like the old 'pie-eyed' design," Rudish said in an interview shared by his alma mater, CalArts. "Those cartoons were so surreal and very physical. I think we just do what Mickey was good at originally. I wanted to take a page from Walt's old playbook." The new shorts drew not only from early Mickey cartoons, but also from the syndicated comic strip incarnation of Mickey from the same period.

The future of Disney will rely on exactly

that multipronged approach, bringing the past into the future and extending beloved stories, while also creating new characters and tales to expand the legacy. Disney grows like a family tree: familial connections link each generation with the next, but the tree also constantly brings in new partners and personalities to sustain its growth.

The interplay between generations of fans is equally important, as Bob Iger, Chief Executive Officer, The Walt Disney Company, knows from personal experience. Iger was four or five years old when he saw *Cinderella*, sitting with his grandparents during his first trip to a movie theater. "I must have connected with it," he recalled of seeing a 1950s rerelease of the Disney animated classic, "because every time I've seen that movie since, it evokes that memory."

Connecting audiences with beloved stories has been at the heart of The Walt Disney Company since the beginning. Storytelling, Iger said, "is how we're best known. All of our art is tied directly to the stories that we tell." His involvement with story development—whether fielding early pitches at Pixar Animation Studios as part of the SparksShorts animated-shorts program or seeing an early screening of a movie with its creative crew—is "probably the most important part of my job."

Iger emphasized that this focus started with Walt Disney himself: "The whole notion of telling stories and setting as the primary goal touching people's hearts—that's definitely a lesson I've learned from learning as much as I can about Walt."

Another lesson? Walt Disney's "relentless pursuit of perfection," Iger said. "He called it 'plussing'—doing whatever you can to make something that is good great and make something that is great even greater."

Walt Disney made his first impact on Iger in childhood, through a small black-and-white television set. "I remember Walt Disney talking about and showcasing his plans to build Disneyland on television," he said. "I remember very, very distinctly watching Disneyland get built and dreaming of one day being able to go there."

Iger's first visit to the park, in his twenties, had to wait until he'd finished high school in Oceanside, New York, and earned a Bachelor of Science degree in Television and Radio from Ithaca College. After a brief stint as a television weatherman in Ithaca, Iger moved to New York City and joined ABC. He rose steadily at the network, and by the time Disney and Capital Cities/ABC merged in 1996, he was president and COO. He became president and COO of The Walt Disney Company in 2000, CEO from 2005 to 2020,

ABOVE: Walt Disney has inspired Bob Iger, Chief Executive Officer, The Walt Disney Company, throughout his career. On December 7, 2015, Iger joined the dedication of the re-creation of Walt's formal and working offices at The Walt Disney Studios in Burbank, California. Left to right are three of Walt's granddaughters—Michelle Lund, Jennifer Goff, and Joanna Miller—with Iger. The office suite was faithfully reconstructed by the staff of the Walt Disney Archives. Using original furnishings, some items from Walt's collection of miniatures and awards, and his piano, the staff established an immersive exhibit experience where Disney employees and studio guests can gain insight into the company's founder.

executive chairman from 2020 to 2021, and returned as CEO in November 2022.

At every level, Iger has faith in cast members to fulfill the company's storytelling traditions. "Walt gave our cast the name 'cast members' for a reason. He knew that our cast were basically performers—people responsible for creating and delivering magic to others, particularly at our parks," Iger said.

Some of his most satisfying moments on the job are witnessing the impact of that magic in person: seeing a Disney movie with a regular audience, for example, or spending time in the parks. "It's beyond thrilling when I get to see firsthand just how the stories that we tell excite people around the world," he said. "Nothing's better than walking down Main Street in one of our parks and watching guests immerse themselves in the greatness that is Disney theme parks. It never gets old."

LIVING THE STORY

One bottom-line philosophy for The Walt Disney Company that will remain as true in the century to come as it was for the century that's passed is this: "We certainly think that we as Disney can help people make their dreams come true." Those words, from Imagineer Michael Hundgen, could apply to one of several new storytelling ventures—but, in fact, Hundgen was talking about the company's bold exploration of a concept known as Storyliving by Disney. Working with leading developers and other partners, the Walt Disney Imagineering project will create planned residential communities with the flair and attention to detail that Imagineering is known for. The first such development, called Cotino, was announced to be built in the Coachella Valley near Palm Springs, California. "At its core, this is a community," Hundgen said. "This is about people coming together. And it's about what we want people and residents to feel when they're there."

The Palm Springs area has ties to Walt Disney himself, since Walt's family had vacation homes there. In the spirit of Walt's experience, Hundgen said, "We're asking [potential residents] to aspire to make this place their creative oasis, to come dream, and to come think about all of the exciting adventures they can take on in this next chapter. For us it feels like it has an intrinsic link to our founder and our company." Although still subject to changes, the Cotino plan features a Town Center, a lagoon with its own beach, and more than 1,900 homes, both condos and single-family houses. But what will set the project apart from other planned communities is, as Hundgen put it, "that Disney difference. And that will show up in the cast members who are there to operate this development. That will show up in the placemaking. That will show up in the programming and the activities. This is not just a 'build it and then walk away.' This is a living, breathing thing."

More such communities are envisioned at other sites yet to be named, each one planned to take the details of its design and programming from the landscape, history,

and culture from which it emerges, and each, also, with a substantial dose of Disney magic. And what, exactly, does that mean? "I love this question because I think we've wrestled with this as Imagineers," Hundgen said. "What is Disney? What makes something Disney?" The answer may be difficult to define in words, but it is lived out every day through the unique stories the company shares, the comforting placemaking of Disney theme parks and resorts, the singular vacation experiences offered by Disney Cruise Line ships and Adventures by Disney excursions, and the boundless charisma of one particular mouse. It's that unity of feeling, that sense of hope and joy and optimism that Storyliving by Disney—or almost any Disney project—strives to achieve.

The mandate to forever evolve is one that Walt Disney himself felt as far back as when his primary business was creating entertainment for movie theaters. The vast expansion of the Disney organization, particularly in the past four decades, has essentially guaranteed that it will never be still. Already a world leader in filmed entertainment and theme parks, the company has grown to include ownership of a leading television network in ABC, along with that of ESPN, the still-dominant franchise for live sporting events coverage and sports commentary; the world's first family-oriented cruise company, Disney Cruise Line; a successful global stage production division, Disney Theatrical Productions; Pixar Animation Studios, a computer-animation studio that continually breaks new ground with each successful movie release; the many worlds and thousands of characters represented by Marvel Entertainment and Lucasfilm; the legacy and vibrant present-day properties of 20th Century Studios and its many related divisions; and the open-ended possibilities of more than one streaming service. And all of that's far from an exhaustive list—that seemingly keeps expanding. Each new venture has offered myriad possibilities for storytelling, and for empowering fans to shape their own stories.

The building continues at the company, and new ground is broken nearly every day. Stories layer on one upon another, as they have for a hundred years. With that comes an opportunity for a wider range of inclusion and ways to broaden the community, which can ripple out even beyond Disney. It can take place within a fictional story line, such as the Xandar people sharing their culture with guests at EPCOT during the Wonders of Xandar pavilion preshow (which, of course, leads into the world's first Omnicoaster, Guardians of the Galaxy: Cosmic Rewind). It can happen when choosing what series to green-light, such as championing the first onscreen teen Super Hero who is also Muslim to have her own Marvel Studios

ABOVE: Iman Vellani plays the title role in *Ms. Marvel* (2022), an original Marvel Studios series created for Disney+.

series (*Ms. Marvel* on Disney+). And it can be behind the scenes within the entertainment industry itself, such as the Academy Awards recognizing Ariana DeBose as the best actress in a supporting role for *West Side Story* (2021) and marking the first time a person of color from the LGBTQ+ community has won the category.

There is a blueprint to The Walt Disney Company that's been explored in this book: the primacy of story, the focus on character, the thrill of adventure, the attention to placemaking—to name a few strands. With Walt's shining philosophy as its guiding star, The Walt Disney Company will always be moving forward to share its stories, amaze its fans, and make dreams come true. Even one hundred years is just a beginning.

From the Disney100 Celebration and onward along the path forward, Walt's own words continue to echo with possibility: "In this volatile business of ours . . . we can ill afford to rest on our laurels, even to pause in retrospect. Times and conditions change so rapidly that we must keep our aim constantly focused on the future."

ABOVE: Walt—with Mickey Mouse—at his home on Woking Way in Los Angeles circa 1932. Photograph by Tom Collins.

What must concern is **subject** must appeal to a audience interest

us more thoughtfully **matter**... We far wider range of than ever before.

—Walt Disney

ACKNOWLEDGMENTS

Boundless thanks go to the amazing staff at the Walt Disney Archives for their tireless leadership on this project, particularly Rebecca Cline, director; Joanna Pratt, director, operations & business strategy; Kevin Kern, manager, research, and his team, Nicole Carroll, Matt Moryc, Madlyn Moskowitz, Ed Ovalle, Francesca Scrimgeour, and Julia Vargas; Michael Buckhoff, manager, photo library, and his team; as well as the exhibitions team, including Matthew Adams and Amaris Ma. The team at Semmel Concerts Entertainment GmbH working on *Disney100: The Exhibition*, including Ségolène Tudor and Anna Lenhof, were essential colleagues as well.

Paula Sigman Lowery was a full partner in shaping this book, with her boundless Disney knowledge and unflappable kindness. Longtime Disney Editions editorial director Wendy Lefkon was instrumental in getting this project off the ground, while Jennifer Eastwood, senior editor; Winnie Ho, senior manager, design; Monica Vasquez, managing editor; Marybeth Tregarthen, production director; and Anne Peters, production manager, were tireless collaborators from start to photo finish.

We'd also like to thank Bob Chapek, former Chief Executive Officer, The Walt Disney Company; Rick Dempsey, senior vice president, creative, of Disney Character Voices International; John Canemaker, animator, author, and educator; and J. B. Kaufman, film historian and author, for offering their time and perspective on the history and future of the company through personal interviews.

—John Baxter and Bruce C. Steele

This book's producers would like to specially thank these key partners throughout the decades: Justin Arthur, Randy Bright, Holly Brobst, Denise Brown, Michael Buckhoff, Fox Carney, Nicole Carroll, Jonathan Chew, Rebecca Cline, Elinor De La Torre, Alyce Diamandis, Shane Enoch, Jeffrey R. Epstein, Michele Fortier, Ann Hansen, Jennie Hendrickson, Brian Hoffman, Kiran Jeffery, Mike Jusko, Debra Kohls, Aileen Kutaka, Mark LaVine, Taryn Maister, Ryan March, Matt Moryc, Madlyn Moskowitz, Rose Motzko, Nikki Nguyen, Amy Opoka, Chris Ostrander, Ed Ovalle, David Pacheco, Ty Popko, Joanna Pratt, Bob Schneider, Jeremy Schoolfield, Francesca Scrimgeour, Dave Smith, Dave Stern, Katie Strobel, Kimi Thompson, Robert Tieman, Steven Vagnini, Julia Vargas, Michael Vargo, Jackie Vasquez, Mary Walsh and the staff of the Animation Research Library, Cayla Ward, Anne Wheelock, Mindy Wilson, Juleen Woods, and the team at The Walt Disney Family Museum, especially Bri Bertolaccini, Kirsten Komoroske, Caitlin Moneypenny-Johnston, and Caroline Quinn.

Also thank you to those at Disney Publishing: Elizabeth Ansfield, Jennifer Black, Lori Campos, Ann Day, Monique Diman-Riley, Jim Fanning, Michael Freeman, Kelly Forsythe, Alison Giordano, Daneen Goodwin, Tyra Harris, Winnie Ho, Jackson Kaplan, Kim Knueppel, Vicki Korlishin, Kaitie Leary, Meredith Lisbin, Warren Meislin, Lia Murphy, Scott Piehl, Tim Retzlaff, Rachel Rivera, Carol Roeder, Zan Schneider, Alexandra Serrano, Fanny Sheffield, Dina Sherman, Ken Shue, Megan Speer-Levi, Bonnie Steele, Muriel Tebid, Pat Van Note, Lynn Waggoner, Jessie Ward, and Rudy Zamora.

INDEX

ABC, 88, 221, 222, 227, 275
Abrams, J.J., 207
Adassa, 149
Adventures by Disney, 126, 170, 264, 277
Adventures of Ichabod and Mr. Toad, The (1949), 92
Adventures of the Gummi Bears, *Disney's* (1985–1990), Moment 87
Aguilera, Christina, 259
Alacaraz, Lalo, 119
Aladdin (1992), 72, 85, 142, 151, 155, 158, 199, 224, 233, and Moment 23
Algar, James, 165, 167
Alice Comedies (1924–1927), xiv–1, 20, 21, 24, 25, 192, 261, and Moment 1
Alice in Wonderland (1951), 50, 80, 81, 129, 136, 154, 192, 193, 237, 260, and Moment 21
Alice in Wonderland (2010), 81
Allwine, Wayne, 91, 134, 159
"Along the Oregon Trail" (1956), 114
Amsberry, Bob, 258
Anderson, Bill, 110
Anderson, Ken, 227
Anderson-Lopez, Kristen, 152
Andrews, Julie, 96, 97, 244
Annakin, Ken, 58
Anselmo, Tony, 135
Apple Dumpling Gang, The (1975), 260
Aristocats, The (1970), 136
Ashman, Howard, 35, 40, 41, 150, 158
Atencio, Xavier "X," 142, 143, 227
Audio-Animatronics figures, 5, 25, 62, 110, 126, 142, 144, 184, 198, 199, 201, 202, 204, 205, 207, 208, 230, 231, 237, 271, and Moment 61
Audley, Eleanor, 94
Aulani, A Disney Resort & Spa, 170, 172, 245, 264, and Moment 75
Avengers Campus, 242, 274
Avengers: Endgame (2019, Marvel Studios), Moment 37
Babbitt, Art, 75
Bacher, Hans, 45
Baird, Sharon, 258
Bambi (1942), 4, 5, 54, 79, 94, 105, 106, 129, 140, 167, 179, 186, and Moment 51
Bao, Disney and Pixar's (2018), 207
Barry, Dave, 156
Baxter, Tony, 101, 205, 237
Beachler, Hannah, 116, 117
Beatriz, Stephanie, 149
Beaumont, Kathryn, 81
Beauty and the Beast (1991), 38, 40, 41, 64, 96, 136, 142, 151, 153, 155, 158, and Moment 11
Beauty and the Beast (2017), 40, 96
Becket, Welton, 245
Bedknobs and Broomsticks (1971), 192 and Moment 62
Bergman, Alan, 270
Big Hero 6 (2014), Moment 35
Black Cauldron, The (1985), 206 and Moment 63
Black Hole, The (1979), 260 and Moment 85
Black Panther (2018, Marvel Studios), 116, 117
Black Panther: Wakanda Forever (2022, Marvel Studios), Moment 93
Blair, Mary, 110, 145, 201, 231, 236, 237, 269
Blank, Dorothy Ann, 54
Bletcher, Billy, 16, 136, 159
Blunt, Emily, 97
Boag, Wally, 243
Boardman, Thelma, 134
Boseman, Chadwick, 116
Bové, Lorelay, 49
Bradbury, Ray, 221
Brave, Disney and Pixar's (2012), Moment 34

Brave Engineer, The (1950), 53
Braxton, Toni, 155
Broadway, SEE DISNEY THEATRICAL PRODUCTIONS
Broggie, Roger, 198, 199
Brown, Denise, 201
Bruns, George, 142, 143, 154
Bryan, Sue, 200
Bug's Life, A, Disney and Pixar's (1998), 119, 238
Buhlman, Jocelyn, 73
Burgess, Bobby, 258
Burns, Harriet, 200, 212–213
Burr, Lonnie, 258
Burton, Tim, 81
Cabo, Laura, 90
Campbell, Collin, 176
Captain America: The First Avenger (2011, Marvel Studios), 158
Carlson, Joyce, 237
Cars, Disney and Pixar's (2006), 119, 122, 123, 124, 207, 238, 239, 242, and Moment 33
Carter, Ruth, 117
Casarosa, Enrico, 82
Castillo, Mauro, 149
Chapek, Bob, 273
Chapman, Brenda, 46
Chapman, Dave, 208
Chouinard Art Institute, 129
Churchill, Frank, 154
Cinderella (1950), xii, 41, 50, 60–61, 81, 92, 94, 96, 129, 136, 154, 201, 236, 275, and Moment 9
Cinderella (2015), 81
Clampett, Bob, 249
Clark, Charlotte, 249, 250, and Moment 77
Clark, Les, 138
Clements, Ron, 34, 35, 47, 48, 81, 82, 110, 151
Clifford, Ruth, 91, 134
Close, Glenn, 98
Coco, Disney and Pixar's (2017), 102–103, 119, 120–121, 142, 150, 207, and Moment 47
Cole, Tommy, 258
Collins, Tom, 278
Coltrin, Robert (Rob't), 238
Colvig, Pinto, 75, 135, 136
Computer Wore Tennis Shoes, The (1969), 254
Considine, Tim, 259
Coogler, Ryan, 116
Cottrell, Bill, 53
Country Bear Jamboree, 129, 231
Cravalho, Auli'i, 152
Cruella (2021), 98, 99
Crump, Rolly, 270
D'Amaro, Josh, 207
Daisy Duck, Moment 20
Davis McGhee, Virginia, xiv–1, 20, 21 Davis, Alice Estes, 111, 200, 231
Davis, Marc, 86, 87, 88, 92, 94, 98, 110, 111, 129, 227, 230, 237, 270
Davis, Marvin, 217, 226
Davison Aviles, Marcela, 119
de Santiago, Lupe, 231
DeBose, Ariana, 278
Dempsey, Rick, 180, 181
Denton, Matthew, 208
Der Fuehrer's Face (1942), 154
DeVito, Danny, 136
Diamantopoulos, Chris, 134
Dinosaur (2000), 92
Disney, Elias, 6, 7, 14, 16
Disney, Lillian, 20, 70, 196, 216
Disney, Ray, 16
Disney, Roy E., 167
Disney, Roy O., xii, xiii, 3, 6, 7, 14, 16, 18, 19, 20, 21, 24, 40, 70, 74, 133, 146, 217, 221, 222, 249, 250, 255, 265,

270 and Moment 84
Disney, Ruth, 6, 15, 20
Disney, Walt, v, viii, ix, xii, xiii, xiv–1, 3, 4, 5, 6, 7, 8, 9, 10–11, 12, 14, 15, 16, 17, 18, 19, 20, 21, 22, 23, 24, 25, 29, 30, 31, 32, 33, 34, 36, 37, 40, 41, 50, 51, 52, 53, 55, 57, 58, 59, 61, 62, 63, 65, 66–67, 69, 70, 71, 73, 74, 75, 76, 77, 79, 85, 88, 89, 90, 91, 100, 101, 105, 106, 107, 109, 110, 114, 115, 118, 126, 129, 133, 134, 137, 140, 144, 146, 147, 148, 150, 151, 159, 166, 167, 169, 172, 173, 186, 188–189, 191, 192, 193, 194, 195, 196, 197, 198, 199, 200, 202, 204, 205, 208, 209, 212–213, 215, 216, 217, 218–219, 220, 221, 222, 223, 224, 225, 226, 227, 228, 229, 230, 231, 232, 233, 236, 237, 239, 242, 243, 244, 245, 249, 250, 252, 254, 255, 257, 260, 261, 263, 265, 269, 270, 271, 275, 276, 277, 278, 280–281, and Moments 1, 61, 80, 84
Disney100: The Exhibition, xii, xiii, and Moment 95
Disney California Adventure, 201, 216, 238, 239, 242, 243, 244, 245
Disney Channel, 81, 259, 274, and Moments 86 and 90
Disney Conservation Fund, 187
Disney Cruise Line ships, 5, 90, 91, 126, 148, 170, 171, 201, 217, 262, 264, 273, 276, 277, and Moments 74 and 76
Disney Hotel Santa Fe, 245
Disney Miller, Diane, 146
Disney Store, Moment 88
Disney Story Trust, 41, 42, 43, 48, 54, 184
Disney Theatrical Productions, 5, 41, 64, 72, 84, 150, 155, 156, 157, 158, 159, 262, 277, and Moment 43
Disney Wilderness Preserve, 186
Disney's American Legends (2001), 53
Disney's Animal Kingdom Theme Park, 62, 126, 184, 187, 223, 225, 244, and Moment 73
Disney's Animal Kingdom Villas—Kidani Village, 264
Disney's Beach Club Resort, 245
Disney's Blizzard Beach Water Park, 242
Disney's BoardWalk Inn and Villas, 245
Disney's Grand Californian Hotel & Spa, 245, 264
Disney's Hollywood Studios, 62, 91, 142, 223, 232, 239, 242, 243, 244, 245, 274, and Moments 71 and 90
Disney's Hotel New York – The Art of Marvel, 245
Disney's Old Key West Resort, 264
Disney's Polynesian Village Resort, 245
Disney's Typhoon Lagoon Water Park, 242
Disney's Vero Beach Resort, 186, 264
Disney's Yacht Club Resort, 245
Disneyland Paris, 217, 224, 225, 228, 233, 243, 245, and Moment 72
Disneyland Park, x–xi, 5, 7, 8, 9, 10–11, 12, 12–13, 15, 25, 53, 54, 91, 110, 114, 118, 126, 127, 129, 143, 148, 199, 200, 201, 202, 205, 215, 216, 217, 218–219, 220, 221, 222, 223, 224, 225, 226, 227, 228, 229, 230, 231, 232, 236, 238, 239, 242, 243, 244, 245, 256, 261, 263, 264, 269, 270, 272, 274, 275, 277, and Moments 61 and 66
Disneynature, 106, 168, 169, and Moment 57
Docter, Pete, 179
Dodd, Jimmie, 258
Dollard, Kathleen, 196
Donald Duck, 65, 71, 75, 78, 134, 135, 136, 137, 142, 154, 250, 252, 253, 261, 274, and Moments 19 and 20
Drolette, Greg, 46
Duffy and Friends, 100, 223
Dumbo (1941), 79, 85, 92, 136, 154, 224, 229, 260
Durran, Jacqueline, 96
Earle, Eyvind, 50, 51, 94
Ebsen, Buddy, 198
Edwards, Cliff, 148

284

Eisner, Michael, 184
Elemental, Disney and Pixar's (2023), Moment 98
Elizondo, Mike, 149
Ellenshaw, Peter, 11, 109
Emperor's New Groove, The (2000), 237
Encanto (2021), 48, 49, 71, 81, 133, 149, 151, 152, and Moment 49
Englander, Otto, 54
EPCOT, 62, 100, 101, 126, 128, 172, 173, 174–175, 176, 176–177, 177, 178, 179, 184, 223, 225, 242, 270, 277, and Moment 68
Escape to Witch Mountain (1975), 260 and Moment 85
ESPN, 272, 277
Euro Disneyland, SEE DISNEYLAND PARIS
Evans, Bill, 229
Eyerman, Will, 235
Fantasia (1940), 54, 65, 71, 73, 94, 95, 137, 138, 139, 140, 142, 191, 224, 262, and Moment 41
Fantasia/2000 (2000), 140, 141, and Moment 44
Favreau, Jon, 180
Feinberg, Danielle, 102–103
Felix, Paul, 54
Feliz, Rhenzy, 149
Felton, Verna, 136
Ferguson, Norm, 37
Figment, 100, 101
Finch, James, 47
Finding Nemo, Disney and Pixar's (2003), 105, 161, 179, 263, and Moment 55
Finn, Will, 50
Fleischer, Richard, 58
Float, Disney and Pixar's (2019), 207
Flora, Disney, 6, 16
Fonoti, Dionne, 48
Forssell, Lisa, 123
Franke, John, 198
Freleng, Isadore "Friz," 22
Friedman, David, 151
Frozen (2013), 42, 43, 80, 81, 151, 152, and Moment 15
Funicello, Annette, 254, 258, 259
Gaitán, Carolina, 149
Garner, Marcellite, 91, 134, 159
Gay, Margie, 20, 21
Geraghty, Dr. Paul, 48
Gibson, Blaine, 204, 227, 270
Gill, Florence, 135, 136
Gillett, Burt, 134
Gillmore, Jean, 96
Goff, Harper, 127, 229
Goff, Jennifer, 275
Goliath II (1960), 25
Goofy, 65, 75, 135, 137, 261, 274, and Moment 18
Goozee, Dan, 228, 235
Gosling, Ryan, 259
Gottfredson, Floyd, 262
Gracey, Yale, 227
Graves, Michael, 245
Great Locomotive Chase, The (1956), 59
Great Moments with Mr. Lincoln, SEE LINCOLN, ABRAHAM
Great Mouse Detective, The (1986), 206
Greno, Nathan, 42
Guardians of the Galaxy Vol. 3 (2023, Marvel Studios), 116, 270, 277, and Moment 96
Guerrero, Diane, 149
Hahn, Don, 41, 46
Hall of Presidents, The, 15, 199, 225
Hand, Jason, 48
Hannah, Jack, 78
Hardoon, Doris, 223
Harline, Leigh, 148, 154
Harman, Hugh, 25

Harmonious, 128
Harris, Phil, 85, 136
Haunted Mansion (2023), Moment 99
Hawley, Lowell, 59
Hench, John, 22, 50, 51, 53, 118, 227, 228, 269
Henn, Mark, 136
Hercules (1997), 78, 136, 155, 158, 243
Herring, Brian, 208
Hibler, Winston, 165
High School Musical (2006), Moment 45
Holloway, Sterling, 136
Horn, Alan, 180
Horvath, Ferdinand, 52
Hunchback of Notre Dame, The (1996), 92, 128, 155, 158
Hundgen, Michael, 276
Hunt, Linda, 136
Hurter, Albert, 52
Iger, Bob, 228, 229, 266–267, 271, 275, 276
Imagineering Story, The (2019), 223 and Moment 89
In Search of the Castaways (1962), 107
Incredibles, The, Disney and Pixar's (2004), Moment 13
Industrial Light & Magic, 209, 210–211, 271, 272
Inside Out, Disney and Pixar's (2015), 101, 207
Irvine, Kim, 232, 237
Ising, Rudy, 25
Island at the Top of the World, The (1974), 107
Iwan, Bret, 73, 134
Iwerks, Don, 24
Iwerks, Leslie, 66–67, 70, 76
Iwerks, Ub, 24, 25, 66–67, 70, 74, 76, 133, 134, 194
Jackson, Samuel L., 168
Jackson, Wilfred, 133
Jani, Bob, 243
Jensen, George, 227
Jessup, Harley, 123
Jewell, Stuart, 66
Jiggetts-Tivony, Shelby, 201
John, Elton, 91, 159
Johnston, Ollie, 16, 40, 65, 76, 90, 94, 188–189
Jolie, Angelina, 98
Jones, James Earl, 168
Jungle Book, The (1967), 79, 85, 92, 93, 136, 153, and Moment 52
Jungle Book, The (2016), 179, 180
Jungle Cruise (2021), 230
Kahl, Milt, 79, 93
Kamen, Kay, 255, 265
Keane, Claire, 42
Keane, Glen, 93, 118
Kenworthy, John, 66–67
Kenworthy, Paul N., Jr., 166
Kerry, Margaret, 88
Kidnapped (1960), 107, 110
Kim, Glenn, 93, 118
Kim, Jin, 49
Kim Possible (2002–2007), 81
Kimball, Ward, 88, 89
Kinney, Jack, 65
Kirby, Jack, 117
Kirk, Steve, 101, 233, 235
Kostal, Irwin, 146
Lady and the Tramp (1955), 50, 71, 136, 154
Lane, Nathan, 84
Larson, Eric, 194
Laugh-O-gram Films, 19, 20, 24, 29, 192
Lebo M., 156
Lee, Alex, 273
Lee, Jennifer, 43, 54, 152
Lee, John, 122, 181

Lee, Joshua, 208
"Liberty Story, The" (1956), 114
Lightyear, Disney and Pixar's (2022), 206, 207
Lilo & Stitch (2002), 78, 79, 80, 179, 199, and Moment 24
Lincoln, Abraham, 9, 15, 129, 199, 202, 203, 205, 231
Lion King, The (1994), 44–45, 46, 69, 79, 84, 99, 142, 155, 179, 199, 244, and Moment 53
Little Mermaid, The (1989), 34, 35, 40, 42, 47, 69, 80, 81, 82, 93, 105, 118, 136, 151, 153, 155, 158, 233, and Moment 22
Little Mermaid, The (2023), Moment 97
Lizzie McGuire (2001–2004), 81
Loomis, Ann, 196
Lopez, Robert, 152
Love Bug, The (1969), 260 and Moment 85
Luca, Disney and Pixar's (2021), 82, 83, 84
Lucas, George, 209
Lund, Michelle, 275
Luske, Hamilton, 65, 194
Macdonald, Jimmy, 134, 150, 159
Mack, Ginni, 88
MacMullan, Lauren, 159
MacMurray, Fred, 254
Magic Kingdom Park, 15, 60–61, 61, 62, 63, 91, 199, 201, 204, 205, 216, 222, 223, 224, 225, 227, 228, 232, 233, 235, 237, 242, 243, 245, 275, and Moment 68
Make Mine Music (1946), 51, 140
Maleficent (2014), 81
Maleficent: Mistress of Evil (2019), 81
"Man and the Moon" (1955), 115
"Man in Space" (1955), 115
Mancina, Mark, 130–131
Mandalorian, The (2019–, Lucasfilm), 125, 209, 210–211, 261, 271, and Moment 89
Markle, Fletcher, 198
"Mars and Beyond" (1957), 115, 191
Martiniere, Stephan, 113
Mary Poppins (1964), 24, 97, 109, 146, 147, 192, 198, and Moment 42
Mary Poppins Returns (2018), 97
McKim, Sam, 127, 227
Mellomen, The, 142
Melody Time (1948), 51, 140
Menken, Alan, 35, 41, 151, 155, 158
Mickey Mouse, xii, 3, 15, 16, 24, 36, 37, 54, 65, 70, 71, 72, 73, 74, 75, 76, 77, 78, 89, 90, 91, 100, 133, 134, 136, 137, 138, 139, 141, 142, 150, 159, 186, 200, 218–219, 223, 225, 228, 229, 232, 243, 246–247, 249, 250, 251, 252, 253, 256, 257, 258, 259, 261, 262, 263, 265, 274, 275, 278, and Moments 5, 7, 17, 18, 77, 78, 81, 90
Mickey Mouse Book (1930, book), Moment 78
Mickey Mouse Club, 89, 91, 200, 257, 258, 259, 261, and Moment 81
Miller, Joanna, 275
Mills, Hayley, 22, 254
Milotte, Alfred and Elma, 106, 162–163, 166, 167
Minnie Mouse, 24, 72, 74, 75, 76, 77, 90, 91, 100, 133, 134, 159, 223, 232, 250, 251, 261, 265, 274, and Moments 5 and 90
Mintz, Charles, 70, 76, 77
Miranda, Lin-Manuel, 48, 149, 152, 154, 159
Mistry, Bhavna, 245
Miziker, Ron, 243
Moana (2016), 26–27, 47, 48, 79, 80, 82, 85, 130–131, 151, 152, 155, 161, 179, and Moment 36
Moberly-Holland, Sylvia, 54
Monsters, Inc., Disney and Pixar's (2001), 84, 123, 124
Monsters University, Disney and Pixar's (2003), 84
Montan, Chris, 41
Moore, Fred, 65, 73
Moses, Robert, 199

285

INDEX

Ms. Marvel (2022), 277, 278
Mulan (1998), 78, 80, 128, 155, and Moment 12
Muppet Treasure Island (1996), 110
Murphy, Hinano, 161
Musker, John, 35, 47, 81, 82, 110, 151
Mylniczenko, Dr. Natalie, 184
Nash, Clarence "Ducky," 75, 135, 136
National Geographic Expeditions, 126
National Geographic Partners, 169
Nemesio, Ernesto, 120
Newsies (1992), 156, 158
Newton, Robert, 109, 111
Nielsen, Kay, 34
Nierva, Ricky, 123
1964–1965 New York World's Fair, 15, 144, 145, 199, 200, 201, 202, 204, 205, 227, 231, 237, 245, 269, and Moment 67
Now You See Him, Now You Don't (1972), 254
Nunis, Dick, 243
O'Brien, Cubby, 258
Oceanic Story Trust, 47
O'Hara, Paige, 151
Oliver & Company (1988), 15
One Hour in Wonderland (1950), Moment 79
One Hundred and One Dalmatians (1961), 25, 78, 92, 94, 98, 142, 153, and Moment 60
101 Dalmatians (1996), 98
Orbach, Jerry, 136
Oriental Land Company (OLC), 232, 233, 235
Oswald the Lucky Rabbit, 24, 70, 74, 76, 135, 249, 261, 262, and Moment 4
Out, Disney and Pixar's (2020), 207
Ovalle, Ed, 3, 5, 7, 8, 16, 18, 20, 22
Parent Trap, The (1961), 254
Parker, Fess, 59
Paul Bunyan (1958), 51, 53
Pearce, Perce, 54
Pearson, Ridley, 159
Peet, Bill, 98
Pena, Hilcia, 201
Pendleton, Karen, 258
People and Places (1953–1960), 114, 169
Percy Jackson and the Olympians (2024), 209
Peter Pan (1953), 50, 85, 86, 87, 88, 101, 118, 142, 154, 221, 222, 229, 236, 237, 238, and Moment 29
Pete's Dragon (1977), Moment 85
Pfeiffer, Walter, 14, 15
Pinocchio (1940), xii, 29, 33, 34, 40, 79, 82, 85, 88, 89, 90, 94, 105, 140, 148, 153, 179, 194, 255, 260, and Moment 8
Pirates of the Caribbean: The Curse of the Black Pearl (2003), 111, 114, and Moment 32
Pluto, 73, 74, 90, 135, 250, 261, 274 and Moment 17
Pocahontas (1995), 80, 85, 96, 136, 155, 158, and Moment 54
Pollyanna (1960), 254 and Moment 83
Porter, Hank, 252, 253
Powell, Sandy, 97
Predock, Antoine, 245
Price, Harrison "Buzz," 220
Princess and the Frog, The (2009), 69, 80, 81, 136, 153, and Moment 46
Rafferty, Kevin, 238, 239
Ralph Breaks the Internet (2018), 84, 158
Ralston, Marjorie, 91, 134
Ratatouille, Disney and Pixar's (2007), 207
Raya and the Last Dragon (2021), 26–27, 54, 80, 81, and Moment 39
Reddy, Joe, 109
Redmond, Dorothea, 201
Reeves, Bill, 119
Reihm Casaletto, Julie, 200, 269
Rescuers, The (1977), 71

Rice, Tim, 155, 158, 159
Ripa, John, 41, 42
Robin Hood (1973), 136 and Moment 10
Rogers, Wathel, 25, 198, 227
Rohde, Joe, 172, 184
Rose, Anika Noni, 136
Rothschild, Marc, 273
Rudish, Paul, 274
Russell, Keri, 259
Russell, Kurt, 254
Ryman, Herb, 174–175, 217, 221
Sabella, Ernie, 84
Saludos Amigos (1943), 140, 198, 201, 236, 252
Sanders, George, 92
Saving Mr. Banks (2013), 146
Scanlan, Neal, 208
Schwab, Bill, 42, 43, 49, 82
Scifo, Bob, 176, 177
Sears, Ted, 53
Sethi, Neel, 180
Sewell, Hazel, 196
Shaggy Dog, The (1959), Moment 82
Shanghai Disneyland, 100, 111, 112–113, 223, 224
Shank, Don, 82
Sharpsteen, Ben, 15
Sherman, Robert and Richard, 85, 97, 144, 146, 147, 199, 205, 244
Sherwood, Doc, 3, 5, 8, 22
Shurer, Osnat, 26–27, 82
Silly Symphony (1929–1939), 25, 29, 36, 37, 54, 75, 78, 105, 133, 134, 135, 136, 137, 192, 250, 251, 255, and Moments 6, 19, 40, and 50
Sklar, Marty, 216, 263
Skywalker Sound, 209
Sleeping Beauty (1959), 25, 50, 51, 53, 69, 81, 94, 95, 136, 142, 220, 260
Smith, Betty, 194
Smith, Dave, xiii, 3, 222, 244, and Moment 84
Smith, Paul, 154
Smith, Shinique, 246–247
Snoddy, Jon, 207
Snow White and the Seven Dwarfs (1937), xii, 3, 29, 30, 31, 32, 33, 36, 40, 41, 47, 50, 51, 52, 53, 54, 62, 64, 65, 78, 79, 81, 82, 85, 92, 93, 101, 129, 136, 137, 152, 160, 161, 192, 229, 255, 256, 260, 261, 265, and Moment 58
Solis, Octavio, 119
Soul, Disney and Pixar's (2020), 207 and Moment 48
Spears, Britney, 259
Spector, Warren, 262
Stalling, Carl, 36, 77, 133, 134
Stanton, Andrew, 124
Star Wars films, attractions, and experiences (Lucasfilm), 72, 85, 92, 99, 105, 125, 126, 201, 207, 208, 209, 210–211, 239, 240–241, 242, 261, 271, 272, 273, 274, and Moments 38, 89, and 92
Stern, Robert A. M., 245
Stewart, Patrick, 168
Stokes, Robert, 93
Stokowski, Leopold, 73, 137
Stone, Emma, 98, 99
Storyliving by Disney, 217, 276, 277
Strange World (2022), 181, 182, 182–183, 183, and Moment 94
Strongest Man in the World, The (1975), 254
Svensson, Henrik, 208
Swiss Family Robinson (1960), 58, 107, 109, 110, 229
Sword and the Rose, The (1953), 22
Tangled (2010), 41, 42, 80, 85, 153, 158, 263, and Moment 14
Taylor, Erastus, 8
Taylor, Russi, 91, 134, 159

Taymor, Julie, 156
Tenggren, Gustaf, 52
That's So Raven (2003–2007), 81
Thomas, Frank, 16, 65, 85, 90, 94, 98, 99, 188–189
Thomas, Leota Toombs, 200, 201
Thompson, Emma, 98
Three Caballeros, The (1945), 140, 198, 201, 236, 252
Tiemens, Erik, 240
Timberlake, Justin, 259
Tokyo Disneyland Park, 199, 222, 225, 232, 233, 235, 243, and Moment 70
Tokyo DisneySea, 126, 216, 232, 233, 234–235, 235, 245
Tokyo DisneySea Hotel MiraCosta, 233, 245
Tompson, Ruthie, 197
Tonner, Jeanette, 197
Topolos, Paul, 124
Toy Story films and attractions, Disney and Pixar's, 62, 101, 160, 161, 207, 242, 245, 272, and Moment 64
Treasure Cove, 111, 112–113, 223
Treasure Island (1950), 15, 55, 58, 107, 109, 110, 111, and Moment 28
Treasure Planet (2002), 110
Tron (1982), 206
Troob, Danny, 151
Trowbridge, Scott, 126, 239
True-Life Adventures (1948–1960), 105, 106, 107, 114, 126, 162–163, 165, 166, 167, 168, 169, 229, and Moment 27
Trujillo, Dara, 100
Turning Red, Disney and Pixar's (2022), Moment 16
20th Century Studios, 270, 277
20,000 Leagues Under the Sea (1954), 56–57, 58, 59, 107, 108, 109, 222, 233, and Moment 30
21st Century Fox, 169
Tytla, Bill, 64, 65
Up, Disney and Pixar's (2009), 179, 207
Vellani, Iman, 277
Wallace, Oliver, 154
WALL·E, Disney and Pixar's (2008), 124, 181, 207
Walt Disney Studios Park, 242
Walt Disney World Dolphin Hotel, 245
Walt Disney World Resort, 15, 60–61, 61, 62, 63, 91, 100, 101,126, 128, 142, 143, 172, 173, 174–175, 176, 176–177, 177, 178, 179, 184, 185, 186, 187, 199, 201, 204, 205, 216, 222, 223, 224, 225, 227, 228, 230, 232, 233, 235, 237, 239, 242, 243, 244, 245, 263, 264, 270, 272, 273, 274, 275, 278, and Moments 68, 69, 71, 73, and 92
Walt Disney World Swan Hotel, 245
Walton, Tony, 96, 97
WandaVision (2021, Marvel Studios), Moment 91
Ward, Jay, 123
Washington, Ned, 148
Wasikowska, Mia, 81
Watson, Emma, 96
Weiser, Mary, 196, 197
Wenzel, Paul, 58
West Side Story (2021), 278
Williams, Chris, 43
Williams, Roy, 253, 258
Winchell, Paul, 136
Winkler, Margaret, 20, 21, 25
Winnie the Pooh, 69, 97, 136
Wizards of Waverly Place (2007–2012), 81
Wonderful World of Mickey Mouse, The (2022–), 274 and Moment 90
Woolverton, Linda, 40, 155
Wreck-It Ralph (2012), 84, 89, and Moment 25
Wright, Alex, 270
Wright, Samuel E., 137
Zimmer, Hans, 156
Zootopia (2016), 71, 72, and Moment 26

BIBLIOGRAPHY AND SOURCES

Pages viii–ix
Disney, Walt. Quoted in Wisdom, Vol. 32, 1959 (WDA).

Chapter 1
Disney, Ruth F. Personal interview conducted by Dave Smith. 04 November 1974 (WDA).
Disney, Walt. Quoted in "The Marceline Walt Disney Knew" (a reprint of "The Marceline I Knew," *Marceline News*, 02 September 1938). *Missouriland at Yesterland.com*, accessed 26 October 2022, https://www.yesterland.com/marceline.html. Web.
Lane, Anthony. "Wonderful World." *The New Yorker*, 03 December 2006, https://www.newyorker.com/magazine/2006/12/11/wonderful-world. Web.
Ovalle, Ed. Personal interview conducted by Bruce C. Steele. 2022.
Pfeiffer, Walter; Virginia Davis McGhee; Hayley Mills; John Hench. Quoted in *Remembering Walt: Favorite Memories of Walt Disney* by Amy Booth Green and Howard E. Green. Hyperion, 1999, pp. 5, 10, 102, 104.
Price, Thomas. "'Over There': Walt Disney's World War I Adventure." *The Walt Disney Family Museum Blog*, 21 May 2012, https://www.waltdisney.org/blog/over-there-walt-disneys-world-war-i-adventure. Web.
Seastrom, Lucas O. "Hollywood Cartoonland: Walt Disney's Alice Comedies." *The Walt Disney Family Museum Blog*, 25 June 2019, https://www.waltdisney.org/blog/hollywood-cartoonland-walt-disneys-alice-comedies. Web.
"*So Dear to My Heart*: Aunt Margaret." *The Walt Disney Family Museum Blog*, 08 September 2011, https://www.waltdisney.org/blog/so-dear-my-heart-aunt-margaret. Web.
Swopes, Bryan R. "5 November 1911: At 4:04 p.m., Calbraith Perry Rodgers . . ." *This Day in Aviation: Important Dates in Aviation History* on WordPress, 2018, accessed 26 October 2022, https://www.thisdayinaviation.com/5-november-1911/. Web.
Thomas, Bob. *Walt Disney: An American Original*. Hyperion, 1994.
Thomas, Frank; Ollie Johnston. *Disney Animation: The Illusion of Life*. Abbeville Press, 1981; Hyperion, 1995, pp. 77, 380.

Chapter 2
Burchard, Wolf. "Inspiring Walt Disney: The Animation of French Decorative Arts." *metmuseum.org*, accessed 08 November 2022, https://www.metmuseum.org/exhibitions/listings/2021/inspiring-walt-disney. Web.
Canemaker, John. Personal interview conducted by John Baxter. January 2022.
Clements, Ron; Dionne Fonoti; Dr. Paul Geraghty; John Musker; an unidentified elder from Moʻorea. Quoted in *Moana* (2016) press kit (WDA).
Del Vecho, Peter. Quoted in "The Story Behind the Story of *Frozen*." *Oh My Disney: Disney Insider*, accessed 01 January 2022, https://ohmy.disney.com/insider/2013/07/30/the-story-behind-the-story-of-frozen/. Web.
Disney, Walt. Quoted in "Walt Disney and Live-Action Films." *The Walt Disney Family Museum Blog*, 11 January 2011, https://www.waltdisney.org/blog/walt-disney-and-live-action-films. Web.
Disney, Walt; Will Finn. Quoted in *Picture Perfect: The Making of Sleeping Beauty*. EMC West, 2008. Documentary.
Greno, Nathan; Jennifer Lee; John Ripa. Quoted in "The Disney Story Trust." *Disney twenty-three* magazine, Disney Enterprises, Inc., Spring 2016.
Hahn, Don. *Disney's Art of Animation: From Mickey Mouse to Hercules* by Bob Thomas. Hyperion, 1997, p. 138.
Hand, Jason; Lin-Manuel Miranda; Bill Schwab. Quoted in *Encanto* (2021) production notes (WDA).
Hench, John. Quoted in "Walt Disney Archives / Disney Legends / John Hench." *D23.com*, accessed 26 October 2022, https://d23.com/walt-disney-legend/john-hench/. Web.
Kaufman, J. B. Personal interview conducted by John Baxter. January 2022.
McCay, Dick. Quoted in *20,000 Leagues Under the Sea* (1954) production story (WDA).
Shurer, Osnat. Quoted in "Disney Animation Makes Women's History While Making *Raya and the Last Dragon*" by Beth Deitchman. *D23.com*, 25 March 2021, https://d23.com/disney-animation-makes-womens-history-while-making-raya-and-the-last-dragon/. Web.
Thomas, Bob. *Disney's Art of Animation: From Mickey Mouse to Hercules*. Hyperion, 1997, pp. 65–66, 127–131.
Thomas, Frank. Quoted in "Did You Know? 11 Giant-Sized Facts About Walt Disney's Brave Little Tailor" by Jim Fanning. *D23.com*, 20 September 2018, https://d23.com/facts-about-brave-little-tailor/. Web.

Chapter 3
Ali, Lorraine. "Commentary: About Disneyland's Pirates of the Caribbean Bride Auction Redo and Why People Hate It and Love It." *Los Angeles Times*, 14 June 2018, https://www.latimes.com/entertainment/tv/la-et-mn-pirates-of-the-caribbean-auction-makeover-20180614-story.html. Web.
Baxter, Tony. Quoted in "Disney Legend Tony Baxter Doubles Down on Redoing Journey Into Imagination With Figment, Suggests Feature Film." *Attractions Magazine*, 05 December 2020, https://attractionsmagazine.com/disney-legend-tony-baxter-redoing-journey-into-imagination-film-figment/. Web.
Buhlman, Jocelyn. "7 Reasons We Love Celebrating Mickey Mouse." *D23.com*, 17 November 2016, https://d23.com/7-reasons-we-love-celebrating-mickey-mouse/. Web.
Cabo, Laura. Quoted in an interview for *Disney twenty-three* magazine, conducted by Jeffrey R. Epstein, Disney Enterprises, Inc., Summer 2022.
Clements, Ron; Osnat Shurer. Quoted in *Moana* (2016) press kit (WDA).
"Disney Legend Russi Taylor Dies at 75." *D23.com*, 27 July 2019, https://d23.com/about-legends/disney-legend-russi-taylor-dies-at-75/. Web.
Disney, Walt, host. "The Disneyland Story" (aka "What is Disneyland? / The Story of Mickey Mouse"), directed by Robert Florey, 27 October 1954. Aired on television.
Disney, Walt. Quoted in "The Cartoon's Contribution to Children." *Overland Monthly* and *Out West Magazine*, October 1933.
Disney, Walt. Quoted in *Pinocchio* (1940) story meeting notes, 11 December 1937 (WDA).
Fanning, Jim. "Did You Know? 11 Pixie-Dusted Facts About Tinker Bell." *D23.com*, 12 December 2018, https://d23.com/did-you-know-11-pixie-dusted-facts-about-tinker-bell/. Web.
Finch, Christopher. *The Art of Walt Disney: From Mickey Mouse to the Magic Kingdoms and Beyond*. Abrams, 1973, pp. 306, 310.
Garcia, Jason. "Duffy the Disney Bear Lands on U.S. Shores." *Los Angeles Times*, 23 November 2010, https://www.latimes.com/archives/la-xpm-2010-nov-23-la-fi-disney-bear-20101123-story.html. Web.
Gilchrist, Todd. "Interview: Ron Clements and John Musker," *IGN.com*, 02 October 2006, updated 17 May 2012, https://

BIBLIOGRAPHY AND SOURCES

www.ign.com/articles/2006/10/02/interview-ron-clements-and-john-musker. Web.

Hannah, Jack; Art Babbitt. Quoted in *Disney's Art of Animation: From Mickey Mouse to Beauty and the Beast* by Bob Thomas. Hyperion, 1991, pp. 52, 57.

Imagineers, The. *Walt Disney Imagineering: A Behind the Dreams Look at Making the Magic Real*. Hyperion, 1996, 1998, pp. 42–45.

Iwan, Bret. Quoted in "Catching Up with Mickey and Minnie: A D23 Interview with Bret Iwan and Kaitlyn Robrock" by Justin Arthur. *D23.com*, 26 August 2021, https://d23.com/catching-up-with-mickey-and-minnie-a-d23-interview-with-bret-iwan-and-kaitlyn-robrock/. Web.

Iwerks, Leslie; John Kenworthy. *The Hand Behind the Mouse: An Intimate Biography of Ub Iwerks*. Disney Editions, 2001, p. 54.

Johnson, Mindy. *Ink & Paint: The Women of Walt Disney's Animation*. Disney Editions, 2017, pp. 54, 67.

Johnson, Mindy. *Tinker Bell: An Evolution*. Disney Editions, 2013.

Johnson, Zach. "Meet the Characters of Disney and Pixar's *Luca*." *D23.com*, 15 June 2021, https://d23.com/meet-the-characters-of-disney-and-pixars-luca/. Web.

Johnston, Ollie; Frank Thomas. *The Disney Villain*. Hyperion, 1993, pp. 15, 120.

Kaufman, J. B. Personal interview conducted by John Baxter. January 2022.

Kimball, Ward; Milt Kahl; Frank Thomas. Quoted in *Walt Disney's Nine Old Men and the Art of Animation* by John Canemaker. Disney Editions, 2001, pp. 101–102, 137, 189, 203.

Kurtti, Jeff; the Staff of the Walt Disney Archives. *The Art of Disney Costuming: Heroes, Villains, and Spaces Between*. Disney Editions, 2019, pp. 141, 164–167.

Kurtti, Jeff. *Practically Poppins in Every Way: A Magical Carpetbag of Countless Wonders*. Disney Editions, 2018, pp. 14, 62.

Martens, Todd. "At Haunted Mansion 50th Anniversary Bash, Disneyland Stays Weird." *Los Angeles Times*, 09 August 2019, https://www.latimes.com/entertainment-arts/story/2019-08-09/disneyland-haunted-mansion-at-50-party. Web.

Martín, Hugo. "Disney Fans Wait Six Hours for a Popcorn Bucket. Inside the Latest Rare Merch Frenzy." *Los Angeles Times*, 10 February 2022, https://www.latimes.com/business/story/2022-02-10/disney-collectibles-figment-dragon-popcorn-bucket-merchandise. Web.

Maslin, Janet. "Run, Spot, Run. Act, Spot, Act." *The New York Times*, 27 November 1996.

McCartney, Stella. Quoted in a press release about her Minnie Mouse clothing line. January 2022.

Peet, Bill. *Bill Peet: An Autobiography*. HMH Books for Young Readers, 1994.

Rebello, Stephen. *The Art of Pocahontas*. Hyperion, 1995, p. 117.

Stokowski, Leopold. Quoted in "The Sorcerer's Apprentice: Birthplace of *Fantasia*" by David R. Smith. *Millimeter*, June 2016, p. 20.

Thomas, Bob. *Disney's Art of Animation: From Mickey Mouse to Beauty and the Beast*. Hyperion, 1991, p. 58.

Thomas, Frank; Ollie Johnston. *Disney Animation: The Illusion of Life*. Abbeville Press, 1981; Hyperion, 1995, pp. 329, 419, 505.

"Walt Disney Archives / Disney Legends / Russi Taylor" *D23.com*, accessed 26 October 2022, https://d23.com/walt-disney-legend/russi-taylor/. Web.

Walton, Tony. Personal interview, accessed 26 October 2022, https://tonywalton.net/mary-poppins/. Web.

Webb, Eric. "*Cruella* Stars Emma Stone and Emma Thompson Had a Ball Being Evil." *Austin American-Statesman*, 27 May 2021, https://www.statesman.com/story/entertainment/movies-tv/2021/05/27/cruella-interview-emma-stone-emma-thompson-disney/5198860001/. Web.

Wise, Stacy. Quoted in "Minnie Mouse Blooms at Disneyland Park in Honor of Women's History Month" by Sasha Azoqa. *Disney Parks Blog*, 01 March 2022, https://disneyparks.disney.go.com/blog/2022/03/minnie-mouse-blooms-at-disneyland-park-in-honor-of-womens-history-month/. Web.

Chapter 4

Anderson, Bill; Joe Reddy. Quoted in *Swiss Family Robinson* (1960) production notes (WDA).

Disney, Walt, host. "Man in Space," directed by Ward Kimball, 09 March 1955. Aired on television.

Disney, Walt; Alice Estes Davis. Quoted in *Disney Pirates: The Definitive Collector's Anthology* by Michael Singer. Disney Editions, 2017, pp. 21, 53, 58.

Feinberg, Danielle. Quoted in an episode of *The Oh My Disney Show*. Oh My Disney YouTube channel, accessed 01 January 2022, https://www.youtube.com/watch?v=9nssfQH7IVE. Web.

Forssell, Lisa; Jay Ward. Quoted in Disney and Pixar's *Cars* (2006) production notes (WDA).

Singer, Michael. *Disney Pirates: The Definitive Collector's Anthology* by Michael Singer. Disney Editions, 2017, p. 18.

Trowbridge, Scott. Quoted in "Chewie, We're Home." *Disney twenty-three* magazine, Disney Enterprises, Inc., Winter 2015.

Chapter 5

Crother, Bowsley. Review of *Fantasia*. *The New York Times*, 14 November 1940. https://www.nytimes.com/1940/11/14/archives/the-screen-in-review-walt-disneys-fantasia-an-exciting-new.html. Web.

Disney, Walt. Quoted in "Fifteen Fascinating Facts About Fantasia" by Jim Fanning. *D23.com*, accessed 26 October 2022, https://d23.com/15-fascinating-facts-about-fantasia/. Web.

Disney, Walt. Quoted in *Disney's Art of Animation: From Mickey Mouse to Hercules* by Bob Thomas. Hyperion, 1997, pp. 13–14.

Elizondo, Mike; Lin-Manuel Miranda. Quoted in *Encanto* (2021) press release (WDA).

Lee, Jennifer. Quoted in "The Disney Story Trust." *Disney twenty-three* magazine, Disney Enterprises, Inc., Spring 2016.

Mancina, Mark. Quoted in "Disney's *Moana* Original Motion Picture Soundtrack Available Today" press release. Cision PR Newswire, 18 November 2016, https://www.prnewswire.com/news-releases/disneys-moana-original-motion-picture-soundtrack-available-today-300365700.html. Web.

McCarron, Charlie. "Melodic Analysis of 'When You Wish Upon a Star.'" 17 January 2013, https://www.charliemccarron.com/2013/01/melodic-analysis-of-when-you-wish-upon-a-star/. Web.

Sherman, Richard. Quoted in "Behind the Song: 'It's a Small World' by Richard & Robert Sherman." *American Songwriter*, accessed 26 October 2022, https://americansongwriter.com/behind-the-song-its-a-small-world-by-richard-robert-sherman/. Web.

Thomas, Bob. *Walt Disney: An American Original*. Hyperion,

1994, pp. 15, 152.
Zollo, Paul. Quoted in "Behind the Song: 'It's a Small World' by Richard & Robert Sherman." *American Songwriter*, accessed 26 October 2022, https://americansongwriter.com/behind-the-song-its-a-small-world-by-richard-robert-sherman/. Web.

Chapter 6
Disney, Roy E. Quoted in "Roy Disney and True-Life Adventures." Disney Pets and Animals YouTube channel, 01 March 2012, https://www.youtube.com/watch?v=8vodCjv5aK4. Web.
Disney, Walt. Quoted in *The Disney Conservation Fund: Carrying Forward a Conservation Legacy* by John Baxter. Disney Editions, 2016, 2020, p. 14.
Disney, Walt. Quoted in *Walt Disney: An American Original* by Bob Thomas. Hyperion, 1994, p. 238.
Disney, Walt. Quoted in Walt's Files (Publicity)—Byline Stories by Walt Disney, Folder 4 (WDA).
Docter, Pete. Quoted in "Pixar Reveals Early Look at *Up*" by James Keast. *EXCLAIM!* 06 February 2009, http://exclaim.ca/music/article/pixar_reveals_early_look_at_up. Web.
Favreau, Jon. Quoted in "*Jungle Book* Director Jon Favreau Keeps the 19th Century Kipling Tone but Updates the Classic for Modern Times" by Rebecca Keegan. *Los Angeles Times*, 15 April 2016.
Horn, Alan. Quoted in "Jon Favreau Breathes New Life to Kipling Classic The Jungle Book" by Sugandha Rawa. *Business Standard*, 24 February 2016, https://www.business-standard.com/article/news-ians/jon-favreau-breathes-new-life-to-kipling-classic-the-jungle-book-116022400306_1.html. Web.
Milotte, Alfred. Essay in the True-Life Adventures Folder (WDA).
Rohde, Joe. Quoted in "Unforgettable Details of Aulani, A Disney Resort & Spa: Imagineer Joe Rohde on Design and Inspiration" by Tyler Slater. *Disney Parks Blog*, 27 June 2014, https://disneyparks.disney.go.com/blog/2014/06/unforgettable-details-of-aulani-a-disney-resort-spa-imagineer-joe-rohde-on-design-and-inspiration/. Web.
Rohde, Joe. Quoted in *The Disney Conservation Fund: Carrying Forward a Conservation Legacy* by John Baxter. Disney Editions, 2016, 2020, p. 29.

Chapter 7
Baxter, Tony. Quoted in "Disney's Tony Baxter and Scott Trowbridge on Animatronic Storytelling." malibucreek YouTube channel, accessed 26 October 2022, https://www.youtube.com/watch?v=YHOuPkDUP6c. Web.
Broggie, Roger; Walt Disney; Robert Moses. Quoted in "The Early Days of Audio-Animatronics" by Keith Gluck. *The Walt Disney Family Museum Blog*, 18 June 2013, https://www.waltdisney.org/blog/early-days-audio-animatronicsc. Web.
D'Amaro, Josh; Jon Snoddy. Quoted in "Are You Ready for Sentient Disney Robots?" *The New York Times*, 19 August 2021, https://www.nytimes.com/2021/08/19/business/media/disney-parks-robots.html. Web.
Disney, Walt. Quoted in *Walt Disney: The Triumph of the American Imagination* by Neal Gabler. Knopf, 2006, p. 70.
Huemer, Dick. Quoted in "Recollections of Richard Huemer Oral History Transcript." Interview conducted by Joe Adamson, University of California, Los Angeles, Dept. of Theater Arts. Internet Archive, accessed 26 October 2022, https://archive.org/details/recollectionsofr00huem. Web.
Lee, Joshua; Neal Scanlan. Quoted in "Droid Dreams: How Neal Scanlan and the *Star Wars: The Force Awakens* Team Brought BB-8 to Life" by Dan Brooks. StarWars.com, 26 August 2015, https://www.starwars.com/news/droid-dreams-how-neal-scanlan-and-the-star-wars-the-force-awakens-team-brought-bb-8-to-life. Web.
Thomas, Frank; Ollie Johnston. *Disney Animation: The Illusion of Life*. Abbeville Press, 1981; Hyperion, 1995, p. 531.
Tompson, Ruthie. Quoted in *Ink & Paint: The Women of Walt Disney's Animation* by Mindy Johnson. Disney Editions, 2017, p. 105.

Chapter 8
Baxter, Tony. "From the Office of Walt Disney: The World's Fair and Mary Blair." DisneyD23 YouTube channel, 21 April 2016, https://www.youtube.com/watch?v=mOiCR4w5pTU. Web.
Bradbury, Ray. "Letters to the Editor." *The Nation*, 28 June 1958. Also quoted in *Walt Disney Imagineering: A Behind the Dreams Look at Making the Magic Real* by the Imagineers. Hyperion, 1996, 1998, p. 19.
Canemaker, John. *The Art and Flair of Mary Blair*. Disney Editions, 2003, 2014, p. 19.
Davis, Marc; Joyce Carlson. Quoted in *Ink & Paint: The Women of Walt Disney's Animation* by Mindy Johnson. Disney Editions, 2017, pp. 221, 294.
de Santiago, Lupe. Personal interview conducted by Bruce C. Steele. 2019.
Disney, Walt. Quoted in "Disney to Build Futuristic 'World' in Florida" by Norma Lee Browning. *Chicago Tribune*, 25 October 1966. Also quoted in "Walt Disney World Background and Philosophy" by Marty Sklar, 1967 (WDA).
Disney, Walt. Quoted in an interview for the Canadian Broadcasting Company, conducted by Fletcher Markle, 25 September 1963 (WDA).
Docter, Pete; Christopher Merritt. *Marc Davis in His Own Words: Imagineering the Disney Theme Parks*. Disney Editions, 2019, Vol. 1, pp. 47, 340.
Dunlop, Beth. *Building a Dream: The Art of Disney Architecture*. Abrams, 1996; Disney Editions, 2011, p. 71.
Iger, Bob. Quoted in *The Imagineering Story: The Official Biography of Walt Disney Imagineering* by Leslie Iwerks with Bruce C. Steele and special contributions by Mark Catalena. Disney Editions, 2022, pp. 415, 486, 487.
Imagineers, The. *Walt Disney Imagineering: A Behind the Dreams Look at Making the Magic Real*. Hyperion, 1996, 1998, pp. 40–43, 84.
Irvine, Kim. Quoted in "Behind The Scenes: New Adventures Await On The World-famous Jungle Cruise." Disney Parks YouTube channel, 09 July 2021, https://www.youtube.com/watch?v=KWpgLnwB_WI&t=140s. Web.
Irvine, Kim. Quoted in "Take a Trip Back to the Beginning of 'it's a small world.'" Disney Parks YouTube channel, 21 March 2014, https://www.youtube.com/watch?v=9LeQogBE9oM. Web.
Jungmeyer, Jack; Charles Moore. Quoted in *Walt Disney Imagineering: A Behind the Dreams Look at Making the Magic Real* by the Imagineers. Hyperion, 1996, 1998, p. 18, 84.
Kern, Kevin M.; Tim O'Day; Steven Vagnini. *A Portrait of Walt Disney World: 50 Years of the Most Magical Place on Earth*. Disney Editions, 2021, p. 278.
Lynch, Kelsey. "Mickey's Toontown at Disneyland Park to be Reimagined with New Experiences, More Play and Interactivity for Young Families in 2023." *Disney Parks Blog*, 15 November 2021, https://disneyparks.disney.go.com/blog/2021/11/mickeys-toontown-at-disneyland-park-to-be-

BIBLIOGRAPHY AND SOURCES

reimagined-with-new-experiences-and-more-play-and-interactivity-for-young-families-in-2023/. Web.

Marling, Karal Ann, ed. *Designing Disney's Theme Parks: The Architecture of Reassurance*. Flammarion, 1997, p. 105.

McNamara, Mary. "Critic's Notebook: California Adventure Finds Its Happy Place." *Los Angeles Times*, 16 June 2012, https://www.latimes.com/entertainment/la-xpm-2012-jun-16-la-et-cars-land-disney-20120616-story.html. Web.

Neary, Kevin; Susan Neary; Vanessa Hunt. *Maps of the Disney Parks: Charting 60 Years from California to Shanghai*. Disney Editions, 2016, pp. 8–9.

Nunis, Dick. Quoted in "Walt's Apprentice" by Kevin M. Kern and Tim O'Day. *Disney twenty-three* magazine, Disney Enterprises, Inc., Summer 2022.

"1. The Happiest Place on Earth," "4. Hit or Miss," "5. A Carousel of Progress," and "6. To Infinity and Beyond." *The Imagineering Story*. Disney+, 2019. Documentary.

Oriental Land Co., Ltd. "Tokyo DisneySea Project." OLC Group website, accessed 26 October 2022, http://www.olc.co.jp/en/company/history/history05.html. Web.

Rafferty, Kevin. *Magic Journey: My Fantastical Walt Disney Imagineering Career*. Disney Editions, 2019, p. 257.

Ride, Sally. Quoted in "America's First Woman in Space: Sally and Her E-Ticket Ride" by New Mexico Museum of Space History. KRWG.com, 23 May 2018, https://www.krwg.org/regional/2018-05-23/americas-first-woman-in-space-sally-and-her-e-ticket-ride. Web.

Ryman, Herb; Harriet Burns. Quoted in *Walt Disney's Imagineering Legends and the Genesis of the Disney Theme Park* by Jeff Kurtti. Disney Editions, 2008, pp. 12, 87.

Sklar, Marty; John Hench. Quoted in "The Artist as Imagineer," *Designing Disney's Theme Parks: The Architecture of Reassurance* by Karal Ann Marling, ed. Flammarion, 1997, p. 15, 67–68.

"Summer Fireworks at Disneyland, a Beautiful Tradition." *Disney Parks Blog*, 01 July 2010, https://disneyparks.disney.go.com/blog/2010/07/summer-fireworks-at-disneyland-a-beautiful-tradition/. Web.

"The First Ticket Books Are Made Available at Disneyland." D23.com, accessed 26 October 2022, https://d23.com/this-day/the-first-ticket-books-are-made-available-at-disneyland/. Web.

Thomas, Bob. *Walt Disney: An American Original*. Hyperion, 1994, chapter 20, etc.

Vagnini, Steven. "'E' Ticket Memories: Five Favorite Facts About Ticket Books." D23.com, accessed 26 October 2022, https://d23.com/e-ticket-memories-five-favorite-facts-about-ticket-books/. Web.

Chapter 9

Courvoisier, Guthrie. Quoted in "The Courvoisier Galleries: Selling Disney Magic" by Tracie Timmer. *The Walt Disney Family Museum Blog*, 21 February 2017, https://www.waltdisney.org/blog/courvoisier-galleries-selling-disney-magic. Web.

Gluck, Keith. "Selling Mickey: The Rise of Disney Marketing." *The Walt Disney Family Museum Blog*, 08 June 2012, https://www.waltdisney.org/blog/selling-mickey-rise-disney-marketing. Web.

Philadelphia Record. Quoted in "The Courvoisier Galleries: Selling Disney Magic" by Tracie Timmer. *The Walt Disney Family Museum Blog*, 21 February 2017, https://www.waltdisney.org/blog/courvoisier-galleries-selling-disney-magic. Web.

Russell, Kurt. Quoted in "Walt Disney Archives / Disney Legends / Kurt Russell." D23.com, accessed 26 October 2022, https://d23.com/walt-disney-legend/kurt-russell/. Web.

Smith, Shinique. Quoted in *Mickey: The Story of a Mouse*. Disney+, 2022. Documentary.

Tumbusch, Tom. Quoted in "Walt Disney Archives / Disney Legends / Kay Kamen." D23.com, accessed 26 October 2022, https://d23.com/walt-disney-legend/kay-kamen/. Web.

Chapter 10

Chapek, Bob. Personal interview conducted by Bruce C. Steele. 2022.

Disney, Roy O. Quoted in "'We're Just Getting Started': Disneyland's Tencennial in 1965" by Lucas O. Seastrom. *The Walt Disney Family Museum Blog*, 16 July 2020, https://www.waltdisney.org/blog/were-just-getting-started-disneylands-tencennial-1965. Web.

Disney, Walt. Disneyland Tencennial Awards Presentation, 18 July 1965, Disneyland Hotel, Anaheim, California. Speech (WDA).

Disney, Walt, host. "The Disneyland Tenth Anniversary Show," directed by Hamilton S. Luske, 03 January 1965. Aired on television.

Disney, Walt. Quoted in "A Production Viewpoint," *Independent Film Journal*, 01 June 1957. Also quoted in Walt's Files (Publicity)—Byline Stories by Walt Disney, Folder 2 (WDA).

Disney, Walt. Quoted in *Walt Disney Productions Annual Report*, 1950 (WDA).

Disney, Walt. Quoted in Walt's Files (Publicity)—Byline Stories by Walt Disney, Folder 2 (WDA).

Iger, Bob. Quoted in "Disney's massive streaming gamble has arrived. It may change the TV industry forever" by Ryan Faughnder and Meg James. *Los Angeles Times*, 12 November 2019, https://www.latimes.com/entertainment-arts/business/story/2019-11-12/disney-plus-streaming. Web.

Iger, Bob. Quoted in *One Day at Disney: Meet the People Who Make Magic Across the Globe* by Bruce C. Steele. Disney Editions, 2019, pp. 20, 108.

Johnson, Zach. "5 Ways to Fully Immerse Yourself in *Star Wars: Galactic Starcruiser*." D23.com, 25 February 2022, https://d23.com/5-ways-to-fully-immerse-yourself-in-star-wars-galactic-starcruiser/. Web.

Kondolojy, Amanda. "Mickey Mouse to Star in All-New Cartoon Shorts With Classic Comedy, Contemporary Flair" press release. *TV by the Numbers*, 12 March 2013, https://web.archive.org/web/20130316070525/http://tvbythenumbers.zap2it.com/2013/03/12/mickey-mouse-to-star-in-all-new-cartoon-shorts-with-classic-comedy-contemporary-flair/173209/. Web.

Rudish, Paul. Quoted in "Mickey Mouse Returns to Disney+ with CalArtian Paul Rudish at Helm" by Christine N. Ziemba. *24700: News from California Institute of the Arts*, 18 November 2020, https://blog.calarts.edu/2020/11/18/mickey-mouse-returns-to-disney-with-calartian-paul-rudish-at-helm/. Web.

"The Wonders of Xandar Pavilion – Stories from Guardians of the Galaxy: Cosmic Rewind." Walt Disney Imagineering YouTube channel, 03 June 2022, https://www.youtube.com/watch?v=flYGytn04Wk. Web.

Zachary, Brandon. "Wonderful World of Mickey Mouse Director Defines the Series' Magic in Season 2." CBR.com, 18 November 2021, https://www.cbr.com/wonderful-world-of-mickey-mouse-paul-rudish-interview/. Web.

100 MOMENTS OF WONDER

On October 16, 1923, a young man from Kansas City, Missouri, signed a contract in his uncle's modest Hollywood home. That action became the foundation of one of the world's most beloved companies—an entertainment powerhouse that has produced incomparable tales of adventure and discovery, magic, music, and the wonders of history and nature all over the globe.

That contract was the beginning of The Walt Disney Company, and ever since, cherished characters and environments have been brought forth—drawn, stitched, molded, painted, assembled, digitized, printed, and more. All those efforts have led to memorable releases, premieres, and openings across the entertainment spectrum by the company. Unfold these pages to reveal a hundred of our favorites.

THE SPIRIT OF ADVENTURE AND DISCOVERY

27. **December 21, 1948:** *Seal Island*, the first film in the True-Life Adventures series, initially released in theaters.

28. **July 19, 1950:** *Treasure Island*, the company's first complete live-action feature film, released in theaters.

29. **February 5, 1953:** *Peter Pan* released in theaters.

30. **December 23, 1954:** *20,000 Leagues Under the Sea* released in theaters.

31. **November 2, 2001:** Disney and Pixar's *Monsters, Inc.* released in theaters.

32. **July 9, 2003:** *Pirates of the Caribbean: The Curse of the Black Pearl*, the first live-action movie based on the popular Disney theme park attraction, released in theaters, kicking off a fan-favorite franchise.

33. **June 9, 2006:** Disney and Pixar's *Cars* released in theaters, launching the popular franchise.

34. **June 22, 2012:** Disney and Pixar's *Brave* released in theaters.

35. **November 7, 2014:** *Big Hero 6* released in theaters.

36. **November 23, 2016:** *Moana* released in theaters.

37. **April 26, 2019:** *Avengers: Endgame* from Marvel Studios released in theaters, completing the "Phase Three" film series within the Marvel Cinematic Universe.

38. **December 20, 2019:** *Star Wars: The Rise of Skywalker* released in theaters, concluding the Skywalker Saga film series from Lucasfilm, Ltd.

39. **March 5, 2021:** *Raya and the Last Dragon* begins streaming on Disney+.

THE MAGIC OF SOUND AND MUSIC

40. **May 27, 1933:** The Silly Symphony cartoon series short *Three Little Pigs* released in theaters.

41. **November 13, 1940:** *Fantasia*, featuring the first use of stereophonic sound in a movie, released in theaters.

42. **August 29, 1964:** *Mary Poppins* released in theaters.

43. **November 13, 1997:** *The Lion King* stage production premiered on Broadway and ultimately won six Tony Awards.

44. **January 1, 2000:** *Fantasia/2000* released in theaters.

45. **January 20, 2006:** *High School Musical* premiered on television and started a whole new franchise.

46. **December 11, 2009:** *The Princess and the Frog* released in theaters.

47. **November 22, 2017:** Disney and Pixar's *Coco* released in theaters.

48. **December 25, 2020:** Disney and Pixar's *Soul* begins streaming on Disney+.

49. **November 24, 2021:** *Encanto* released in theaters.

THE WORLD AROUND US

50. **July 30, 1932:** *Flowers and Trees*, the first full-color cartoon and first Disney film to win an Academy Award, released in theaters.

51. **August 13, 1942:** *Bambi* released in theaters.

WHERE IT ALL BEGAN

1. **October 16, 1923:** Walt Disney signed a contract to produce the Alice Comedies series, establishing what we now know as The Walt Disney Company.

2. **March 1, 1924:** *Alice's Day at Sea*, the first Alice Comedy film, released in theaters.

3. **January 1926:** The Walt Disney Studios staff moved into a new facility along Hyperion Avenue in Los Angeles. Staff worked from that location until fully moving out in 1940.

4. **September 5, 1927:** *Trolley Troubles*, the first Oswald the Lucky Rabbit cartoon, released in theaters.

5. **November 18, 1928:** The Mickey Mouse cartoon short *Steamboat Willie*, the first appearance of Mickey Mouse and Minnie Mouse, premiered at the Colony Theatre in New York. It was the first fully synchronized sound cartoon.

6. **August 22, 1929:** *The Skeleton Dance*, the first Silly Symphony cartoon series short, released in theaters.

7. **January 13, 1930:** The first Mickey Mouse comic story, eventually known as "Lost on a Desert Island," published.

WHERE DO THE STORIES COME FROM?

8. **February 7, 1940:** *Pinocchio* released in theaters.

9. **February 15, 1950:** *Cinderella* released in theaters.

10. **November 8, 1973:** *Robin Hood* released in theaters.

11. **November 22, 1991:** *Beauty and the Beast* released in theaters.

12. **June 19, 1998:** *Mulan* released in theaters.

13. **November 5, 2004:** Disney and Pixar's *The Incredibles* released in theaters.

14. **November 24, 2010:** *Tangled* released in theaters.

15. **November 27, 2013:** *Frozen* released in theaters.

16. **March 11, 2022:** Disney and Pixar's *Turning Red* begins streaming on Disney+.

THE ILLUSION OF LIFE

17. **September 5, 1930:** The Mickey Mouse cartoon short *The Chain Gang*, with the first appearance of the dog that would become known as Pluto, released in theaters.

18. **May 25, 1932:** The Mickey Mouse cartoon short *Mickey's Revue*, with the first appearance of Goofy (initially called Dippy Dawg), released in theaters.

19. **June 9, 1934:** The Silly Symphony cartoon series short *The Wise Little Hen*, with the first appearance of Donald Duck, released in theaters.

20. **June 7, 1940:** The Donald Duck cartoon short *Mr. Duck Steps Out*, the first time Daisy Duck was referred to by name, released in theaters. Her character, originally referenced as Donna Duck, had debuted in the 1937 short *Don Donald*.

21. **July 28, 1951:** *Alice in Wonderland* released in theaters.

22. **November 15, 1989:** *The Little Mermaid* premiered in theaters in Los Angeles and New York before general release two days later.

23. **November 25, 1992:** *Aladdin* released in theaters.

24. **June 21, 2002:** *Lilo & Stitch* released in theaters.

25. **November 2, 2012:** *Wreck-It Ralph* released in theaters.

26. **March 4, 2016:** *Zootopia* released in theaters.

D

10

YEARS OF

SNEY

WONDER

THE WONDER OF DISNEY

77. 1930: Charlotte Clark and her team began designing and creating the first Mickey Mouse plush dolls.

78. 1930: The first Disney book, *Mickey Mouse Book*, was published by Bibo-Lang.

79. December 25, 1950: *One Hour in Wonderland*, the first Disney television show, broadcasted.

80. October 27, 1954: *Disneyland*, the first weekly Disney television series, began broadcasting. It was later known as *Walt Disney Presents* and *Walt Disney's Wonderful World of Color*, among other names.

81. October 3, 1955: *Mickey Mouse Club*, the first daily Disney television series, began broadcasting.

82. March 19, 1959: *The Shaggy Dog*, the first in a series of wacky live-action comedies, released in theaters.

83. May 19, 1960: *Pollyanna*, the first Disney film to feature fan-favorite actress Hayley Mills, released in theaters.

84. June 22, 1970: Roy O. Disney, Walt's brother and co-founder of The Walt Disney Company, established the Walt Disney Archives in Burbank, California, hiring Disney Legend Dave Smith as chief archivist.

85. October 1980: Ten feature films, including *The Love Bug* (1969), *Escape to Witch Mountain* (1975), *Pete's Dragon* (1977), and *The Black Hole* (1979), became the first Disney home videocassette releases.

86. April 18, 1983: The Disney Channel, Disney's first pay-cable television service, began broadcasting. "The" was removed from the name in 1997.

87. September 14, 1985: The first block of Disney animated television shows began broadcasting on Saturday mornings. Notable programming included *Disney's Adventures of the Gummi Bears*.

88. March 28, 1987: The first Disney Store opened at the Glendale Galleria in California. (A Disney Store located in New York's Times Square opened in 1997.)

WE ARE JUST GETTING STARTED

89. November 12, 2019: Disney+, the flagship Disney streaming service, premiered. Notable programming included *The Mandalorian* and *The Imagineering Story*.

90. March 4, 2020: Mickey & Minnie's Runaway Railway, the theme park attraction based on the hit Disney Channel *Mickey Mouse* cartoon short series (2013–2019), opened at Disney's Hollywood Studios. The shorts also inspired an extension series, *The Wonderful World of Mickey Mouse*, which premiered on Disney+ February 18, 2022.

91. January 15, 2021: *WandaVision*, the first Marvel Studios series to debut on Disney+, begins streaming.

92. March 1, 2022: Star Wars: Galactic Starcruiser, the first multiday immersive experience, opened at Walt Disney World, placing guests into story lines aboard the *Halcyon*.

93. November 11, 2022: *Black Panther: Wakanda Forever* from Marvel Studios released in theaters.

94. November 23, 2022: *Strange World* released in theaters.

95. February 18, 2023: *Disney100: The Exhibition*, an innovative show produced by the Walt Disney Archives and Semmel Exhibitions, launched its global tour at the Franklin Institute in Philadelphia.

96. May 5, 2023: *Guardians of the Galaxy Vol. 3* from Marvel Studios released in theaters.

97. May 26, 2023: *The Little Mermaid*, the live-action reimagining of the Disney animated feature film, released in theaters.

98. June 16, 2023: Disney and Pixar's *Elemental* released in theaters.

99. August 11, 2023: *Haunted Mansion* released in theaters.

100. October 16, 2023: The Walt Disney Company reflects on its hundredth anniversary. The global, multi-month celebration, *Disney 100 Years of Wonder*, honors the milestone.

52. October 18, 1967: *The Jungle Book* released in theaters.

53. June 15, 1994: *The Lion King* premiered in theaters in Los Angeles and New York before general release on June 24.

54. June 23, 1995: *Pocahontas* released in theaters.

55. May 30, 2003: Disney and Pixar's *Finding Nemo* released in theaters.

56. June 27, 2008: Disney and Pixar's *WALL·E* released in theaters.

57. April 22, 2009: *Earth*, the first Disneynature film, released in theaters.

INNOVENTIONS

58. December 21, 1937: *Snow White and the Seven Dwarfs*, the first feature-length animated film, premiered at the Carthay Circle Theatre in Los Angeles.

59. May 6, 1940: The Walt Disney Studios staff completed moving into its newly constructed, state-of-the-art campus in Burbank, California—which remains the company's corporate headquarters to this day.

60. January 25, 1961: *One Hundred and One Dalmatians* released in theaters.

61. June 23, 1963: Walt Disney's Enchanted Tiki Room, the first attraction to use Audio-Animatronics technology, opened in Adventureland at Disneyland.

62. October 7, 1971: *Bedknobs and Broomsticks* had its world premiere in England before opening in the United States on December 13.

63. July 24, 1985: *The Black Cauldron*, Disney's first animated feature film to use early computer-generated animation technology, released in theaters.

64. November 22, 1995: Disney and Pixar's *Toy Story*, the first full-length computer-generated animated feature film, released in theaters.

65. May 29, 2009: Disney and Pixar's *Up*, the first computer-generated animated feature film nominated for a Best Picture Academy Award, released in theaters.

YOUR DISNEY WORLD—A DAY IN THE PARKS

66. July 17, 1955: Disneyland, the world's first "theme park," opened in Anaheim, California.

67. April 22, 1964: Four Disney attractions opened at the 1964–1965 New York World's Fair.

68. October 1, 1971: The Walt Disney World Resort, featuring the Magic Kingdom theme park, opened near Orlando, Florida.

69. October 1, 1982: EPCOT Center, now known as EPCOT, opened at Walt Disney World.

70. April 15, 1983: Tokyo Disney Resort, including the Tokyo Disneyland theme park, opened in Urayasu, Japan.

71. May 5, 1989: The theme park now known as Disney's Hollywood Studios opened at Walt Disney World.

72. April 12, 1992: The Euro Disney Resort, now known as Disneyland Paris, opened near Paris, France.

73. April 22, 1998: Disney's Animal Kingdom Theme Park opened at Walt Disney World.

74. July 30, 1998: The *Disney Magic*, the first Disney Cruise Line ship, set sail on its maiden voyage.

75. August 29, 2011: Aulani, A Disney Resort & Spa, opened on the Hawaiian island of Oahu.

76. July 14, 2022: The *Disney Wish*, the newest Disney Cruise Line ship, set sail on its maiden voyage.

IMAGE CREDITS

Disney Parks, Experiences and Products
Courtesy the **Walt Disney Imagineering Art Collection** on book pages 112–113, 127 (both), 145 (both), 174–175, 176–177 (top), 176 (bottom), 177 (bottom), 201 (bottom), 227 (both), 228, 234–235, 237 (top), and 240–241 (in partnership with Lucasfilm Ltd.).
Courtesy the **Walt Disney Imagineering Photo Collection** on book pages 10–11, 62 (top—left), 143 (top—right and bottom—both), 172, 200 (both), 201 (top—left and right), 203, 204 (top—left), 216, 231, 236 (both), 237 (bottom), and 263 (in partnership with the Sklar family).
Courtesy the **Yellow Shoes Resource Center** on book pages x–xi, 12–13, 60–61, 62 (top—right and bottom—left and right), 100, 128, 170 (all), 171, 173 (both), 178 (all on right), 185 (in partnership with the *One Day at Disney* project), 186 (all), 187, 204 (bottom—left and all on right), 207, 218–219, 239 (all), 244, 245, 264 (all), and 272 (all).

Disney Theatrical Productions
Courtesy the **Disney Theatrical Productions team** on pages 155, 156, and 157 (all).

Lucasfilm Ltd.
© & TM Lucasfilm Ltd. on book pages 207, 208, 210–211, and 240–241 and also for Lucasfilm Ltd. elements in the developmental art by Shane Enoch for the "The Spirit of Adventure and Discovery" and "The Wonder of Disney" gallery posters from *Disney100: The Exhibition* on the "100 Moments of Wonder" pages and the end sheets.

Marvel
© 2023 MARVEL on book pages 116, 117 (all), and 278 and also for Marvel elements in the developmental art by Shane Enoch for the "The Spirit of Adventure and Discovery" and "The Wonder of Disney" gallery posters from *Disney100: The Exhibition* on the "100 Moments of Wonder" pages and the end sheets.

Pixar Animation Studios
© **Disney/Pixar** on book pages 82, 83 (all), 120–121, 122 (in partnership with Disney Publishing), 123 (both), 124, 181, and 206 (bottom) and also for Pixar elements in the developmental art by Shane Enoch for the "The Spirit of Adventure and Discovery" and "The Wonder of Disney" gallery posters from *Disney100: The Exhibition* on the "100 Moments of Wonder" pages and the end sheets.

Walt Disney Animation Studios
Courtesy the **Animation Research Library** on book pages 30 (all), 31 (all), 32, 33 (all), 34 (both), 35, 36 (all), 37 (left—top and bottom), 38 (inset), 42 (all), 43 (all), 44–45, 46, 47, 49 (both), 50, 51, 52, 54 (all), 73, 74, 80, 86 (all), 87 (all), 88, 93 (all), 95 (all), 101 (all), 138 (all), 139 (all), and 195 (all sequence drawings).
Final film frames on book pages 37 (right), 38–39, 48, 64, 69 (all), 72 (second, third, and bottom), 75, 77, 78 (all), 83 (right), 90 (all), 91 (all), 93 (top; middle; and bottom—right), 133, 146 (bottom), 147 (both), 159 (both), 182 (top), 182–183 (top and bottom), 183 (top), and 253.

Walt Disney Archives
Courtesy the **Walt Disney Archives Photo Library and the Walt Disney Archives Research collection** on book pages xii (both), 3 (all), 4, 6 (both), 8, 9, 12 (insets—top and bottom), 14 (both), 17 (both), 20 (all), 21 (all), 23, 24, 25 (all), 29, 55, 56–57, 58 (in partnership with Walt Disney Records), 59, 63, 65, 70, 71, 72 (top), 79, 81 (top), 89, 96, 97, 105 (all), 106 (both), 108 (all), 110, 111 (top and middle), 115, 129 (both), 135 (all), 141, 143 (top—left), 144 (both), 146 (top), 148, 149, 150, 151 (all), 154, 158 (both), 166 (all), 167 (all), 168 (all), 169 (all), 180, 191, 192 (all), 193, 195 (top—left and bottom—right), 196 (all), 198 (all), 202 (both), 204 (middle—left), 215, 216 (both), 220 (all), 221, 222, 249 (both), 250, 251 (all), 252, 254, 256 (all), 258 (both), 259 (both), 261 (both), 265, 269 (both), 270, and 279 and also for the developmental art for the ten gallery posters from *Disney100: The Exhibition* on the "100 Moments of Wonder" pages and the end sheets. "Where Do the Stories Come From?," "The Illusion of Life," and "We Are Just Getting Started" by Shane Enoch and David Pacheco; the remainder poster art by Shane Enoch.
Final film frames courtesy the **Walt Disney Archives Photo Library** on book pages 37 (right), 72 (second, third, and bottom), 75, 77, 90 (all), 91 (all), 111 (bottom, in partnership with The Walt Disney Studios), 159 (both), 206 (top, in partnership with The Walt Disney Studios), 253, and 278 (in partnership with Marvel Studios).

The Walt Disney Studios
Courtesy **The Walt Disney Studios marketing and publicity team** on book pages 81 (bottom) and 99.
Courtesy **Walt Disney Studios Home Entertainment** on book pages 160 (all) and 161 (all).